American Art Since 1900

American Art Since 1900

Revised and expanded edition

BARBARA ROSE

Holt, Rinehart and Winston
New York Chicago San Francisco
Atlanta Dallas Montreal Toronto

To Frank

This is the revised edition of a book originally published in 1967 by
Frederick A. Praeger, Inc., Publishers

Library of Congress Cataloging in Publication Data

Rose, Barbara.
 American art since 1900.

 (World of art series)
 Bibliography: p.
 1. Art, American History. 2. Art, Modern—20th
century—United States. I. Title.
N6512.R63 1975 709'.73 72-83563
ISBN 0-275-43900-3
ISBN 0-275-71650-3 (pbk.)

Printed in the United States of America

789 054 9876543

Contents

Acknowledgments

Since the publication in 1967 of the first edition of this book, which was written chiefly as a text for my own students, the field of modern American art has been far more thoroughly explored than it was when I began my research. I remain now, as I was then, indebted to Meyer Schapiro for his teaching, to Milton Brown for his fundamental discoveries, to Clement Greenberg for his illuminating criticism, and to John Cage for his intellectual stimulation.

I am grateful, too, for the friendship and many insights of William Rubin, Leo Steinberg, E. C. Goossen, Thomas B. Hess, Annette Michelson, and Sheldon Nodelman. I would also like to thank Leo Castelli, John Weber, Lawrence Rubin, André Emmerich, Virginia Zabriskie, Betty Parsons, Klaus Kertess, John B. Myers, and Richard Bellamy for their help and generosity.

The present edition could not have been written without discussions with contemporary artists, especially the late Barnett Newman, Ad Reinhardt, and Robert Smithson, as well as Georgia O'Keeffe, George L. K. Morris, Robert Motherwell, Kenneth Noland, Helen Frankenthaler, Robert Irwin, Claes Oldenburg, Don Judd, and Jasper Johns, whose remarks made over the years have added much to my understanding. I have also learned a great deal from Michael Fried's essays.

I would, in addition, like to acknowledge the contributions to my thinking of my former students Emily Wasserman, Linda Shearer, Willis Domingo, and Nina Bremer. Finally, I want to thank my editors Brenda Gilchrist and Ellyn Childs for their patience and good humor, and Jerry Leiber for his tolerant indulgence.

Chapter One

Apostles of Ugliness

America has yet morally and artistically originated nothing. She seems singularly unaware that the models of persons, books, manners, etc. appropriate for former conditions and for European lands are but exiles and exotics here.
—WALT WHITMAN, *Democratic Vistas*

Nearly two centuries after winning political independence from England, America was still an artistic colony of Europe. The first American artists to aim programmatically at founding a native style consonant with the American experience called themselves The Eight; because of their humble subjects, they later came to be known as the Ash Can School. Carried out for the sake of democracy in art rather than in the name of art for art's sake, the Ash Can School's revolt was determined not by the strength of the American academic tradition but by its weakness. In France, where modern painting took shape, the Ecole des Beaux-Arts and the various private academies provided a solid training, discipline, and tradition from which a new art, still grounded on the principles that made the old masters great, could gradually emerge. In America, the academies were hardly more than organizations that held annual exhibitions. When the American artist rebelled, it was not against the pictorial traditions of Western art (with which he was hardly acquainted in any case), but against the exclusiveness and privilege of the academies and against rules and regulations in general.

The Eight treated themes new to American art—the shabby neighborhoods and seamy life of the urban lower classes. Because some, like Robert Henri and John Sloan, were avowed socialists, they have been equated with the American naturalistic novelists and the muckraking journalists. Actually, their taste in literature like their taste in art was for the French realists; their favorite authors were Balzac and Maupassant. Because they described but did not judge, their intentions

were in effect much closer to those of Balzac and Maupassant than to those of Theodore Dreiser and Frank Norris, who were their contemporaries.

Henri and his "revolutionary black gang," as hostile critics dubbed them, challenged the stuffy discipline of the Academy just as reformers were opposing the authority of the entrenched establishment in other sectors of American life. They were willing to forsake the sacred precincts of high art for the more immediate vitality of popular culture. Their studios were not the plush carpeted ateliers of successful academic artists, but the spare ascetic quarters of brownstone tenements, the forerunners of today's manufacturing-loft studios.

Although the awareness of a national consciousness, of an "American spirit" distinct from European ways of thinking and feeling, came first to such writers as Hawthorne and Melville, Emerson and Thoreau, by the end of the nineteenth century, the painters Winslow Homer and Thomas Eakins had also deliberately begun to turn to native themes. Eakins, responsive to Emerson's and Whitman's pleas for an art that would reflect the unique qualities of the American experience, counseled his students at the Pennsylvania Academy of Fine Arts to "study their own country and to portray its life and types" rather than "spend their time abroad obtaining a superficial view of the art of the old world."[1]

For the most part Eakins' words were not heeded. This was understandable since American art was so little esteemed that when Americans did not purchase from the prestigious French Salon, they bought native imitations of the slick academic works of fashionable Salon painters like Bouguereau and Cabanel.

As the Gilded Age clanked into the twentieth century, American art was cloistered and anemic. Official taste, according to Everett Shinn, the most garrulous member of The Eight, was "swaddled in accessories, fenced in with tasseled ropes and weighted down with chatelaines of bronze name plates." Equally "effete, delicate and supinely refined," painting "lockstepped in monotonous parade in a deadly unbroken circle, each canvas scratching the back of the one in its lead."[2]

It was this vicious circle that Shinn and his friends sought to break. Philadelphia was the scene of this insurrection, whose seeds had already been sown in the musty corridors of the Pennsylvania Academy itself, specifically in Eakins' life class. Eakins' insistence on using nude models for figure studies instead of plaster casts of antique statues marked a break with the spirit as well as the power of the Academy. Eakins' quarrel was not only with the method of academic training as it was retrogressively practiced in puritanical America, but also with

the academic mind, which spurned the everyday reality of contemporary life for the empty formulas of a saccharine Neoclassicism, itself a secondhand imitation of the weakest French examples.

Although Eakins was forced to resign in 1886 for removing the loin cloth from a nude male model, his courageous defiance of prudery and convention made him a hero to young Robert Henri. The son of a fugitive from a Nebraska gun fight, robust young Henri, disenchanted with the fig leaves and gauze draperies of the official style, soon gravitated to the life class of Thomas Anshutz, Eakins' most gifted pupil.

Absorbing as much as he could from Anshutz, Henri became impatient with the provincialism of the Academy. In 1888, he left Philadelphia for Paris. But at the height of the excitement of Post-Impressionism, Henri involved himself not in its challenging milieu, but in the academic atmosphere of the Ecole des Beaux-Arts. Although Henri was impressed with Bouguereau, who cautioned him against the heretical ideas of the Impressionists, he regarded his chance to see Manet's *Olympia* and *The Balcony* as the high point of his trip. What he appreciated in Manet, however, was not his modernism, his flattening of forms and advanced pictorial structure, but his flashy brushwork. And throughout his career, the Manet Henri continued to admire was not the Manet who looked forward to Cézanne but the "Spanish" Manet of the somber palette, who looked backward to Velázquez.

In 1891, Henri was back in Philadelphia. Shortly after his arrival, Charles Grafly, an instructor at the Academy whom Henri had known in Paris, introduced him to two young newspaper illustrators. They were William Glackens and John Sloan, who became Henri's disciple and lifelong friend. Soon Henri's studio at 806 Walnut Street, in the heart of downtown Philadelphia, became the gathering place for a group that included George Luks and Everett Shinn, fellow artist-reporters with Glackens and Sloan on the *Philadelphia Press*. At these gatherings, music, literature, and above all, art were discussed—away from the stifling confines of the Academy.

At twenty-seven, Henri seemed worldly and experienced to his friends, who, although working artists, were scarcely out of their teens. Evenings at 806 Walnut differed from meetings of New York artists' clubs like the Tile Club or the Art Club because there were no officers or any set functions. Henri's studio provided the kind of forum for ideas European artists could find in cafés, but which was rare in America. During the summer of 1893, such discussions were carried on at the Charcoal Club, which had been founded so that artists could sketch informally from life under lighting more adequate than that provided by the dimly lit Academy. At these meetings Henri criticized

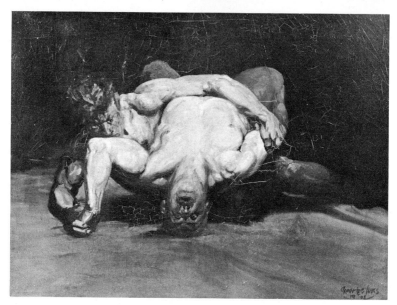

I-I. GEORGE LUKS, *The Wrestlers,* 1905.

sketches and encouraged Glackens and Sloan to try oil painting. Glackens, in fact, painted his first oil, a figure study, the following year, while sharing a studio with Henri. In turn, Glackens persuaded Luks, who previously had done only drawings, to attempt pastels and oils. Soon Luks was exuberantly claiming that he could paint "with a shoestring dipped in pitch and lard," a notion compatible with his ignorance of paint chemistry that later caused many of his pictures to crack.

Luks, who was raised in the Pennsylvania mining district, had a firsthand knowledge of the poverty-stricken miners who were the subjects of his early works. His shabby, unbeautified country people with their dirty animals shocked a public accustomed to the neat and tidy landscapes of the Barbizon masters. Later, like Sloan and Henri, Luks was most attracted by the life of the streets. Urging that art have "guts," he chose as subjects the derelicts and urchins of the poorest neighborhoods, or sweat-drenched athletes like *The Wrestlers (Ill. I-I)*.

For many years Sloan continued to consider himself a newspaperman who painted only as an avocation. As a teen-ager, he had worked for a print dealer, which gave him the opportunity to examine old-master prints. Finally the skill he developed as a draftsman and his eye for detail (he once copied all the illustrations in the dictionary) gained him a job as a newspaper artist-reporter.

In the decade between 1890 and 1900, before newspapers had adapted the photograph to the requirements of daily publications, artist-re-

porters, following in the footsteps of Winslow Homer, who had sketched Civil War battles, functioned as photographers do today. Rushing to fires, strikes, murders, mine disasters, and other sensational events, Sloan, Glackens, Luks, and Shinn recorded their perceptions on any available scrap of paper in a kind of visual shorthand. Encouraged by Henri to translate their sketches into paintings, they used to great advantage the rapid execution and spontaneous style they had developed as newspaper artists.

Adopting the reporter's coolness and lack of sentimentality, they considered picturesque details mere embroidery. Of the group, only Luks, in his unbridled admiration for Hals, chose to paint picaresque waifs and sad old crones. Yet despite their sympathy for liberal causes, their works carried no didactic social message other than a feeling for humanity in all of its possible conditions.

No matter how progressive their social views, the painting of The Eight remained essentially conservative: "Art" for them was remote, intellectual, and European, but "life"—vital, changing, and growing— was American. They could thus agree with Oscar Wilde's views on socialism while rejecting his plea for an art for art's sake, proclaiming, like Henri, the superiority of life over art.

Because of their newspaper experience, they were able to capture what the camera could record in a split-second snap of the shutter; they became expert as well at depicting figures in motion and the psychological nuances of gesture. Atmospheric effects, too, were observed and recorded. Gray was the prevailing tone of their paintings because it was the dominant tone of the city.

Although the realists among The Eight worked often from on-the-spot sketches made during excursions to the country around Philadelphia, they were not *plein-air* painters like the Impressionists. The Americans spurned as "unreal" the light palette and colored shadows of the French. Their own paintings were composed and finished in the studio.

As artist-journalists, they depended a great deal on their ability to recall detail and worked hard at training their memories. Using routines learned from Horace de Boisbaudran's *Training of the Memory in Art,* they would play games to sharpen their perceptions. In a typical game, one member of the group would walk out of a room and then recite its contents from memory. Sometimes they followed strangers to observe and memorize their movements.

When the Charcoal Club disbanded in 1894, talk and sketching continued in Henri's studio. The group at 806 Walnut Street now included James Preston, Edward Davis (art editor of the *Philadelphia Press* and father of Stuart Davis), landscape painter Charles Redfield,

and sculptor A. Stirling Calder (father of Alexander Calder). Often in the course of these sessions, Henri referred to *Talks on Art* by the painter William Morris Hunt. Specifically, Hunt's method emphasized the contrasting of highlights and shadows. Hunt insisted on the possibility of an independent American art, a radical notion in its time. Henri also quoted from George Moore's *Confessions of a Young Man* and from his book on art, which criticized those who admired the Salon painter Bouguereau instead of Manet. Many other writers were discussed too, including Whitman, Emerson, Ibsen, and Chekhov. Tolstoy's essay "What is Art?," which dealt with some of the social implications of art, was a frequent subject for discussion.

By 1898, Robert Henri, just married, had returned to Paris on his honeymoon; Glackens and Luks were in Cuba reporting the war with Spain; and Sloan had temporarily taken a job with a New York newspaper. That year the American Impressionists J. Alden Weir, John Twachtman, and Childe Hassam, along with a group of other malcontents, decided to exhibit together as the American Ten. They intended not so much to be revolutionary as to lure buyers who were ignoring native Impressionism in favor of Paris originals.

Henri, who had first painted in Paris a decade before, by now was reducing his compositions to a series of broadly painted figures, contrasted with equally simple silhouettes of cast shadows. Dramatic lighting provided strong oppositions of light and dark, and broad impasto brushstrokes sufficed to summarize a hand or a sleeve. Often just a single brushstroke could stand for a figure in the distance. Clearly this formula had nothing to do with the brilliantly colored, flat painting of Gauguin and Seurat, nor did it have anything in common with the highly structured compositions being painted by Cézanne. Thus, in 1899, when Henri decided to exhibit a recent painting, *Snow,* he submitted it not to the progressive Salon des Indépendants, but to the official Salon. Although it was rejected, the French Government subsequently purchased the work for the Luxembourg Museum—a triumph for an American.

During his trip, Henri saw the Goyas in Madrid. Goya's ability to capture the textures of flesh and fabrics in a few swift strokes only served to strengthen Henri's commitment to the loose painterly style he had already adopted. On his return to the United States, he settled in New York rather than in Philadelphia. Within the next few years, he was joined there by Glackens, Shinn, Luks, and finally Sloan. By 1904, as work became harder to get on the Philadelphia newspapers, all had migrated to New York. At this time Henri was an instructor at the New York School of Art, also known as the Chase School. Its

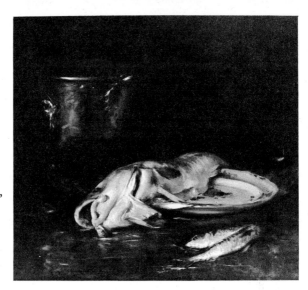

founder, William Merritt Chase, himself a highly successful prac-
titioner of John Singer Sargent's bravura technique, had a number of
pupils, many as distinguished as Henri's. Among them were Charles
Sheeler and Morton Schamberg, both of whom were to revolt against
Chase's methods; and Charles Hawthorne, who worked for many
years in his Provincetown studio, refining and tightening up Chase's
slapdash style.

Although Henri's down-to-earth manner of speech and dress con-
trasted vividly with Chase's aristocratic airs, their painting styles were
not very different. They differed mainly in their choice of subjects:
Chase painted conventional portraits and still lifes, such as *An English
Cod* (*Ill. 1-2*), while Henri chose unglamorized models and action
scenes drawn from the life around him. But both Chase and Henri
were insistent that the marks of excellence in painting were spontaneity
and rapid execution. Chase was famous for his complete figure studies
executed in three hours, from start to finish, standing before the as-
sembled student body. Chase, however, emphasized "delicacy of detail,"
which he claimed was the "essence of art," while Henri believed that
the camera could capture detail so well that the artist should concen-
trate on such subjective matters as the expression of the model and the
communication of his own feelings.

Yet despite these differences of emphasis, neither painter had pro-
gressed far from the "slashing brush" attack and bravura manner of
the Munich School. This broad painterly technique was popularized
by Frank Duveneck in America at the end of the nineteenth century.

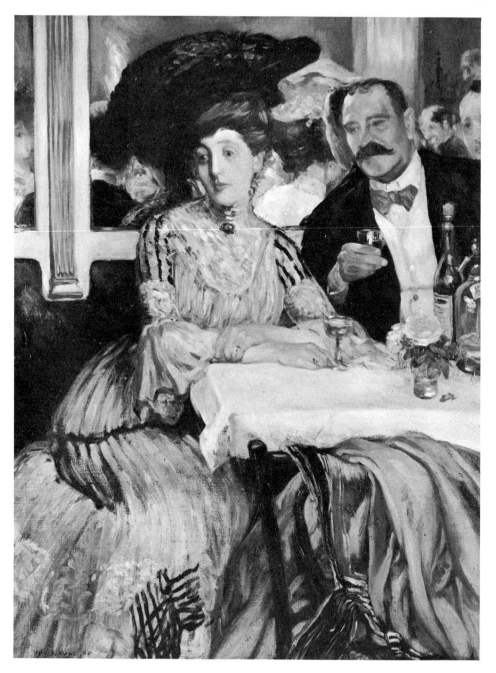

1-3. WILLIAM GLACKENS, *Chez Mouquin,* 1905.

And for Henri, the brushstroke, which could convey so many nuances of feeling, was still the basis for expression in painting. He would categorize strokes according to their function. The single stroke, he noted, might "render form in very wonderful variation"; the charged stroke might carry "the full swing of the body"; and the seemingly effortless stroke might give a look of ease and spontaneity even to a picture that had been "a perfect battle field in its making."[3] (On this score, Henri would often chide Sloan for working so long on a painting that he once described Sloan as the past tense of "slow.")

Much as Henri deprecated the superficiality of Chase's manner and the conventionality of his subjects, he still admired virtuoso painting in which a pyrotechnical display of highlights could mask a faulty if not nonexistent sense of form or structure. As Henri grew older, his technique in fact became looser and less structured, more dependent than ever on glittering surface effects. Of his former disciples, only Shinn continued to delight in showy effects at the expense of composition and form. The others rejected bravura painting. Around 1910, Glackens turned for guidance to the evenly textured surfaces of Renoir, while Sloan adopted the firm structured modeling of Cézanne. In time, Sloan was to become severely critical of his former mentor. "Facility is a dangerous thing," he warned. "Where there is too much technical ease the brain stops criticizing. Don't let the hand fall into a smart way of putting the mind to sleep."[4]

In New York, Sloan, Glackens, and Henri, together with their wives, often met for dinner at Mouquin's, the restaurant Glackens commemorated in his painting *Chez Mouquin* (*Ill. 1-3*). The restaurant proprietor, James Moore, sits at a table with one of his "daughters." Behind Moore, reflected in the mirror, can be seen Glackens' wife, Edith Dimock, and the critic Charles FitzGerald, who later became Glackens' brother-in-law. Both the mirrored images and the free execution of the painting suggest that Glackens was consciously paying homage to Manet's *Bar at the Folies Bergère*. Often joining the group at Mouquin's was Ernest Lawson, the soft-spoken Scot whom Glackens met just after moving to Washington Square in Greenwich Village. On a typical evening at the restaurant in 1904, they might have been discussing FitzGerald's article in the *Evening Sun* defending the first show at the National Arts Club, which the group, now known as the "New York Realists," dominated. Although their work generally had been dismissed as joyless and unhealthy, these former artist-reporters from Philadelphia were receiving some recognition in New York. By 1905, all had been accepted as members of the Society of American Artists, the year before that organization merged with the more con-

servative National Academy of Design. But even though official acceptance seemed imminent, they still had to support themselves by teaching and illustrating.

When Henri was appointed a judge for the National Academy's 1907 spring exhibition, his friends were understandably elated. Their hopes were soon shattered, however, when they learned that Henri was unable to get the jury to accept any of the paintings by his friends Glackens, Luks, and Shinn or by his gifted students Rockwell Kent and Carl Sprinchorn. The final blow came when two of Henri's own canvases were given a "number 2" rating. This meant they were to be hung, not "on the line," which was the preferential position, but either above or below eye level. The furious Henri quickly withdrew his entries. He also gave an interview to *Putnam's* magazine in which he likened those artists who were rejected to other "creators of new art" who had offended official taste, such as Wagner, Walt Whitman, Degas, Manet, and Whistler. In rebuttal, the members of the Academy did not appoint Henri to the jury for the following year. They also denied membership to Ernest Lawson, Arthur B. Davies, and Jerome Myers. Since Lawson, who had studied with Twachtman, was an Impressionist and Davies a romantic in the nineteenth-century tradition, it was difficult to understand the Academy's reason for rejecting them, unless the old guard simply feared to relinquish its privilege to a younger generation.

Sloan and Glackens, angered by the Academy's slight to Henri and realizing that they too would not get their own work shown there, met with Henri to discuss the possibility of a cooperative exhibition to be financed by the artists themselves. An opportunity soon presented itself when William Macbeth, a friend of Davies, offered them exhibition space in his gallery, then the only one in New York that showed contemporary American work. They quickly accepted Macbeth's offer and invited Shinn, Luks, Davies, Lawson, and Maurice Prendergast (a Boston artist whose work Davies particularly admired) to participate with them in the show. FitzGerald, their eager propagandist, was probably responsible for the item that appeared in the *Evening Sun* announcing the exhibit. The item noted it was to be a show of eight artists who were often referred to by those who painted with "T-square and plumb line" as the "apostles of ugliness."

Although some came to jeer, the exhibition of The Eight held in February, 1908, at Macbeth's gallery was at least a qualified success. Macbeth soon ran out of catalogues and sold seven paintings for a grand total of $4,000. Included in the exhibition were Sloan's *Hairdresser's Window* (*Ill. 1-4*) and eight works by Glackens, including

I-4. JOHN SLOAN,
Hairdresser's Window, 1907.

I-5. WILLIAM GLACKENS,
The Shoppers, 1908.

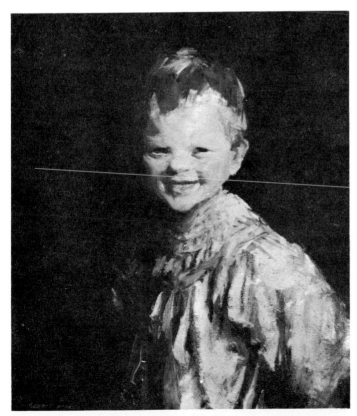

**Paintings in the
1908 exhibition
of The Eight.**

I-6. ROBERT HENRI,
Laughing Boy, 1907.

Chez Mouquin, May Day, Central Park, and *The Shoppers* (*Ill. 1-5*). Among those sold were Henri's *Laughing Boy* (*Ill. 1-6*), but Glackens, Sloan, and Prendergast did not sell a picture. For most of their lives, they were to have trouble with sales, although some years later Dr. Albert Barnes of Philadelphia began buying up their works in quantity. Since they were the most progressive artists of the group, their work was the most likely to outdistance contemporary taste.

Most of the criticism of the show related to the subject matter, which many thought not fit for the living room. "Is it fine art," one critic asked, "to exhibit our sores?" Davies' work was described as somewhere "between genius and insanity," while Henri was berated for his "streak of coarseness." Prendergast's bright, evenly lit Neo-Impressionist landscapes were called "explosions in a paint factory." These were more or less the same terms that critics had used some thirty-five years before when the Impressionists were first denounced. But the work the public found most outrageous was Luks's painting of pigs, although apart from its subject matter, it was an entirely conventional work. The exhibition as a whole was condemned for its "clashing dissonances of eight differently tuned orchestras." The works of the group were indeed heterogeneous: they included realistic cityscapes and genre scenes by Henri, Glackens, Sloan, Shinn, and Luks; quiet Impressionist landscapes by Lawson; the idyllic fantasies of Davies; and the strictly patterned compositions of Prendergast. This so-called dissonance was to set the pattern for later groups of American artists who showed together under no other banner save that of nonconformity.

The following year, Henri established his own art school on upper Broadway in the area where Lincoln Center now stands. Many of his loyal students at the New York School of Art followed him there, including Glenn O. Coleman, Guy Pène du Bois, Rockwell Kent, Carl Sprinchorn, George Bellows, and the young Edward Hopper. Among his students were also several artists who would become the first American modernists, such as Stanton Macdonald-Wright, Patrick Henry Bruce, and Stuart Davis, as well as the poet Vachel Lindsay and such realistic painters as Yasuo Kuniyoshi, Eugene Speicher, and Kenneth Hayes Miller. Near Henri's school, in a Bohemian quarter filled with actors, singers, and dancers, lived other young rebels like Walt Kuhn and Walter Pach. Many of the Bohemians were often recruited as models for the school. Even the playwright Eugene O'Neill frequented the quarter and lived in Bellows' studio during the winter of 1909.

As in the old days at 806 Walnut, Robert Henri was a focus for the energies of the young, stimulating them with his vigorous philosophy

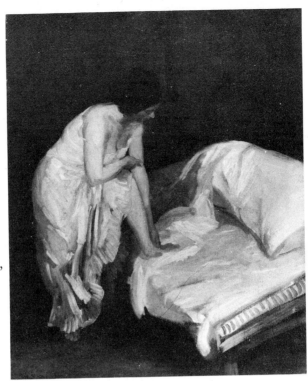

1-7. JOHN SLOAN, *The Cot*, 1907.

of freedom of expression. Often Henri quoted from a book Sloan had given him—a copy of Walt Whitman's *Leaves of Grass*—and inspired his students with Whitman's example of independence and courage. Sometimes he escorted his students to the Metropolitan Museum, where they could see Manet's *Boy with the Sword*, the *Woman with a Parrot*, and the then recently acquired *Funeral*.

Henri's students and friends, trained to wander the streets in search of subjects, began to paint the various ethnic quarters of New York, which in those years were bustling with new immigrants. Sloan especially was attracted to Coney Island, Union Square, and the Bowery; but he also enjoyed recording the homely melodramas he observed from the window of his Twenty-third Street studio. In *The Cot* (*Ill. 1-7*), Sloan captures a slice-of-life fragment in a few broad strokes, achieving the economy of style and candor of treatment that were to distinguish his work.

Another typical Ash Can School subject, Everett Shinn's *Sixth Avenue Elevated After Midnight* (*Ill. 1-8*), evokes the forlorn quality of the city late at night. George Bellows' painting *The Circus* (*Ill. 3-5*) records a moment of high action in the rapid notational manner of the quick sketch. Glackens, although surrounded by the beggars and

21

1-8. EVERETT SHINN,
*Sixth Avenue Elevated
After Midnight,* 1899.

low life who loitered around his Washington Square home, preferred, like Prendergast, to paint the happier scenes of the middle class enjoying itself in Central Park. Henri, Sloan, and Lawson loved the rivers in and around New York. Some of their best canvases depict the bleak winter grimness of these rivers and their slush-covered banks. For these painters, the drama of the New York skyline, with its big overhead constructions and steel bridges, so different from the picturesque bridges of the Seine, came to stand for the energy and dynamism of the city, as it would later for many other painters and poets. In *The Wake of the Ferry* (*Ill. 1-9*), Sloan dramatically contrasts the dark silhouette of the boat in the foreground against the melancholy grayness of the background sky and water. Luks was also capable of suc-

1-9. JOHN SLOAN,
The Wake of the Ferry,
1907.

I-10. GEORGE LUKS, *Roundhouses at Highbridge,* 1909–10.

cessfully rendering atmospheric effects in terms of tonal harmonies, as he demonstrates in his *Roundhouses at Highbridge* (*Ill. 1-10*).

Unlike the former newspaper artists, who chose their subject matter from the immediate contemporary milieu, Arthur B. Davies turned his back on such realities, inventing dreamy landscapes that were the antithesis of the industrial age. His twilight scenes of nymphs enveloped in mist, such as *Unicorns* (*Ill. 1-11*), are closer in spirit to the lyric allegories of Giorgione, or the reveries of Böcklin, than to any actual landscape.

Henri, seeking a means of exhibiting the work of his friends and pupils, and prompted by a new wave of rejections from the National Academy, set out to organize a second group show of independent artists. He had always been against juries, medals, and prizes because, as he pointed out, "great art cannot be measured." In this spirit, he helped Rockwell Kent plan an unjuried independent show to coincide

I-11. ARTHUR B. DAVIES, *Unicorns,* 1906.

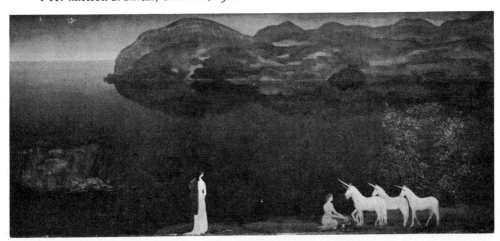

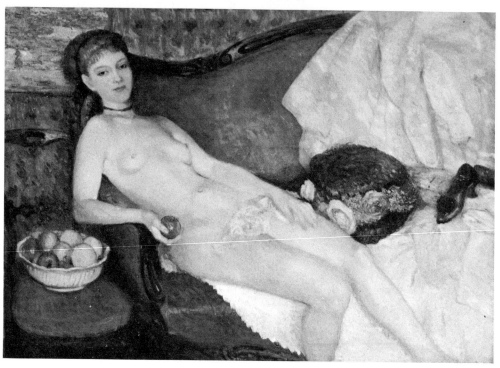

I-12. WILLIAM GLACKENS, *Nude with Apple,* 1910.

with the Academy's spring exhibition in 1910. When the Independents'
show opened in a large building on West 35th Street, hanging in the
place of honor was Henri's portrait of his wife that the Academy had
rejected. Exhibitors, in addition to The Eight, included Henri's stu-
dents Bellows, Davis, Hopper, and Kent, along with more than 200
others. All their entries were democratically hung in alphabetical order.
An hour after the opening, 1,000 people were inside the building;
while outside in the street, a crowd of 1,500 had become so disorderly
that the riot squad had to be summoned. The paintings were attacked
by critics much in the same way that Manet's work had been in 1863.
Sloan's *Three A.M.* was considered "too frank and vulgar"; Glackens'
Nude with Apple (Ill. 1-12) was called coarse and wooden. And
Prendergast, the critics said, couldn't draw properly. But the number
of viewers jamming the exhibition demonstrated that the revolt of
The Eight had been successful. Eventually, Henri brightened his
murky palette, and the others lightened theirs too. Glackens arrived at
a high-colored Impressionism, and Davies converted his idyllic dancers
into bright Cubist mannequins. However, with the exception of Pren-
dergast, America's first modernist, only Sloan struggled (unsuccess-

1-13. MAURICE PRENDERGAST,
Piazza di San Marco, ca. 1898.

fully in the eyes of many) to grasp the fundamental concepts of modernism. This was ironic since Sloan was the only member of The Eight who had not studied in Europe. As their careers progressed, it became clear that the orientation of Shinn, Glackens, and Prendergast was mainly French, while Henri and Luks continued to look to Hals for inspiration. Shinn was indebted to Degas, Glackens to the later Manet and Renoir, and Prendergast—alone among the group—to Cézanne and Seurat.

Of The Eight, only Prendergast, who was never a realist or a pupil of Henri, kept pace with the developments of Neo-Impressionism. First impressed by the Venetian painters on a trip to Venice in 1898, he painted sunny water colors of the canals and piazzas, such as the *Piazza di San Marco (Ill. 1-13).* In Paris, however, he abandoned these conventional compositions in favor of the flattened, artificial space of the Nabis, whose brilliant, decorative patterns inspired by Gauguin's Pont-Aven paintings were the talk of the Parisian art world. Like the young Vuillard, Prendergast broke up his dry, chalky surfaces into a mosaiclike pattern of spots and dabs. Discarding conventional perspective and modeling through chiaroscuro, in *The Promenade (Ill. 1-14),* he united foreground and background in a single continuous plane, as the most advanced French painters were doing.

More typical of the American misunderstanding of the basic concepts

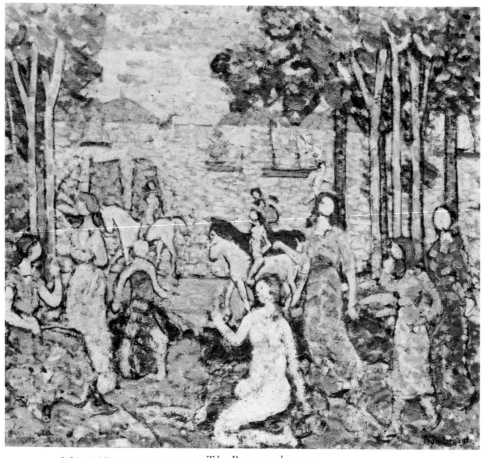

I-14. MAURICE PRENDERGAST, *The Promenade,* 1913.

of European modernism with its diminished illusionism and abstract patterning was Sloan's earnest struggle. Early in his career, Sloan had shown an interest in two-dimensional design as it was applied in Japanese prints. These prints were a main source of the new space and perspective of Impressionist paintings. But Sloan's naive interpretation of the Japanese masters revealed how inadequate his understanding was of their concepts of space and pattern. His interpretations, in contrast with the sophisticated adaptations of Manet and Van Gogh, only clothed the old Western conventions in Japanese guise. They were as modern and as convincing as a Gibson girl in a kimono. Henri, also enthusiastic about Japanese art (he introduced Sloan to the Japanese Commissioner of the 1893 Chicago Fair), was even less adventurous: He went no further than hanging Japanese lanterns in his studio.

If The Eight were not the aesthetic rebels they have been made out to be, at least they were fighters. They introduced a healthy vitality into American art, proclaiming its independence, and raising the possibility of rejecting European models. Against polish, sophistication, contrivance, and finish, they established as their goals candor, immediacy, and directness—the goals adopted by future generations of American artists. Tolerant of stylistic deviations from any norm, they were tolerant of eccentric behavior as well. In such an open, unrestrictive atmosphere American art, freed from the hypocrisies of official taste and academic juries, could flourish and develop.

Because the beginnings of American modernism had such popular sources as newspaper illustration and political cartooning, when the time came for a genuine aesthetic revolt, such a revolt was carried out not against any academic notion of style, but against a provincial, illustrational art, which had in turn become officially entrenched.

Chapter Two

The Largest Small Room in the World

The idea of Secession is hateful to the Americans—they'll be thinking of the Civil War.

—ALFRED STIEGLITZ, *Twice a Year*, 1942

While Henri and his "black gang" in their successful *putsch* against the National Academy exalted the primacy of life over art, the aesthetic revolution that marks the beginning of American modernism was gathering force under the aegis of art for art's sake. This palace revolt took place in what Marsden Hartley described as "the largest small room of its kind in the world." The room was the attic of the brownstone at 291 Fifth Avenue where the photographer Alfred Stieglitz presided over exhibitions of paintings and photographs. With the painter and photographer Edward Steichen, Stieglitz had founded the Little Gallery of the Photo-Secession in 1905 to show photographs. In 1907 he expanded its program to include paintings with an exhibition of the works of Pamela Colman Smith.

By naming his gallery "Photo-Secession," Stieglitz deliberately invoked the spirit of the modernists who called themselves "Secessionists" in Germany and Austria. According to Stieglitz, "Photo-Secession actually means seceding from the accepted idea of what constitutes a photograph."[1] Similarly, the painting and sculpture eventually shown at 291 seceded from the accepted ideas of what constituted art, especially in America. During the decade in which 291 was a center for avant-garde art, Stieglitz presented the first American exhibitions of Matisse (1908), Toulouse-Lautrec (1909), Rousseau (1910), Picabia (1913), and Severini (1917). In April, 1911, 291 exhibited drawings and water colors by Picasso showing his complete evolution through Cubism, and in March, 1914, Stieglitz gave Brancusi his first one-man show anywhere. Stieglitz was responsible for the first exhibition of children's art and the first major exhibition of Negro sculpture. Among the American painters he introduced were Alfred Maurer and John Marin

28

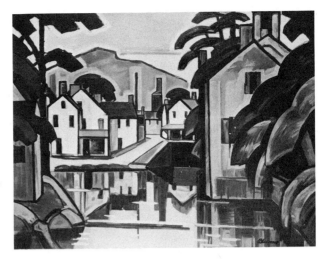

2-1. OSCAR BLUEMNER,
Old Canal Port, 1914.

(1909); Marsden Hartley, Max Weber, Arthur Dove, and Arthur B. Carles (in a group show in 1910); Abraham Walkowitz (1912); Oscar Bluemner (1915); the sculptor Elie Nadelman (1915); Georgia O'Keeffe (1916) and Stanton Macdonald-Wright (1917).

Although 1908 is remembered as the year in which The Eight held their historic exhibition, other events mark it as a signal year in American art. In that year, the socialite sculptress Gertrude Vanderbilt Whitney, purchaser of four of the seven paintings sold by The Eight at Macbeth's, opened the Whitney Studio, which eventually became the Whitney Museum of American Art. In January, 1908, Stieglitz showed fifty-eight drawings by Auguste Rodin at 291. This was the first exhibition of a modern artist in America. During the years just preceding World War I, when Stieglitz sponsored this series of remarkable exhibitions, many of the American artists he exhibited were in Europe, mainly in Paris. In 1908, for example, there was a sufficient number of American artists in Paris to warrant founding a New Society of American Artists there. Thus, when Steichen reported to Stieglitz on the new developments in Paris, he mentioned not only Picasso's first Cubist works and Matisse's Fauve paintings, but also the work of the Americans Alfred Maurer and John Marin. During the explosive first decade of the century, the young Americans frequented the annual Salon des Indépendants and the Salon d'Automne, where they saw retrospectives of Van Gogh, Gauguin, and Cézanne, as well as the work of Matisse and his friends Braque, Derain, and Vlaminck, who had been called *les Fauves* because of their wild colors. When, in 1907, Matisse inaugurated a painting class, several Americans, including Patrick Henry Bruce and Max Weber, were among his first pupils. Other Americans in Paris included the figure painter Bernard

29

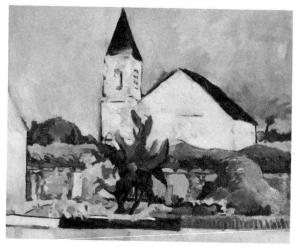

Karfiol, and the future Fauvists Samuel Halpert, Oscar Bluemner, and
Arthur B. Carles. In Bluemner's *Old Canal Port* (*Ill. 2-1*) and Carles's
L'Eglise (*Ill. 2-2*), one can see how profoundly impressed the young
Americans were by Matisse's vision of bold drawing and brilliant color.
Also in Paris during the first decade of the century were the future
Cubists Maurice Sterne, Marguerite and William Zorach, John Covert,
Preston Dickinson, and Andrew Dasburg. The founders of Synchro-
mism, Morgan Russell and Stanton Macdonald-Wright, were there,
too, as were Charles Sheeler and Charles Demuth, who would put
their knowledge of Cubism to a distinctively American use.

Stieglitz described his mission as "trying to establish for myself an
America in which I could breathe as a free man." This was opposite
to the point of view of a whole generation of expatriate writers and
artists who, rather than face America's philistine hostility to modernism
in any form, fled to where the air was already free. Stieglitz was con-
stantly in touch with many of the expatriates, often giving them space
in *Camera Work* before they appeared elsewhere. He was also in close
contact with Gertrude Stein (whom he was first to publish) and her
brothers Michael and Leo, who provided a base of operations for
Americans in Paris. These writers were in search of a more direct
language, just as the painters Stieglitz showed were in search of a
more direct form of visual communication.

In contrast with Henri, whose single cause was American art,
Stieglitz was equally devoted to modern art and to American art. That
there was rivalry between the leaders of the two main art factions is
revealed by contemporary accounts. In April, 1910, when the Society
of Independent Artists held their first exhibition, Stieglitz presented
his first group show of American modernists at 291. Included were

paintings by Dove, Marin, Maurer, and Weber. A review in *Camera Work* castigated the Independents, warning them "you'll never beat the Academy at its own stupid game by substituting quantity for quality!"

To the Stieglitz group Henri and his friends were conventional if not retarded. Henri, on the other hand, found Stieglitz' "ultramodernism" faddish, and since it was unintelligible to the majority, undemocratic. But no one, least of all Stieglitz, would argue that 291 was democratic. "Life" might appeal to the masses, but "art," as Stendhal had pointed out earlier, was for the sensitive, the enlightened, the committed—"the happy few." And it was to the happy few that Stieglitz addressed himself. The audience for the art he showed was miniscule; it consisted mainly of the artists Stieglitz supported and the few writers like Van Wyck Brooks, Waldo Frank, Jerome Mellquist, Randolph Bourne, and Lewis Mumford, who enjoyed the cozy familiarity of the back room at 291.

Stieglitz aroused a good deal of controversy. An enemy described him as "the kind of man who sits when others stand and stands when others sit"; but Oscar Bluemner spoke of him as the man who had renewed his faith in America, "a missionary in blackest Fifth Avenue, a pioneer battling with the white Indians of obsolete New York." To which Stieglitz replied, not quite convincingly, "I am nobody."[2] For Waldo Frank, Stieglitz was one of the great teachers in line with Socrates, Paul of Tarsus, and Karl Marx.

Messiah or false prophet, in any event, Stieglitz was the antithesis of Henri, and 291 represented a viewpoint at odds with that of The Eight and the Independents. Henri's position made it possible for the artist to reject academic practice and official taste without embracing the modern attitude or any of its implications. Thus, the polarization of nonacademic painters in America into two groups, a socially oriented faction and an avant-garde faction—which has endured more or less until the present—was already an accomplished fact early in the twentieth century. But both factions played necessary roles. Henri's democratic, nationalistic stance was necessary to give American art a broad enough base from which to work, to the same degree that Stieglitz' insistence on quality was needed in order to set a standard.

Henri's egalitarianism reflected one aspect of the American character: that celebrated by Whitman in his optimistic populist poems. Stieglitz' fierce independence and relentless defense of the extreme and the radical were representative of another, equally important, aspect: the introspective individualism and spiritual intensity of Thoreau, who chose to isolate himself from society, acknowledging no authority

other than his own conscience. Like Thoreau, those closest to Stieglitz —Marin, Hartley, Dove, and O'Keeffe—all eventually sought refuge in nature from the superficial materialism of the city and the diversions of social life. For them, Thoreau's *Walden* might easily have served as a handbook for daily living, or even as the philosophic guide Thoreau intended it to be.

In other respects, too, the cosmopolitan group that gathered at 291 differed from Henri's rough-and-tumble band. A number, like Weber, Walkowitz, Bluemner, Nadelman, and Joseph Stella, were of European origin. This contrast is intensified by a comparison of Stieglitz' and Henri's backgrounds: Henri, fresh from the frontier just recently closed, became the partisan of democracy in art; Stieglitz, the Berlin-educated son of German-Jewish parents, emerged as the champion of the elite and the avant-garde. Yet these two radically divergent personalities who dominated American art in the first decades of the century shared certain ideals. Both encouraged artists to break with the Academy and to work independently; both were uncompromising in their disregard for fashion and public approval and in their encouragement of young artists. And both were artists themselves, as well as educators. However, Stieglitz was an artist of the first rank, an innovator (who changed the history of photography), which Henri was not.

Stieglitz' early photographs are masterpieces of mood and tonal harmony, easily comparable in theme and treatment to the paintings

2-3. MAX WEBER, *Figure Study,* 1911.

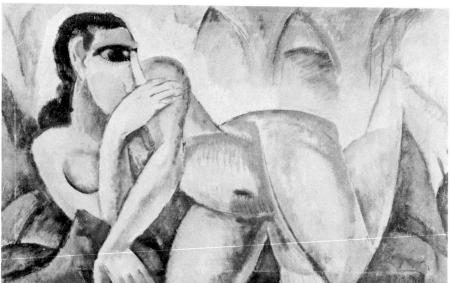

of The Eight. Indeed, Stieglitz' first attacks on the conservative photographic salons resembled Henri's assaults on the Academy to the degree that the photographers of the Photo-Secession were called the Mop and Pail Brigade, as The Eight were later classified as the Ash Can School. Through his conversion to the modernist aesthetic, however, Stieglitz came to believe in the right of the picture to speak for itself, without being subjected to total exhaustion through verbalization. At the same time he conceived of photography as an increasingly abstract medium, in which images are divorced from any other than formal meaning. Inspired by painting, Stieglitz achieved a confluence of the abstract and the concrete which in turn would influence painters.

Although Stieglitz went back and forth to Europe four times between 1904 and 1911, his contact with Max Weber and Abraham Walkowitz, who returned from Paris in 1910, helped to sharpen Stieglitz' eye. Weber, one of the first to recognize the Douanier Rousseau's gifts, had assimilated Cézanne's message almost as quickly as Picasso himself. His nudes of 1910–11 (*Ill. 2-3*), although derivative of Cézanne and Picasso, are remarkable for their acute comprehension of Cubist composition, which was willing to distort reality in the interests of a greater formal coherence.

Like Georgia O'Keeffe, Weber had the good fortune to study with Arthur Wesley Dow, who taught that art resides in harmonious spacing. In Paris, Weber and his friend Samuel Halpert admired the brilliant colors of the Fauves, but Weber was far more original. Although he continued to use high color, he embodied it in a Cubist framework.

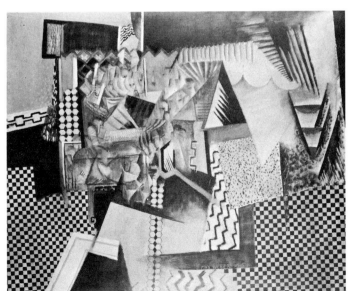

2-4. MAX WEBER, *Chinese Restaurant,* 1915.

33

He insisted that "There can be no color without there being a form, in space and in light with substance and weight, to hold the color. I prefer a form, even if it is in black and white, rather than a *tache* of formless color."[3]

Back in New York, Weber frequented the Museum of Natural History where he found "Chinese dolls, Hopi Katchinas images, and also Indian quilts and blankets . . . much finer in color than the works of modern painter-colorists."[4] These may have been the sources for the abstract patterns of his Cubist paintings on city themes, such as *Chinese Restaurant* (*Ill. 2-4*), and for his original palette of yellows, faded reds, and blacks, and rich full colors. After a series of brilliantly evocative Cubist abstractions celebrating the city, Weber began in 1917 to look inward. He moved to Long Island where he painted scenes remembered from childhood, personal fantasies of grave Talmudists, wistful rabbis, and ceremonial scenes.

Abraham Walkowitz was also a product of the immigrant ghetto culture who found his way to Paris. Jerome Myers described him as the "John the Baptist of pre-Armory days, returning from Paris to preach the gospel of modern art." Interested in children's drawings, he captured the naive freshness of the child's vision in his sketches of subway diggers and workers and in his water colors of bathers. After drawing some notice with his restless studies of skyscrapers effaced in a tangle of lines (*Ill. 2-5*) and of Rodin-like dancers, Walkowitz

2-5. ABRAHAM WALKOWITZ, *New York*, 1917.

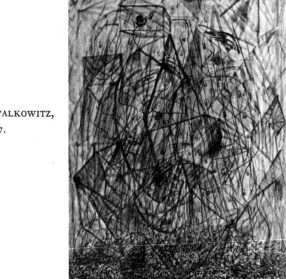

faded into obscurity during the twenties, when he was doing some of his most original work.

In 1916 Stieglitz was shown a roll of sketches by a young woman art teacher. The delicacy of these charcoal drawings moved Stieglitz to exclaim, "finally a woman on paper!" He included ten of them in a group show in May. But O'Keeffe, who had recently returned to New York to continue her study with Dow, ordered him to remove them. Soon, however, they were able to agree. Stieglitz became her dealer and later her husband, and O'Keeffe became the model for some of Stieglitz' most inspired photographs. Rebelling against her early training at the Art Students League, O'Keeffe developed a highly personal vocabulary of forms derived from nature, and an equally personal sense of color, based on the subtle contrasts and massing of tones that Dow counseled. Although her paintings were praised as embodying the feminine principle, O'Keeffe declined to decipher their literal meaning, in a syntax reminiscent of Gertrude Stein, "I found I could say

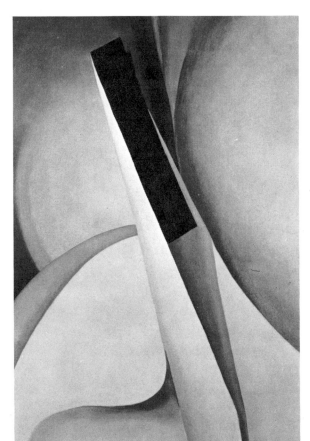

2-6. GEORGIA O'KEEFFE, *Black Spot, No. 2,* 1919.

things with color and shapes that I couldn't say in any other way—things that I had no words for. Some of the wise men say it is not painting, some of them say it is. Art or not Art—they disagree. Some of them do not care."[5]

O'Keeffe, enlarging flowers until they filled the entire canvas with their voluptuous curving petals and tendrils, created a private world in which natural forms were adapted or transformed to express a lyric vision, and real objects became the vehicles for poetic fantasy. Her strange, grayed palette, with its dark greens and muted violets, as well as the degree of simplification and isolation of images from any identifying context, served to heighten the dream-like quality of a work like *Portrait W, No. II* (*Ill. 2-7*). Like Marin, Hartley, and Dove, O'Keeffe found in nature symbolic equivalents for inner emotional states. She did not think of abstracting from nature but of symbolizing nature's generative force. In *Black Spot, No. 2* (*Ill. 2-6*) she evokes landscape without referring to any specific landscape. Stieglitz, too, subscribed to this Symbolist method, calling his photographs "equivalents," in the same spirit that Dove had referred to his series of paintings of 1911–14 as "Nature Symbolized" (*Ill. 2-12*).

Beginning in the late twenties, when O'Keeffe moved to New Mexico and began finding her subjects in the crystalline vistas of the Southwest or in simple architectural forms, her art, like that of Hartley, Dove, and Stella, became more mystical and visionary. In her quivering landscapes, nature is imbued with a pantheistic, transcendental life of its own.

O'Keeffe's later work is increasingly majestic and monumental. A single image—a bleached, desiccated animal skull contrasted with the rich coloration of flowers in bloom, or smooth pelvic bones through which brilliant sky is seen—fills the entire space. Although the strangeness of these images, which deal with death, suggests certain analogies with Surrealism, the images are quite comprehensible within the terms of her own development as an artist.

O'Keeffe's independence and personal struggle made her a symbol of "the new woman." Like Isadora Duncan—the image of uninhibited womanhood for artists like Sloan and Walkowitz who painted her—O'Keeffe, too, was seen as the newly liberated, unconventional modern woman. Modern woman became increasingly popular as a subject for painters at exactly the moment when American women first asserted themselves in the Suffragette movement (in which artists like Glackens and Sloan became personally involved). But the reaction was clearly ambivalent; was modern woman, in terms of the dichotomy of Henry Adams, the Virgin or the Dynamo? Davies saw her as the former,

elevating her to the majestic status of the "Great Mother," whereas the Dadaists Duchamp and Picabia portrayed her as an animated machine, the bitch goddess of the dynamo.

Like the attitude of artists toward women during this transitional period, the American attitude toward sexuality and its representation in art was at best ambivalent. The Puritan downgrading of the life of the senses—even leisure was considered a sin—had so colored American life that writers like William Carlos Williams studied it as a special problem, perhaps the central problem of American culture.

Stieglitz, and the artists closest to him, O'Keeffe, Marin, and Dove, intended their work to convey a specifically sexual charge, although this aim was not part of a formalized program. They believed that the creative life was tied to the life of the senses. Social progress, they thought, would issue from sensual liberation, without which there could be no aesthetic appreciation. The question of whether the repressive, inhibiting antivisual aspect of the Puritan legacy had permanently crippled the American ability to have an aesthetic experience was asked more than once. For example, the unabashed eroticism of Rodin's drawings caused half the subscribers of *Camera Work* to cancel their subscriptions when Stieglitz published several in 1911. The sense of the hidden forces in the subconscious and nature struggling to realize themselves, of the "sublime" as an aspect of American romanticism, unites Stieglitz and his friends to later American painters who sought to externalize these hidden forces in their equally romantic art. Similarly, the return to nature of Stieglitz' most devoted followers hints at the future conflicts of nature versus the city, the human versus the mechanical, which would dominate American art for the next two decades.

John Marin, like Georgia O'Keeffe, found his introduction to modernism through the medium of Oriental art. When he left for France in 1905, Whistler's misty, tonal art was his ideal. By the time he returned from Austria in 1911, he was painting transparent landscapes with an economy, airiness, and spaciousness reminiscent of the old Chinese masters of the brush. The ellisions in his paintings, which parallel the elliptical style of his many letters to Stieglitz, are particularly radical in American painting, which errs in telling too much rather than too little. They seem an answer to the critic Sadakichi Hartmann's plea for an art that is partial, allusive, and fragmentary, an art capable of subtlety and nuance.

Taking as his model Cézanne's sparse, tinted water colors, Marin allowed areas of white canvas to remain bare. Usually the image, a landscape or cityscape, was not painted out to the edge, but floated in

the center, adding to the sense of weightlessness and buoyancy. Marin preferred to qualify his works, not as complete statements but as "pertaining to" a particular scene such as *Region of Brooklyn Bridge Fantasy (Ill. 2-10)*. In his partial, suggestive views of New York and the Maine coast, his two principal themes, he modified Cubism; although objects were fragmented and broken into facets, they were not shattered completely.

In 1914, Marin discovered that the Maine coast and the White Mountains could provide a subject as spectacular as the Alps. Moving gradually eastward, by the twenties he was painting the little islands and lighthouses off Stonington. From this point on, Marin's style—remarkable for its unity and light touch—crystallized; although it grew richer, it did not change much in later years as he continued to find new interpretations for his familiar themes.

Unlike Cubist painters, Marin was interested in capturing atmospheric effects. Air circulates through his paintings, waves are churned by wind, lines bordering facets are often rays of sunlight. Both the transparency of his paint—he even used oil with the fluidity and freshness of water color—and the looseness of his structures, which often explode or are tilted expressionistically, differentiate Marin's space from orthodox Cubist space. His notion of space was based on an understanding of spatial tensions and balances. "As my body exerts a downward pressure on the floor, the floor in turn exerts an upward pressure on my body," he observed, and he wished to express the impact of such forces acting against one another in space. The image he chose was thus not static, but one of a restless world of movement and flux.

Marsden Hartley's early works were influenced by the Italian Impressionist Segantini, rather than by the French artists shown by Stieglitz. In landscapes painted in 1908, such as *Mountain Lake, Autumn (Ill. 2-8)*, Hartley began using Segantini's "stitch," a small, even embroiderylike stroke, to fill in a richly colored canvas. However, the darkly brooding "black mountain" landscapes of 1910, exhibited in his first one-man show at 291, seem close to Ryder's melancholy vision and are more prophetic of his later work.

In 1912, Hartley went to Paris, financed by Stieglitz. The following year he found himself in Berlin, where he met the members of the Blue Rider group, the German Expressionists who used Fauve color in an emotional rather than a decorative style. In the turbulent, sometimes violently distorted art of the German Expressionists Hartley found a spirit in keeping with his own intense nature.

After a brief trip to the United States, Hartley returned to Berlin in 1914. He found Kaiser Wilhelm's Germany, on the brink of World

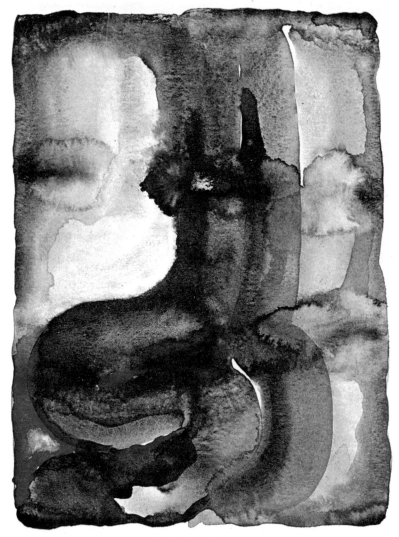

2-7. GEORGIA O'KEEFFE, *Portrait W, No. II*, 1917.

War I, in a military mood. In this atmosphere Hartley painted perhaps his most brilliant pictures, a series of still lifes based on German military emblems, such as *Painting, Number 5 (Ill. 2-11)*. Reviving a modified version of the Segantini "stitch," which gave a kind of uniform pulsating beat to the brushwork, he painted arrangements of badges, ensigns like the Iron Cross and the German imperial flag, and epaulettes in strong reds, blues, and greens, set against dramatic blacks and whites. Flattened out and locked together, these objects became the

2-8. MARSDEN HARTLEY,
*Mountain Lake,
Autumn, ca.* 1908.

basis for an imprecise, intuitive geometry; the stripes of a flag became abstract bands, and contours were reduced to rough repeated arcs. In such a scheme, more abstract and tightly knit than that of the German Expressionists, yet freer than that of the Cubists, Hartley was able to combine the expressive with the highly structured in a remarkable synthesis, not strictly Expressionist or Cubist. This ability to deal decoratively with patterns such as the checkerboard or the zig-zag was probably aided by his close study of American Indian arts, and perhaps of the Coptic textiles he admired.

Back in the United States, Hartley abandoned the hot Expressionist palette, and began to paint delicate Cubist abstractions in pastel colors. Executed in 1916–17, these were his last abstract paintings (*Ill. 4-4*). A wanderer for the next decade, Hartley shuttled back and forth between France, Germany, and New England. In 1926 he settled in Aix-en-Provence, where Cézanne had lived. As if in homage to the French master, he painted several views of Mont-Sainte-Victoire, the mountain painted so often by Cézanne, although the broad broken strokes and raw primaries of Hartley's landscapes are clearly post-Cézanne.

In Mexico during 1932–33, Hartley began to paint in the crude, deliberately primitive manner that marks his late style. Having experimented with Fauvism and Cubism, he found them ultimately alien to his sensibility, and returned to the rough, churning manner that is evocative of Ryder. Early in his career Hartley had explained Ryder's

attraction for him, stating that Pissarro, Cézanne, and Seurat were mere "logicians of color" compared to Ryder, who stimulated his "already tormented imagination."[6]

Ultimately, Hartley found the heroic subject for which he had searched in the powerful silhouette of Mt. Katahdin and the giant forests and craggy rocks of the Maine coast. Celebrating his return to his birthplace in a poem entitled "The Return of the Native," he insisted on declaring himself "the painter from Maine." In the drama of the simple fishermen, Hartley found the tragic theme of death at sea which inspired such paintings as the *Fishermen's Last Supper—Nova Scotia* (*Ill. 2-9*). Like Eugene O'Neill, he was able to extract the tragic from the prosaic realities of American life.

Arthur Dove, like Marin, was essentially a nature painter of lyrical impulse whose orientation was Expressionist. Dove's attachment to nature ran deep; for a time he supported himself as a farmer. He differed from the other members of the Stieglitz group in that he viewed nature in abstract terms. A successful illustrator, Dove was attracted to Fauvism as soon as he encountered it at the Salon d'Automne, to which he and his friend Alfred Maurer both submitted works.

Dove's 1910 "extractions" from nature, as he called them, are among the earliest abstract works painted in America, and bear the same date as Kandinsky's first abstractions, which Dove could not have known. In early landscapes, such as *Nature Symbolized, No. 2* (*Ill. 2-12*), Dove often opposed the swelling curves of radial forms to the saw-

2-9. MARSDEN HARTLEY, *Fishermen's Last Supper—Nova Scotia*, 1940–41.

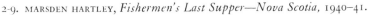

2-10. JOHN MARIN, *Region of Brooklyn Bridge Fantasy*, 1932.

tooth edges of pronged or cog-like forms, using black or white lines as a pulsating, breathing contour for mass. His ambition, he said, was to "take wind and water and sand as a motif and work with them" but, he cautioned, that the motif "has to be simplified in most cases to color and force lines and substances, just as music has done with sound."[7] In color he sought to capture the essential characteristic of a form or an atmospheric effect. He called this its "condition of light."

Dove understood modernism as Stieglitz did, as an experimental, laboratory situation "making research into life and all human thought and emotion to find young healthy plants that can stand the test of growing among things that are lasting through the ages."[8] It is hard to know where Dove came by such an adequate understanding, given his limited acquaintance with modern art and its history. But like O'Keeffe, who did not travel in Europe, he seems to have arrived at a spontaneous modern style generated by a philosophy of life which

42

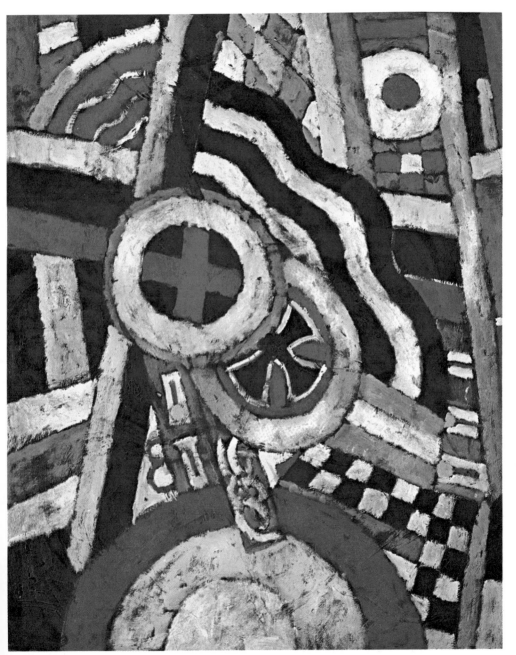

2-11. MARSDEN HARTLEY, *Painting, Number 5*, 1914–15.

2-12. ARTHUR DOVE, *Nature Symbolized, No. 2,* 1914.

exalted the spiritual in nature. Perhaps he might have arrived at such a formulation as easily from reading Thoreau as from reading Kandinsky's *On the Spiritual in Art.*

Although he never identified it as such, synesthesia, too, interested Dove. He thought he could not only symbolize the forces of nature, but also create concrete images of sounds, like the foghorn whistle he could hear from his houseboat as he floated around Long Island Sound. Like John Marin, Charles Burchfield, and other Americans, he invested natural forms and inanimate objects—dancing trees, bug-eyed ferries—with a pulsating energy of their own. Gradually purging this tendency to anthropomorphize, Dove arrived at an increasingly pure abstraction which, in its lyric grace and simplicity, appears now as prophetic of the most recent developments in American painting. In the late thirties he began to set areas of color side by side, substituting flatter, more regular shapes for the expanding and contracting organic forms of his early work (*Ill. 2-15*). At the same time, the damp earth colors of his earlier paintings give way to a more abstract palette, still, however, basically tied to nature. In general, Dove's faults were faults in taste and in technique, but not faults in feeling. Even when the illustrator is seen behind the painter, the vigorousness and conviction of

the statement are sufficient to identify Dove as a highly original fine artist.

Dove's closest friend, Alfred Maurer, was, of all Stieglitz' protégés, perhaps the most tragic case. His biographer, Elizabeth McCausland, characterizes Maurer's career as typical of the nonconforming artist in America, one of "talent, even genius; success; revolt; long silence, and withdrawal into the solitude of his work." [9]

Among the first of his generation to go abroad, Maurer was also among the last to leave. In Paris from 1897 to 1914, he witnessed the birth of the modern movement. His early paintings, executed in Whistler's tonal manner, were extremely promising. But despite their success, Maurer turned his back on representational art. His conversion was sudden; according to the sculptor Mahonri Young, from the day of his thirty-sixth birthday Maurer "painted like a wild man. He was never again the light-hearted, gay Alfy we had known." His Fauvist still lifes and landscapes, such as *Autumn* (*Ill. 3-1*), brilliant essays in Derain's airy, broken-color manner, found favor, it seemed, with no one except Stieglitz.

After his return from Europe, Maurer appeared to lose confidence in his own intuition, and began to cast about for surer means. During

2-13. ALFRED MAURER, *Green Striped Bowl*, 1927–28.

45

the twenties he worked with Jay Hambidge's diagrams which offered mechanical solutions to compositional problems. Abandoning the traditional color wheel, he divided a circle into twenty-four segments; but his preferred palette remained, into the twenties, the light oranges, yellow-reds and pale blue-greens and violets of his Fauve works. In the later still lifes, such as *Green Striped Bowl* (*Ill. 2-13*), the broken stroke is replaced by slab-like planes of paint applied with the palette knife; these planes, however, do not shift cubistically, but remain statically defined.

For years after the war forced him to come home to New York, where he moved in with his aging father, Maurer planned to return to Paris. In fact, he kept his Paris studio until 1925, when the paintings were sold for back rent. (Some of these were recovered and exhibited in 1950.) Like Walkowitz, Maurer dropped into almost total obscurity after the Armory Show.

Frequently painted on Masonite panels, Maurer's late paintings are scrubbed, scraped, and repainted many times, although the ultimate result is often quite fresh. In Maurer's eyes, a painting was finished when it had a frame. His habit of constantly repainting the same surface led to the effacement of a series of nudes executed in 1927–28.

The few abstract paintings of the early thirties, mainly of the condensed double image of interpenetrating heads, are related to Picasso in their forms, although they are more freely and loosely painted than Picasso's late Cubist works. Like all of Stieglitz' artists, Maurer was des-

2-14. ALFRED MAURER,
Twin Heads, ca. 1930.

2-15. ARTHUR DOVE, *High Noon*, 1944.

perately involved in finding his identity as a modern American artist, and painted a Cubist George Washington on the occasion of the two-hundredth birthday of the first President, perhaps in answer to those who resented the "foreignness" of his art. Exhibited during the Depression, the painting was offered for barter for the equivalent of $500 worth of clothing.

Maurer's final humiliation, however, occurred when his father, the Currier and Ives lithographer Louis Maurer, famed for his popular recreations of the Old West, held his first one-man show in 1931. In the newspaper accounts, Alfred was mentioned as "also an artist." His father's popular success in the face of his own failure was doubly crushing to Maurer. Maurer's last paintings of interpenetrating Cubist heads (*Ill. 2-14*) have been interpreted as symbolic of his uncomfortable relationship with his aged father, who died at the age of one hundred on July 19, 1932. The following August 4, Maurer, recently discharged from a hospital where he had undergone a serious operation, ended his own life.

Maurer's story, though particularly depressing, is not atypical. Stieglitz' Secession Idea proved to be no bright beginning. When 291

closed its door in 1917, the artists who had exhibited there were exiles in their own land. They dispersed to follow their own increasingly personal directions, communicating with each other by letter or note. They wrote of loneliness, discouragement, the pains of isolation, and sometimes the joys of discovery.

World War I sealed America off from Europe as effectively as any artificial curtain. Stieglitz, unable to get work from abroad, closed 291 with the exhibition of the Italian Futurist Severini. It was the last show he would arrange for a European artist. The rest of his life was dedicated to keeping alive the reputations of Marin, Hartley, O'Keeffe, and Dove. From 1925 to 1929 he showed their work at the Intimate Gallery, a section of the Anderson Gallery, where he also showed Lachaise and Demuth; and from 1929 to 1934 he exhibited it at An American Place. In the forties, Stieglitz' mission of promoting the work of the American modernists was taken over by Edith Gregor Halpert of the Downtown Gallery, who continued to show the artists Stieglitz had supported along with younger American modernists.

Like the little magazines, 291 helped to introduce two notions into American art: that of art as experimental research, and that of quality in art. Both went against the American grain; the first because it threatened the status quo and the second because it seemed to negate the principle of democracy. By insisting that there was a superior or "high" art corresponding to what had been the aristocratic art of the past, available only to the noble in spirit, Stieglitz and his friends battled against what Whitman termed "the leveling character of democracy."

Chapter Three

The Armory Show: Success by Scandal

Probably in any reform movement . . . the penalty for avoiding the common-
place is a liability to extravagance. It is vitally necessary to move forward to
shake off the dead hand of the reactionaries; and yet we have to face the fact
that there is apt to be a lunatic fringe among votaries of any forward movement.
—THEODORE ROOSEVELT, "A Layman's View
of an Art Exhibition," *Outlook,* 1913

Shortly after Woodrow Wilson was sworn in as President of the
United States, Theodore Roosevelt visited the International Exhibition
of Modern Art held in the former Armory of New York's Sixty-ninth
Regiment. The reaction of the ex-President to the estimated 1,600
pieces of European and American painting, sculpture, and graphics on
view as reported in the *Outlook* was typical of that of the enlightened
but chary layman: admitting the "real good that is coming out of the
new movements," he was not yet ready to accept the "European
extremists whose pictures are here exhibited." For Teddy Roosevelt, as
for most Americans—including even artists as personally concerned
with the reforming spirit as Robert Henri—progress was good so long
as it did not end in extremism.

The exhibition which Roosevelt viewed with such mixed feelings
was the most important event in the history of American modernism.
Organized by a group of practicing artists, rather than by museum
professionals, dealers, or official academies, it set out to exhibit work
"usually neglected by current shows." Mainly this neglected work was
by the modernists, both European and American, who previously
had exhibited only at Stieglitz' gallery.

The need for another large invitational show on the order of the
successful Independents' exhibition had been felt by many. Late in
1911, Walt Kuhn, Jerome Myers, and Elmer MacRae, who were ex-
hibiting with a group called the Pastelists at the Madison Gallery,

began discussing the possibilities for an exhibition of larger scope than that of the Independents. The gallery, backed by the unconventional interior decorator Mrs. Clara Potter Davidge, was run by Mrs. Davidge's protégé (later her husband), the painter Henry Fitch Taylor, who was also interested in forming a new society to organize such an exhibition. During the winter, these talks continued in Myers' studio. In December, 1911, others were invited to join the group, now officially known as the Association of American Painters and Sculptors. Of the sixteen charter members, most were conservative, either members of the National Academy or, like Kuhn, Myers, and MacRae, realists associated with the Henri circle. At the first official meeting, the thirteen charter members present included, besides Kuhn, Myers, MacRae, and Taylor, four members of The Eight—Davies, Glackens, Luks, and Lawson; two sculptors—Gutzon Borglum and John Mowbray Clarke; and several academic painters—Jonas Lie, D. Putnam Brinley, and Leon Dabo. In addition, Karl Anderson, James E. Fraser, Allen Tucker, and J. Alden Weir were represented by proxy. Thus the original make-up of the Association was somewhere between conservative and reactionary. By the time that the exhibition, which was called a "harbinger of universal anarchy," opened, however, the viewpoint of the Association had shifted toward the distinctly radical.

Since the Association was to be widely representative, it was felt that the president should be a figurehead, an eminent art-world figure behind whom all could unite. With this in mind, those present quickly elected the respected American Impressionist J. Alden Weir as president. However, when Weir read a news release stating that the Association's purpose was to exhibit anti-academic artists, he declined the presidency of a new society "openly at war with the Academy of Design," of which he had been a member for twenty-five years. Kuhn, envisioning an organization "as big or bigger than the Academy within two or three years," rejected Henri, the next logical choice, on the grounds that he had "queered himself with the Independent show," presumably by including only the work of realistic artists. It was Kuhn's view that "the way to get the confidence of the artists is to give the opposite type a chance,"[1] which represented the first change in the Association's position.

Kuhn, who had refused to accept the praise that he was better than Cézanne because it meant only "the same *damned* provincial loyalty which has hurt us so long," was determined to have someone with a broader, more international view as president. Secure in the positive reception of his recent work, Kuhn was able to prevail, and convinced the others to elect Arthur B. Davies as a compromise candidate. Of

the possible choices, Davies was the best for many reasons. He was, for example, the only man who could bridge the various factions in the art world. Respected by academicians and praised by conservative critics, he was the single member of The Eight to frequent 291. In addition, Davies was a perceptive connoisseur with a wide range of taste, who had acquired two paintings from Max Weber's first one-man show at the Haas Gallery in 1909. Well-connected socially, he could gain the financial assistance needed; an erudite man who subscribed to various European art journals, he had a sophistication few of his peers could equal.

Reluctantly persuaded to assume office, the enigmatic Davies (who throughout this period was leading a complex double life as the head of two separate families) was transformed, according to Guy Pène du Bois, from a "perfervid dweller in the land of romance . . . incapable of making the contacts of the real world" into "a dictator, severe, arrogant, implacable . . . [who] governed with something equivalent to the terrible Ivan's rod of iron."[2] With Kuhn as its energetic mouthpiece and Davies as its suave *eminence grise*, the Association had two remarkable and devoted leaders, capable of directing its policy toward a more liberal and international course.

Originally the Armory Show had been conceived as a more ambitious version of the Independents' exhibition. Now Davies had another model in mind. On receiving the catalogue of the Sonderbund exhibition of modern art in Cologne, he proposed to Kuhn that their exhibition emulate this historical survey of the various modern movements. Agreeing, Kuhn left for Cologne in the fall of 1912, where he arrived on the last day of the exhibition. On the way to Paris, where he was to meet Davies, he stopped at The Hague, Munich, and Berlin. Then, for three frantic days in Paris, Davies and Kuhn were hustled around in taxis by Walter Pach, the expatriate painter and critic. As a member of the Stein circle, Pach had many important entrees into the Parisian avant-garde. Through him Davies and Kuhn met the Duchamp brothers: the painters Marcel Duchamp and Jacques Villon, and the sculptor Raymond Duchamp-Villon. As the Association's European agent, Pach performed invaluable tasks selecting, expediting, and shipping works. Alfred Maurer proved another useful contact, introducing Davies and Kuhn to the celebrated Post-Impressionist dealer Ambroise Vollard, who loaned a number of works to the show.

From Paris the two proceeded to London to see critic Roger Fry's exhibition of modern art. Featuring Matisse and Picasso, this exhibition, held at the Grafton Galleries, was the second part of an historical survey organized by Fry, the first having featured Manet and the

Post-Impressionists. Like the Sonderbund exhibition, the second Grafton show, from which a number of works went directly to the Armory Show, provided Kuhn and Davies with a model of an historical survey on which to base their exhibition. Ready to outdo Fry, Kuhn wrote to Pach: "We are going to put it *all over it* with our proposition," and ordered Pach to get as many of Matisse's works as possible for the New York show.

Back in New York, Davies and Kuhn were frantically occupied soliciting contributions, cataloguing entries, and preparing publicity. The last was largely Kuhn's task. Acting on the advice of his friend, the lawyer and collector John Quinn, who had volunteered to serve as legal advisor to the Association, Kuhn set out to get as much publicity as possible for the exhibition. Admirably successful, he planted sympathetic stories with FitzGerald, Gregg, and a number of other critics in advance of the opening.

Elated over the exhibition's prospects, Kuhn wrote to Pach in December, 1912: "We want this old show of ours to mark the starting point of the new spirit in art, at least as far as America is concerned. I feel it will show its effect even further and make the big wheel turn over in both hemispheres."[3] This new spirit Kuhn spoke of so glowingly was to do nothing less than marry Henri's democratic "art spirit" with the experimental "Secession Idea" of 291. By including all the various tendencies in American art—from the "soft guys," as Kuhn called them, who painted sentimental genre, to the Impressionists like Weir and Lawson, to the abstractionists Macdonald-Wright and Morgan Russell—the Armory Show followed the nondiscriminatory policy of the Independents. In giving space to the most advanced experimental art, it accepted Stieglitz' point of view.

After a year's hard work, the exhibition was ready to open on February 17, 1913. The enormous Armory on Twenty-fifth Street, rented for $5,500, was decorated with $1,000 worth of banners and pine branches donated by Mrs. Whitney. On opening night, Davies escorted the aging Ryder, who had become a near hermit from abuse, into the crowded hall where ten of Ryder's canvases were hanging. The homage to Ryder, a neglected American modernist, was pointed. Quinn's opening speech made this clear: "The members of this Association have shown you that American artists—young American artists, that is—do not dread and have no need to dread, the ideas or culture of Europe. They believe in the domain of art only the best should rule."[4] Quinn's bravado, however, may have rung false to those who had already publicly voiced misgivings about the American section.

Looking around, Quinn's elegant audience could see an enormous variety of paintings and, to a lesser extent, sculpture, some of it reassuringly familiar and much of it distressingly strange. Illustrations 3-1 to 3-5 show paintings exhibited by Sloan, Sheeler, Maurer, Glackens, and Bellows; some of the important European works appear in Illustrations 3-6 to 3-11. In all, there were over 1,000 catalogued entries; in addition, more than 1,000 other works, of which a number were multiple entries, were listed in a supplement. One-third of the works were foreign, predominantly French; two Ingres drawings and Delacroix's 1853 *Christ on the Lake of Genezareth* were (with the exception of a Goya miniature loaned by Quinn) the earliest works on view. Although Daumier, Courbet, Corot, and Manet were not well represented, the major Impressionists had good showings. The Post-Impressionists, including Gauguin (with eight oils, several lithographs, and a sculpture) and Van Gogh (with seventeen oils), were seen to advantage. Among the thirteen oils by Cézanne was the 1877 *Poorhouse on the Hill* (*Ill. 3-10*), the first Cézanne purchased by an American museum, sold from the show to the Metropolitan Museum for $6,700. Seurat and his followers, Signac and Cross, represented Neo-Impressionism with several works. Fauvism was remarkably complete in its presentation, with canvases by Derain, Manguin, Marquet, Villon, Friesz, Dufy, and of course, its leader, Matisse, whose thirteen paintings drew the most vitriolic critical blasts. Finally, important Cubist paintings by Picasso, Braque, Léger, de la Fresnaye, Gleizes, Picabia, and Duchamp provided examples of the most advanced European mode.

As an exhibition, however, the Armory Show had a number of flaws. Its limitations were essentially the limitations of the taste of Davies, Kuhn, and perhaps Pach, who also seems to have been influential in making selections. Matisse was well represented because Kuhn, soon to become one of his imitators, insisted on it. In *Dressing Room* (*Ill. 3-12*), Kuhn demonstrates how well he learned Matisse's lesson of flattening out shapes and juxtaposing broad simple forms with more complex patterns to form a decorative unity. Davies, on the other hand, with his interest in Symbolism, must have been responsible for the concentration of works by Puvis de Chavannes and the Nabis—Bonnard, Vuillard, Denis, Roussel, and Vallotton. Early in the affair, he had decided to make Redon the star of the show—which indeed he was; Redon's thirty-two oils were the largest single group of works in the show. The far more crucial works of the German Expressionists were represented only by a Kirchner landscape and Kandinsky's *Improvisation No. 27* (*Ill. 3-11*), which Stieglitz bought for

Americans in the Armory Show, 1913.

3-1. ALFRED MAURER, *Autumn, ca.* 1912.

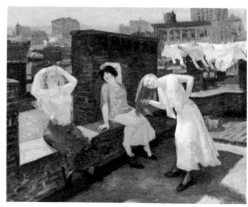

3-2. JOHN SLOAN, *Sunday, Women Drying Their Hair,* 1912.

3-3. WILLIAM GLACKENS, *Family Group,* 1911.

3-4. CHARLES SHEELER, *Chrysanthemums,* 1912.

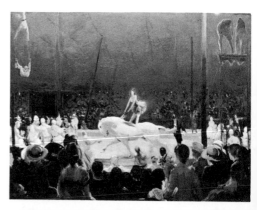

3-5. GEORGE BELLOWS, *The Circus,* 1912.

3-6. HENRI MATISSE, *The Red Studio*, 1911.

3-7. FRANCIS PICABIA, *Dances at the Spring*, 1912.

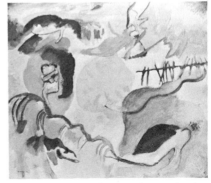

3-9. GEORGES BRAQUE, *L'Affiche de Kubelick* (*Le Violon*), 1912.

3-8. MARCEL DUCHAMP, *Nude Descending a Staircase, No. 2*, 1912.

3-11. WASSILY KANDINSKY, *Improvisation No. 27*, 1912.

3-10. PAUL CÉZANNE, *Poorhouse on the Hill, ca.* 1895.

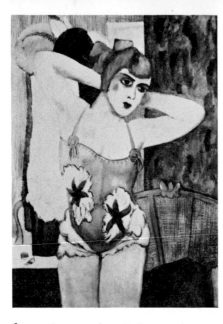

3-12. WALT KUHN,
Dressing Room, 1926.

$500. Apparently, Kuhn and Davies believed that the Germans were merely imitators of the Fauves. Davies' last-minute decision not to hang Delaunay's *City of Paris* because it was too large caused the founder of Orphic Cubism to remove his entries from the exhibition. Although Max Weber had loaned his Rousseaus, he felt insulted when asked to submit only two of his own works and did not participate himself. This was another mistake on Davies' part, since Weber was the single American painter in America at the moment whose works could stand comparison with European Cubism. The Futurists, told that they could not have their own booth, decided not to enter. Although works by Rodin, Maillol, Brancusi, and Lehmbruck were included, sculpture in general was so poorly represented that the sculptor Gutzon Borglum withdrew from the Association in protest.

Thus, at best, it was an incomplete picture of modernism that the Armory Show offered. Of the hundreds of paintings and sculptures by Americans, perhaps a few dozen could be described as modern. These included the sculpture of Nadelman and Lachaise, and the paintings by Bruce, Burlin, Bluemner, Carles, Dasburg, Halpert, Hartley, Marin, Prendergast, Russell, Schamberg, Sheeler, Stella, Walkowitz, and Macdonald-Wright. More typical of the American entries were the genre paintings of Guy Pène du Bois, Glackens, Luks, Myers, Sloan, and Eugene Higgins, the street scenes of Bellows and Glenn O. Coleman, and the landscapes of James Preston and Van Dearing Perrine. Many entries, like Boardman Robinson's cartoons, were compromises

with popular illustration, whereas the work of Leon Kroll, Bernard Karfiol, Carl Sprinchorn, and Jonas Lie represented compromises with academicism.

Once the show opened, an avalanche of publicity descended upon it. Since Kuhn had carefully prepared the way, the early publicity had been mostly favorable, urging viewers to keep an open mind. But after Teddy Roosevelt let it be known that Duchamp's *Nude Descending a Staircase* (*Ill. 3-8*) reminded him of a Navajo blanket and Lehmbruck's *Kneeling Woman* of a praying mantis, it was open season on modern art. Not until the present "culture boom" have the mass media had such a field day ballyhooing the scandalous goings-on of the avant-garde. A popular photograph of a donkey painting with its tail may have been the ancestor of the painting monkeys who appeared decades later. Cubism was the butt of endless jokes; "futuristic" art, as the modern styles were lumped together by the know-nothing press, inspired cartoons, parodies, skits, and doggerel. The *American Art News* sponsored a contest to find the "nude" in Duchamp's painting. The clever winner discovered "It isn't a lady but only a man." The most popular description was "an explosion in a shingle factory," although it was also seen as a "staircase descending a nude." Disgusted, Walter Pach said the contest was like looking for the moon in the "Moonlight Sonata." Art critic Christian Brinton explained some of the public's reaction by the fact that the awakening of the American public to art was accomplished by a series of shocks from the outside rather than through intensive effort, observation, or participation.

Behind the many statements issued by those involved with the Armory Show, as well as by those who mocked it, were certain assumptions about the nature of art and culture in America. Sometimes these were veiled behind a transparent rhetoric. For the artists, the "new spirit" was revolutionary. More than that, it was the rebirth of the spirit of the American Revolution. Thus, the pine-tree flag of Massachusetts during the Revolution was chosen as the symbol of the Armory Show. Henri endlessly preached "independence"; Stieglitz called for "a battle cry of freedom without any soft pedal on it." But resurrecting the old Revolutionary War slogans and symbols, which no longer corresponded to any political reality, was sheer nostalgia on the part of the Americans. It was, in fact, an attempt to legitimize revolutionary art in the only context intelligible to Americans, who had no tradition of radical art. That context was radical politics. This confusion between art and politics endured for many decades beyond the Armory Show, and in some minds endures today.

The case against modernism, on the other hand, was also frequently couched in political terms. The editorial in *The New York Times* the day after the show closed called the modernists "cousins to the anarchists in politics." Unrest in art was equated with unrest in politics. But since Roosevelt's and Wilson's administrations were in general liberal and progressive, progress in art was just as often equated with progress in politics. Writing of "Art and Unrest" in *The Globe* in 1913, Hutchins Hapgood exulted, "We are living at a most interesting moment in the art development of America. It is no mere accident that we are also living at a most interesting moment in the political, industrial, and social development of America. What we call our 'unrest' is the condition of vital growth, and this beneficent agitation is as noticeable in art and the woman's movement as it is in politics and industry."

As much as Henri and Stieglitz argued that the values asserted by contemporary art were the basic American values, others, like Frank J. Mather, Jr., argued the opposite. Giving his argument a puritanical twist by confusing art with morality, Mather advised the layman to "dismiss on moral grounds an art that lives in the miasma of morbid hallucination or sterile experimentation, and denies in the name of individualism values which are those of society and of life itself."[5] Like Kenyon Cox, Mather argued that license without discipline results in anarchy. Meanwhile, Charles Caffin was attacking the limitations imposed on American culture by its sentimentality, prudishness, and sexual inhibitions. The issues raised by the Armory Show thus could be generalized to cover not only art, but culture, politics, and morality. And throughout the country, all of these matters were being hotly debated as the old clashed with the new in every sphere.

The moment at which American art attempted to assimilate European modernism coincided with the moment that the American nation was confronted with assimilating 13 million new immigrants. The threat posed by this invasion of foreigners was often expressed in contempt for foreign art. Such a defensive position, ending in political chauvinism as well as cultural isolationism, forced the artist to "Americanize" European art, just as the immigrant was "Americanized" and absorbed into the native population. Consequently, the new painting and sculpture proved an admirable target for the various kinds of insecurities and aggressions thus released. And the anger of the conservatives, as F. J. Gregg described it, was directed most of all against the new generation that "appears to be . . . set on a Nietzschean transvaluation of all values."

From New York, the Armory Show traveled to Chicago, where

students at the Art Institute hanged in effigy Matisse, Brancusi, and Walter Pach (who was there lecturing), burning imitations of Matisse's paintings as well. By the time the exhibition closed in Boston, nearly 300,000 people had seen it. Jerome Myers recalls that "Millionaires, art collectors, society people, all were packed in like sardines."[6] During the course of the exhibition, 174 works—132 foreign and 51 American—were sold.

When Quinn predicted that the exhibition would be "epoch-making in the history of American art," he did not exaggerate. But was he equally right that the Americans had nothing to fear from European competition? Not according to Myers, who complained later that "Davies had unlocked the door to foreign art and thrown the key away. . . . we had become provincial . . . while foreign names became familiar, un-American propaganda was ladled out wholesale."[7]

In short, the Armory Show was in many ways a Trojan horse which loosed a band of invaders. Next to the refined, polished, fully realized efforts of the Europeans, the Americans looked tentative, plain, and underdeveloped. For all his sympathy with the cause, Gregg could not help lamenting that the vast mass of American work was a case of "arrested development." If nothing else, the Armory Show established the hegemony of European art for another thirty years.

Aimed at liberating American art from the shadow of European domination, the Armory Show, by displaying more Cubist works than had ever been seen in this country before, provided insecure and unoriginal artists with a formula that many chose to imitate in a vain search for a fashionable mode. Its other intentions were often frustrated as well. A high-flown statement of purpose revealed that the Association wished to choose, from "all the created Beauty of this Epoch, that which best reveals the individual or group among the creative works, or the contributions of a race."[8] If this meant that some *Volksgeist* or notion of an American style would emerge, then the heterogeneous array of works displayed was hardly calculated to produce such an effect. On the contrary, the diversity, fierce individualism, and lack of focus or common denominators characteristic of twentieth-century American art were made all the more evident.

But the Armory Show was at least partially successful in its twofold aim of educating the public and enlarging the art market to include the young Americans. Those who troubled to read the four pamphlets published by the Association must have been at least somewhat enlightened. (These were: *Cézanne* by Elie Faure, *Odilon Redon* by Pach, extracts from Gauguin's *Noa-Noa*, translated by Kuhn, and *A Sculptor's Architecture,* Pach's study of the architectural façade by

Raymond Duchamp-Villon exhibited in the show.) In addition, the dispersal of the fifty-seven half-tone postcard reproductions on sale must have aided artists and the public to familiarize themselves with modern works. As for the glut of publicity, it acted at least to stimulate awareness of art, although, as Milton Brown dourly observed: "The critical controversy which arose out of the Armory Show served not so much to clarify aesthetic thought, since it was not conducted on a very logical and informed plane, as to extend the area of conflict."[9]

But if few converts were made among curators, critics, or the general public, artists, dealers, and collectors responded with more enthusiasm. Within a year or two of the Armory Show, a number of new galleries were opened. These included the Daniels Gallery in 1913, and in the following year the N. E. Montross Gallery, with Davies as advisor; the Bourgeois Gallery, which Pach advised; and the Carroll Gallery, backed by Quinn. In October, 1915, the Mexican caricaturist Marius de Zayas, who had been associated with Stieglitz, opened the Modern Gallery, financed by Walter Arensberg, with an exhibition of Picasso, Braque, and Picabia.

The Armory Show, for all practical purposes, marks the beginning of American collecting. Those who purchased from it were different from Duveen's clients, men like Henry Clay Frick, Andrew Mellon, and J. P. Morgan, who used their immense wealth and power to plunder Europe of its art treasures. By contrast, the lawyers John Quinn and Arthur Jerome Eddy, the scholars Walter Arensberg and A. E. Gallatin, the society bluestockings Lillie P. Bliss and Katherine Dreier, and the eccentric Horatio Alger hero of science Dr. Albert Barnes immersed themselves in the art of the present and became its evangelists. Through them and the collections they founded, modern art became a permanent fixture of American culture. Among this group of collectors were some of the first to write and talk about modern art in America. A. J. Eddy, for example, produced the first book on Cubism in English. Several, such as Duncan Phillips, a sensitive collector and art writer who became converted to modernism some years after the Armory Show, institutionalized their collections, making them instruments of public education. Thus, the Phillips Memorial Gallery, founded in 1918, was the first public gallery devoted to contemporary art; the Bliss collection formed the nucleus for the Museum of Modern Art, founded in 1929; and A. E. Gallatin installed his "Gallery of Living Art" at New York University in 1927, where it remained until 1942, when it became part of the Philadelphia Museum. Aided by Marcel Duchamp and Man Ray, Katherine Dreier founded the Société Anonyme in 1920, the first modern art museum in America.

The Barnes collection, established as a foundation for study and research in Merion, Pennsylvania, was unfortunately open only to those who subscribed to Dr. Barnes' views on art and education. (A 1961 court ruling, however, has opened the matchless collection of Matisse, Picasso, Renoir, and Cézanne, not to mention Glackens, Sloan, and Prendergast, to the public on a limited basis.) The Eddy collection now forms part of the Chicago Art Institute, and the Arensberg collection, including the sensation of the Armory Show, Duchamp's *Nude Descending a Staircase,* now hangs in the Philadelphia Museum of Art.

These new collectors differed from their predecessors also in that they were advised, not by connoisseurs or dealers, but by artists. Dr. Barnes leaned on the judgment of his boyhood friend, Glackens; Quinn was advised by Kuhn and Pach, and Mrs. Bliss by Davies. Katherine Dreier and Walter Arensberg relied on Duchamp, who would later counsel Peggy Guggenheim as well.

Despite the effect the Armory Show had on molding the taste of these pioneer collectors, it had little effect in other spheres. The universities did not alter curriculum to embrace contemporary art; nor did the art schools become more progressive. The large museums predictably continued to scorn modernism. The single exception was the Newark Museum, directed by John Cotton Dana, where a large Weber exhibition was held in 1913. It was the first museum show of a living American artist.

Naturally, the Armory Show had some direct impact on American art, although perhaps not as much as one might assume. A few artists radically altered their styles, choosing to work more abstractly. But such changes might have occurred in any case, since those few had been exposed to modernism through living or traveling abroad. If, however, the Armory Show had a single aesthetic message, it was the message of form. Realists like Kuhn, Sloan, and Bellows began criticizing the lack of structure in their work. Ben Benn recalls that when he saw the modern masters, they "opened my eyes to the necessity for something of more permanent value—interdependence of parts (called organization), pattern (the just disposition of masses), and rhythm to unite these other elements."[10]

A comparison of two boxing scenes by Bellows, *Stag at Sharkey's* (*Ill. 3-13*) and *Dempsey and Firpo* (*Ill. 3-15*), the former painted before the Armory Show and the latter after, may serve to illustrate the new self-consciousness with regard to formal values that enters into Bellows' later work. After the Armory Show, for thoughtful artists like Bellows, Sloan, Guy Pène du Bois, and Edward Hopper, the

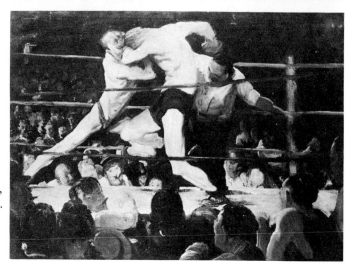

3-13. GEORGE BELLOWS,
Stag at Sharkey's, 1907.

realism of the "slashing brush" was not enough. Although all remained realists, their realism was relative. Sloan, for example, gave up painting from direct observation in favor of an entirely conceptual approach to art, one which depended on conventions as artificial and arbitrary as those which abstract artists adopted. Seeking a more durable art, Sloan adapted the graphic technique of cross-hatching in order to give his forms a sense of sculptural solidity. Similarly, the others, made aware of the importance of structure, arrived at forms that were generalized into simple volumes. In *Woman with Cigarette (Ill. 3-14),* Guy Pène du Bois derived a sense of substance by firmly modeling the

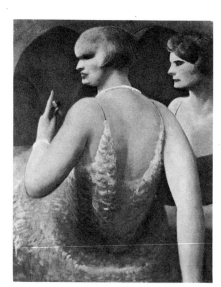

3-14. GUY PÈNE DU BOIS,
Woman with Cigarette, 1929.

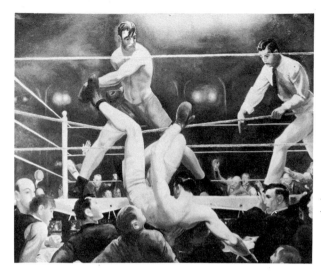

3-15. GEORGE BELLOWS,
Dempsey and Firpo, 1924.

few simple rounded volumes of the women's heads and dresses, es-
chewing the highlights and other surface effects he had learned as
a Henri student. Still others, like the former landscape painter Henry
Fitch Taylor and Davies himself, became full converts to the new
doctrine of Cubism. But the inadequacies of Taylor's *Guitar Series*
(*Ill. 3-16*) and similar paintings by Davies reveal how incomplete
was their understanding of the dynamics of Cubism. Convinced of
the value of modernism, they nevertheless did not have sufficient
background or experience in its fundamental principles. Consequently,
they produced pictures which, however courageous or provocative,
showed only a superficial acquaintance with the vocabulary, not the
grammar, of modern art.

In the wake of the Armory Show, two exhibitions were held which
helped to correct certain of the Armory Show's flaws. The Panama-
Pacific exhibition, a comprehensive survey held in San Francisco in
1916, brought Futurism to America. In the same year, the Forum ex-
hibition held at the Anderson Gallery isolated the best in American
art. Its aim was to challenge the image of European supremacy estab-
lished by the Armory Show. Because the Armory Show "failed to set
any logical standards by which modern work could be estimated,"
the purpose of the Forum exhibition was "to separate the wheat from
the tares."[11] Selected by a jury including Henri, Stieglitz, the critics
Christian Brinton and W. H. Wright, and John Weichsel, organizer
of the first American artists' cooperative, the People's Art Guild, the
Forum exhibition included nearly 200 paintings and drawings by
seventeen artists. Among them were Marin, Dove, Walkowitz, Man

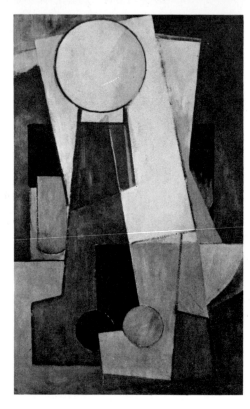

3-16. HENRY FITCH TAYLOR,
Guitar Series, ca. 1914.

Ray, Sheeler, Hartley, Maurer, Macdonald-Wright, Morgan Russell, and Thomas Hart Benton.

In 1917, another large unjuried exhibition resembling the 1910 Independents' exhibition was held by the Society of American Artists. Marcel Duchamp, vice president of the Society, submitted one of his "ready-mades," a urinal signed R. Mutt. Although the show was presumably open to all who paid the $5 registration fee, *Fountain* by R. Mutt was rejected. In protest, Duchamp resigned from the Society the night before the exhibition opened. Thus the decade of the Armory Show drew to a close: Duchamp, the representative of Europe's avant-garde, challenged the premise of democracy in art, as he would continue for more than a half-century to challenge art's most sacred tenets. For the moment, democracy could not be extended to tolerate extremism. It was safe to say that until it did, modernism would remain an artificial flower, rootless in American soil.

Chapter Four

After the Ball: Cubism in America

It is annoying that there is nothing Gothic about a grain elevator since we have been taught that Gothic architecture is beautiful. It is distressing that the man in the subway in New York is not at all like a Shakespearean or a Rabelaisian or a Cervantic character. But is there any reason to be so angry that we refuse to look at the grain elevator or the man in the subway? . . . As long as the European eye goes on looking for the Gothic cathedral in the grain elevator or for Hamlet in the man in the subway we are not likely to get much forward.
—GILBERT CANNON, "Observations on Returning
to the Remnants of Civilization," *Broom*, 1922

If we accept critic Edwin Avery Park's assessment, American art during the twenties was "the smallest ham sandwich ever unwrapped at the world's biggest and noisiest banquet." The optimistic experimentation that took place in the early twenties ended in most cases in a series of retreats to more conservative and defensible positions, as the reforming spirit of the teens gave way to the complacency of a security-minded, business-oriented society. Cut off from Europe by the war, American artists found themselves in a cultural vacuum that was not encouraging to their art; they were surrounded by a spirit of chauvinistic isolationism that encompassed art as well as politics.

When America emerged from the first European conflict in which she had engaged, she was ready to lose any remaining innocence in the frenzy of the Jazz Age. The great issues for the moment were political and economic. When submerged minority groups threatened to assert themselves, there was great concern about the evils of Bolshevism, the activities of the Ku Klux Klan, the growing menace of the IWW, and the problem of immigration. As Henry McBride observed in 1920, "The time was out of joint for any great outcry over morality or art."[1]

Nonetheless, both morality and art were undergoing great transformations. With the proliferation of galleries and exhibitions follow-

ing the Armory Show, the power of the National Academy of Design—mainly its ability to decide what would be exhibited—was rendered negligible. Its spring annual was now just an exhibition among exhibitions. But although the Academy had lost its hold on the art market, academicism as a manner was not dead. It had merely changed guises. The hollow Neoclassicism that The Eight had rejected was brought up to date and modified in favor of a freer technique and more contemporary subject matter. On the defensive now, academic artists were ready to compromise. In 1914, academician Edwin Blashfield argued against the excesses of an unconstrained modernism, counseling instead a compromise between the old masters and the moderns. Such a solution appealed to American artists because it offered a middle-of-the-road course between extremes. Its adoption as an artistic formula accounted for any number of tepid still lifes, figure studies, and landscapes produced from the time the Armory Show made modernism fashionable until the point at which abstraction made realism unfashionable. In the twenties, the desire to compromise, to strike a balance between the old and the new, led painters to concoct an eclectic synthesis that would combine the best of all possible styles.

Not all artists, of course, were in favor of such indiscriminate borrowing. Andrew Dasburg warned that "this idea of combining a variety of forms of perfection into one complete ideal realization prevents any creative work being done which possesses the contagious force of Cubism. . . . Not until it is realized that originality never follows from this attitude of assimilation and refinement can we become innovators."[2] Unfortunately, Dasburg's preachment was better than his practice; the kind of Cubism he and many American artists adopted was just such an eclectic mélange.

For the majority of Americans who called themselves Cubists, Cubism meant little more than sharp lines and acute angles. Cubism was seen, not as a new attitude of mind, but in terms of its surface effects. Thus, many blithely set about superimposing directional lines and fragmented shapes on top of essentially realistic compositions. Some, like Maurice Sterne, tried to imitate the shallow space of Cubism. But most accepted compromise solutions, resulting in a kind of semi-abstraction that was still at bottom anecdotal and illustrational. The late work of Davies himself is an example of such unassimilated modernism. Apparently it was not possible to move from the idyllic romanticism of Marées to the logic of Cubism. Davies' charming failures are just one indication of the confusions that resulted from telescoping art from Van Gogh and Gauguin to Matisse and Picasso into a single style called "Post-Impressionism," the term most critics used as a

catch-all to cover the diversity of styles and periods reviewed at the Armory Show.

"The difficulty is not that we are influenced by Europe," critic Lee Simonson observed, but that artists are liable "to make a fad of a particular experiment, without analyzing or understanding the ideas and impulses which are really at the bottom of it."[3] Even the efforts of some artists, such as William and Marguerite Zorach and Konrad Cramer, who had a firmer grasp of Cubism because they had watched it develop in Europe, were remarkable only because they were early examples of modern painting in America, not because they were successful Cubist pictures.

To be an American Cubist was by definition to be an imitator. Like English or Scandinavian approximations of French art, American Cubism was, as Stuart Davis later titled a painting, "Provincial Cubism." As the latest import from Europe in the decade following the Armory Show, Cubism attracted both the serious and the superficial. In the hands of vulgarizers it quickly degenerated into a period style to be paraphrased, like Greek, or Gothic, or Renaissance. This was the case partly because the craft revival, preached as an extension of the Arts and Crafts movement earlier in the century, did not come to fruition in America in a coordinated program of design reform like that of de Stijl or the Bauhaus. Instead, as Simonson complained, modernism became "the stylist's momentary holiday, a manufacturer's fad, a department store novelty," rather than the "business of soundly relating design to machine production and to the capacities of popular taste."[4] If Cubism was transformed, in the hands of irresponsible manufacturers, into the vulgar geometric "moderne" of the thirties, even in the hands of serious artists, it was often misunderstood.

Thus, the real issues at stake in Cubism—the preservation of the integrity of the picture plane, the analysis of both the structure of objects and the means by which objects are perceived, the assertion of the independent, self-referential reality of the work of art—often passed over the heads of even the most dedicated. Those artists who, like Dove, O'Keeffe, Hartley, and Marin, embraced the modernist attitude, usually did so on an emotional, intuitive basis. Significantly, the most intellectual phase of Cubism, its formative analytic period, made little discernible impression on American artists. There is almost no evidence that the analytic Cubist works of Braque and Picasso that were shown at the Armory Show were understood or imitated by American artists. The classical rigor, monochrome severity, and static tranquillity of these works evidently could not serve restless Americans as models. Nor can one find in the works of Americans any consistent concern with the theoretical analysis of three-dimensional forms.

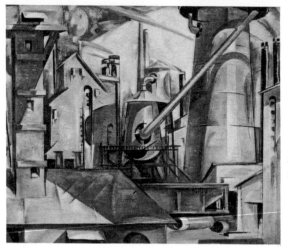

4-1. PRESTON DICKINSON, *Industry, II, ca,* 1924.

The most talked about and widely imitated artists in the Armory Show were not the major artists, but the minor Cubists—Duchamp, Picabia, and Gleizes. This may be because all three came to America about the time of the show. Picabia's visit was especially publicized. He was widely quoted, and his dogmatic assertion, made at the opening of the Armory Show, that "Cubism is modern painting" which would "supplant all other forms of painting," impressed many.

Even when they chose Cubist models, American modernists pre-

4-2. MAX WEBER, *Rush Hour, New York,* 1915.

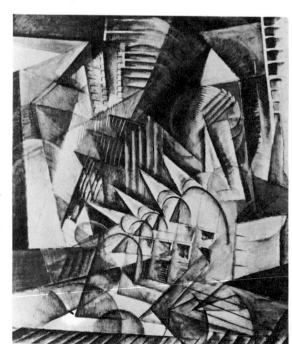

ferred throughout the teens and twenties to preserve the high color they had learned from Matisse and the Fauves. On the other hand, conservatives like Henry Lee McFee and Preston Dickinson continued throughout the twenties to remain faithful both to Cézanne's compositions and to his palette. Dickinson's *Industry, II* (*Ill. 4-1*) is an example of such a retrograde solution. Moreover, neither was the most advanced Cubist work that Americans produced much indebted to Braque and Picasso. The dynamic, splintered abstractions of Max Weber, for example, such as *Rush Hour, New York* (*Ill. 4-2*), in their movement and contrasting textures were closer to Futurism than to orthodox Cubism, even though Weber's early figure studies had derived from Picasso. Closer still to Futurism in his approach, Joseph Stella had learned Cubism directly from the Futurists during his trip to Italy in 1910–11. So it is not surprising that the dancing, whirling

4-3. JOSEPH STELLA, *Battle of Lights, Coney Island,* 1914.

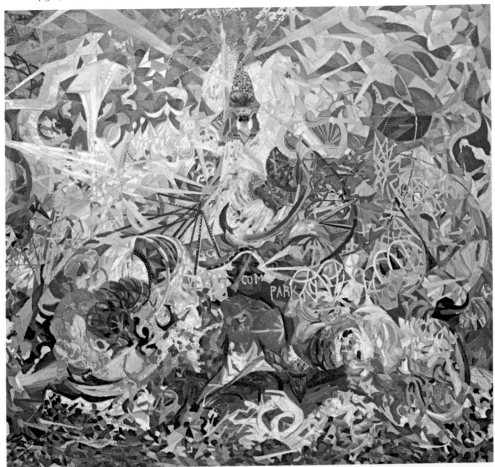

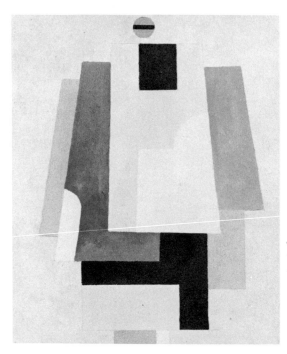

4-4. MARSDEN HARTLEY, *Movement #2, 1916.*

splinters of light and color in paintings like *Battle of Lights, Coney Island (Ill. 4-3)* are reminiscent of Severini's ballrooms rather than of French work. In addition, the subjects of analytic Cubism, the narrow world of the studio and the café still life, held limited appeal to the more dramatic and flamboyant Americans, who preferred the urban subject matter of the Futurists or the heroic landscapes of the "epic" Cubists Gleizes and Metzinger.

As for the later phase of French Cubism, only two Americans working directly after the Armory Show produced successful synthetic Cubist abstractions. They were Marsden Hartley and Man Ray. Hartley's *Movement #2 (Ill. 4-4)* and Man Ray's *The Rope Dancer Accompanies Herself with Her Shadows (Ill. 4-5)* are among the few genuine synthetic Cubist works produced at the time in America. Their activity in this area, however, lasted only a few years. By 1920, Hartley had permanently renounced abstraction. Man Ray, under the influence of Duchamp and Picabia, became a Dadaist, devoting himself more and more to creating Dada objects and to experiments, such as his "aerographs," the first spray-gun paintings, and "rayographs," photographic impressions made on sensitized plates. Moreover, Hartley's and Man Ray's abstractions based on figure studies, although exhibiting the flatness and geometric simplification of synthetic Cubism,

were hardly as complex or sophisticated as contemporary French work. Not until the middle twenties did Stuart Davis begin to create flat shapes that were as sharply cut out as Hartley's and Man Ray's, but more complicated and developed in their relationships.

If the Americans did not learn much from classical Cubism, either because they did not have the necessary technical means or theoretical background—or simply because a classicizing style contradicted the romantic American spirit—they found more congenial the branch of Cubism that Apollinaire termed "Orphic," because of its lyric content. Thus, Delaunay, the leading Orphist, was an important stimulus to Synchromism, the only American art movement with a program, a formulated aesthetic, and a manifesto. Even so, as a movement, Synchromism lasted less than a year and took place in Paris. But its ramifications, in terms of the diffusion of modern scientific color theory in America, were considerable.

Synchromism was born as a movement when Stanton Macdonald-Wright and Morgan Russell issued a statement of intentions during their joint exhibitions, first at Munich's Neue Kunstsalon in June, 1913, and then in Paris in October, 1913, at the Galerie Bernheim-Jeune. Their work was part of a general effort to extend the color theory formulated by Seurat and the Neo-Impressionists from the scientific laws which governed the perception of colors. The main sources of

4-5. MAN RAY, *The Rope Dancer Accompanies Herself with Her Shadows*, 1916.

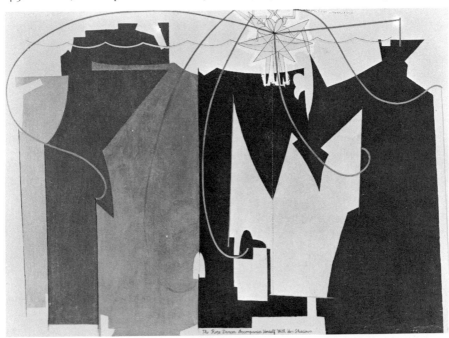

Synchromism were identical with those of Neo-Impressionism: Chevreul's *De la loi du contraste simultané des couleurs,* Charles Blanc's and Helmholtz' studies of optics, and Rood's *Modern Chromatics.* From Chevreul they learned that adjacent complementary colors influence one another—when used in large areas, the colors are intensified and when used in small quantities, they are blended by the eye into a neutral tone. From Rood they learned that the spectrum could be divided into harmonizing pairs and triads of colors which, corresponding to the dominant chord in music, could provide a tonal "key" for a painting.

Arriving in Paris in the first decade of the century, the young Californian Macdonald-Wright and his fellow American Morgan Russell were quickly drawn to these color theories, which Robert Delaunay and the Czech Frank Kupka were beginning to apply around 1910–11 in paintings that rapidly approached total abstraction. Although both knew

4-6. MORGAN RUSSELL, *Synchromy,* 1914–15.

4-7. STANTON MACDONALD-WRIGHT, *"Oriental." Synchromy in Blue-Green,* 1918.

Delaunay, recently it has been found that Russell's interest in pure color composition antedates his knowledge of Delaunay's experiments. So, despite Apollinaire's dismissal of Synchromism as "vaguement Orphiste," evidence points to a certain parallel development of Synchromism and Orphic Cubism. By 1912, for example, Russell was considering painting "solely by means of color and the way it is put down, in showers and broad patches, distinct from each other or blended, but with force and clearness, and with large geometric patterns, with the effect of the whole as being constructed with volumes of color."[5] Yet, in the 1913 Paris exhibition, all but two of the canvases (both by Russell) were representational still lifes and figure studies, which leads one to believe that seeing Delaunay's and Kupka's discs of color was nonetheless crucial to the development of Synchromism as an *abstract* style. In his *Synchromy (Ill. 4-6),* Russell splits discs of color into segments, each modulated to correspond or contrast with the dominant or key tone. Similarly, in *"Oriental" (Ill. 4-7),* Macdonald-Wright harmonizes the dominant blue-green tonality with its complementary orange.

Although they were partners in their enterprise, Russell and Mac-

73

4-8. ARTHUR B. FROST,
Colored Forms, 1917.

donald-Wright had different interpretations of Synchromism. Russell's work was more clearly abstract; behind Macdonald-Wright's forms there is usually some structure in nature that has been idealized and abstracted. Macdonald-Wright was particularly interested in the rhythmic coordination of the muscular organization of the human body, an interest Thomas Hart Benton was eventually to expand into a complex mechanical system of composition. In place of Russell's opaque planes and sculptural forms—Russell had worked on sculpture with his friend Matisse—Macdonald-Wright preferred the diaphanous quality of intersecting transparent planes. Both, however, were equally insistent on the importance of the tactile sensation evoked by value contrasts suggesting three-dimensional depth. According to Russell, in fact, color was to be seen primarily as a series of value gradations logically and harmonically related by means of a step-by-step progression of tones.

Besides the two who called their movement "Synchromism" (a term meaning "with color," derived from Russell's early studio interior *Synchromie en Vert*), two other expatriate Americans were unofficially known as Synchromists. Arthur Burdett Frost, whose *Colored Forms* (*Ill. 4-8*) was exhibited in the 1917 Independents' exhibition, and Patrick Henry Bruce—both former students of Matisse—were friends of Delaunay as well. Frost, upon his return to New York in 1914, helped to disseminate Synchromist principles and to explain the work shown that year by Macdonald-Wright and Russell at the Carroll Gallery. Shortly thereafter, a group of artists, including Andrew Dasburg,

Thomas Hart Benton, and Morton Schamberg, began painting Cubist abstractions in which a prismatic shattering of light into its component spectral colors was the sole subject. (Around 1920 Benton and Dasburg returned to representational art; but both showed Synchromist abstractions in the 1916 Forum exhibition.) By 1918, abstract color volumes were the formal basis of the work of Joseph Stella, Arnold Friedman, Alexander P. Couard, and Arthur B. Davies, although it should be emphasized none of these artists was officially a Synchromist. At the same time, two formerly academic painters, James Daugherty and Jay van Everen, were also converted to color abstraction. But the compositional organization of their works often derived from Picabia's Armory Show paintings in which flat planes interlocked to create sculptural volumes (*Ill. 3-7*) rather than from Synchromism.

Remaining in Paris, Russell and Bruce separated themselves from the Parisian art world. In 1916, Russell returned to figurative paintings, although from 1920 to 1929, he apparently again painted abstractly. Bruce, on the other hand, now independent of Delaunay, under whom he had worked from 1912 to 1914, became an increasingly original painter. His geometric still lifes of the twenties combined an unusual palette, in which pastel pink and blue were played off against black and white, with an equally original sense of form; three-quarter, profile, and frontal views of objects were presented so as to shift between flat and illusionistic readings without disrupting the integrity of the picture plane, as in *Still Life* (*Ill. 4-9*). Choosing solid forms, Bruce rejected line, which he considered "only the border of surface," insisting that "if line is apparent, it is a drawing."[6]

Discouraged by the lack of interest in his work, Bruce wrote to his friend Henri Pierre Roché in 1928: "I am doing all my traveling in the apartment on ten canvases. One visits many unknown countries in that way. You should be well prepared to appreciate my paintings after Greece."[7] If the reference to Greece can be interpreted as an ambition to produce classical compositions, Bruce was one of the very few Americans of his generation to hold such an ambition. In 1932, Bruce moved to Versailles, gave up painting, and destroyed all but fifteen canvases, which he sent to Roché in a wheelbarrow, along with the note: "You are the only person in the world who likes them." Shortly after a brief trip to the United States in 1936, Bruce took his own life in Paris. Later Roché wrote of his friend: "His slowness, perseverance and seriousness were unbelievable for Paris. His isolation, his irascible modesty, his exclusiveness formed a wall."[8] According to Roché, Bruce's efforts were directed "toward building paintings which would be supported mainly by their four sides having a structural

4-9. PATRICK HENRY BRUCE, *Still Life, ca.* 1929–30.

quality. The absence of this quality in other modern paintings made him suffer rightly or wrongly."[9]

There is no question that Synchromism was among the most advanced painting styles that emerged out of Post-Impressionism early in this century. According to Macdonald-Wright's brother, the brilliant, eccentric critic, Willard Huntington Wright, Synchromism represented the apogee of Western art, the culmination of its entire historical development from the Renaissance through Cubism. In many ways—particularly in its emphasis on the central role of color and its insistence on the suppression of line—Synchromism prefigured the concerns of sixties' abstraction. But such is the discontinuity of modernism in this country that nothing links the two movements.

One of the effects of the Armory Show, as we have seen, was to enlarge the art world, and to create multiple focuses of artistic activity. One such focus was the salon kept by Walter Arensberg, who became for New York what Gertrude Stein had been to Paris. Arensberg, who spent most of his own time unraveling Elizabethan riddles and trying to prove that Bacon was Shakespeare, opened his living room on Sixty-seventh Street to a lively group that included Duchamp, Picabia, Man Ray, Marsden Hartley, Joseph Stella, Charles Demuth, Charles

Sheeler, Isadora Duncan, William Carlos Williams, Edgard Varèse, and miscellaneous other figures from the artistic and musical avant-garde. From time to time even a few outsiders from the old guard like Bellows and Sloan would drop in.

Within a few months after Duchamp's arrival in 1915, Arensberg's living room became the center of proto-Dada activity in New York. (Dadaism as a movement was not formally founded or named until 1916 in Zurich.) Anti-art, antiwar, antimaterialism, and antirationalism, Dada suited the disenchanted mood of American intellectuals as the country was on the verge of World War I. In a sense, however, when Duchamp and Picabia began their Dada activity in New York, they were working in a prepared context. Even before the Armory Show there had been intimations of a Dada attitude in the negative appraisal *Camera Work* critics were constantly making of American culture. Later, H. L. Mencken's debunking of the American "booboisie" as hypocritical, cowardly, and stupid was characterized as journalistic Dada. The more serious criticism of American materialism and pro-vincialism by George Jean Nathan, Lewis Mumford, and Van Wyck Brooks reflected a general indictment of American culture by her best artists and critics which could be appropriated to Dada ends.

Indeed, the bizarreness of the American scene and the paradoxes of the American experience continue to lend themselves easily to a Dada interpretation. The unresolved feelings of the Americans toward their industrial civilization (was man the master, slave, or double of the ma-chine?) jibed perfectly with Dada's ambivalence toward the Machine Age. If Western culture was bad, was not the vulgarity and assertive-ness of American popular culture that much worse? Because of the prevalence of these negative attitudes among artists and intellectuals, Dada, curiously enough, was the first international art movement in which the Americans had a head start. What Dada served to do in America was to crystallize the antisocial aspects of the avant-garde, but by so doing, to give the avant-garde a sense of its own identity, for better or for worse. Irony was prescribed as a cure for despair, and an aggressive stance counseled as the best defense against a hostile society. Typical of the attitude of the group surrounding Arensberg is Morton Schamberg's sardonic assemblage *God* (*Ill. 4-10*).

Obviously, if the public chose to take modern art as a scandal, the answer was to give them more scandals. Unconventional behavior, sexual liberation, even dissipation were condoned; chess playing and transvestitism took their place as artistic activities. The trappings, if not the living arrangements, of a Bohemia had arrived. If there were not sufficient scandals to suit the public, then scandals were arranged.

4-10. MORTON SCHAMBERG, *God,* ca. 1918.

One of the first of such arranged scandals took place at the opening of the 1917 Independents' exhibition, from which the *Fountain* by R. Mutt had been banned. Picabia and Duchamp invited the boxer Arthur Cravan, who had a reputation for outrageous behavior, to deliver a lecture. Cravan, not unexpectedly, arrived drunk and began disrobing; the public gasped, and Duchamp pronounced his performance a "wonderful lecture."

Duchamp and Picabia gathered around them a motley group of eccentrics, including the Baroness Elsa von Loringhoven, who dressed in rags, wore sardine cans on her head, and had objects suspended from her clothes on chains. Duchamp's apartment itself was a spectacle; a friend described how it was "strewn with clothes pegs like a forest of wolf traps," while on the glass walls "spirals revolved beside a shovel inscribed, 'Ahead of the broken arm.'" Perhaps the best explanation of what was behind these activities was offered by the Dada poet Tristan Tzara. Writing in the magazine *New York dada,* he insisted that "we shall see certain liberties we constantly take in the sphere of sentiment, social life, morals, once more become normal standards. These liberties no longer will be looked upon as crime, but as itches." To the critics who cried out that modern art was immoral and anarchistic, the Dadaists answered in the affirmative, and claimed that the rights of the artist transcended morality and politics. In holding that anything goes, they may have discredited art, but they also created a climate of experimentation in which many artists felt liberated for the first time from the repressive aspects of American culture. In such an atmosphere

4-11. JOSEPH STELLA,
Collage #11, ca. 1921.

Holger Cahill's Inje-Inje group sponsored concerts in which only percussion instruments were played and dances in which the performers were costumed only in mitts.

Often, however, this urge to experiment, without the guidelines of a definite tradition, took artists to the periphery of artistic activity. And in many ways this kind of experimentation remained a characteristic of American art. A number of collages executed by American artists around 1920 might be described as experiments from the periphery. In their literalness and use of objects from the environment, the collages of Stella, Dove, and Maurer have more in common with Schwitters' Dada *Merzbilder* than with Cubist collage. Stella's torn and faded papers and old cigarette packages, and his extraordinary series of abstract collages (*Ill. 4-11*) seem to anticipate the Abstract Ex-

4-12. ARTHUR DOVE,
Portrait of Ralph Dusenberry, 1924.

79

4-13. JOHN COVERT,
Vocalization, 1919.

4-14. ALFRED MAURER,
Still Life with Doily, ca. 1930.

pressionist sensibility; Dove's collage *Portrait of Ralph Dusenberry* (*Ill. 4-12*) goes beyond Cubist collage in its literal use of actual materials. And John Covert's string paintings, such as *Vocalization* (*Ill. 4-13*), are an unexpected form of abstract collage. Similarly, Maurer's use of oilcloth and textiles as backgrounds in pictures like *Still Life with Doily* (*Ill. 4-14*) shows original experimentation which takes advantage of the properties of materials.

In a sense this kind of experimental activity becomes more comprehensible when viewed in the context of the Dada revolt against the conventional limits of art. It was an important moment when the American artist discovered that freedom from tradition meant freedom from rules; and that if there was no tradition, at least there were no rules either. Some artists later repudiated this freedom to steer a safer course within known boundaries, at times repudiating their experimental work as well. Thus one of the difficulties in reconstructing American art history in the twenties and thirties is that much experimental work of the period was destroyed. Bruce, Benton, Covert, and Burchfield, among others, demolished many of their own paintings. Burchfield was especially contrite. He wrote with distaste of the time immediately following his discharge from the Army in 1919 as "a period of degeneracy in my art that I have never been able to explain . . . the vagaries of the Da-Da school were nothing compared to mine at this time, though I had never heard of Da-Daism."[10] As soon as his native American common sense returned, however, he destroyed these offensive works.

For every artist who turned his back on modernism, there were others determined to find new forms adequate to express the qualities

of modern life, "to produce the tickling sensation of a new way of thinking and feeling," in Gilbert Cannon's words. Adapting to the realities of an industrial society was central to America's aesthetic coming of age. The acceptance of the idea that culture could be contemporary and that the breaking with old traditions did not preclude the founding of a new tradition was an important step in this coming of age. In Europe, the Futurists and the Purists had already begun to use machine imagery as the basis for their art. In America, a group of artists who became known as the Precisionists or Immaculates also turned to mechanical and industrial forms as a way of stamping their work as contemporary.

In this context, the machine imagery of Precisionism may be considered part of a general trend toward using mechanical forms, as in the work of Kupka or Léger. Others, however, continued to find the machines not a blessing but a threat. Perhaps only foreigners like Duchamp and Picabia had sufficient perspective to enjoy all the ironies of the situation: America, the most industrially advanced nation in the world, the country of automobiles, airplanes, fast trains, and power engines, should have fulfilled Marinetti's and Tatlin's prophecies for a new machine art. Instead, Americans were just as likely to feel with Rilke that American machines were turning out "life-decoys" to replace the old objects of love and devotion. For them, the machine itself became an object of ironical devotion or equally ironical derision, and man's dehumanization the instrument of the humanization of the ma-

4-16. MORTON SCHAMBERG,
Machine, 1916.

4-15. MARCEL DUCHAMP,
Chocolate Grinder, No. 2, 1914.

chine. Attributing human qualities to the machine, Picabia made the first of his satires on mechanization in his 1913 drawing, *Girl Born Without a Mother*. A year earlier, Duchamp had painted the *Bride,* a complex diagram of a female machine. The project that occupied Duchamp throughout the war and into the twenties was *The Large Glass,* a big, complex group of quasi-human machines connected by means of quasi-mechanical relationships. Picabia's 1915 cover for the magazine *291, Young American Girl in a State of Nudity,* and Duchamp's *Chocolate Grinder (Ill. 4-15),* which appeared on the cover of *Blind Man* in 1917, were prototypes of mechanical objects rendered in a dry, factual manner and placed in an anonymous setting. They provided a point of departure for Precisionist imagery; certainly their clean, hard edges and simple geometry must have impressed Schamberg, Sheeler, and Demuth, friends of the Dadaists, who were already beginning to work in such a direction. Schamberg was the first to develop these machine forms into the basis for a lucid geometric art, as in *Machine (Ill. 4-16).* But shortly after the Armory Show, Sheeler, too, had abandoned his Fauvist manner in order to experiment with

4-17. CHARLES SHEELER,
Barns, 1917.

4-18. CHARLES SHEELER,
Barn Abstraction, 1918.

Cubist reductions of objects into volumes, planes, and lines of direction. His aim was "to divorce the object from the dictionary." Since Sheeler's studies reveal the underlying structure of objects, they are related to analytic Cubism. But to the degree that their source remains Cézanne, they miss the complex spatial ambiguities of Braque and Picasso, and are not genuinely analytic Cubist works. Beginning in 1917 with *Barns* (*Ill. 4-17*), Sheeler reconstructed his flattened masses into a solidly integrated composition, in which color and texture were arbitrarily added. His analyses consisted mainly of diagramming structure rather than disintegrating it; these reconstructions idealize reality rather than reformulate it through distortion. In his 1918 paintings of barns, structures are further simplified to a few straight lines and rectangles set squarely and directly in the middle ground, coolly floating in an anonymous setting as in *Barn Abstraction* (*Ill. 4-18*). "In these paintings," Sheeler has said, "I sought to reduce natural forms to the borderline of abstraction, retaining only those forms which I believed to be indispensable to the design of the picture."[11]

At about the same time, Demuth seems to have arrived at a similar solution to the problem of unifying abstract design based on Cubist precedent without destroying the recognizability of objects. Two important influences on Demuth at this time were Duchamp, through whom he said he gained an interest in good workmanship, and Marsden Hartley, who was painting his most abstract Cubist works when he vacationed with Demuth in Bermuda in 1917. During this Bermuda trip, Demuth began to paint landscapes, such as *Trees and Barns, Bermuda* (*Ill. 4-19*), which exhibit the same clarity, dryness, and geometric simplifications as Sheeler's barns. Demuth, however, made greater use of the Futurist "lines of force"—ray-like projections that crossed and recrossed over objects creating linear patterns that in turn were played off against the mass of the objects. But, unlike Stella, Weber, or Feininger, who also appropriated these lines of force, Demuth did not shatter masses into fragmented planes. This unwillingness to shatter the object is what mainly distinguishes Precisionism as a Cubist style; instead of fragmenting, the Precisionists simplified, stylized, and arranged objects in such a way as to emphasize their purity of line and structure. For this reason, Precisionism has also been called Cubist-Realism.

Obviously, certain kinds of objects lent themselves more easily than others to such treatment. With this in mind, the Precisionists usually chose forms that were geometric to begin with. They found the rectangles of windows and barns, the cylinders of grain elevators, the circular wheels and cogs of machinery best suited to their aims. The

4-19. CHARLES DEMUTH, *Trees and Barns, Bermuda,* 1917.

cool objectivity of Demuth's *Machinery* (*Ill. 4-20*) is characteristic of the Precisionist approach.

In the carefully wrought, pared-down shapes of Shaker furniture and utensils, Sheeler found a favorite subject. The plainness of Shaker shapes, their refined finish, and especially their craftsmanship—so precious in an era of mass production—expressed an integrity of work-

4-20. CHARLES DEMUTH, *Machinery,* 1920.

manship and design Sheeler wished to emulate in paintings such as
American Interior (*Ill. 4-21*).

Sometimes the intermediary of the camera was employed to freeze
a scene so that it could be transformed into a static composition. For
this reason, many Precisionist paintings have the quality, common to
photographs, of the frozen moment. In many respects the hard edges,
slick impersonal surfaces, solid shadows, and upward tilted perspectives
of Precisionist paintings seem inspired by the study of photographs.
In Schamberg's and Sheeler's cases, the relationship is clear; both sup-
ported themselves as photographers. Sheeler in fact based specific com-
positions on photographs he had taken. The 1931 *Classic Landscape*
(*Ill. 4-22*), for example, is patterned on the photographs Sheeler took

4-22. CHARLES SHEELER,
Classic Landscape
(*River Rouge Plant*), 1931.

4-23. CHARLES DEMUTH,
Incense of a New Church, 1921.

of the Ford Motor plant at River Rouge in 1927. The movie *Manahatta,* which Sheeler made with the photographer Paul Haviland, helped to fix in his mind the image of the skyscraper. Beginning in 1920, he used this image again and again. Although O'Keeffe has denied being influenced by photography, the way that her giant close-ups of flowers fill the frame reminds one of photographic blow-ups. Demuth and Stella, too, painted flowers in a manner more related to the photographic enlargement than to conventional still life. Interestingly, one of the rationales for photography as the most modern of the arts was that photographs are the result of man bending the machine to his will.

Because the theme of the factory seemed particularly appropriate to the Machine Age, it soon became a standard of Precisionist iconography. Although Joseph Stella had painted industrial subjects such as factories and gas tanks from 1915 to 1918, Demuth's factories, beginning with the 1921 *Incense of a New Church* (*Ill. 4-23*), were more clearly flattened, stylized, and simplified. Soon other artists such as Stefan Hirsch, George Ault, Louis Lozowick, Edmund Lewandowski, Niles Spencer, Ralston Crawford, Peter Blume, and Preston Dickinson were interpreting native American subjects in terms of their potential as abstract design (*Ills. 4-24, 4-25, 4-26*). Joseph Stella, although painting in the Futurist style, continued to share the Precisionists' concern with finding epic material in urban and industrial images.

Like many American artists of the forties and fifties, Joseph Stella— one of the outstanding draftsmen in the history of American art—re-

4-24. GEORGE AULT,
Sullivan Street Abstraction, 1928.

4-25. RALSTON CRAWFORD,
Grain Elevators from the Bridge, 1942.

jected his own virtuosity in order to arrive at a more authentic expression of his feelings. Born in Italy, he was an arch romantic who wholeheartedly embraced the American dream. Combing contemporary American experience for viable universal symbols, he arrived at a visionary interpretation of the industrial landscape which sought to capture the quality, texture, and tempo of American life. For Joseph Stella, as for Marin, the city was the nexus of explosive, form-shattering power. Fond of quoting Whitman, whose portrait he drew, he discovered heroic images in the banal and the prosaic. In the Brooklyn

4-26. NILES SPENCER,
Erie Underpass, 1949.

4-27. JOSEPH STELLA, *Brooklyn Bridge*, 1917–18.

Bridge, Stella, like Hart Crane, found a contemporary subject worthy of elegiac and lyric treatment.

Since his arrival in America, the Brooklyn Bridge had been his ever-growing obsession. He saw it for the first time as a "weird metallic apparition under a metallic sky, out of proportion with the winged lightness of its arch" (*Ill. 4-27*). He was inspired by the "massive dark towers dominating the surrounding tumult of surging skyscrapers with their gothic majesty sealed in the purity of their arches." For Stella the bridge was "the shrine containing all the efforts of the new civilization, *America*—the eloquent meeting point of all the forces arising in a superb assertion of their powers, an Apotheosis."[12]

In choosing banal or commonplace themes, the Precisionists were, like the best American critics of the time, beginning to reject the mock heroics of a grand style. Such a style seemed unsuited to the down-to-earth realities of the American experience. In 1924, Lewis Mumford

wrote in *Sticks and Stones* of the greatness of the anonymous architecture of the American countryside, the factories and the grain elevators, as opposed to the pretentious glamour of official architecture. In focusing on indigenous subject matter and relating it to earlier American art traditions, the Precisionists were able to translate the language of Cubism into local usage. Noting, perhaps, that this earlier American art also had been anonymous, like the grain elevators and factories Mumford praised, they sought an anonymity of time and place. But the anonymity they arrived at was less charged with nostalgia and associations than de Chirico's deserted railroad stations, although these paintings may have inspired the Precisionists.

The virtue of much of this work is that it did not transform an abstract substructure into a figurative art in order to give viewers a way into the painting, but instead sought in reality geometric shapes, patterns, and rhythms that expressed a sense of order and permanence. In the hands of these artists, the skyscraper, also a favorite theme of Georgia O'Keeffe from 1926 to 1929 (*Ill. 4-28*), became a heroic subject. In their calm, reflective view, the Precisionists seemed to agree with Sheeler that: "Banging one's fist upon the table until the glasses dance is not as impressive as claiming the same attention by means of a well-ordered statement."[13]

4-28. GEORGIA O'KEEFFE,
New York Night, 1928–29.

In Europe, F. Scott Fitzgerald's friend Gerald Murphy was also painting abstractions of common objects, like matchboxes and cigarette packages, in a cool impersonal style that had much in common with Precisionism. Murphy's compositions, such as *Wasp and Pear* (*Ill. 4-29*), however, with their complex overlapping of planes which brought the image close to the picture surface, are more reminiscent of Stuart Davis' early abstractions than of Precisionist work.

Although less technically advanced and less ambitious than Synchromism, the Cubist-Realism of Demuth and Sheeler was the more distinctively American version of Cubism. And it had a more lasting effect on American art. Its modest productions possessed a resolve, finish, and quiet integrity that distinguished them from, as Forbes Watson put it, the "fog-horn chorus of blah" that was American painting in the twenties. In comparison with French painting, Precisionism was conservative, but it was not a compromise with either academicism or illustration. By renouncing the European mold, the Precisionists achieved their own dignity, even if this meant renouncing any pretension to grandeur. The acknowledgment that American subjects were commonplace and banal, and that the American landscape could claim as its monuments, not the pyramids or ruins of antiquity, but only the humble utilitarian objects of the here and now, was difficult for sensitive artists to make. To find something worth celebrating with honesty sometimes drove an artist like Demuth to ironic conclusions. Although he was able to discover monumentality in the plain forms of a grain elevator (as O'Keeffe and Sheeler had in barns and skyscrapers, and as Stella had in the bridge), Demuth expressed his sense of loss by comparing the grain elevators with the pyramids of antiquity, ironically titling them *My Egypt* (*Ill. 4-30*).

4-29. GERALD MURPHY, *Wasp and Pear*, 1927.

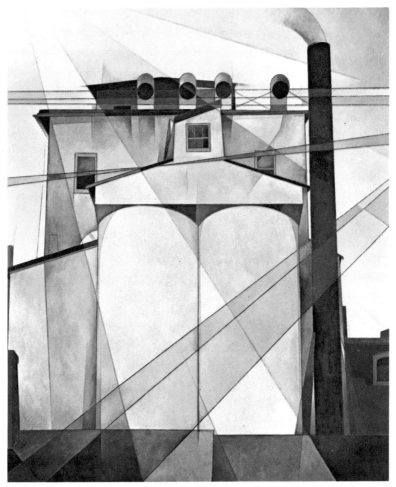

4-30. CHARLES DEMUTH, *My Egypt,* 1927.

In their programmatic return to American sources, to the art of the Shakers, the Indians, and the colonial primitives, American artists of the twenties clarified their relationship to the American tradition. In general, despite the provincialism that continued on some fronts, there was a gradual advance toward a more sophisticated outlook. The little magazines continued to print defenses of modernism; the *Dial,* for example, published articles by the leading European critics, Clive Bell, Roger Fry, and Julius Meier-Graefe, as well as a regular column by Henry McBride. In 1921, the Metropolitan Museum held an exhibition of modern art, and in 1923, W. R. Valentiner organized the first full-scale American exhibition of German Expressionism at the Anderson Gallery. Between 1921 and 1930, sixty new museums were founded,

a further indication of how greatly the art world had expanded. In addition, the American public could see abstract art at the Carroll and Montross galleries, and at the exhibitions of the Société Anonyme, where Kandinsky, Klee, Léger, Villon, and Archipenko had their first one-man shows. There, Schwitters, Miró, Mondrian, Ernst, and Malevich also had their first shows anywhere. The work of these artists was proof of the society's motto: "Traditions are beautiful—but to create them—not to follow." Besides these exhibitions, Katherine Dreier and her friends sponsored lectures on the psychology of modern art and a symposium on Dada, and published the English translation of Apollinaire's work on Cubism.

Summarizing the new attitude toward modernism, Christian Brinton wrote in 1926: "Modernism as a definite, specific issue has entered into the consciousness of the public at large, and modern art today is recognized and accepted by the leading museums of the country, and by our more astute and progressive professional dealers. We do not need another Armory Show, for the days of the Circus Maximus are over."[14]

Despite Brinton's optimism, the twenties were not an altogether happy epoch for American art. During the disillusioning postwar period, many artists felt that their only choices were to give up abstraction, give up art, give up society, or give up life. In many ways this mood coincided with the conservative European retreat from abstraction and experimentation; that is, with the time when many progressive European artists returned to tighter, more realistic styles. But the collapse of American modernism in the twenties was more complete, tragic, and inevitable than the European *détente*.

By 1920 O'Keeffe, Hartley, Weber, Macdonald-Wright, Dasburg, and Benton, to name the most prominent examples, had renounced abstraction. Of the major painters, only Dove maintained his commitment to abstract art. Stieglitz' gallery, 291, had closed, and the artists associated with it had disappeared. When *Camera Work* suspended publication in 1917, its circulation was thirty-six subscribers. Walkowitz was forgotten, and Frost, unable to pursue his friend Cravan's career of dissipation, was dead of a tubercular hemorrhage, four days before his thirtieth birthday. Morton Schamberg had died at the age of thirty-seven, a victim of the 1918 flu epidemic. John Covert had given up painting to return to business. Throughout the entire decade, only one major painter, Stuart Davis, emerged to take up the cause of modernism. With the coming of the Depression, what little serious interest there had been in art would soon be distracted by the more pressing issue of the country's economic collapse.

The Thirties: Reaction and Rebellion

Revolution is possible only in instances and domains where tradition is present. No tradition, no revolution.

—JOHN GRAHAM, *System and Dialectics of Art*, 1937

Discovering the futility of reconciling the old with the new in a compromise with modernism, artists of the twenties had attempted to end imitation and to create a style that was both modern and American. The Depression years, however tragic and difficult they may have been otherwise, saw the birth of such a modern style in America. During the thirties the search for the roots of an American tradition took on an even more urgent character. The political and economic crisis seemed to augment the need to define the nation's cultural identity.

The crucial years of the Depression, as they are brought into historical focus, increasingly emerge as the decisive decade for American art, if not for American culture in general. For it was during this decade that many of the conflicts which had blocked the progress of American art in the past came to a head and sometimes boiled over. Janus-faced, the thirties looked backward, sometimes as far as the Renaissance; and at the same time forward, as far as the present and beyond. It was the moment when artists, like Thomas Hart Benton, who wished to turn back the clock to regain the virtues of simpler times came into direct conflict with others, like Stuart Davis and Frank Lloyd Wright, who were ready to come to terms with the Machine Age and to deal with its consequences.

America in the thirties was changing rapidly. In many areas the past was giving way to the present, although not without a struggle. A predominately rural and small town society was being replaced by the giant complexes of the big cities; power was becoming increasingly centralized in the federal government and in large corporations. As a result, traditional American types such as the independent farmer and

93

the small businessman were being replaced by the executive and the bureaucrat. Many Americans, deeply attached to the old way of life, felt disinherited. At the same time, as immigration decreased and the population became more homogeneous, the need arose in art and literature to commemorate the ethnic and regional differences that were fast disappearing. The incursions of government controls on the laissez-faire system, acting to erode the Calvinist ethic of hard work and personal sacrifice on which both the economy and public morality had rested, called forth a similar reaction. Thus, paradoxically, the conviction that art, at least, should serve some purpose or carry some message of moral uplift grew stronger as the Puritan ethos lost its contemporary reality. Often this elevating message was a sermon in favor of just those traditional American virtues which were now threatened with obsolescence in a changed social and political context.

In this new context, the appeal of the paintings by the Regionalists and the American Scene painters often lay in their ability to recreate an atmosphere that glorified the traditional American values—self-reliance tempered with good-neighborliness, independence modified by a sense of community, hard work rewarded by a sense of order and purpose. Given the actual temper of the times, these themes were strangely anachronistic, just as the rhetoric supporting political isolationism was equally inappropriate in an international situation soon to involve America in a second world war. Such themes gained popularity because they filled a genuine need for a comfortable collective fantasy of a God-fearing, white-picket-fence America, which in retrospect took on the nostalgic appeal of a lost Golden Age.

In this light, an autonomous art-for-art's sake was viewed as a foreign invader liable to subvert the native American desire for a purposeful art. Abstract art was assigned the role of the villainous alien; realism was to personify the genuine American means of expression. The argument drew favor in many camps: among the artists, because most were realists; among the politically-oriented intellectuals, because abstract art was apolitical; and among museum officials, because they were surfeited with mediocre imitations of European modernism and were convinced that American art must develop its own distinct identity. To help along this road to self-definition, the museums were prepared to set up an artificial double standard, one for American art, and another for European art. In 1934, Ralph Flint wrote in *Art News*, "We have today in our midst a greater array of what may be called second-, third-, and fourth-string artists than any other country. Our big annuals are marvelous outpourings of intelligence and skill; they have all the diversity and animation of a five-ring circus."

The most commanding attraction in this circus was surely that of the American Scene painters, a category that may be broadened to accommodate both the urban realists, like Reginald Marsh, Isabel Bishop, Alexander Brook, and the brothers Isaac, Moses, and Raphael Soyer, and the Regionalists, like Thomas Hart Benton, John Steuart Curry, and Grant Wood. American Scene painting was, to a degree, a continuation of the tradition of Henri and the New York realists, which had by no means died out. Its stronghold was the Art Students League, where John Sloan was elected director in 1931, and Kenneth Hayes Miller and Yasuo Kuniyoshi, also former Henri students, perpetuated Henri's approach. Here, too, Thomas Hart Benton preached the gospel of Regionalism.

Sloan, of course, continued Henri's great liberating influence, stressing individual expression, in whatever form, as long as it was authentic, rather than insisting on any doctrinaire adherence to formula. But Sloan

5-1. KENNETH HAYES MILLER,
The Shopper, 1928.

5-3. REGINALD MARSH,
Bowery and Pell Street—
Looking North, 1944.

5-2. RAPHAEL SOYER,
Office Girls, 1936.

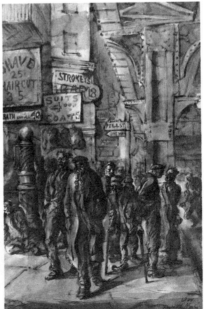

5-4. ISABEL BISHOP, *Nude*, 1934.

5-5. YASUO KUNIYOSHI, *I'm Tired*, 1938.

was exceptional in his convictions—so exceptional in fact that he re-
signed his position during a controversy over hiring foreign teachers, in
this case, the distinguished German Expressionist George Grosz. Also
unusual was Sloan's position on social consciousness in art. Criticized
for not propagandizing for social reform, Sloan, an active socialist since
his youth, countered: "They may say that I am now fiddling while
Rome burns, but I question whether social propaganda is necessary to
the life of a work of art."[1] Earlier he had been subject to similar criti-
cism when he and Stuart Davis resigned from the *Masses* in 1916; the
magazine, edited by Floyd Dell, had attempted to dictate the subject
matter of their art and direct it toward a more socially critical orienta-
tion. Significantly, the unsentimental objectivity that distinguishes
Sloan's work from the acrid or maudlin genre produced by the major-
ity of American Scene painters was viewed in its time as an irresponsible
refusal to take sides.

Like the paintings of The Eight, Kenneth Hayes Miller's *The Shop-
per* (*Ill. 5-1*), Raphael Soyer's *Office Girls* (*Ill. 5-2*), and Reginald
Marsh's *Bowery and Pell Street—Looking North* (*Ill. 5-3*) depict fa-
miliar urban scenes. Similarly, *Nude* by Isabel Bishop (*Ill. 5-4*) and
Yasuo Kuniyoshi's *I'm Tired* (*Ill. 5-5*) are typical of the modest, care-
ful figure studies turned out by the faculty and students of the Art
Students League. Yet although American Scene painting appropriated
Ash Can School subjects, its practitioners often lagged behind Henri
technically. The wholesale attempt to revive Renaissance techniques of
draftsmanship, composition, and execution, such as the use of tempera
as a medium, may be seen as yet another aspect of the search for a
tradition. But among insecure or conservative artists, this search was
often translated solely into a quest for a set of rules for the artist on

which the bewildered public could base standards. Toward this end the American Scene painters revived all of the old tricks of academic illusionism long discarded by the modernists. Chiaroscuro, foreshortening, perspective, and fine detail were enlisted in the service of an art that was contemporary only in depicting contemporary settings and costumes.

American Scene painting arose partially out of the same growing conviction that the American experience was tangibly different from the European experience that had inspired the art of O'Keeffe, Dove, Hartley, Marin, Stella, and the Precisionists. Artists came to realize that American art required not only its own subjects, but also its own forms and means of expression. Many believed that the homely style of the American Scene painters provided these. Some artists, however, although they painted typically American subjects and scenes, renounced the concept of an "American Scene" as too restrictive.

Discussing American painting with Maurer, Dove criticized the shortcomings of a literary interpretation of the American scene: "When a man paints the El, a 1740 house or a miner's shack, he is likely to be called by his critics, American. These things may be in America, but it's what is in the artist that counts. What do we call American outside of painting? Inventiveness, restlessness, speed, change." Suggesting a broader conception of a national style than the mere rendering of indigenous objects, locales, or types, Dove held that the means of expression took priority over subject matter, observing that "a painter may put all these qualities in a still life or an abstraction, and be going more native than another who sits quietly copying a skyscraper." Dove found particularly objectionable the popular attitude that "the American painter is supposed to paint as though he had never seen another painting."[2]

Stuart Davis, too, condemned provincialism, but declared, "I paint what I see in America, in other words, I paint the American Scene." Despite the fact that he painted abstractions, Davis still called himself a realist: "I want to paint and do paint particular aspects of this country which interest me," he stated. "But I use, as a great many others do, some of the methods of modern French painting which I consider to have universal validity."[3] Davis was among the first publicly to prescribe an accommodation with modernism that would not compromise American art, or rob it of its national stamp, but, nonetheless, would extract it from the provincialism which was the core of American Scene painting.

The group of artists who became known as Regionalists, which included Benton, Wood, Curry, Aaron Bohrod, Joe Jones, and by associ-

ation, Charles Burchfield, aimed at capturing the image of America's heartland, and a nostalgic interest in preserving disappearing local types and scenes soon monopolized their art. Although New York has been the center of American art throughout the twentieth century, many native-born artists maintained strong attachments to the insular farms, midwestern towns, and coastal hamlets where they were born. Hartley's New England fishing villages fit the Regionalist iconography as easily as Curry's prairies and farms, Wood's steepled towns and villages, and Benton's plantations and corn fields. The difference, however, is that Hartley presented his themes in terms of the conventions of modern art, specifically Expressionism, whereas the Regionalists by and large wished to escape the art of their time, just as they wished to turn their backs on contemporary reality in order to preserve the atmosphere and life styles of times gone by.

As leader and spokesman of the group, Benton attacked the internationalism of the modern movement and focused his criticism particularly on Alfred Stieglitz, whom he saw as the personification of all the evils of the decadent Old World. In his attacks on Stieglitz, he displayed the typical virulence of a convert to a new religion against his former beliefs—and with good reason. Benton's hard-nosed individualism, though it had taken a reactionary turn, was cut from the same cloth as that of Hartley, Marin, and of Stieglitz himself. For Benton, in fact, had been a frequent visitor to 291, and his early paintings, although based on Renaissance compositions, were nonetheless Synchromist abstractions. As he confided later to his friend and apologist, the critic Thomas Craven, "I wallowed in every cockeyed ism that came along and it took me ten years to get all that modernist dirt out of my system."[4] Like Burchfield, upon seeing the light, he repudiated his brief fall from grace into the degeneracy of modernism and was rabid in his denunciation of heretics. The Stieglitz group he dismissed as "an intellectually diseased lot, victims of sickly rationalizations, psychic inversions, and God-awful self-cultivations."[5]

As for Benton's diatribes against urban life, they seem now the last outcry of midwestern populism, the defensiveness of the country boy afraid of being taken by the city slickers. In his autobiography, *An Artist in America,* Benton voiced his many frustrations. Suspicious and chauvinistic, he gloried in the fact that "the people of the West are highly intolerant of aberration." Appalled by the corruption of the urban milieu, he thundered, "The great cities are dead. They offer nothing but coffins for living and thinking." He and Craven, analyzing the state of moral decay about them, saw Marxists and homosexuals wherever they looked. Opposed to the aestheticism of the "curving

5-6. THOMAS HART BENTON, *City Scenes*, 1930.

wrist and the outthrust hip," they embraced a hairy-chested masculinity that was a vulgarization of the Henri stance, much as Regionalism was a vulgarization of Ash Can School subjects.

Benton began to be suspicious of "political and aesthetic doctrines drawn from middle European philosophizing" during World War I when he worked as an architectural draftsman in a Norfolk naval base. Away from New York and its subjective theorizing, his interests changed, and became "in a flash, of an objective nature." At this time, "the mechanical contrivances of buildings, the new airplanes, the blimps, the dredges, the ships of the base, because they were so interesting in themselves" tore Benton away from his "play with colored cubes and classic attenuations, from aesthetic drivelings and morbid self-concern." Curiously, the very subjects that had inspired Malevich to invent non-objective art brought Benton back down to earth.

After the war, Benton describes how he, Wood, and Curry revolted "against the general cultural inconsequences of modern art," separately arriving at the belief that "only by our own participation in the reality of American life . . . could we come to forms in which Americans would find an opportunity for genuine spectator participation."[6] In the name of democratizing art, Benton conceived a grandiose new monumental, public art, whose program was not much removed from those espoused by the totalitarian "people's governments." As part of

such a program, he planned a comprehensive, pictorial history of the United States in sixty-four panels, sixteen of which were completed. Such a narrative sequence was in a sense but an up-dated version of the popular art form, the cyclorama. In 1930, when he was commissioned to paint a series of murals at the New School for Social Research, Benton interpreted contemporary Americana in a crammed, churning panorama filled with bulging, muscular figures, drawn from Michelangelo and combined with popular images (*Ill. 5-6*). If these murals are vulgar in spirit and crude in technique, nonetheless they are bursting with energy. Their enormous popular appeal must be attributed to their ability to satisfy that aspect of American popular taste which applauded the flamboyantly tasteless murals of Sorolla earlier in the century while spurning the "ugliness" of The Eight. If Benton's compositions strike the viewer as false or contrived, it is because they are first plotted as abstractions, and then turned into figurative motifs, and not vice versa, as is the case with Hopper or Sloan. The figures are often unconvincing as figures, although Benton's ability to render the plasticity of three-dimensional form is such that they are charged with a seething vitality.

Grant Wood's cardboard-stiff forms and dry, laconic style, as shown in *Stone City, Iowa* (*Ill. 5-7*), are quite the opposite of Benton's rolling, bulging forms and rhetorical expression. With its slick surfaces, hard edges, and sharp focus, Wood's work, like that of the Magic Realists, was related to Precisionism. Finding a "quality in American newness," he perversely attempted to express this quality in the terms of the meticulous detail of the German and Flemish primitives, whom he had

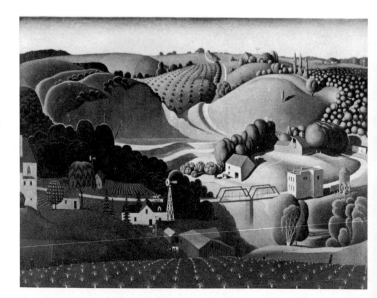

5-7. GRANT WOOD, *Stone City, Iowa,* 1930.

studied during a trip to Munich in 1928. A designer of model houses and stained glass interiors, Wood also made some little-known surrealistic objects.

Like Wood, Curry chose to celebrate the achievement of legendary American folk heroes. In the saga of John Brown, he found a theme he considered sufficiently heroic, and clumsily attempted to paint it in the style of the heroic painting of the past, in the swelling forms of Rubens and the soft light of Turner. The result was a naive and inept travesty of heroic painting. Just as Benton and a large part of the great public that admired his work had confused the folk tradition with popular culture, Curry too confused the two by introducing Charlie Chaplin and Walt Disney creatures into his Pageant of America. Like most Americans of his generation, Curry resented that art "as a reality was as foreign as Chinese."

Charles Burchfield never set out to confine himself to Regionalist themes; he was a Regionalist only by association. His earliest surviving paintings were composed of florid, curvilinear, two-dimensional patterns based on exotic plant motifs. These were the symbolic motifs

5-8. CHARLES BURCHFIELD,
Noontide in Late May, 1917.

that he called "conventions for abstract thought." By 1917, in such works as *Noontide in Late May* (*Ill. 5-8*), Burchfield had retreated to a more conventional interpretation of landscape motifs. After his rejection of modernism, his later works became less decorative and more bizarre. In these paintings of strange haunted houses, inanimate objects are invested with a life of their own. In his many variations on a number of standard themes—the deserted street, the empty house, the haunted wood—Burchfield exaggerated the quality of fantasy and unreality, his object being "the expression of a completely personal mood." An admirer of Sherwood Anderson's *Winesburg, Ohio,* Burchfield himself lived in Salem, Ohio. Like Anderson, he used the modest, undramatic houses and streets of his town as the inspiration for richer fantasies.

Although he praised Burchfield's work, Edward Hopper dismissed the less imaginative versions of American Scene painting as mere caricature. Hopper was more interested in the psychological investigation of the characteristics of American experience—its loneliness, barrenness, and lack of variety or high moments. Instead of the grandiose themes of the Regionalists, Hopper chose the genuine pathos of daily life. Whereas his contemporary Stuart Davis found the city a subject for abstract transformation, Hopper saw only the doomed yearning of lonely figures in cold offices and desolate hotel rooms. To the clamorousness of Davis' collective and synthetic experience, he opposed melancholy single figures, isolated in anonymous, depersonalized surroundings.

Returning from Europe in 1910, where Bruce had introduced him to the Impressionists, Hopper soon moved to Washington Square, admitting that he liked the neighborhood because it gave him a sense of continuity with The Eight. After he showed a small painting, *Sailing,* in the Armory Show, he devoted himself mostly to etching everyday scenes and rural landscapes. Around 1920, Hopper began to paint more oils. Like Bellows and Guy Pène du Bois, during the twenties Hopper learned to generalize forms, treating them summarily, and eliminating trivial detail in such paintings as *Early Sunday Morning* (*Ill. 5-9*). In 1930 he bought a house in Truro, and most of his landscapes after that time were based on Cape Cod scenes. In these studies of rooftops and architectural forms, Hopper achieved a new sense of solidity and weightiness. Approving of Burchfield's interpretation of the American landscape, Hopper called the United States a "chaos of ugliness," but admired Burchfield's ability to find the "hideous beauty" of native architecture with its "fantastic roofs, pseudo-Gothic, French Mansard, Colonial, mongrel or what not," and of the houses with their "eye-

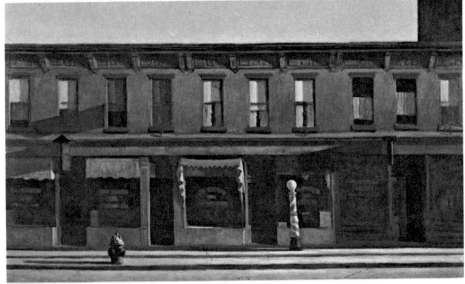

5-9. EDWARD HOPPER, *Early Sunday Morning*, 1930.

searing color or delicate harmonies of faded paint, shouldering one another along interminable streets that taper off into swamps or dump heaps."[7]

Hopper defined his goal as making "the most exact transcription possible of my most intimate impressions of nature." Because this goal remained constant, Hopper did not feel compelled to alter drastically the means he had acquired early in his career. For that reason, the pictures of the fifties and sixties, such as *Second-Story Sunlight* (*Ill. 5-10*), resemble those of the twenties, with the exception perhaps that they seem starker, barer, and more frontally oriented. As Hopper's art matured, one noted also an increasing ability to give solidity to mass and to integrate patterns of theatrically focused light and shadow within a highly organized compositional structure. Hopper differed from most of the other realists of the thirties in that he was able to maintain realism as a viable mode by choosing a subject compatible with his style and by refining his style to fit the needs of his subject. In such a coincidence of form and content, he achieved an honest and harmonious unity.

As a style, the illustrational realism of American Scene painting gained a large audience, partially because it appealed to popular taste and partially because it was widely disseminated throughout the country by mural painters, such as Mitchell Siporin, Boardman Robinson, George Biddle, and Anton Refregier. These artists were commissioned to decorate local banks, railway stations, and public buildings, as part

103

of a public works program to employ those out of work because of the Depression. Artists, who were living on the fringes of the economy in the best times, were particularly hard hit. To give them relief, the Public Works of Art Project, administered by Edward Bruce and Forbes Watson through the Treasury Department, was set up in 1933. Abandoned in June, 1934, it was replaced a year later by several programs. The most important was the Works Progress Administration's Federal Art Project (WPA/FAP). The project was supervised by Holger Cahill, who also organized the *Index of American Design,* a vast record of the history of decorative arts in America.

Through the Federal Art Project, painters, sculptors, and graphic artists were employed by the government at a monthly stipend. Among the artists who worked for the WPA mural and easel painting projects were Stuart Davis, Yasuo Kuniyoshi, Marsden Hartley, Jack Levine, Hyman Bloom, Loren MacIver, and Morris Graves. Younger artists included de Kooning, Gorky, Pollock, Gottlieb, Reinhardt, Rothko, and Guston. By the time the Federal Art Project was abandoned in 1943, more than 5,000 artists had created thousands of works of art in over 1,000 American cities. The murals illustrated familiar scenes considered appropriate to their settings in bus and airline terminals, radio stations, schools, and housing projects; their subjects included trains pulling into stations, crowds at work, and events in the history of communications and transportation. Unfortunately, many have since been destroyed or painted over. Among the murals created for the Federal Art Project were George Biddle's *Sweatshop* (*Ill. 5-11*) and Arshile Gorky's *Aviation: Evolution of Forms Under Aerodynamic Limitations* (*Ill. 5-12*).

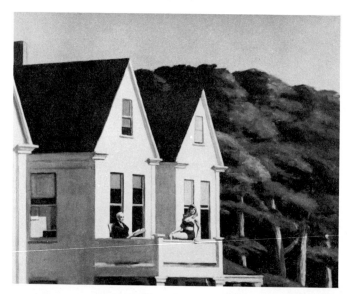

5-10. EDWARD HOPPER, *Second-Story Sunlight,* 1960.

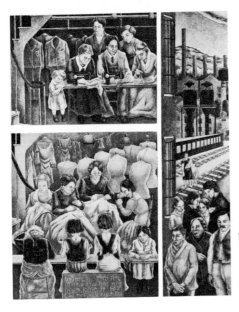

5-11. GEORGE BIDDLE,
Sweatshop, Study, *ca.* 1935.

When the WPA muralists were not inspired by the master fresco painters of the Renaissance, they often took as their models the Mexican mural painters, particularly Diego Rivera and José Clemente Orozco, both of whom were working in the United States during the thirties. The vigor of the Mexicans' style, and their protest against economic and social injustice in forceful expressionistic images, often couched in allegorical or religious terms, impressed the Americans, who were still convinced that art should serve a higher purpose than itself. At a time when American painters were so involved in finding an authentically American means of expression, the Mexicans' successful marriage of native Indian art with modernism seemed a particularly attractive solution.

The WPA is a unique but crucial chapter in American art. This is so despite the fact that, outside of a few murals known only through sketches or reconstructions, such as Gorky's Newark Airport mural and de Kooning's sketch for the Williamsburg housing project, the WPA programs produced very little art of any consequence that has survived. Nevertheless, it radically altered the relationship of art and the artist to the art audience and to society. By making no formal distinction between abstract and representational art, the WPA supported the budding avant-garde's contention that both were equally "American." (However, it must be admitted that far more commissions were given to representational artists.) By affording artists the opportunity—which most had never had—to paint full time, the WPA gave them a sense of professionalism previously unavailable outside

5-12. ARSHILE GORKY, *Aviation: Evolution of Forms Under Aerodynamic Limitations,* Study, *ca.* 1936.

the academic context. By giving artists materials and time, it allowed them to develop their skills and technique to a new level. Throwing artists together in communal enterprises, the WPA experience provided an esprit de corps that carried over into the forties. Not the least of its contributions was the sponsorship of exhibitions and classes which served to arouse a consciousness of art in the far reaches of the country, where many people had never before seen an original work of art. On another level, the muralists' practice of creating for the large area of the wall rather than for a limited space of the easel picture helped to prepare artists to paint large-scale pictures a decade later.

Many of the WPA artists played an active role in politics, and many sought to convey a specifically political message through their art. These artists were often referred to as social realists. Even the artists who did not paint social protest themes were often politically active during the Depression. In 1936, between 300–400 painters, designers, photographers, and sculptors formed the Artists' Congress, dedicated to propagandizing antifascism. At the first meeting, Lewis Mumford announced that "The time has come for the people who love life and culture to form a united front . . . to be ready to protect, and guard, and if necessary, fight for the human heritage which we, as artists, embody."[8] Among its members were Peter Blume, Moses Soyer, and William Gropper, and the photographers Paul Strand, Margaret Bourke-White, and Ben Shahn, whose Depression photographs supplied him with many subjects for painting. Stuart Davis, Executive Secretary of the Congress, complained how the "prevalence of meetings, petitions, picket lines, and arrests" left him little time to work. Similarly, fine artists were even organized into an artists' union.

It is not surprising, then, that the theme of the worker and his plight was one of the principal subjects of the social realists. However, the "realism" of the social realists, it should be pointed out here, was twice removed from the realism of Courbet or Daumier. Although it often claimed them as ancestors, social realism in America emerged, not from the painterly tradition of nineteenth-century French realism, as the realism of The Eight had to an extent, but directly from the graphic tradition of magazine illustration and poster art. Often the paintings of the social realists were little more than stylized drawing in which paint was merely a fill between contours. Typical of social realism was Shahn's indictment of the treatment of the Italian anarchists Sacco and Vanzetti, who were condemned to death for murder in a trial that was the cause célèbre of American intellectuals in the thirties (*Ill. 5-13*). Shahn's series of paintings commemorating the trial are animated by the same sense of outrage that impelled Grosz to satirize the industrialists of postwar Berlin, but lack Grosz's sophistication and wit.

The "realism" of painters such as Shahn, Evergood, Hirsch, and Jacob Lawrence, who saw art primarily as a means of communicating a social message, ought not to be confused with the realism of artists like George Bellows, Reginald Marsh, and Edward Hopper, who continued the best of the Henri tradition. If, as Hopper suggested, the American Scene painters were engaged in caricature, then the social realists, who editorialized in paint, were often not far removed from

5-13. BEN SHAHN,
The Passion of Sacco and Vanzetti,
1931–32.

5-14. IVAN ALBRIGHT,
*That Which I Should Have
Done I Did Not Do,* 1931–41.

5-15. PETER BLUME,
South of Scranton,
1931.

political cartoonists. A typical example, William Gropper, worked mainly in the graphic medium as an illustrator for the *New Masses,* and not surprisingly, his paintings are little more than translations of his cartoons of tycoons and bread lines.

For some artists, the reality of the thirties—the poverty, the joblessness, and the threat of the coming war in Europe—was too oppressive to deal with realistically. Many chose to escape reality through personal fantasy. Like the Surrealists, such as Dalí, they presented the inner world of the imagination in the precise, detailed realism of the photograph. Because they combined the factual with the fantastic, they were known as Magic Realists. However, the images used by artists like Ivan Albright, Peter Blume, Louis Guglielmi, Henry Koerner, and Alton Pickens were not, by and large, the monstrous or nightmarish images of Surrealism, but the factual, everyday images of the American Scene painters turned upside down.

Ivan Albright's *horror vacui* results in a hyper-realism which fills the canvas with a writhing, pulsating mass, reducing all textures to the same unpleasant common denominator, as in *That Which I Should Have Done I Did Not Do* (*Ill. 5-14*). In the forties and fifties, artists like Honoré Sharrer, George Tooker, and Paul Cadmus continued to work in a manner that could be characterized as Magic Realist, in that it married a highly cultivated, precise technique and slick, polished surfaces with a perverse version of the everyday.

The most sophisticated of its practitioners, Peter Blume, offered a

rationale for the unabashedly literary content of Magic Realism: "Since I am concerned with the communication of ideas I am not at all ashamed of 'telling stories' in my paintings, because I consider this to be one of the primary functions of the plastic arts. Visual or pictorial images are as much a part of the material of a painter as the color, shapes and forms he uses."[9] In *South of Scranton* (*Ill. 5-15*), he presents surreal images in a matter-of-fact, realistic manner. Blume, whose early work was inspired by the Precisionists, insisted on the primacy of a highly developed technique capable of capturing fine detail. Admiration for his technical skill was of the same order as that which now greets the extraordinary technical accomplishment of Andrew Wyeth's more reticent and story-telling art, shown in *Christina's World* (*Ill. 5-16*).

Blume's search for the "permanent values in painting" led him, as it led many others, to attempt to restore the pictorial ideas of the past. Finding fault with this practice, the critic George L. K. Morris stated, "The plastic language requires a broader definition of 'technique' for sustenance than the mere ability to follow boundary-lines on a smooth gesso panel. . . . The painting 'looks like' the Quattrocento, but one will search in vain for an internal vitality such as the Italian masters produced throughout their struggle with the shapes of their new expression."[10]

Several artists who did not use the sharp focus or photographic detail of the Magic Realists are allied to them through their use of fantastic or bizarre images. Philip Evergood, whose anger at social injustice relates him to the social realists, often used the combined or fantastic images of Magic Realism. Evergood's *The New Lazarus* (*Ill. 5-17*) is a complex religious allegory which translates the theme of the raising of Lazarus into contemporary terms. In the forties, a

5-16. ANDREW WYETH, *Christina's World*, 1948.

5-17. PHILIP EVERGOOD, *The New Lazarus*, 1927–54.

number of American artists painted religious or allegorical themes with surreal overtones, probably under the influence of Max Beckmann, who was teaching in America at the time. Younger members of this group, such as Stephen Greene, later turned to abstraction. Like Evergood's representation of the Lazarus episode, Greene's *The Burial* (*Ill. 5-18*) has complex allegorical overtones.

Other artists whose realistic paintings have a mystical or surreal quality are Edwin Dickinson and Morris Graves. Dickinson's layered fantasies, with their superimposed images and meanings, and Graves's strange birds and landscapes defy strict categorization. Dickinson, a sophisticated romantic who spent much of his life in isolation in Provincetown, worked in a sensitive, highly developed, realistic style

5-18. STEPHEN GREENE, *The Burial*, 1947.

5-19. EDWIN DICKINSON,
The Fossil Hunters, 1926–28.

of a higher order than that of the Magic Realists, in order to explore the world of his private fantasies. In *The Fossil Hunters (Ill. 5-19),* for example, bodies tumble down on one another, entwined in drapery, smoke, and haze, evoking ghostly images, effecting mysterious transformations. Dickinson's constant reworking of the same themes, often on the same canvas, gives his work an obsessive fascination; his decaying images are echoes of the Gothic themes of nineteenth-century romantic painters. Graves, a painter of the Pacific Northwest like Mark Tobey, shares with Tobey an interest in Zen Buddhism. His fragile transparent *Bird in the Spirit (Ill. 5-20)* seems a metaphor for the fragility of human experience.

5-20. MORRIS GRAVES, *Bird in the Spirit,* 1940–41.

5-21. ADOLPH GOTTLIEB, *Sun Deck*, 1936.

5-22. MILTON AVERY, *Baby Avery*, 1932.

During the thirties, figure painting per se, devoid of literary or social content, was not a popular mode, although artists like Lee Gatch and especially Milton Avery were able to find a fresh approach to painting the figure. Although both Gatch's and Avery's interwoven patterns of flattened figures and landscapes are essentially a departure from Fauvism, Avery's paintings show his grasp of Matisse's direct use of color and his treatment of the figure and landscape as flat patterns with rhythmic contours. Avery's work was one of the main channels through which Matisse's decorative color painting survived in American art in the forties, when much painting took on the pallid chalkiness of tempera or the lurid rotogravure tonalities of commercial illustration. Avery's ability to eliminate detail and to organize masses as flat areas of pure color, dividing the canvas into transparent yet brilliant zones, mark him as one of the outstanding American painters of recent years. Admired by younger painters like Rothko and Gottlieb, Avery's work became the model of an art of subtle, close-valued color. *Sun Deck* (*Ill. 5-21*), a painting Gottlieb executed for the easel painting section of the WPA, is reminiscent in its sensitive paint application and muted palette of Avery's paintings of the thirties, such as *Baby Avery* (*Ill. 5-22*), the first of many portraits of the artist's daughter. In the forties and fifties, in such paintings as *Mother and Child* (*Ill. 5-23*), Avery's use of color became bolder as his formal inventiveness and assurance increased.

In the forties, important figure painting was also done by "the two kids from Boston," Hyman Bloom and Jack Levine. Encouraged by art educator Harold Zimmerman and Harvard professor Denman Ross, Bloom and Levine left the world of the ghetto to develop their

5-23. MILTON AVERY, *Mother and Child,* 1944.

5-24. JACK LEVINE, *Gangster Funeral*, 1952–53.

considerable talents. Bloom acquired a masterful technique, rich in sensuous surface effects (all the more remarkable because it was so rare in previous American painting). Bloom was a moralist like Rouault and a mystic like his hero Blake; he painted fantastic visions in brilliant, visceral colors, whose smeared impasto and writhing, melting forms are reminiscent of Soutine.

In contrast with Bloom's other-worldly mysticism, Levine's works are very much of this world. His bejeweled dowagers and grossly corpulent businessmen are stereotypes of capitalist corruption which descend from Grosz through the left-wing cartoons and paintings of American social-protest art. Like Pascin and Kuniyoshi, Levine was able to use line to give a convincing sense of plasticity. His *Gangster Funeral* (*Ill. 5-24*) is a searing indictment of human corruption as personified by gangster-tycoons.

Fewer in number than the realists and more insecure in their position, abstract artists during the thirties could look to few American precedents for their work. Only Stuart Davis seemed capable of reconciling the diametrically opposed currents of American Scene painting and Cubist abstraction. Davis' career, like Hopper's, spans half the century, and represents a straight line of continuous development from

the origins of twentieth-century American art. Like Hopper, Davis was a Henri student who exhibited in the Armory Show. Otherwise, however, the two stand for the antithetical currents in American art which were dramatically polarized in the thirties. Although both artists were engaged in defining a specifically American tradition in art, the solutions they arrived at were mutually exclusive. In a sense, Davis and Hopper may be taken to represent the two faces of the thirties: Hopper looked backward in order to record the plain virtues and undramatic pathos of life in small-town America, or to find poignant beauty in the homely, sometimes grotesque, American landscape; Davis celebrated the present, transforming the American scene into symbols and signs charged with the electricity of the moment. Hopper, like Sloan, was the detached reporter—with perhaps a more poetic bent than Sloan—who hardly altered his technique or subject. Davis, the restless experimenter, constantly recast and enlarged his repertoire of images in order to distill more intensely and succinctly the reality of the present.

For Hopper, contact with Europe meant little, even though he visited Paris three times between 1906 and 1910; but Davis called the Armory Show "the greatest single influence I have experienced." Hopper's emphasis on structure and coherence of pictorial design, however, suggest that he, like Davis, reacted against the casualness of Henri's surface effects. But in Hopper's case, the rejection of bravura painting appears to be based on a puritanical rejection of the glamorous. In contrast, Davis had specific complaints about Henri's approach, which he felt repudiated academic rules without establishing "new ones suitable to the new purpose." That there was a new purpose was clear to Davis as soon as he saw the Armory Show. Davis' criticism of Henri is applicable not only to Henri's teaching, but also to American art education in general: Davis complained that the "borderline between descriptive and illustrative painting, and art as an autonomous sensate object, was never clarified."[11] To clarify this distinction was the task Davis set himself, although he admits, "I did not spring into the world fully equipped to paint the kind of pictures I want to paint."[12] Davis' struggle to acquire the technical means of painting was arduous. As he gradually expunged crudeness, awkwardness, and laboriousness from his paintings, he was able to reach the level he sought, and in so doing, to raise the general level of American painting. It is hardly exaggerating to suggest that Davis was the first American artist to appropriate successfully the means of French art toward the end of making distinctively American pictures.

Like many in the Henri circle, Davis began as a cartoonist and

5-25. STUART DAVIS,
The President, 1917.

illustrator, and his attitude remained that of the wandering sketch
hunter, even when he began to transform his impressions of the city
into abstract signs and symbols. Shortly after his conversion to "the
new purpose," Davis met Demuth in Provincetown. During the period
following the Armory Show, while Demuth and Sheeler worked to

5-26. STUART DAVIS,
Lucky Strike, 1921.

5-27. STUART DAVIS, *The Paris Bit*, 1959.

create a native version of Cubism, Davis painted a number of precocious abstractions, such as *The President* of 1917 (*Ill. 5-25*), as well as experimenting with collage, in which he sometimes incorporated *trompe-l'oeil* labels. Beginning with the 1921 *Lucky Strike* (*Ill. 5-26*), the labels alone became the subjects for a series of paintings. In these, Davis first introduced words and lettering, using them as the Cubists had done, to emphasize the actual two-dimensionality of the painting by identifying the flat letters with the flat surface plane. In his later works, these words would be transformed into a lively calligraphy of cut-outs which functioned as abstract shapes themselves. The flattened, reorganized packages of commercial products of the twenties are related to Demuth's work, not only in their clear, hard-edged forms and use of commercial lettering, but also in their choice of banal subjects.

Like the Precisionists, Davis began by searching for abstract patterns in real objects. Gradually, he concentrated his attention on logical elements, as he explains it, "groping towards a structural concept." In 1927, concluding that "a subject had its emotional reality funda-

5-28. STUART DAVIS, *Egg Beater, Number 2,* 1927.

mentally through our awareness of . . . planes and their spatial relationships,"[13] he began his first abstract paintings. These were the brilliant "egg beater" series (*Ill. 5-28*). Revealing the attitude of the modernist who strives to refine and purify a single theme, Davis used a still-life arrangement of an electric fan, a rubber glove, and an egg beater as his exclusive subject for a year. "The act of painting," he had decided, "is not a duplication of experience but the extension of experience on the plane of formal invention."[14]

In the paintings of the next few years, such as the street scenes inspired by a trip to Paris in 1928–29, figurative elements re-emerged; but the men and houses were definitively flattened out and stylized into patterned shapes. Later, these elements were recaptured in *The Paris Bit* (*Ill. 5-27*). In the thirties, Davis continued to paint landscapes made up of many small, jagged elements locked together like the pieces of a complex jigsaw puzzle. He appears at this time to have been influenced by Léger's bold assertive shapes and thick black lines. As editor of *Art Front,* the magazine of the Artists' Congress, from 1934 to 1939, Davis found his painting time curtailed. Nevertheless, he managed to paint four major murals during the thirties: *Men Without Women* (1932), in the men's lounge of Radio City Music Hall; *Swing Landscape* (1938), now at the University of Indiana; an abstraction based on musical and electronic symbols for radio station WNYC

(1939); and a huge *History of Communication* for the 1939 New York World's Fair (which was later destroyed).

In the following decade, Davis' ability to translate the sights and sounds of American life was solidly established. He was one of the first artists to appreciate jazz as a distinctly American idiom. The technical means he had disciplined himself to master were now by and large in his grasp; his color, evidently stimulated by Matisse, became increasingly active and brilliant. To the primaries he favored in the thirties, he added hot, fully saturated oranges, pinks, and magentas, and the black and white which Matisse had used as a foil for color in his *Jazz* cut-outs. Like Matisse's *Jazz,* Davis' paintings, such as *Hot Still-Scape for Six Colors* (*Ill. 5-29*), contain an astonishing variety of lively, dancing shapes, sharply contoured and smoothly fitted together in a sequence of syncopated rhythms. But in the tension of their relationships, and in the sheer quantity of nervous energy discharged by their coordinated activity, they express Davis' concern with ordering the frenzy he found in the American scene.

Despite their degree of abstraction, Davis claimed that all his paintings have their origin in things seen. Describing his method of working on *The Paris Bit,* a 1959 recapitulation of the Paris street scenes of the twenties, Davis revealed that he composed his paintings first as line drawings, because this method was "most amenable to inspiration and change." Drawing until he felt that the "all-over configuration has

5-29. STUART DAVIS, *Hot Still-Scape for Six Colors, 1940.*

reached a degree of complexity and completeness satisfactory to the impulse that initiated it," he increased the visual impact "through the use of stimulating color intervals."[15] In the sense that Davis stored up from observation innumerable images which he could later draw on, he remains, like Hopper, the heir of Henri. But by transforming the context and form in which these impressions and memories will reappear, he points forward to the new American painting.

Davis represents the crest of the first wave of American modernism. His friendship with Arshile Gorky was one of the few bridges between the pioneer modernists and the new American painting. Among the first to recognize his unique genius, Gorky admired Davis' understanding of the canvas "as a rectangular shape with a two-dimensional surface plane," into which he refused to "poke bumps and holes." When Gorky wrote about Davis in 1931, he wrote also of the embattled role of the abstract artist, condemning the "critics, artists, and public suspended like vultures, waiting in the air for the death of the distinctive art of this century, the art of Léger, Picasso, Miró, Kandinsky, Stuart Davis." These were the gods of the young American abstract artists. They shared Gorky's conviction that "for centuries to come artists of gigantic stature will draw positive elements from Cubism."[16] Already, in works of the early thirties, such as *Organization* (*Ill. 5-38*), Gorky had begun to adapt the means of Cubism to his own more painterly ends. Other artists, too, such as the Russian émigré John Graham, from whom Gorky's generation learned to appreciate the finer lessons of Cubism, were painting fully developed

5-30. JOHN GRAHAM, *Anschluss*, 1932.

5-31. JOHN FERREN, *Multiplicity,* 1937.

Cubist works in New York in the thirties. Graham's 1932 *Anschluss* (*Ill. 5-30*), for example, shows an understanding of the dynamics of synthetic Cubism which was rare, if not nonexistent, in America before that date.

By 1936, the year in which Alfred H. Barr, Jr., organized the historic survey "Cubism and Abstract Art" at the Museum of Modern Art, the younger abstract artists had banded together in an association

5-32. KARL KNATHS, *Maritime,* 1931. 5-33. CARL HOLTY, *Of War,* 1942.

known as the American Abstract Artists. The importance to young artists of Barr's vision of internationalism in art and his application of art historical methods to the study of contemporary art should be noted. Soon the annual exhibition of the American Abstract Artists was the focus for the energies of the emerging American avant-garde. The group was formed at that moment when the international abstract movement, in which French Purism, Dutch de Stijl, Russian Constructivism, and Bauhaus abstraction, having briefly coalesced in the Paris-based Cercle et Carré and Abstraction-Création groups, was dispersing as Hitler menaced Europe. Among the artists who originally exhibited with the American group were Carl Holty and John Ferren, both recently back from Paris, Karl Knaths, Jean Xceron, Charles Shaw, Balcomb and Gertrude Greene, Ad Reinhardt, Byron Browne, Giorgio Cavallon, and George McNeil.

Ferren's *Multiplicity* (*Ill. 5-31*), Knaths's *Maritime* (*Ill. 5-32*), Holty's *Of War* (*Ill. 5-33*), McNeil's *Green Forms Dominant,* and Cavallon's untitled abstraction (*Ill. 5-34*) are examples of the high quality achieved by members of the association during the thirties and forties. By 1938–39, the group also included Josef Albers, Ilya Bolotowsky, Fritz Glarner, Burgoyne Diller, Alice Mason, Albert Swinden, I. Rice Pereira, Lee Krasner, Willem de Kooning, and David Smith. Most association artists tended to work within the conventions of Purism or Neo-Plasticism. Bolotowsky's *White Abstraction* (*Ill. 5-35*), a study in cool Purist

5-35. ILYA BOLOTOWSKY, *White Abstraction,* 1934–35.

5-34. GIORGIO CAVALLON, *Untitled,* 1938–39.

5-36. WILLEM DE KOONING, *Untitled*, 1937.

5-38. ARSHILE GORKY, *Organization*, 1932.

5-37. LEE KRASNER, *Untitled*, 1939.

5-39. PABLO PICASSO, *The Studio*, 1927–28.

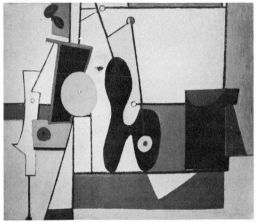

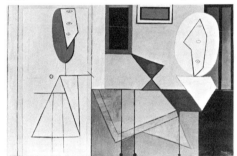

terms, is typical of their work. However, others, such as de Kooning, Krasner, and Gorky, chose Picasso as their mentor; three abstract paintings by these artists (*Ills. 5-36, 5-37, 5-38*) recall Picasso's studio interiors of the late twenties (*Ill. 5-39*) and his expressionistic sur-realizing Cubism of the late thirties.

Although the American Abstract Artists was international in character, its aim was to make New York a center for abstract art. (Glarner and Albers, recent arrivals from Europe, were frankly oriented toward geometric abstraction; some of the members also belonged to Vantongerloo's and Herbin's Abstraction-Création group.) The association's annuals were still dominated by strict geometric abstraction based on the horizontals and verticals derived ultimately from de Stijl or Constructivist prototypes. Typical catalogue essays were "On Simplification" by Albert Swinden, "The Quest for an Abstract Tradition"

by George L. K. Morris, and "On Inventing our Own Art" by Ibram Lassaw.

In the late thirties abstract art in America was a voice crying out in the wilderness. With no hope of winning a mass audience away from the realistic styles, abstract art also was spurned by the museums as hopelessly out of date—the modern style of the twenties. Although the Whitney had lent impetus to the movement by holding an exhibition of abstract painting in America in 1935, when the Abstract Artists wished to hold its annual showing there in the late thirties, it was refused. In 1940, members of the Abstract Artists picketed the Museum of Modern Art demanding that the museum show American art.

The small but militant avant-garde was fortunate to find a few supporters like the critic George L. K. Morris and the collector A. E. Gallatin, both also abstract painters. Morris wrote about their work, and Gallatin showed some young Americans, along with the latest work of Picasso, Braque, Gris, Léger, Arp, and Masson, at his Museum of Living Art, installed at New York University's Washington Square College. Further uptown, abstract art could be seen at the Dudensing Gallery, the Pinacotheca (later Rose Fried) Gallery, and at Curt Valentin's, where Matisse's large 1916–17 *Bathers by a River* showed what open areas of saturated color could do in a large format. At the Solomon R. Guggenheim Museum of Non-Objective Art, founded in 1937, Kandinsky's freely painted lyric abstractions provided another alternative to the hard linear contours and architectonic compositions of late Cubism. With the gradual influx of the leading artists of France, Holland, and especially Germany, examples of the most ambitious European art were more plentiful in New York than ever before. Even more important, perhaps, was the opportunity for direct contact with these artists whose standards the Americans now felt that they could—and must—measure up to.

Certain of the Europeans were, of course, more influential than others. Jean Helion, one of the leading French Purists, who came to America during the mid-thirties and later left to join the French Resistance, was influential in disseminating the fundamental principles of abstract art. In interviews, lectures, and statements, Helion presented the argument, well-known in Europe but not in America, that abstract art was best suited to express the abstract thought of the technological age. Helion's compositions, based on the juxtaposition of flat shapes with modeled shapes, influenced a number of American abstractionists. Léger's visit in the late thirties also helped to stimulate native abstraction; in their audacity and directness, his bold mechanistic images held great appeal for the Americans. Albers became an

important force in American art from the moment he took over the art department at the experimental Black Mountain College in North Carolina in 1933. Here he raised art instruction to the sophisticated level it had reached at the Bauhaus, stressing the principles of abstract composition and design that were the core of the Bauhaus curriculum. In the forties and fifties, Black Mountain became an important center of avant-garde activities; Buckminster Fuller, de Kooning, Kline, Motherwell, Tworkov, Clement Greenberg, and John Cage, at one time or another, were on its faculty. Among the students were Robert Rauschenberg, Kenneth Noland, and John Chamberlain.

Although Picasso was respected by the young members of the American Abstract Artists, it was rather the late Cubist geometry of Helion, Léger, Herbin, and Mondrian that the majority chose as their models. In the meantime, a few of the most gifted young painters were already beginning to rebel against the dryness and rigidity of geometric art. Gorky, de Kooning, and Pollock, never attracted by non-objective or Purist art, went straight to Picasso himself. Their posi-

5-40. ARSHILE GORKY, *The Artist and His Mother,* 1926–29.

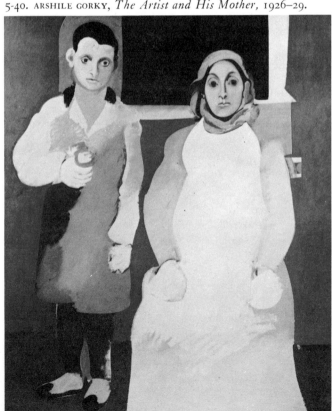

tion vis-à-vis geometric art was that articulated by Picasso: "Abstract art is only painting, but where is the drama?"

Gorky had looked to Picasso since the late twenties. His 1929 *The Artist and His Mother* (*Ill. 5-40*), a haunting and sensitive study based on a photograph taken when he was a boy in Armenia, has many affinities with Picasso's 1906 *Self Portrait,* which Gorky could have seen at the Museum of Living Art. Throughout the thirties Gorky continued to study Picasso, taking as his model the angular forms of Picasso's more recent expressionist Cubism, which he adapted with singular ingenuity in his mural for the Newark airport. But toward the late thirties, he began to demonstrate an impatience with Picasso's strict Cubist structuring. Earlier, Gorky had described how "clumsy painters take a measurable space, a clear definite shape, a rectangle, a vertical or horizontal direction, and they call it blank canvas." Now he was ready to apply his observation that "every time one stretches canvas he is drawing a new space."[17] Gorky's realization that the painter was free to determine the actual space in his work was an important step in liberating his compositions from the fixed structural armature of the Cubist grid in order to open the limited, shallow space of late Cubism into an infinite atmospheric continuum. Both Miró and Kandinsky had hinted at such a possibility. But in Gorky's work are the seeds of a new style. This revolutionary style, which constitutes the first major American contribution to world art, could not, however, have come into being before the European tradition had been thoroughly assimilated. The presence of older European-born artists such as Jan Matulka, John Graham, and Hans Hofmann, who had witnessed the rise of Cubism in Europe, and were willing to transmit its principles to young Americans, was of inestimable value in aiding this assimilation. In addition, the example of painters like Hartley, Marin, Burlin, and above all Arthur B. Carles, whose painterly expressionistic styles had provided earlier alternatives to Cubism within the modernist context, took on new significance. In his last painting, Carles allowed his fluid brushstrokes to break the barrier of the Cubist armature of black lines, releasing explosive energies in a manner prophetic of Abstract Expressionism (*Ill. 5-41*).

Thus, for the first time in America, there was the basis for a genuine avant-garde, capable of absorbing not merely Dada's destructive impulse to shock the bourgeoisie, but also the constructive forces gathering throughout the twentieth century in America which offered an alternative to middle-class conventions and popular taste as they were expressed in academic and commercial art. The members of this avant-garde, which inherited Henri's disdain for the official and the established along with Stieglitz' insistence on an art-for-art's sake, had

many battles still before them. Their refusal to use their art for political ends alienated many intellectuals and reformers. Yet they had precedents for such a stand in Sloan's and Davis' earlier refusal to compromise their art. Sloan had explained, "I hate war and I put that hatred into cartoons in the [old] *Masses*. But I didn't go sentimental and paint pictures of war." Davis, on the other hand, maintained that "the Painting itself is the responsible Social Act of the Artist, and is one of the surest, most direct forms of Communication known to man." One of the problems was that modernism had never taken root in America to the extent of evolving a utopian program tied to revolutionary social reform. Thus, Gorky could argue against the fine artist attempting to make popular art by claiming that "poor art is for poor people." But no American artist would maintain with Léger that there was the possibility of realizing a new collective art.

The emerging American avant-garde held no such hopes for a rapprochement between art and society. Its base was in the dingy lofts and tenements of downtown Manhattan; its cafés were sordid all-night cafeterias. In this area below Fourteenth Street, where WPA classes were conducted, and Hans Hofmann had opened his school on Eighth Street, a small but committed fellowship developed. In these unpromising circumstances, American art, through the stimulation of direct contact with the European avant-garde, matured to a vigorous adolescence, and found itself prepared at last to challenge its parent for independence. In the process of defining their own cultural identity and tradition, the best American artists of the twenties and thirties had come to make virtues of their limitations. Boldness, lack of refinement, and even a certain crudity were sought, along with a literalness that tied art incontrovertibly to its environment, and a directness which eschewed subtleties and nuances. These characteristics, it became clear, were what distinguished American art from its European parent.

Disdaining the provincial themes and illustrational approach of the American Scene painters and the social realists, the rebels were most interested in the abstract art coming from Paris, which they could read about in art journals such as *Cahiers d'Art, Plastique, Verve,* and *Minotaure* or in occasional reviews like *transition*. Hofmann, from whom, according to Clement Greenberg, "you could learn more about Matisse's color . . . than from Matisse himself," gave lectures in the late thirties in which Greenberg remembers he stressed that "there was more to high painting than Cubist design."[18] Even had the concept of a "high art" been current among American artists, which clearly it was not, this would have been a radical position. Cubist design was at that point perhaps the only aspect of high art that Americans like Davis had been able to master; they were still

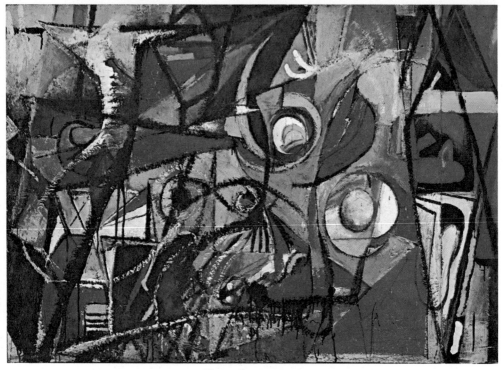

5-41. ARTHUR B. CARLES, *Abstraction*, 1939–41.

struggling with the painting culture behind it. This is what the Europeans, and, above all, Hofmann could teach them. Hofmann had directed an influential art school in Munich from 1915 until 1932, when he settled permanently in the United States. At his Eighth Street school, opened in New York in 1934, he introduced the most advanced concepts of European painting to his students. He taught, as he had in Munich, that "creative expression is . . . the spiritual translation of inner concepts into form, resulting from the fusion of these intuitions with artistic means of expression in a unity of spirit and form." "Imitation of objective reality," Hofmann warned, "is therefore not creation but dilettantism, or else a purely intellectual performance, scientific and sterile."[19]

Painting, for Hofmann, was "forming with color," and nature was the great teacher of painters. Hofmann's method stressed oppositions—of contrasting colors, of positive planes floating in negative space, of expansion versus contraction, of the dynamic opposed to the static. "Every movement [in space] releases a counter-movement," he maintained. "A represented form that does not owe its existence to a perception of movement is not a form, because it is . . . spiritless and

inert."[20] The compositional tension he considered most vital to a living work of art was the opposition created by the simultaneous assertion of the two-dimensional surface plane and that of three-dimensional depth. This tension, he felt, could be harmonized by the balance of "push and pull." Push-pull was his celebrated principle of composition, by means of which the various oppositions within a painting were resolved. In sum, Hofmann stressed the active line, intense color, and assertive paint application.

Although the audience Hofmann addressed was larger than Stieglitz' audience, it was still a minority group, made up mainly of the artists themselves and a few sympathetic writers. Describing the time, Gorky called it the most spirit-crushing period of his life. Of the paralyzing poverty, he said that "if a human being managed to emerge from such a period, it could not be as a whole man."[21] From such a struggle for survival, he maintained, there was no recovery.

In this bleak milieu, two young painters attempted to come to terms with their own compelling visions as well as with the art of their time. Beginning from opposite points of departure, they were to consolidate, each in his own manner, the dynamic impulses of the new world with the painterly tradition of the old. Jackson Pollock, Benton's student and an admirer of Orozco and Siquieros, would transcend the provincialism of the former and the banality of the latter to achieve an art that was universal in its range, and international in its significance. Gorky's young Dutch friend, Willem de Kooning, denying his own extraordinary virtuosity, would bend the refined tradition in which he was steeped toward the end of capturing the explosive tensions and ambiguities of the American experience.

Arriving in New York in 1929, Wyoming-born Pollock was perhaps almost as much a foreigner as de Kooning, who had arrived in 1926 from Amsterdam, where he had studied at the Fine Arts Academy. Pollock's turbulent, dark, romantic seascapes of the mid-thirties are reminiscent of Ryder's possessed visions. De Kooning's paintings of these years were finely wrought melancholy figure studies, distinguished by the fluid line of the master draftsman. For both, the decisive encounter was with Picasso's expressionistic late Cubism. For Pollock, experience with Picasso's sophisticated, highly-structured compositions was a disciplining agent; for de Kooning, who was in the process of rejecting realism, it was a liberating force, which enabled him to distort his own figures to gain a more intense form of expression. Each in his own manner struggled with the genius of Picasso, and in his struggle, helped to free American art permanently from its European ancestry.

Chapter Six

Art of This Century

The Surrealists had the laudable aim of bringing the spiritual to everyone. But in a period as demoralized as our own, this could lead only to the demoralization of art. In the greatest painting, the painter communes with himself.
—ROBERT MOTHERWELL, "The Modern Painter's World," *DYN*, vi, 1944

The Kwakiutl artist painting on a hide did not concern himself with the inconsequentials that made up the opulent social rivalries of the Northwest Coast Indian scene, nor did he, in the name of a higher purity, renounce the living world for the meaningless materialism of design. The abstract shape he used, his entire plastic language, was directed by a ritualistic will towards metaphysical understanding. . . . Not space cutting nor space building, not construction nor fauvist destruction; not the pure line, straight and narrow, nor the tortured line, distorted and humiliating; not the accurate eye, all fingers, nor the wild eye of dream, winking; but the idea-complex that makes contact with mystery—of life, of men, of nature, of the hard black chaos that is death, or the grayer, softer chaos that is tragedy. For it is only the pure idea that has meaning. Everything else has everything else.
—BARNETT NEWMAN, *The Ideographic Picture* (Catalogue, Betty Parsons Gallery, January 20, 1947)

Abstract Expressionism was born of two catastrophes: a depression and a world war. The first, by means of the WPA, provided new opportunities for professionalism and cooperative ventures among artists; the second brought the leading figures of the European avantgarde to America, where their attitudes and their works served as an example to American artists. During the strife-torn years of the late thirties and early forties, the center of world art moved from Paris to New York. It is no wonder, then, that an art maturing in such circumstances should be marked by signs of anxiety, emotional stress, even despair.

In addition, the American artist faced the problem of extricating his art from a debilitating provincialism as well as from the demands of leftist politics, which required that art serve a social purpose. To make matters more difficult, the time when American art prepared to join the mainstream of Western painting was precisely the moment when

abstract art was undergoing the general crisis that accompanied the decline of Cubism.

Between the two wars, the only major international art movements to arise were Dada and its offspring Surrealism. Neither contributed to the continuing evolution of pictorial form which the pioneers of modernism had envisioned. Disillusioned with the myth of political progress through the triumph of reason, Dada and Surrealism set out to destroy the concept of progress in art. By the time World War II broke out in Europe, art had polarized into two camps: Cubist-derived abstraction, including the purist geometry of the non-objective styles, de Stijl and Constructivism; and Surrealism. To synthesize Cubism and Surrealism in an entirely new pictorial style became the goal of American artists.

Certain tentative moves toward imbedding Surrealist forms in a Cubist structure had been made in the thirties, mainly by Gorky and de Kooning, who were inspired by the works of Picasso. However, it was not until the forties, when a sufficient number of refugee artists, both abstract and Surrealist, had arrived in New York, that such a synthesis was accomplished. To the dingy proletarian loft culture of New York came the glittering celebrities of modern art, whose names had been legend and whose reproductions were already tacked to downtown studio walls. Joining Josef Albers were other former members of the Bauhaus faculty: the American-born Cubist Lyonel Feininger, who had lived in Germany until the war's outbreak; the designer Laszlo Moholy-Nagy; the sculptor Naum Gabo; and the architects Walter Gropius, Marcel Breuer, and Mies van der Rohe. On his return to the United States, Feininger continued to practice a modified semi-abstraction. Albers, a far more influential artist, chose the geometric severity of the square as his principal motif, creating innumerable subtle variations on the theme generically called "Homage to the Square" (*Ill. 6-1*). Respected throughout the postwar period, Albers came to new prominence in the sixties when his studies on the interaction of colors served as part of the background of the "new abstraction." Amédée Ozenfant, co-founder with Le Corbusier of Purism, which sought to restore to Cubism its classical purity by basing forms on the clean lines of machinery, set up a Purist school in New York. Fernand Léger, who had visited in the United States briefly in the thirties to paint a never-completed French Line mural, returned to teach at Yale and at Mills College during the early forties.

However, the most important abstract artist who came to America during this period was Piet Mondrian, founder of Neo-Plasticism and the leading member of de Stijl. Like the Surrealists, he had attracted

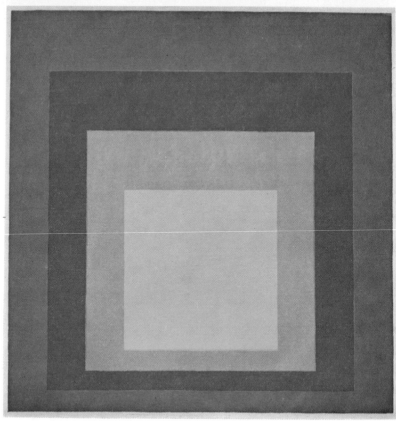

6-1. JOSEF ALBERS, *Homage to the Square: Frislan,* 1955.

considerable attention during the thirties in America, where his cool, geometric abstractions, composed of intersecting right angles and flat planes of color, were highly esteemed. While he had been largely ignored in Europe, his work had been purchased by American collectors such as A. E. Gallatin and Katherine Dreier, as well as by the Museum of Modern Art and the Guggenheim Museum. Among his admirers were American artists like Ilya Bolotowsky, Burgoyne Diller, and I. Rice Pereira, whose work in the thirties had been closer to Constructivism in its use of free-floating planes on a colored ground. Persuaded by the American Neo-Plasticist Harry Holtzman to leave London (where the flat next to his had been bombed out), Mondrian arrived in New York in 1940. Immediately he was surrounded by a devoted circle of abstract artists, some of whom had already been painting in the Neo-Plastic manner before his arrival. Among the group were Holtzman, Bolotowsky, Glarner, Albert Swinden, and Charmion von Wiegand.

Mondrian's contribution to American art was a strengthening of the current of geometric abstraction. This movement, which had been active in the thirties, was to run submerged in the forties and fifties, and become more central once again in the sixties. Supporting and exhibiting with the American Abstract Artists, Mondrian proved a symbol of selfless dedication to art, and his work acted as an important stimulus to the development of the artists around him. Along with Kandinsky, Klee, and Malevich, Mondrian was one of the major theoreticians of modern art; in America he became the source for the diffusion of the principles of pure plastic design.

Like Malevich, Mondrian was convinced that abstract art was the form of expression appropriate to the twentieth century. New York City, with its indomitable energy, swift tempo, flashing lights, and its strict grid of streets with skyscrapers shooting upwards, became for Mondrian the essence of the modern age. The power of abstract art to express feeling is forcefully demonstrated in Mondrian's last works, executed in New York just before his death in 1944. In contrast to some of the refugee artists, such as George Grosz and Marc Chagall, who were relatively untouched by the American environment, Mondrian underwent a profound stylistic change during his last years. Like the young New York artists, Mondrian became interested in the syncopated rhythm of jazz—not in the cool, poetic improvisations of Charlie Parker or Miles Davis, whose music would find sympathy among New York painters somewhat later, but in the measured beat of boogie woogie. In his last masterpieces, *Broadway Boogie Woogie* of 1942–43 (*Ill. 6-2*) and *Victory Boogie Woogie* of 1943–44, which were regularly on exhibition at the Museum of Modern Art during the forties, he replaced the static primary-color rectangles and black grids on a white surface, which had characterized his works since the twenties, with small, irregularly placed rectangles of red, blue, and

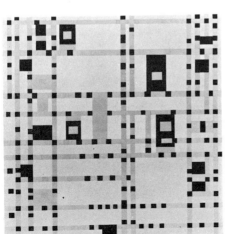

6-2. PIET MONDRIAN,
Broadway Boogie Woogie, 1942–43.

133

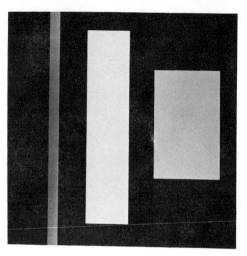

6-3. BURGOYNE DILLER,
First Theme, 1955–60.

yellow which flash to a syncopated beat. A new energy and movement, and an optical flicker, give these works an active quality that is radical for Mondrian.

Mondrian received from America perhaps as much as he contributed. His exhibitions at the Dudensing Gallery continued to inspire artists like Glarner, Diller, and Bolotowsky, whose work of the late forties and fifties became more closely tied to Mondrian's. Diller, for example, began breaking up his canvas into a field activated by a complex, ladder-like configuration of narrow, intersecting horizontal and vertical bars. In later paintings, such as *First Theme* (*Ill. 6-3*), Diller returned to the simpler compositions of a few rectangular elements suspended freely on a colored ground that had characterized his early work. In the later paintings, however, these elements tend to be similar and their placement more rigorously symmetrical.

Fritz Glarner remained close to Mondrian, although he departed from Neo-Plasticism in using diagonals and circular compositions and in introducing colors other than the primaries. Eschewing the grid in favor of interlocking planes of color wedged together, he repeated equivalent planes or wedges which set up a series of echoes. Glarner termed his method of composing "relational painting" (*Ill. 6-4*), as Mondrian had called "relationships" the basis of abstract art.

Although the abstract artists from abroad were important to the future of American painting, the Surrealists-in-exile had an even greater impact. Matta, the first Surrealist painter to arrive, came in 1939; in the early forties he was followed by Dalí, Max Ernst, Kurt Seligmann, and André Masson. The poet André Breton, who in 1924 wrote the first Surrealist manifesto, became the center of the transplanted movement. Resuming his Surrealist court in New York, where

artists and poets played Surrealist games like *cadavre exquis* and made automatic poems and drawings, Breton helped stage exhibitions, publish magazines, and hold events which scandalized the public.

As Max Ernst's wife and hostess to the Surrealists, Peggy Guggenheim played an important role by introducing young American artists to the exiled artists. Miss Guggenheim had been living in Paris at the start of World War II; her earlier plans to open a modern art museum in London had not materialized. In Paris she made purchases based on a list compiled by Marcel Duchamp, Sir Herbert Read, and Petra van Doesburg, widow of Mondrian's collaborator, Theo van Doesburg. During this time, she became active in a committee to send artists to America, through which she met Breton and Max Ernst. By 1941, all three were in New York, where Miss Guggenheim decided to start a combination gallery-museum. Called Art of This Century, it opened in 1942 with an exhibition of her collection. Decorated by the unpredictable architect-designer Frederick Kiesler (who also designed an extraordinary set of furniture with multiple functions), the gallery was arranged so that pictures were suspended in mid-air or projected a foot outward from the walls. The catalogue included a history of Surrealism by Breton, essays by Mondrian and Arp, and statements by the artists. The collection was divided into two groups: abstract and Surrealist. The abstract section included works of the critical years before World War I by Léger, Picasso, Duchamp, and the other leading Cubists; Futurist paintings by Balla and Severini; abstractions by Kandinsky, Delaunay, Mondrian, Malevich, Lissitsky, and Arp; and sculpture by Arp, Archipenko, Brancusi, Lipchitz, Giacometti, Gonzalez, Pevsner, and Vantongerloo. The Surrealist section was called "Fantastic Art, Dada, and Surrealism" (the title of the 1936 Surrealist survey at the Museum of Modern Art); it included works by Chagall, de Chirico, Picabia, Man Ray, Ernst, Schwitters, Klee, Tanguy, Matta, and Magritte.

With the help of her secretary, Howard Putzel, Miss Guggenheim completed her collection in New York. Describing the opening, held for the benefit of the Red Cross on October 29, 1942, she recalls, "I wore one of my Tanguy ear-rings and one made by Calder, in order to show my impartiality between Surrealist and abstract art."[1]

From 1942 to 1947 (the year Miss Guggenheim and most of the Surrealists returned to Europe), Art of This Century showed young American painters along with the Europeans. The young Americans exhibited were Pollock, Motherwell, Baziotes, Rothko, Still, Gottlieb, and David Hare. In addition, Hans Hofmann had his first one-man show there. In his lyric paintings of the early forties, such as *Effer-*

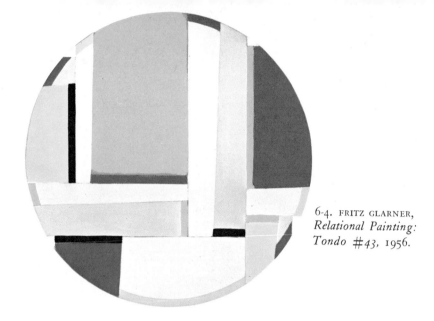

6-4. FRITZ GLARNER, *Relational Painting: Tondo #43,* 1956.

vescence (*Ill. 6-5*), Hofmann achieved an unprecedented degree of painterliness in an abstract style. In later works, such as *Cathedral* (*Ill. 6-6*), he reverted to the more solid structuring of architectonic planes which were balanced by the "push-pull" dynamic of their intricate color relationships. Another artist doing advanced abstract work

6-5. HANS HOFMANN, *Effervescence,* 1944.

6-6. HANS HOFMANN, *Cathedral,* 1959.

6-7. RICHARD POUSETTE-DART, *Desert*, 1940.

in the early forties was Richard Pousette-Dart. His *Desert* (*Ill. 6-7*) was a successful attempt to translate the boldness of Picasso's late Cubist style into an entirely abstract decorative context. But among his fellow artists, Jackson Pollock rose the fastest during those years. "Pollock became the star of the gallery and for five years I supported him and launched him by selling his paintings, which in those days was very difficult," Peggy Guggenheim remembers.[2]

The main lines of the revolt of young New York painters in the late thirties and early forties may be followed in the light of what they borrowed from Surrealism. For them, abstract art was mere formalism, empty decoration which could not embody universal themes. Rejecting the narrow chauvinism of Regionalism, they set out to express the general, the universal, and the elemental. Although the nature painters in the Stieglitz group, O'Keeffe, Dove, Marin, and Hartley, had a similar aim, their approach was not programmatic. The younger painters differed from previous generations of American artists in that they valued content over subject matter, and as much as form, if not more so. But spurning the easily communicated content of religious allegory, they also refused to illustrate the tragedies of the moment in literal terms.

Still following the lead of the Surrealists, who had adopted much of their imagery from Freud, these artists turned to the enduring myths of the race as the source for the most profound and universal emotions. In general, Jung's theories of archetypes and the collective unconscious proved sympathetic to artists like Gottlieb, Rothko, Still, and Pollock, who were seeking symbolic equivalents for interior states of mind.

Freud's theories seemed too intellectualized, and too exclusively a product of Western European culture to be sufficiently universal. Searching for pictorial equivalents of universal experiences, they appropriated ancient myths, symbols, and signs. Often these symbolic forms were simplified to stand for such Manichaean oppositions as light versus darkness, good versus evil, celestial versus chthonian.

If these universally meaningful forms were buried in the subconscious, then the problem was how to bring them to the level of consciousness in order to express them in art. Surrealism was part of that reaction against the deadening and inhibiting factors in Western culture, which may be traced from Jean-Jacques Rousseau through the self-conscious primitivism of late nineteenth-century art. Surrealism put an even higher store on the instinctual and the archaic than Cubism or German Expressionism had done. But it was the buried primitive in modern man that the Surrealists wished to reconstruct. Inspired by the Freudian method of free association, they invented the technique of "psychic automatism." By means of this technique, the poet or artist allowed his thoughts or hand to wander spontaneously, much as the hand moves at random on the Ouija board, and to meander in strange paths unchecked by the fetters of reason or logic.

The purpose of automatism was to allow the subconscious to generate buried images unavailable to the conscious mind. Ostensibly no attempt was made to control these idle doodlings which then might serve as points of departure for more conscious configurations. In this manner, the Surrealists and American artists who practiced automatic techniques, such as Motherwell, Pollock, Gorky, and later, Bradley Walker Tomlin, hoped to tap the free flow of unhampered creativity. Other semi-automatic methods, probably based on the manner in which Rorschach images are interpreted, were developed, especially by Max Ernst, whose imagination was particularly fertile in this area. Ernst's "frottage" involved rubbing grained textures with a pencil and using the impression as the point of departure for an image; "grattage" was Ernst's technique for manipulating the paint surface, scratching over it with an oiled fork or ruler, so that it yielded forms like those of a fantastic landscape. "Decalomania," another Ernst technique, consisted of crushing paint between two canvases and elaborating the resultant hills and valleys of pigment into crevices and encrustations of lunar or volcanic landscapes. Ernst is also said to have invented a machine for randomly spotting the canvas with paint. Common to all of these methods is the precedence of process over conception. This is the reverse of the creation of abstract art which, although it might undergo alteration during its execution, had a con-

6-8. WILLIAM BAZIOTES, *Congo,* 1954.

ceptual basis. This aspect of automatism—its stress on process as central to creativity—was taken over by the Abstract Expressionists, who gradually changed the emphasis from the process of inventing and generating images to the process of painting itself.

Because as little control as possible was exercised in automatic creation, accidents of all kinds, random and chance effects, were frequent. These effects were considered the means for achieving greater spontaneity, and the accidental splashes and drips of paint left by the path of a rapid brushstroke were cultivated. The Surrealists' emphasis on the play element in art became a way of preserving freshness for the Abstract Expressionists.

Although the literal symbols of Freudian dream images did not generally appeal to the Abstract Expressionists, the more ambiguous, but equally sexually charged vocabulary of forms invented by Arp and Miró and adapted by the Surrealists remained a source of in-

spiration throughout the forties. These organic free shapes were called biomorphic because of their similarity to biological forms, such as the amoeba with its pulsating contours and bulbous protrusions. Since these forms are common to all natural life—human as well as plant and animal—they provided the common denominator that the painters sought. William Baziotes, who never developed the fluid painterly freedom of his contemporaries, based his imagery on such biomorphic forms. In *Congo* (*Ill. 6-8*), a work revealing Baziotes' considerable gifts as a subtle colorist, curvilinear biomorphic forms are flattened out into decorative patterns which float in a watery atmosphere. Similarly, Theodoros Stamos used biomorphic forms and turned to the collective unconscious. Gorky, on the other hand, developed a highly personal formal vocabulary based on biomorphism which influenced de Kooning. De Kooning, in turn, exhausted the possibilities of biomorphism toward the end of the forties in his black-and-white paintings. And both Rothko and Gottlieb, in such symbolic works of the forties as Rothko's *Prehistoric Memories* (*Ill. 6-9*) and Gottlieb's *Voyager's Return* (*Ill. 6-10*), couched mythic content in the forms of biomorphism.

Thus, the crisis in American art engendered by the rejection of geometry in the late thirties was resolved in the early forties through the adoption of Surrealist symbols and techniques. Automatism freed painterly qualities and allowed the expression of universal themes, al-

6-9. MARK ROTHKO,
Prehistoric Memories, 1946.

6-10. ADOLPH GOTTLIEB,
Voyager's Return, 1946.

ready implicit in the earlier works of Gorky, de Kooning, and Pollock. However, in the late forties, as the Americans gained confidence and the Surrealists returned to Europe, there was a reaction against Surrealism which was similar in some respects to the earlier reaction against geometric Cubism.

Despite the degree to which American painting is indebted to Surrealism, certain aspects of Surrealism remained distasteful to the Americans. They disdained, for example, the social life and sensational publicity sought after by the Surrealists. Photographic realism, literary content, or perverse overtones were also rejected out of hand. Interest in the meticulously detailed style of Dalí and Tanguy was limited, but the painterly automatism and fluid space of Masson and Matta were particularly influential. What interested the Americans in Surrealism were its processes, its attitudes toward creativity and the unconscious, and its emphasis on content. In many cases, the myth of creation itself became an important metaphor for artistic creation.

Whether Arshile Gorky was the last of the Surrealists or the first of the Abstract Expressionists has not yet been resolved. The answer is that he was both. The last artist to be accepted by the Surrealists as a member of their group, he was the protégé of André Breton, who found Gorky with his poetic temperament a kindred spirit. It was Breton who invented the term "hybrid" to describe Gorky's mysterious, ambiguous images. By means of these biomorphic hybrid images, Gorky was able to reconcile the figurative with the non-figurative. Breton characterized the hybrids as "the resultants provoked in an observer contemplating a natural spectacle and a flux of childhood *and other memories. . . ."*[3]

Although his contact with the Surrealists allowed Gorky to realize himself—by providing him with the technique of automatism through which he could externalize his rich inner world of fantasy—Gorky had also served a long apprenticeship with teachers he never knew. Unlike previous American artists who identified tradition with older art, Gorky accepted the tradition of the modern masters, especially Cézanne, Picasso, and Miró, and the early Kandinsky. He studied and imitated their works as assiduously as Raphael's disciples had copied their master. Meyer Schapiro remembers Gorky in "museums and galleries, fixed in rapt contemplation of pictures with that grave, searching look which was one of the beauties of his face. . . ."[4]

Gorky identified Cubism as the modern tradition, from which one could draw as from the old masters. A number of Gorky's Cubist paintings of the thirties derive specifically from Picasso's 1927–28 studio interiors, in which hard rod-like black lines connect geometric shapes

6-11. ARSHILE GORKY,
Garden in Sochi, 1941.

and act as a foil to the shapes. These paintings, such as *Organization* (*Ill. 5-38*), are Gorky's closest approximation to geometric abstraction; yet they are filled with ideographic eyes and allusions to faces and anatomy. But hard contours and strict rectilinear forms were not to Gorky's taste, and in the late thirties he abandoned them for more loosely painted, irregular organic shapes bounded by flexible, pulsating contours of changing thickness. In these paintings it is already clear that the forms are both elusive and equivocal; a dot may be an eye or a nipple, a curved wedge may suggest a wing or a leaf.

The early forties was the time of Gorky's fulfillment. To assist the war effort, he gave a class in camouflage, which, according to his dealer, Julien Levy, helped him to discover that "if the realistic object can be camouflaged, so can the unreal or 'surreal' object be decoded and decamouflaged."[5] In the several versions of *Garden in Sochi* of 1940–42 (*Ill. 6-11*), Gorky allowed his imagination to reconstruct the idyllic orchard known as the "garden of wish fulfillment" on his father's

6-12. JOAN MIRÓ,
Seated Woman II, 1939.

143

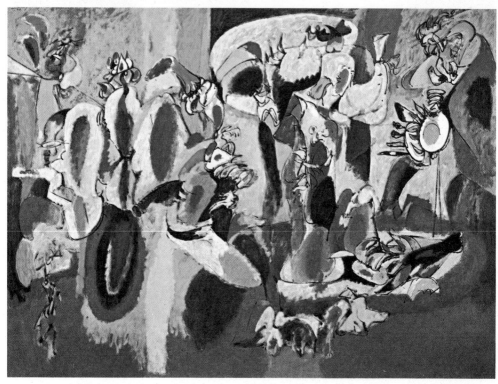

6-13. ARSHILE GORKY, *The Liver Is the Cock's Comb,* 1944.

farm. The tapering and bulging biomorphic forms are still close to
Miró's *Seated Woman II* (*Ill. 6-12*), which Gorky could have seen at
Art of This Century. However, the wish to evoke in abstract terms a
specific landscape, with all of its emotional associations, allies this
work with Kandinsky's first abstract landscapes. A large dead tree,
to which torn strips of clothing were affixed, and a blue rock which
village women believed could induce fertility, invoke ancient folk
legends in the same manner that Kandinsky's early abstractions evoke
the landscape and peasant myths of Russia.

The six or more works related to the "Sochi" theme mark the be-
ginning of Gorky's use of nature as his principal theme. During a
summer at his wife's family's farm in Virginia in 1943, he began a series
of drawings in which the forms of nature were generalized and trans-
formed into universal configurations. By now Gorky had begun to
paint thinly, allowing washes of pale tints to spread and run, and
separating line from patches of color. This was to be the future direc-
tion of his art. According to William Seitz, "The details, delineated

6-14. ARSHILE GORKY,
The Liver Is the Cock's Comb,
Study, 1943.

with surgical precision, convince us of their actuality: they are real things. Hairline distinctions are established between thoracic projections, fleshy masses, and clusters of fluttering membranes. A single contour can define the swelling of an anatomical bulge, delimit an abstract plane, and initiate a movement."[6] Thus, Gorky's already lush, suggestive imagery became even lusher and denser with conflated meanings.

Normally, it was Gorky's practice to work from carefully prepared drawings. The relationship of the drawings to the paintings may be easily discerned in a comparison of the brilliant *The Liver Is the Cock's Comb* (*Ill. 6-13*) with the drawing that served as its point of departure (*Ill. 6-14*). From the wealth of freely invented forms which sprung without inhibition from his pen, Gorky selected the most telling configurations, rearranging them in a more cohesive order and adding spots, patches, haloes, and streams of richly modulated color. In such a process of refinement, the liberating potential of automatism, subjected to the artist's subsequent critical reappraisal, proved a most valuable creative tool.

In his last paintings, the intensity of Gorky's vision caused the forms to be almost unbearably attenuated, tortured, and drawn-out. Tendril-like forms become teeth or claws; and menacing, ominous or eviscerated forms predominate. The nature pictures were followed by a series of "interiors" influenced by Matta, in which furniture, utensils, and anatomical parts were fused. The autobiographical nature of these more intimate last works, done while Gorky suffered a series of tragedies, including a fire which destroyed many paintings and a grave illness, gives us the picture of a psyche brutalized rather than brutal.

145

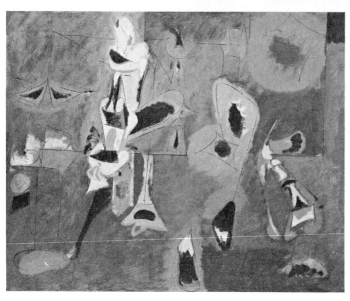

6-15. ARSHILE GORKY,
Agony, 1947.

The background of these paintings is no longer fluid, but richly brushed and modulated. In his final style, in works like *Agony* (*Ill. 6-15*), Gorky was the first to synthesize abstract painterliness with Surrealist motifs. The apprentice to the modern masters had become one of them.

Like Gorky, Jackson Pollock also was a myth in his own time. Throughout most of his life, Pollock struggled with the problem of figuration, as did de Kooning. In Pollock's celebrated "drip" paintings of 1947–50, however, he used automatism as a means of making totally abstract paintings. In these unique works, Pollock changed the face of American painting by introducing "all-over" composition. He was also the first to arrive at a single characteristic image in the interlaced webs of the drip paintings.

The facts of Pollock's biography lend themselves easily to myth-making. Born in Wyoming and raised in California, an admirer of Ryder and American Indian art, Pollock was the natural candidate for all-American painter. In addition, the crudeness, intensity, and passion shown in his works were qualities that had come to be identified as characteristically American. These qualities are evident in his convulsive, turbulent seascapes of the thirties (*Ill. 6-16*), in the ritual themes of the forties, like *Totem Lesson II* (*Ill. 6-17*), and in the later drip paintings. If Gorky and de Kooning fought to free their art from the binding strictures of Cubism through the agent of emotional expression, Pollock's task was to find a means of ordering raw feeling.

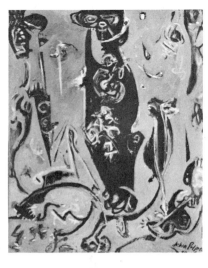

6-16. JACKSON POLLOCK, *Untitled, ca.* 1937.

6-17. JACKSON POLLOCK, *Totem Lesson II, ca.* 1945.

Gorky's and de Kooning's triumphs were in the ultimate release of hidden energy; Pollock's lay in wresting a transcendent order from primordial chaos.

Before he had any direct contact with the Surrealists, Pollock had been involved with certain aspects of Surrealism, such as mythical themes of primeval genealogy. This direct contact came in 1943, when Pollock became affiliated with Art of This Century. Through his friend Robert Motherwell, Pollock learned the technique of automatic creation during the winter of 1941–42. Within a few months, Pollock was producing automatic works, drawings and water colors, culminating in the great, nearly twenty-foot *Mural* (*Ill. 6-18*) (now at The University of Iowa), which Peggy Guggenheim commissioned in 1943 for her entrance hall. This was the first mural-size painting by an artist of Pollock's generation. Already, in this frieze-like work, line

6-18. JACKSON POLLOCK, *Mural,* 1943.

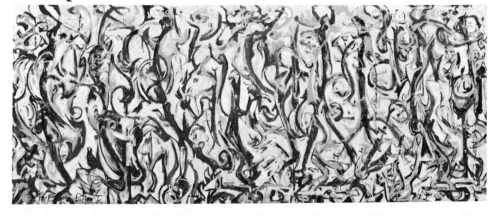

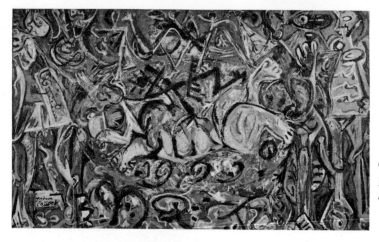

6-19.
JACKSON POLLOCK,
Pasiphaë, 1943.

has become identified with gesture, and shapes and closed forms have disappeared. The dance-like movement of figures rhythmically inter-twined suggests Matisse's *The Dance.* But where the movement in Matisse's composition is rotary, Pollock's frontal disposition of the figures is parallel to the picture surface. His figures interpenetrate and partake of one another like the letters of the Kufic alphabet.

From this point on, Pollock painted an astonishing series of pictures, in which anatomical fragments, heads, ideographic signs, ancient cabal-istic symbols, and free arabesques are described by the same electrically charged, nervous meandering line. In some, like *Pasiphaë (Ill. 6-19)*, totemic figures flank the central portion, which is characteristically or-ganized as the long rectangle of a frieze. In 1946, in such works as

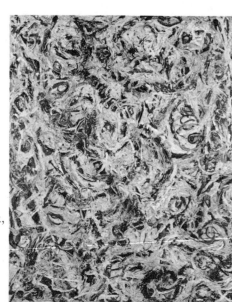

6-20. JACKSON POLLOCK,
Eyes in the Heat, 1946.

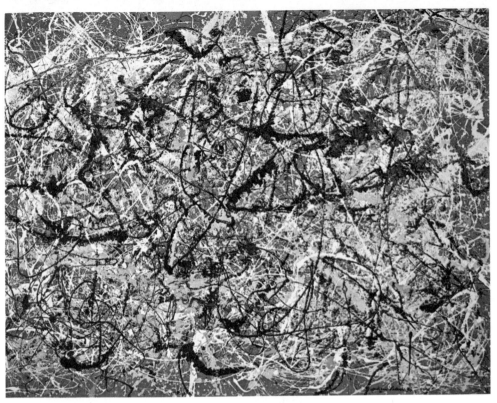

6-21. JACKSON POLLOCK, *Mural on Indian Red Ground,* 1950.

Eyes in the Heat (*Ill. 6-20*), short, curving brushstrokes cross and recross, dissolving their meteoric brilliance in a swirling, churning continuum. These dense, thickly impastoed works were followed in 1947 by Pollock's first drip masterpieces. These works constitute a genuine break-through in the recent formal innovations of American painting; they are moreover the only paintings that can be accurately described as both abstract and Expressionist to the same degree. In such a painting as *Mural on Indian Red Ground* (*Ill. 6-21*), the maelstrom has given way to the lyrical beauty of the open, transparent nets and skeins of paint cast over one another. The eye attempts the impossible task of unraveling the dizzying, labyrinthine complexity of these works, finally accepting the total unity and indissolubility of the created image. That this image does not depend on shape or form in the conventional sense, but rather on line and movement, makes it that much more difficult to comprehend. Because the eye must constantly travel the convoluted paths, the sense of movement is preserved even in the static framework of a painting. Since there is no longer any dis-

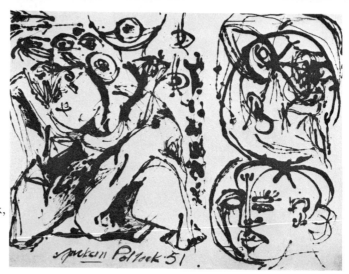

6-22. JACKSON POLLOCK,
Number 27, 1951.

tinction between figure and ground, or any attempt to model forms sculpturally by using line as contour, a new kind of pictorial space is achieved.

This space has been called purely "optical," in contrast to pictorial space composed of a series of planes receding behind the picture plane, which allow the eye to move forward and backward. Since Cubist space, no matter how shallow and how insistent on the integrity of the surface plane, still permits in and out fluctuations in depth, one may interpret Pollock's drip paintings as the first significant change in pictorial space since Cubism. Thus, the drip paintings offered a new kind of "optical" pictorial space as well as a new kind of "all-over" pictorial organization. In this, they became the central point of departure for the abstractions of the fifties and sixties.[7]

Not even Pollock, however, could maintain the volatile synthesis of the contradictory elements of the abstract and the expressionistic represented by the drip paintings. In 1951, he reintroduced figurative elements into paintings such as *Number 27* (*Ill. 6-22*), which were now mainly executed in black Duco enamel on raw canvas. Some of the paintings of the fifties, however, combine the drip technique with impastoed passages for a new richness of surface effects. Pollock did not return again to the free-swinging arcs and hemicycles, the openness and transparency of the drip paintings. Instead, his late works often recapitulate earlier themes, such as the wild turbulence of the flickering seascapes, and the totemic figures of the ritual themes.

It is important to know that Pollock worked on the floor, not on the

wall. He did not prime his canvas, but poured or dripped the paint directly onto the raw canvas, which tended to absorb the first layers of paint. Perhaps because he was able to attack the canvas from all sides, he could give each part of the painting equal emphasis and ignore the need to orient or balance the composition in any single direction. Although his method of composition was radical, it allowed for modifications on the basis of subsequent critical re-evaluations. One of the last decisions to be made was the painting's final dimensions; in the final step the painting was cut out and mounted on a stretcher. Because Pollock's art was so emotional and deeply felt, the tendency to dismiss his paintings as spontaneous outpourings has worked against an understanding of them as the result of conscious ordering, technical control, and critical evaluation.

An artist who was also transformed by contact with Surrealism, Robert Motherwell was as beset by opposing impulses as Pollock, if not more so. A student of aesthetics, he brought to painting a keen awareness of its historical situation. But, distrustful of intellectualization, he sought to illuminate consciousness through probing the unconscious. Attracted to the sun-drenched sensuality of Mediterranean cultures, Motherwell valued painting as a source of pleasure, a value it had seldom, if ever, been assigned in America. Yet the need to rationalize sensation, to provide it with some kind of ordered framework which would make it intelligible, forced him to return time and again to the problem of structure.

Because of his erudition, Motherwell was able to take a large view, to see "the history of modern art . . . as the history of modern freedom." Understanding the radical, critical spirit of the European avant-garde, he helped to transmit its values to his own generation. Although he saw automatism as a means of mediating between the conscious and the unconscious, he also believed that this technique had a broader significance:

The fundamental criticism of automatism is that the unconscious cannot be *directed,* that it presents none of the possible choices which, when taken, constitute any expression's form. To give oneself over completely to the unconscious is to become a slave. But here it must be asserted at once that plastic automatism though perhaps not verbal automatism—as employed by the modern masters, like Masson, Miró and Picasso, is actually very little a question of the unconscious. It is much more a plastic weapon with which to invent new forms. As such it is one of the twentieth century's greatest formal inventions.[8]

Motherwell speaks also of automatism as a kind of doodling or scribbling that is like the original process in children's art. Like Klee,

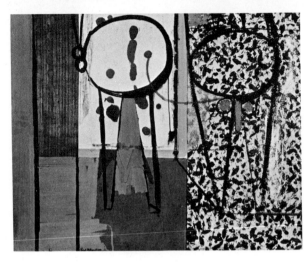

6-23. ROBERT MOTHERWELL,
Pancho Villa,
Dead and Alive, 1943.

the American artists whom Motherwell introduced to automatism sought to preserve the freshness of the naive eye of the child.

The reconciliation of opposites, one of the characteristics of Abstract Expressionism, is perhaps most dramatically diagrammed in Motherwell's work. The struggle to strike a balance between contradictory elements—the conscious and the unconscious, feeling and intellect, structure and openness, freedom and necessity—is, in fact, the heart of Motherwell's effort. Perhaps because he was as concerned with the destructive effects of culture (in so far as it inhibited sensuality) as he was dedicated to its preservation, Motherwell was more attracted to the Freudian than the Jungian aspects of Surrealist iconography. Thus, he was concerned with the discontents of civilization, the dis-

6-24. ROBERT MOTHERWELL,
Western Air, 1946–47.

6-25. ROBERT MOTHERWELL,
At Five in the Afternoon, 1949.

6-26. ROBERT MOTHERWELL, *Irish Elegy*, 1965.

comfort and anxiety of contemporary Western man in his present situation, rather than with the evocation of prehistoric archetypes or myths. In one of his earliest works, *Pancho Villa, Dead and Alive* (*Ill. 6-23*), a painting done with collage for a collage exhibition Peggy Guggenheim held in 1943, one can find the genesis of Motherwell's major themes. The random drips and spatters testify that he had already adopted the Surrealist attitude that chance and accident enhance spontaneity. On the other hand, the insistence on a logical and coherent structure, in which the picture is divided into quasi-geometrical compartments, exerts some control over accident. Here for the first time Motherwell announces the theme of life versus death, the opposition of Eros and Thanatos that occupied Freud in his late works. Pancho Villa "alive" is distinguished from his dead, blood-drenched mirror image by the presence of genitals, which the "dead" man does not possess. The theme of the Spanish hero (in Pancho Villa's case, 153

Mexican) will find its final form in the phallic configurations of the series of elegies to the Spanish Republic. But in opposition to the somber tragic Spanish themes of death, there will be the life-affirming paintings based on French themes, like the "je t'aime" series of the late forties.

The necessity of maintaining the integrity of the picture plane was clear to Motherwell; his dilemma was how to maintain it in an open painterly style. The problem was to integrate the structure of the more rigid Picassoid works, such as *Western Air* (*Ill. 6-24*), with the freedom and spontaneity of the automatic collages. Having rejected the more formal, hard-edged solution of the earlier "wall paintings," around 1950 he eliminated color in the elegies, restricting himself to black and white. Where background white makes incursions into the foreground black, or vice versa, Motherwell allows painted edge to overlap painted edge so that the two are locked together in a single plane. Thus he is able to reconcile the contrary demands of pictorial structure with those of painterly expressiveness dependent on the play of the brush and the individuality of the artist's personal mark. In the theme of the Spanish "Elegies," with their few dominant Stonehenge-like shapes (which nonetheless have freely brushed edges), Motherwell found a subject and a composition in which he could unite both drives. The subject has occupied him since 1949, when he painted the prototype of the Elegy motif, *At Five in the Afternoon* (*Ill. 6-25*). A typical late Elegy, *Irish Elegy* (*Ill. 6-26*), commemorates the tragedy of Irish nationalism.

Motherwell's paintings of the fifties occupy a point midway between gestural and chromatic abstraction. Although painterly improvisation is important, gesture—as the path of a nervous line—is not. Clarity is not lost in a welter of charged strokes. Shapes tend to be simple, large, and easily distinguishable, with the improvisation kept to the irregularly brushed edges. In the sixties, landscape was Motherwell's most frequent motif; the harsh monochromatic tones of the Spanish landscape are often replaced by the more brilliant blues and greens of the Mediterranean coast.

Gorky had no direct heir among the Abstract Expressionists, but certain aspects of his work, particularly his free interpretation of Cubism and his delicate, disembodied line, had parallels in the work of Willem de Kooning. But de Kooning, who had shared a studio with Gorky in the late thirties, had no interest in Surrealism. He resembled Gorky mainly in his respect for the old masters. His subjects were not the remote evocations of poetic fantasy, but the most tangible realities of the human figure and the urban environment. This pre-

occupation with the tangible and the immediate experience characterizes de Kooning's tougher, more brutal, sensibility.

During the thirties, de Kooning painted in several manners. His sketch for the Williamsburg Federal Housing Project, done during the year he spent working on the Federal Art Project, is close to Gorky's interpretations of Picasso. But more important to his development were the series of muted abstractions of a few simple biomorphic or loose geometric shapes and the sensitive portraits of himself and his friends. The grayed tints of these works and the transparent painting add to the ghostly quality of the figures, which seem to merge with their diaphanous backgrounds.

Of the major artists of his generation, de Kooning was the only one to choose the human figure, first male, then female, as his principal theme. From the late thirties on into the present, he has developed variations on the "woman" that quickly came to be identified as his characteristic image. From the more gentle and lyrical *Queen of Hearts* (*Ill. 6-27*) of the early forties to the scarred and scumbled *Woman* (*Ill. 6-28*) of the middle forties to the culminating fragmented and violated women of the early fifties (*Ill. 6-29*), one can trace both a pictorial and psychological development of the theme.

De Kooning's pictorial dilemma is spatial. Contours are opened to allow flesh and environment to flow into one another, and anatomical forms themselves have been fragmented; hence there is no clear statement as to where the figure is actually located in space. This ambigu-

6-27. WILLEM DE KOONING, *Queen of Hearts*, 1943–46.

6-28. WILLEM DE KOONING, *Woman*, 1948.

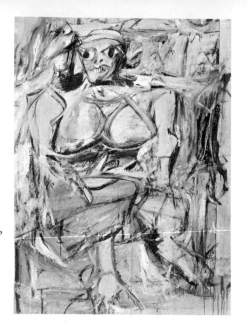

6-29. WILLEM DE KOONING, *Woman, I,* 1950–52.

ous space de Kooning has referred to as the "no-environment," a metaphor for the dislocated space in which the flux of modern life takes place. Tension then arises out of the difficulty in determining where the figure is placed as it emerges from its chaotic environment to assume its own identity. In the paintings of the early fifties there is a new violence, aggressiveness, and brusqueness of attack as the paint is hurled on the canvas in the heat of execution. Such an attack, in which the loaded brush is allowed to drag and sweep across the canvas trailing meteoric splashes and drips, came to be identified as the characteristic means of execution of gestural abstraction or "action painting."

Paralleling the opening up and fragmenting of the "women" paintings in the fifties were the increasingly violent accidents and collisions of de Kooning's painterly abstractions. In *Sailcloth* (*Ill. 6-30*), for example, fragments of anatomy are described by fine-angled lines which also serve to bound planes without closing them off; and planes seem to spill into each other, as if rent open by some dynamic, explosive force. De Kooning's abstract works of the fifties, although simpler and employing larger forms than Gorky's, are related to Gorky in their displacement of humanoid forms into a landscape context. In this spirit, patches of flesh pink recall skin even when no specific anatomical correspondences exist.

De Kooning's "women" of the fifties may be taken as symptomatic of the crisis facing figure painting, or more specifically, of the difficulty

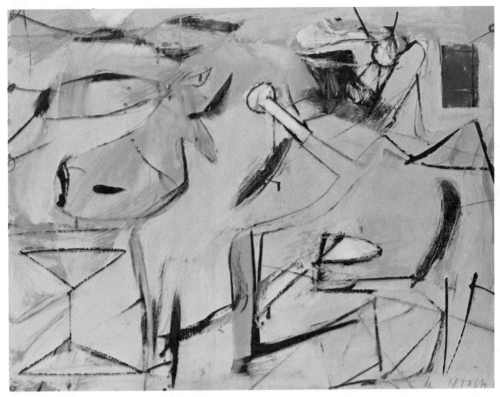

6-30. WILLEM DE KOONING, *Sailcloth, ca.* 1949.

of representing the figure without contour or modeling. The impossible transitions, suggested perhaps by de Kooning's practice of ripping up drawings and sticking them back together with the parts slightly askew, suggest jumps in space that are analogous to the manner in which forms dissolve, disappear, and reappear in the paintings. Earlier, such discontinuities were suggested in the elegant figures of the forties, such as *Pink Angels* (*Ill. 6-31*), in which ribbonlike curves travel along, weaving in and out of space with roller-coaster speed, ending in amorphous hands and feet. Like the other painters of his generation who wrestled with the problem of figuration, de Kooning left physiognomic and anatomical fragments floating around in an ambiguous ambience, sometimes superimposing them in the heat of revisions and modifications. Taking certain existential concepts as his point of departure, de Kooning, among others, saw each painting as constantly in the state of being defined. In this sense, the skirmishes and conflicts he pictured reflect a world view that sees man in constant struggle, both with himself and with his environment.

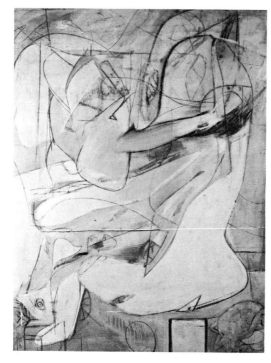

6-31. WILLEM DE KOONING, *Pink Angels, ca.* 1947.

De Kooning's work of the late forties is perhaps his finest. In a remarkable series of works of this period—many executed in black and white—line is allowed to function independently of form; its normal job of describing contour is minimized in the interest of an all-over rhythm of swiftly executed dramatic movement. At this point, de Kooning is closest to automatic procedures, his nervous calligraphy dancing wildly and brilliantly across the canvas surface. These black-and-white de Koonings, and the collage paintings of Marca-Relli, such

6-32. CONRAD MARCA-RELLI, *The Battle,* 1956.

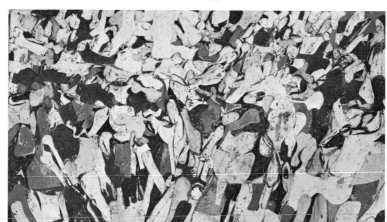

as *The Battle* (*Ill. 6-32*), which are based upon them, represent the end of the biomorphic phase of Abstract Expressionism.

In the fifties, slipping planes and open contours gave way to denser, more crowded works, in which charged brushstrokes smash against one another. Rejecting geometric structure, de Kooning announced that "nothing is less clear than geometry." His works, consequently, grew more unstructured. Because of this development toward increased painterliness, by the late fifties, line had become merely a residual element. The wild strokes, which seem to describe the broad planes of landscape, collide with each other with the brutal force of tidal waves.

Tracing the development of Gorky, Pollock, Motherwell, and de Kooning, we have seen how Abstract Expressionism in the late forties, having rejected "abstraction" or formalism per se, ultimately turned its back on Surrealism to find its own identity. During this period, other aspects of American art of the late thirties began to reassert themselves. For example, whether or not it was intentional, a distinctly American character began to emerge in the new painting. It involved an unconditional pragmatic approach toward materials and techniques, which allowed greater freedom and more dramatic gestures. This, in turn, led to the appropriation of the house painter's brushes and paints. The easel, on the other hand, gave way to the painting wall. Artists saw the possibility of mural-scale art which, by virtue of its sheer size, would encompass the spectator and become his total environment, thus forcing him into a more direct confrontation with the work of art. By the end of the forties, the mythic symbols and biomorphic forms of Surrealism were replaced, on one hand, by rapidly executed, sweeping gestures, and on the other, by large fields of resonant color. In this manner, by 1950 the "first generation" of Abstract Expressionists had distilled the characteristic images by which they would be known.

The adjective "heroic" has been applied to the first-generation Abstract Expressionists. Certainly their aim was to restore to painting the heroic dimension, in a time when men had shown themselves at their least heroic and often at their most bestial. This contradiction—between contemporary reality and the intention of art—must be seen as adding to the difficulty of creating works which assumed that modern man remained the spiritual heir to the entire complex of Western culture. The ideals of the ancient classical and Judeo-Christian tradition were often invoked by artists as disparate as de Kooning, Motherwell, Newman, and Rothko, when describing their own aspirations. Although little is said of the relationship of Abstract Expressionism to World War II, surely some of the tensions in the works arose out of the attempt to maintain humanistic values—to present a heroic image—dur-

ing a time of world holocaust. The Messianic, heroic, and humanistic aspects of Abstract Expressionism, however, must be seen in the general context of American art, which so often in the twentieth century tried to transcend the merely aesthetic.

To complicate matters further, the Abstract Expressionists wished to maintain only the humanistic values of classical art, not its forms. They knew that an authentic American art could only express itself in terms of the American experience. This presented yet another contradiction, since the very qualities that define the American experience—dynamism, flux, violence—may be described as antithetical to the classic spirit.

Chapter Seven

The New American Painting

It was with the utmost reluctance that I found the figure could not serve my purposes. . . . But a time came when none of us could use the figure without mutilating it.

—MARK ROTHKO (quoted by Dore Ashton,
The New York Times, October 31, 1958)

Around 1950, Abstract Expressionism broke into two clearly defined camps, which may be called gestural abstraction or, as Harold Rosenberg termed it, "action painting," and chromatic abstraction. Among the artists for whom gesture was paramount were Pollock, Kline, Guston, and de Kooning; whereas Newman, Rothko, Gottlieb, and Reinhardt became primarily interested in focusing a single, central image in terms of large, barely inflected fields of color. The work of Motherwell, Still, and Tomlin can be seen as occupying a position somewhere between the two extremes. By the early fifties each of the leading Abstract Expressionists had achieved a highly individualized style, a kind of personal imprimatur that was more closely identified with the painter's ego than style had previously been.

The "action painters," with the exception of Pollock, remained closer to late Cubist structure and space; the "color field" painters, originally more deeply involved with Surrealism, eventually distilled simple, unified, abstract images from the richness of their Surrealist experience, but maintained the atmospheric space of Surrealism. The former, in their emphasis on surface effects created by a loaded brush cutting a wide swath across the canvas, achieved an unprecedented degree of looseness and painterliness. By means of gesture, the artist made of his personal "handwriting" or calligraphy an individualized personal stamp. The movement of the wrist and the arm came into play, displacing the previous emphasis on the hand and making possible a new breadth and speed of execution. De Kooning, whose success in transforming his draftsman's line into painterly gesture made him the cen-

7-1. MARK TOBEY,
New Life (Resurrection), 1957.

7-2. BARNETT NEWMAN,
The Euclidean Abyss, 1946–47.

tral figure among the action painters, acknowledged that Pollock "broke the ice" for the others. Indeed, although Gorky's late paintings of 1947 exhibited a new fluidity, openness, and freedom, they still combined drawing with painting in a relatively conventional manner. On the other hand, Pollock's series of "drip" paintings begun in 1947 provided the key to a broader, bolder way of working. Hofmann had hinted at this way in his paintings of the middle forties, which combined painting with drawing as gesture. Pollock resolved any conflict between the two extremes of linearity and painterliness by uniting them in a single process.

The term "all-over" has been used to describe the composition of the drip paintings. Although Pollock was the first to realize fully the implications of all-over paintings, he was not the first to treat the canvas surface in such a way that there was no central focus. Monet, in his late water-lily paintings, had eliminated sharp value contrasts, treating the entire canvas surface as a densely packed continuum. In these paintings hierarchical distinctions among forms disappeared, and no single element detached itself from the total image. Later, Miró in his "Constellations" had strewn shapes across the entire field of the canvas, and Klee and Tobey had used tangled webs of lines in an atmospheric space. In Pollock's drip paintings, however, these tendencies

toward all-over, nonhierarchical compositions without a single climactic focus came to fruition.

A member of the mystical Baha'i faith, Mark Tobey studied Japanese calligraphy. Inspired by Oriental script, he developed the all-over markings of his delicate "white writing" paintings. Tobey's pale grisaille paintings like *New Life (Resurrection)* (*Ill. 7-1*) preserve the intimate scale of European cabinet painting. Pollock's drip paintings, on the other hand, in their vast scale, dramatic contrasts, and unconventional technique, mark a more genuine break with the European tradition.

During the crucial years of the late forties, while de Kooning and Pollock explored the possibilities of gestural abstraction, Clyfford Still, Barnett Newman, and Mark Rothko were working toward a more static, reductive abstraction, emphasizing the power of large areas of pure color to provide dramatic impact.

Although Still, Newman, and Rothko were the first to work toward a simplified art based on color rather than gesture, their approaches were radically different. Beginning in the late forties with such works as *The Euclidean Abyss* (*Ill. 7-2*), Newman grappled with the problem of structuring his compositions without recourse to the internal relationships of forms or to the dry precision of geometric painting. As he put it, "Instead of using outlines, instead of making shapes or setting off spaces, my drawings declare the space. Instead of working with the remnants of space, I work with the whole space."[1] Ultimately, he arrived at the solution hinted at in *The Euclidean Abyss:* that of dividing

7-3. CLYFFORD STILL, *Jamais*, 1944.

7-4. CLYFFORD STILL, *1943-A.*

7-5. BARNETT NEWMAN, *Tundra*, 1950.

up the colored field by an irregular, pulsating vertical band or bands. By lining up these bands parallel to the framing edge, Newman made it explicit that the structure of the painting was derived from the canvas support, as in *Tundra* (*Ill. 7-5*). By dividing space into areas by means of bands, he introduced a pictorial structure based on the relationship of the single image to the framing edge. In a sense, the treatment of the canvas as a unified, uniformly articulated field is an extension of Pollock's all-over principle of composition. That is, neither Pollock's skeins nor Newman's fields create shapes in the conventional sense. All-over composition differs from Cubist composition in that it is not based on the repetition of analogous forms or on the relationship of parts, but on the coherence and integrity of a single image that fills the entire space of the canvas. Because it does not depend on hierarchical ordering or on relationships of discrete elements, Newman's method of composing has been called "non-relational."

Clyfford Still was among the first to arrive at a characteristic image by which his work is identifiable. In the late forties, he painted broad

fields of impastoed pigment eaten away by flamelike patches. The raw
vigor of these paintings was already discernible in Still's crude Sur-
realist works like *Jamais* (*Ill. 7-3*), which he showed at Art of This
Century in 1946. His dark romantic paintings, wrenched open by bolts
of lightning, such as the early abstraction *1943-A* (*Ill. 7-4*), have an
affinity with Ryder's romanticism and Pollock's turbulent landscapes.
The suggestion of ravines, gorges, crevices, and other natural forma-
tions in the paintings of the late forties, such as *1948-D* (*Ill. 7-6*), re-
mains even after Still has expunged any Surrealist metaphors. In the

7-6. CLYFFORD STILL, *1948-D,* 1948.

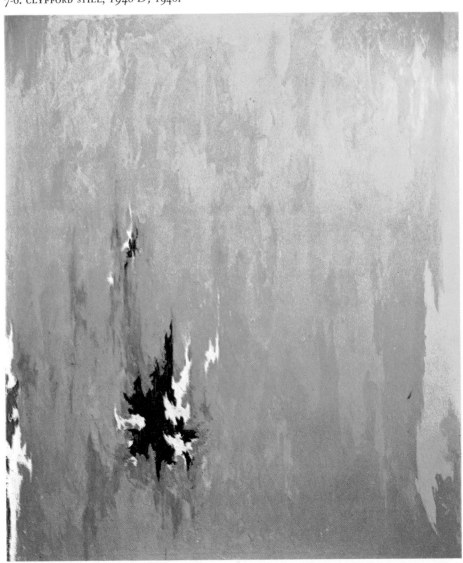

works of the fifties and sixties, the feeling is often that of a romantic landscape cut by canyons and waterfalls, and lit by a strange phosphorescent unnatural light.

Still is known as a pioneer of the mural-size painting. (William Rubin has suggested that the unique type of wall-size painting created by the Abstract Expressionist generation—neither a mural nor an easel picture—was arrived at more or less simultaneously in 1950 by Pollock, Newman, Still, and Rothko.)[2] In some of his works, the vast, irregular fields of dense color are so heavily loaded with paint that they appear literally ploughed by the knife or brush. Forms seem gouged out of the palpable pigment with the elemental force of ice-age glaciers tearing out lakes and uprooting forests. However, because the flamelike patches bite into the adjoining fields, any conventional figure-ground reading is prevented; the forms are not seen as objects against a background. Like Motherwell, Still is the dramatist who deals in the starkest contrast—wild yellows and sizzling reds against somber blues and sinister blacks; like Newman, he presents color as pure optical sensation by using areas of rich, fully saturated color in open fields. But Still's thick pigment is the opposite of Newman's fluidity. Newman offers a lyrical atmospheric continuum, but Still presents the impervious surface of a wall. Thus the opticality of Still's color is contradicted by the tactile quality of his paint surface. In his emphasis on the texture of the pigment rather than on the texture of the canvas, Still is closer to the action painters than he is to the chromatic abstractionists like Rothko and Newman.

In his "environmental" paintings, Still achieves an impact that forces the viewer into a more immediate confrontation with the work of art. The rawness of the paint quality, the willingness to accept as aesthetic what might be considered ugly or inartistic in another context, is the mark, not only of Still's powerful abstractions, but also of American avant-garde work in general. Like many of the new American painters, Still turned awkwardness into an asset, extracting from it an impressive originality of color and of format. His direct two- and three-color arrangements, stretched like a taut skin across the canvas surface, eliminate conventional modeling and volume. In them, clawlike forms reach across the canvas to mesh into the larger painted field, rather than passing in front of or behind a series of receding planes. This works to establish the continuity of the unbroken picture plane by bringing the image up forward, nearer the viewer and flush with the surface.

Although Newman was first, in his drawings and paintings of 1947-48, to deduce pictorial structure from the actual structure of the

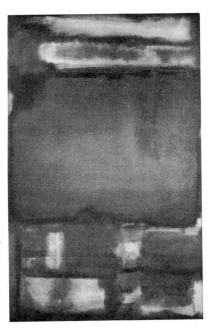

7-7. MARK ROTHKO, *Number 24,* 1949.

rectangle, Mark Rothko and Ad Reinhardt were also working toward similar modes of composition, but from different points of departure. Like Newman and Still, Rothko distilled his characteristic image of two or three delicately brushed rectangles, which echoed the perimeter of the frame and floated in an atmospheric continuum, from his early paintings by expunging all references to Surrealism. A painting like *Number 24* (*Ill. 7-7*) represents the gradual transition from the Surrealist-inspired landscapes to Rothko's typical arrangement of abstract rectangles, such as *Black, Pink and Yellow over Orange* (*Ill. 7-8*). The resulting centralized image is still in a sense a symbol—of oneness or wholeness or transcendent unity—but of a much more abstract and conceptual nature than the more literal Surrealist symbols.

Rothko's large fields, divided into two or three parallel rectangles which echo the framing edge, are painted in close-valued, luminous colors. The quality of light radiating from some hidden central source within the painting is what distinguishes Rothko's color from that of his contemporaries. This is achieved by means of Rothko's sensitive handling of edges, which are softly brushed into the adjoining field, causing a slight vibration to be set up; and by means of his choice of colors, which tend to augment the gentle vibration. As a result of the close-keyed harmonies and painterly edges, Rothko's images appear to float, the rectangles hovering buoyantly in the resonant space.

The apparent simplicity of Rothko's rectangular motif provides a

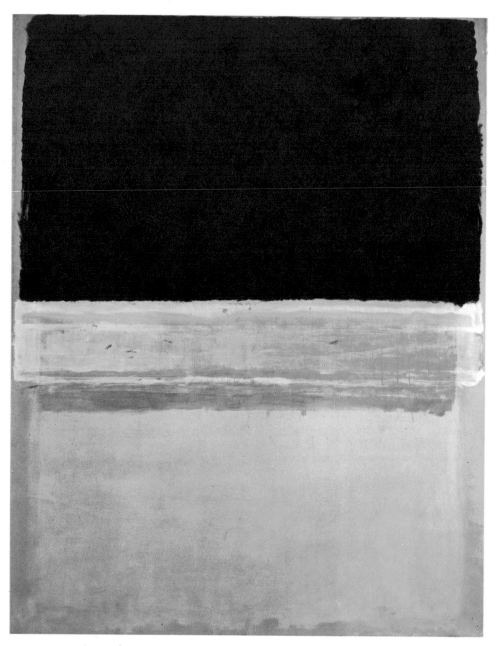

7-8. MARK ROTHKO, *Black, Pink and Yellow over Orange*, 1951–52.

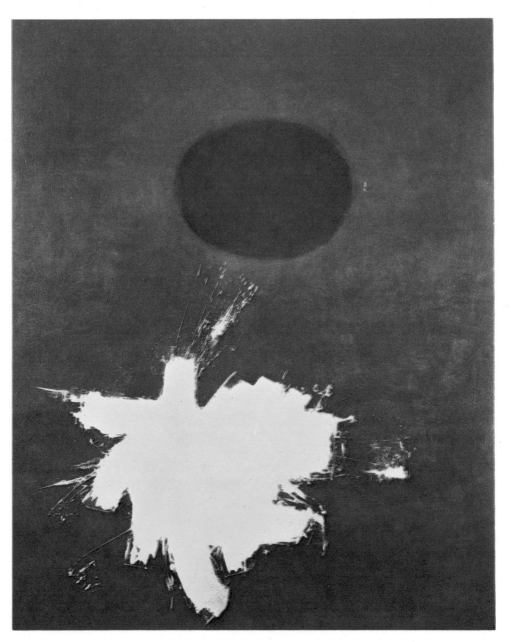

7-9. ADOLPH GOTTLIEB, *Counterpoise*, 1959.

contrast with the richness and opulence of his color. In his works of the late forties, thin washes of delicately hued paint are allowed to soak into the canvas, indicating the direction his later work will take. Although Rothko was one of the most adept draftsmen of his generation, by the late forties he had abandoned the elaborate automatic drawing of his earlier paintings in favor of pure areas of color set side by side, adjacent but not touching. These works suggest tranquil idyllic landscapes, differing greatly from Still's brutal and violent primeval images. The sense of tranquillity and harmony is preserved in the paintings of the fifties. These later works, however, take on the grandeur of objects for contemplation. In a joint statement prepared by Gottlieb, Newman, and Rothko, the three artists speak of the "impact of elemental truth," which favors the "simple expression of the complex thought, and the importance of the large shape because it has the impact of the unequivocal."

The works of the fifties of Rothko, Newman, and Gottlieb, although simple in format, are meant to convey a content as rich as their earlier Surrealist work. Asserting that "there is no such thing as a good painting about nothing," they were equally adamant that "the subject is crucial and only that subject-matter is valid which is tragic and timeless."[3]

Adolph Gottlieb was interested in Matisse's color at a time when most New York painters were involved with Picasso or Miró. After leaving the WPA Federal Art Project in 1937, Gottlieb painted for a year in the Arizona desert. The series of still lifes based on cactus forms of the late thirties are a prelude to his "pictographs" of the forties, like *Voyager's Return* (*Ill. 6-10*), which were stylized symbolic motifs based on human and natural forms isolated in compartments. The cryptic images of the pictographs, which bring to mind both ancient hieroglyphics and the compartments of Torres-Garcia, were a means of structuring the composition; they also have certain similarities to the decorative signs of the Kwakiutl Indians.

Like his contemporaries, Gottlieb looked for mythic, universal themes. For a while he thought that the myths of the American Indians might be a possible subject, but ultimately he concentrated on ancient mythology. Gradually, the symbols of the pictographs became simpler and less specific, until they were refined into two essential images: a peaceful disc for the sun or moon and an angry exploding ball of undifferentiated matter for the earth. This process of refinement was nearly complete when Gottlieb began his "stratified landscapes" in 1951. By the time he painted *The Frozen Sounds* (*Ill. 7-10*), Gottlieb had discarded the confining grid of the compartments and the linear

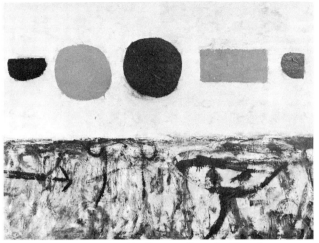

7-10. ADOLPH GOTTLIEB, *The Frozen Sounds, Number 1*, 1951.

pictographs in favor of zoned compositions divided by a horizon line. Above the horizon hang the celestial symbols; and below, the earth seethes in chaos.

From the early thirties—when his paintings were reminiscent of Avery's interpretation of Matisse—Gottlieb's work had been distinguished by refined technique and subtle color. In the late fifties he began to simplify and center his images. Balancing out areas in terms of their weight as colors, he often achieved startlingly original effects with his use of ice-cream colors and pastel tints. Typical of the imagery of his later paintings is the masterful *Counterpoise* (*Ill.* 7-9), in which the stable brown disc of the "sun" hangs peacefully above the exploding yellow mass of the "earth."

Ad Reinhardt, one of the few New York artists who remained an abstract painter from the thirties, was never drawn to Surrealism, action painting, or figurative art. Instead, he found his inspiration from the first in Oriental, Indian, and Arabic abstract decorative art. In the late forties, his geometric abstractions, such as the *Abstract Painting* of 1947 (*Ill.* 7-11), were shattered into calligraphic strokes disposed in the all-over fashion of Oriental calligraphy and of Tobey's "white writing." Reminiscent of the misty, layered space of classical Chinese landscapes, these works anticipate the dusky twilight atmosphere of Reinhardt's "black" paintings. Around 1950, the fragments of the tracery began to coalesce into larger horizontal and vertical brushstrokes, ultimately becoming a series of interlocking rectangles, as in the 1952 *Red Painting* (*Ill.* 7-12). After 1953, Reinhardt confined himself to making only black paintings.

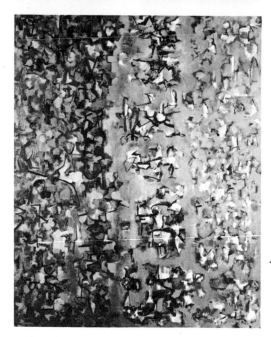

7-11. AD REINHARDT,
Abstract Painting, 1947.

In his search for an absolute, Reinhardt wished to arrive at an indivisible image and a single color; he sought a scheme that was, like the Buddha image in Eastern art, "breathless, timeless, styleless, lifeless, deathless, endless." Finding this image in the trisected "black" canvas, he chose low-key greens, browns, and violets, so close in value as to be virtually indistinguishable. Reinhardt's relentless polemicizing for a mystically pure art-for-art's sake (embodied, it would appear, only in his own work) made him a thorn in the side of his contemporaries, who called him the "black monk." However, his insistence on an uncompromising, reductive, minimal art has made him an important source for younger artists, who came to share his views on the rhetorical nature of action painting.

The most influential artist to reject representational art around 1950 was Franz Kline. Celebrating the special dynamism of the urban environment, Kline had much in common, in terms of his sensibility at least, with his friend Reginald Marsh, although Kline's genius was much greater. Kline's feeling for the great looming structures of the metropolis links him with the earlier New York realists, who had also found their inspiration in the forms and colors of the city. In fact, his paintings of the early forties echo Ash Can School themes.

Until the late forties, Kline painted modest but moving urban landscapes; they show his ability to perceive monumentality in the shapes of the railroads and bridges that streak across Manhattan. In the late

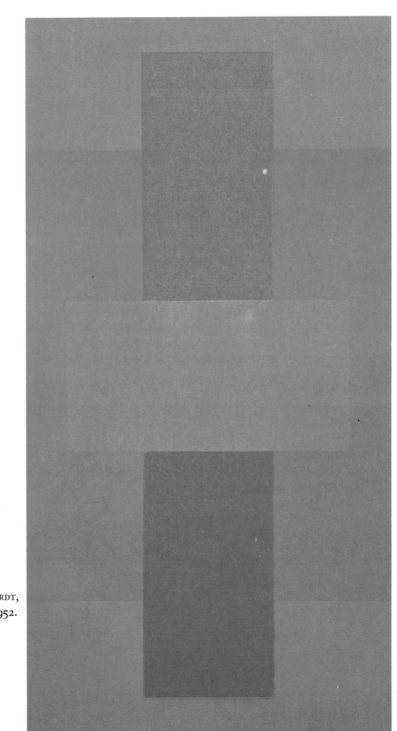

7-12. AD REINHARDT,
Red Painting, 1952.

forties, he began experimenting with brush drawings that were mainly free versions of figures. In 1950, he took the step toward which these drawings pointed; he magnified the brushstrokes into enormous, abstract ideograms which filled the canvas, as the many sketches he had made on telephone books and sheets of newspaper had filled the page. The drawings were done in black enamel, a quick-drying house paint Kline used in his paintings because it was cheap and fluid. His use of this paint caused contrasts in texture and finish that seem essential to the variety of the brushstroke. The two portraits of the dancer Nijinsky (*Ills. 7-13, 7-14*) show the transition of Kline's style from representational to abstract. Although the black shapes in his abstract paintings read as strong silhouettes, Kline, like Motherwell, did not conceive of the white as background in the conventional sense. The white areas in these works are as much painted figure as the black, and modifications in white paint smudge over or cut into black areas underneath. Kline's attitude toward his work was direct and pragmatic; he did not clothe his methods or motives with metaphysical pretensions. In such powerful black-and-white paintings as *Chief* (*Ill. 7-15*), he did not literally extract his images from the characteristic structures of the city, but invented abstract equivalents—massive trajectories which speed across the canvas field, capturing the energy of the urban experience. Even so, in some cases, the sweeping diagonals and girderlike strokes seem to find analogies in his realistic cityscapes of the forties. In the middle

7-13. FRANZ KLINE,
Nijinsky (Petrouchka), 1948.

7-14. FRANZ KLINE,
Nijinsky, ca. 1950.

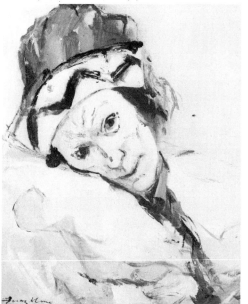

7-15. FRANZ KLINE, *Chief,* 1950.

fifties, Kline reintroduced color, as his paintings became denser (like de Kooning's later works), and the energies grew more explosive.

Kline was not the only artist who limited himself to black and white around 1950. A number of others, including Motherwell, de Kooning, Pollock, and Newman, also painted canvases restricted to the dramatic contrast of black and white. Such an opposition was easily interpreted as a Manichaean struggle of the powers of light against the powers of darkness. Its practical advantage was that black enamel was the cheapest paint, and in the late forties, this was still an important consideration, even for an artist like de Kooning. These black-and-white pictures seem especially typical of the New York School. The sooty black has been equated with the grime of downtown New York, and the white has been identified with the white-washed walls of the studio-lofts.

Kline's conversion to abstraction came at the moment when a number of other painters were abandoning figurative styles for abstract

7-16. PHILIP GUSTON, *Passage*, 1957-58.

styles. Around 1950, these included Philip Guston, Jack Tworkov, James Brooks, and Bradley Walker Tomlin. Guston became the master of a subdued gestural style which concentrated on delicately brushed, roughly square patches of cool pastel tints huddled together in the center of the canvas. His vaporous lyrical image and more controlled painterly brushwork became the model for painters like Esteban Vicente, Milton Resnick, and Adja Yunkers who were drawn toward a more intimate kind of "abstract impressionism." In *Passage* (*Ill. 7-16*), sensitively brushed passages evoke a poetic landscape. The flamelike diagonal brushstrokes dancing and flickering across Jack Tworkov's *Watergame* (*Ill. 7-17*), although more restless as an image, are equally controlled and purposeful. Tomlin's statement, on the other hand, represents a more complex and self-conscious resolution of the problem of loosening the hold of the Cubist grid on pictorial structure. His earlier paintings, sensitive Cubist still lifes, were sometimes surprising in their interjection of Surrealist motifs like disembodied

eyes. They were transformed into open, calligraphic configurations, apparently under the influence of automatism, to which he was introduced by Motherwell. Tomlin was also influenced by Gottlieb's pictographs, from which he derived his imagery of the late forties. In 1949, in paintings like *Number 20* (*Ill. 7-18*), Tomlin's loose brushstrokes were hardened into simple curves, channeled into place by means of an underlying grid framework. But Tomlin's grids allowed a greater freedom of movement than orthodox Cubist structure.

The years 1947–53 were in many ways the high point of Abstract Expressionism. The intensity of activity and the interchange and dialogue among artists, as well as the quality of performance and richness of innovation, was greatest during these years. However, public recognition did not attend these achievements. In desperation, in 1951 a group of artists who called themselves "the irascible eighteen," including Motherwell, Newman, Kline, Pollock, Baziotes, Hofmann, Rothko, Reinhardt, Gottlieb, and de Kooning, picketed the Metropolitan Museum, demanding that a department of American art be set up. Then, taking matters into their own hands, the artists organized the Ninth Street Show in a store front on East Ninth Street, as a collective statement of their progress and aims. Among those represented were Pollock, Motherwell, de Kooning, Kline, Tworkov, Marca-Relli, and Cavallon, and a number of sculptors, such as James Rosati and Peter Grippe. The show was organized mainly by the members of the Artists' Club, a discussion group that had formed in late fall, 1949. The Club, in turn,

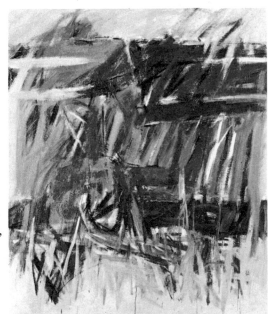

7-17. JACK TWORKOV, *Watergame*, 1955.

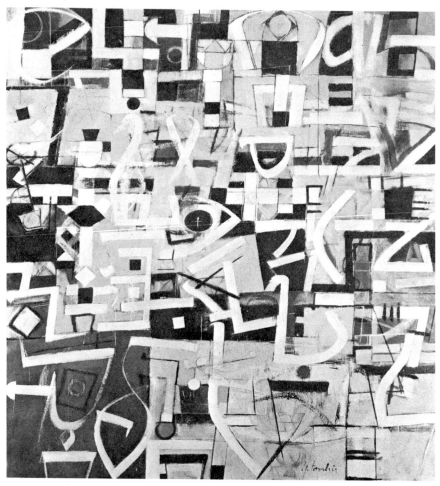

7-18. BRADLEY WALKER TOMLIN, *Number 20*, 1949.

had grown out of the need to find a time and place to discuss informally issues of general interest. Earlier, the "Subjects of the Artist" school, organized by Baziotes, Motherwell, Rothko, and David Hare, held open sessions and lectures which many artists attended. (Although Still had helped to formulate plans for the school, he did not teach there; and Newman joined the faculty after the school opened.) After one year, the school closed, but the loft where it was housed was taken over by a group of artists. For two seasons discussion groups continued at "Studio 35." Lectures were delivered by Baziotes, Joseph Cornell, de Kooning, Motherwell, Newman, Rothko, and Reinhardt, and by such European luminaries as Hans Arp and Richard Hulsenbeck. Topics of interest to the avant-garde were discussed, and a generally

lively tone prevailed, at least until the mid-fifties, when older members began to lose interest in the Club as the avant-garde became established and accepted.

It is always tempting to identify the end of a creative epoch with the death of its leader. Yet it is impossible not to remark that Gorky's suicide in 1948, Pollock's death in an auto accident in 1956, and Kline's untimely death in 1960 at the age of 51 dramatically close chapters in the history of Abstract Expressionism. By 1948, the Surrealists had returned home to Europe, automatism had spurred Gorky to a new fluidity and painterliness and inspired Pollock to make the breakthrough to the "all-over" drip paintings, which in turn permitted others a new freedom of gesture. By 1956, Surrealist content and morphology had been rejected, and the last of the major Abstract Expressionists—Kline, Guston, and Tomlin—had cleansed their work of representational elements and were painting large-scale gestural abstractions. After Pollock's death, a market for these paintings was found, and the avant-garde had few battles left to fight—mainly with the mass media and the museums.

From 1956 to 1960, American art received international recognition, and a second generation of New York painters emerged. They were, it has been pointed out, the first American artists to have domestic heroes. Some like Alfred Leslie, Michael Goldberg, Grace Hartigan, and Joan Mitchell, to name the most talented, chose to imitate de Kooning; others turned to the potential implicit in Pollock and in chromatic abstraction. Although the work of Newman, Still, and Rothko became the point of departure for the new abstraction of the sixties, during the fifties it took second place to the spectacular pyrotechnics of the action painters, whose more flamboyant personalities were also magnets for attraction. During the late fifties, new artists poured into New York to join the loft Bohemia, which had shifted its center from Eighth Street to East Tenth Street. Here a series of cooperative galleries exhibited a potpourri of works covering the entire range from the figurative to the abstract. Imitating the life style of the first-generation Abstract Expressionists, the second generation often slavishly imitated their pictorial styles as well. At the Five Spot Cafe and the Cedar Bar, "action painting" became a modish phrase and its technique a subject for endless discussion. As the art market was glutted with the works of de Kooning's admirers, the real achievements of de Kooning and his generation were becoming obscured. Soon their art was to undergo re-evaluation by the strongest and most original among their successors.

If the end of an art style may be marked by the moment when no

young painters of the first rank choose to work within it, then 1960 constitutes such a date for Abstract Expressionism. The physical destruction of the original neighborhood in which it flourished—the tearing down of Tenth Street, the closing of the original Cedar Bar, and the dissolution of the Club—were only the external events that paralleled a general shift in sensibility within the art world. In the sixties, the remaining members of the first generation would continue their development, and gifted members of the second generation would make significant contributions. However, Abstract Expressionism as a style would not serve as a point of departure, but as an established tradition, as the new Academy—perhaps the first Academy worthy of the name in the history of American art—to be attacked in terms of its own limitations and contradictions.

The internal contradictions implicit in Abstract Expressionism as a style are most visible in the works of de Kooning's followers. They include the conflicts of figuration versus abstraction, the unresolvedness of an ambiguous pictorial space, and the lack of structure of gestural abstraction. These were the basic pictorial problems that younger artists would be considering. Equally important, perhaps, would be their rejection of the rhetoric of action painting—the notion of the artist as existential matador alone in the "arena" of his canvas. To the extent that the world view of Abstract Expressionism was tied to the philosophy of Existentialism, one must understand the cool, factual art of the sixties as rejecting that world view and its implications.

Chapter Eight

After Abstract Expressionism

Though it may have started toward modernism earlier than the other arts, painting has turned out to have a greater number of *expendable* conventions imbedded in it, or at least a greater number of conventions that are difficult to isolate in order to expend. It seems to be a law of modernism—thus one that applies to almost all art that remains truly alive in our time—that the conventions not essential to the viability of a medium be discarded as soon as they are recognized.

 —CLEMENT GREENBERG, " 'American-Type' Painting," *Art and Culture*, 1961

The novelty of our work derives therefore from our having moved away from simply private human concerns towards the world of nature and society of which all of us are part.

. . . object is *fact*, not symbol.

 —JOHN CAGE, *Silence*, 1961

For about fifteen years Abstract Expressionism was able to absorb the energy of the indigenous tradition in the context of a high art by making virtues of its characteristics: speed of execution, rawness, and vitality. But when the internal contradictions that marked Abstract Expressionism as a style could no longer be held together in a viable synthesis, the demands for an art tied more directly to the moment and to the realities of the American scene could no longer be denied. These internal contradictions derived mainly from the figurative and Cubist roots of Abstract Expressionism. The lack of clarity or apparent structure of action painting in its most painterly phase of the late fifties was taken by younger artists as a sign of a lack of pictorial or emotional conviction. In reaction, they discarded not only the painterliness, but also the emotional, autobiographical quality of Abstract Expressionism.

 Young artists began to question whether or not the marks of struggle and anxiety—the dragged brush and the violent attack—might be as easily simulated as felt. They wondered to what extent the spontaneous

splashes and random drips had become mere mannerisms, stylistic effects that could be manufactured at will. By the end of the fifties, the high purpose of the first-generation Abstract Expressionists impressed many of their heirs as mere rhetoric; their drama was considered inflated or bathetic, and the latest phase of the movement chaotic, academic, or mannered. Fortunately, however, the exhaustion of the gestural manner in the hands of de Kooning's and Kline's imitators coincided with the finding of new potential in the works of Pollock and the chromatic abstractionists.

Rejecting the expressionistic basis of Abstract Expressionism, the new generation also renounced the symbolic and the metaphoric, along with the mystical. They questioned whether or not emotional states were indeed communicable and whether communication depended on the use of recognizable objects and images or on formal relationships; they were skeptical regarding the possibility of communicating a subjective content through the means of an abstract art, which Abstract Expressionism held to be not only possible but necessary.

The younger artists came of age at the time when the "New American Painting" (the name of the exhibition that toured Europe in 1958–59) was bringing international recognition to American painting. As is so often the case in the recent history of art, Abstract Expressionism began to lose impetus as a style at the point when it began to win public acclaim. For the most fruitful and revolutionary decade in American art, Abstract Expressionism temporarily wedded the contradictory impulses of Cubism and Surrealism. When such an unstable compound ultimately dissolved, the opposing tendencies once more assumed their divergent paths. By 1960, these two movements were clearly identifiable as pop art and sixties' color-field abstraction (termed "post-painterly abstraction" by its champion, Clement Greenberg).

In pop art, certain aspects of action painting continue to find expression—for example, the emphasis on tactile surface qualities and the close tie to the environment and urban life, as well as the implicit romanticism. The new abstraction, on the other hand, by insisting on the primacy of color presented in terms of non-relational, all-over composition, carried painting forward in the direction that chromatic abstraction had begun to travel. Both pop art and the new abstraction, however, remained faithful to the scale, impact, and directness of Abstract Expressionism.

The polarization began in the late fifties with the revolt of some second-generation artists, such as Robert Goodnough, Ray Parker, and Al Held. Reacting against the formlessness of the Tenth Street phase of Abstract Expressionism, they began to order painterly areas into more discrete, legible shapes. In Parker's untitled 1959 abstraction

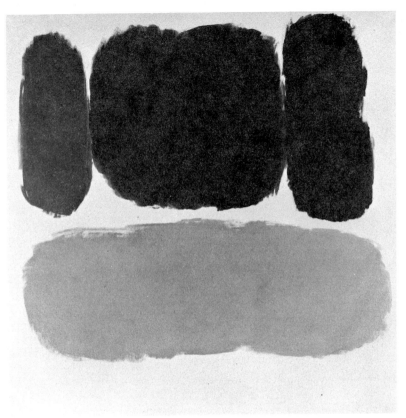

8-1. RAY PARKER, *Untitled*, 1959.

(*Ill. 8-1*), Abstract Expressionist brushwork is disciplined into a more coherent structure.

Both post-painterly abstraction and pop art reacted against Abstract Expressionism in favor of a more impersonal, detached, and clearly articulated art. Because it was the most overtly sensational, pop art was the first of these reactions to claim public notice. It is, however, a mistake to characterize pop are as popular art. Its creators were part of the same artistic milieu as contemporary abstract painters. Intended for the same public as Abstract Expressionism, their works share similar antecedents and, in some cases, the same pictorial conventions as contemporary abstraction. That pop art was so readily assimilated as artistic novelty rather than as art is attributable to the new appetites of the mass media for material carrying the cachet of culture, which might be digested and spewed back at a mass literate public, more eager for gossip and sensation than for art itself. In an ironic metamorphosis, the American artist, whom John Sloan described as the

unwanted cockroach in the kitchen of a frontier society, became a national hero, the rival of movie stars and TV celebrities for public attention.

In fact, it could be argued, in more or less the same terms used to vindicate American Scene painting during the thirties, that pop art was the genuinely American expression of the American experience. John Sloan, after all, insisted that Hieronymus Bosch was the first artist to capture the American scene. In any event, it is undeniable that aspects of pop art have antecedents in earlier American art: Stuart Davis' still lifes of soap boxes and cigarette packs, de Kooning's gargantuan breasty Marilyn Monroe, Demuth's ironic titles, Marsh's Broadway marquees. All these represent responses to the bewildering vulgarity of the carnival of American life and the orgiastic fantasy of the American Dream, just as Hopper's lonely filling stations and Wyeth's empty fields reflect its barrenness and lack of fulfillment.

Thus there is no need to search for the source of pop imagery in Dada. To the degree that American pop was distinctly an American art, it partook of the parochialism that has always shadowed American art. Because Andy Warhol's theatricality made him an international celebrity, the American avant-garde might presume to have its own Salvador Dalí, a sign both of its maturity and its decadence. Since the line between commercial and fine art has never been finely drawn in this country, pop art was unusual in the context of American art only in that it self-consciously, with an eye to parody, appropriated the techniques and images of commercial illustration and advertising; but it used them with the sophistication of the fine artist instead of the naïveté of the "buckeye" painter. The billboard images, Ben Day dots, and cartoons were interpreted and transformed in accord with a solid, firmly established pictorial tradition. Not to see this is to miss the irony at the heart of pop art.

Because it is fine art rather than popular art or illustration, pop art differs from earlier movements that sought to gain closer contact with the American public. It resembles them in its nostalgic evocation of things past—forties' movies, thirties' cars, twenties' underwear. Fraught with irony and ambiguity, pop art allowed itself to be characterized as cousin to the comic strip, when in actuality its nearest relatives are Léger, Magritte, Matisse, and de Kooning. Although it was eagerly embraced by a mass public happy once again to recognize familiar objects and to relax from the strain of attempting to interpret Abstract Expressionism, pop art was rejected by the most respected critics of the older generation.

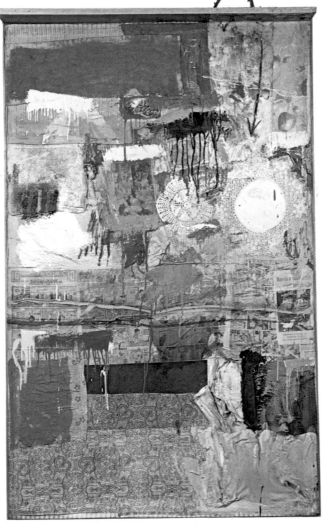

By the mid-sixties the best pop artists were already moving away from the most blatant aspects of pop imagery. To trace the genealogy of pop art, one must re-create the atmosphere in which it came into being. That atmosphere was generated mainly by the composer John Cage, whose essays and lectures have been instrumental in forming the sensibility of some of the most important young composers, chore-

ographers, painters, and sculptors at work today. Cage's aesthetic, derived in equal parts from Dada and Zen, in many respects served to open a situation that had closed down, much in the manner that Surrealism helped open the door to Abstract Expressionism.

In a series of lectures, beginning with those he gave as an instructor at Black Mountain College in 1952, and continuing with his classes at the New School, Cage, like the Surrealists before him, called on artists to efface the boundary between art and life. An advocate of noise as music, he attacked preconceived notions about the function, meaning, and context of art. He asked such questions as, "Is a truck in a music school more musical than a truck passing by in the street?" Favoring the use of repetition and the elimination of dramatic climax, he denied the existence of an "objective correlative" for subjective experience, damned the audience's demand to be entertained, and urged that each moment be appreciated for its own singular value. Denying the validity of teleological reasoning, Cage proposed instead an association of meanings that resembled collage, which in many ways anticipated Marshall McLuhan's thesis of "everything influencing everything."

Two artists close to Cage who applied his attitude toward painting and, in doing so, attacked Abstract Expressionism at its foundations were Robert Rauschenberg and Jasper Johns. Rauschenberg, who met Cage at Black Mountain where he was studying with Josef Albers, was already sympathetic to Cage's basic attitude that even the banal and the commonplace had an aesthetic potential. Earlier, in 1950–51, Rauschenberg had painted a series of all-white paintings whose only image was the shadow reflected by the viewer. This was followed by a series of all-black paintings in which torn and crushed newspapers, pasted down and coated with black enamel, created a surface as irregular as the crumbling façades of New York's decaying downtown neighborhoods. A series of audacious constructions made from the refuse of the city—rusty nails, rags, pieces of rope—anticipated the "combine" paintings of 1953–55, such as *Satellite* (*Ill. 8-2*). In these predominantly red paintings, Rauschenberg used images for the first time, not painted images but found images: pieces of printed fabric, newspaper photographs, postcards. The title of one of these paintings, *Rebus,* suggests the manner in which the images should be read, not as literal narrative but as a fused metaphor.

The painterly medium Rauschenberg chose resembled Abstract Expressionist brushwork, except that it was denser. Soon he began to affix real three-dimensional objects to the surface of his paintings as a challenge to the ambiguous, illusionistic space of Abstract Expression-

ism. By allowing the contents of the paintings to spill out into the spectator's space, Rauschenberg literally began to fill the "gap between art and life." In such a use of materials, his work is not far from the literalness of Dove's collages.

In 1953 Rauschenberg erased a de Kooning drawing, an act that has been variously interpreted as paying homage to an admired hero and as wiping out, literally and symbolically, his achievement. That this erased drawing became a valuable commodity was doubly shocking, because such an act attacked not only Abstract Expressionism but also the newly won success of American painting and its aspirations to old-master status. It was an act reminiscent of Duchamp's painting a mustache on the Mona Lisa. Similarly, in *Factum I* and *Factum II*, Rauschenberg meticulously duplicated each splash and drip, thus exposing the myth of Abstract Expressionist spontaneity.

Although Rauschenberg has been dismissed by some as a latter-day Schwitters, and his compositions seen as paraphrases of Cubist collage, it is much more fruitful to consider his work in relation to Abstract Expressionism. By the same token, Jasper Johns has been described as a follower of Duchamp, although nothing in his work implies that he was even aware of Duchamp until after 1960, when certain direct references to the Dada master began to appear. There is, however, no question but that Johns and Duchamp belong to the same "family of mind," which sees art as a speculative activity related to physics or philosophy. Like Duchamp, Johns has devoted himself to challenging some of our most cherished preconceptions about aesthetics and perception. Because of his play with the theme of illusion versus reality, his work is one of the most important sources for pop imagery.

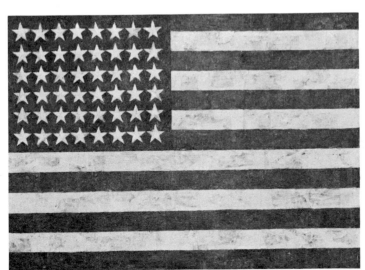

8-3. JASPER JOHNS, *Flag,* 1954.

When Johns's 1954–55 flags (*Ill. 8-3*) and targets were seen at his first one-man show in 1958, they created a storm of controversy. Dismissed as Neo-Dada by unsympathetic critics, they were hailed by others as the first viable alternative to Abstract Expressionism. Organizing the all-over pattern of brushwork into coherently structured bands or concentric rings, Johns reduced gesture once again to the small, controlled maneuverings of the hand. In his revival of the ancient technique of encaustic, he was able to call attention to surface texture without resorting to splashy execution. Like Rauschenberg, he attacked the ambiguity of Abstract Expressionist space, not by making a statement about its actual nature, as Rauschenberg had done, but by presenting a more clearly structured alternative in the stripes of the flag and the concentric circles of the targets.

Although the formal innovations of these paintings were immediately recognized and capitalized on by younger artists, Johns himself chose not to pursue their implications. Beginning in 1960, like Rauschenberg, he turned to a more fluid, broad, painterly style. But unlike Rauschenberg, whose imagery appears to oscillate between the macrocosmic and the microcosmic, Johns concentrated on a limited number of themes. He explored his themes with a kind of dogged logic, combining motifs, paraphrasing them, and changing their context, as if to extract the last drop of meaning from the most banal object. In later works, however, the official public images of the flags and maps are replaced by the more intimate, personal world of coat-hangers, coffee cups, and domestic paraphernalia. Often in the recent paintings the levels of meaning are so numerous that a guide as exhaustive as the "Green Box," Duchamp's explanatory notes to the *Bride Stripped Bare by her Bachelors, Even,* is needed to decode even a single aspect. Like Duchamp's *Large Glass,* Johns's later works offer entire systems of seeing, while maintaining a running dialogue with the history of art. At the same time, the lonely, isolated coat-hangers and homely coffee cups provide a genuine continuity with American still life and genre painting from Peto to Hopper.

Johns's blatantly American imagery, as well as his elevation of the commonplace, as in *Painted Bronze* (*Ill. 8-4*), touched off a flurry of interest in common objects and the banal trivia in the everyday environment. Had a tradition of genre been alive, doubtless such debased themes would not have seemed so shocking. In the context of Abstract Expressionist heroics, however, they were doubly jarring. But Johns's irony is directed toward art, not toward life, which is meant to be valued in even its pettiest manifestations. In this sense, both Johns's and Rauschenberg's post-Abstract Expressionist affirmations were dis-

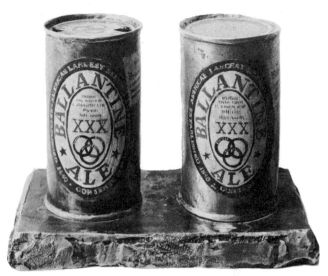

8-4. JASPER JOHNS,
Painted Bronze, 1960.

tinctly different from those of the Dadaists who were (or so they claimed) anti-art. Pro-art in that they were willing to remove the boundaries separating life from art, these two second-generation artists set the detached tone, at least with regard to value judgments, of the pop artists who took over many of their attitudes.

Independent of one another, the group who became known as the pop artists, Claes Oldenburg, George Segal, Jim Dine, Roy Lichtenstein, Tom Wesselmann, James Rosenquist, Robert Indiana, Marisol, and Andy Warhol, based their work on images from discredited mass

8-5. CLAES OLDENBURG,
*Hamburger with Pickle
and Tomato Attached,*
1963.

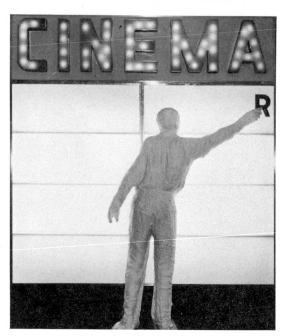

8-6. GEORGE SEGAL,
Cinema, 1963.

8-7. JAMES ROSENQUIST,
Early in the Morning, 1963.

culture sources like advertisements, billboards, comic books, movies, and TV. Intent on mining art history and commenting on its development, they were aware that the "museums without walls" and widescreen movies had changed ways of seeing, and that the abundance of reproductions had turned masterpieces overnight into clichés. Taking Cage's advice to wake up to the life they were living, they painted what they saw around them—seeming in the process to embrace the materialism, spiritual vacuity, and ludicrously sexualized environment of affluent America. But just as Lichtenstein's re-creations of Picasso and Mondrian in the idiom of the comic book were double-edged, the pop artists' use of commercial images was equally ambivalent.

Closest to the Abstract Expressionists, Dine and Oldenburg both developed their art in the atmosphere of the "environments" and "Happenings," theatrical events that use people as part of living environments. Environments made out of the detritus of the city were originally Allan Kaprow's response to Abstract Expressionist paintings. In 1958 Kaprow wrote, "Pollock left us at the point where we must become preoccupied with and even dazzled by the space and objects of our everyday life. . . . Not satisfied with the suggestion, through paint, of our other senses, we shall utilize the specific substances of sight, sound,

movement, people, odors, touch. . . ."[1] As Pollock had incorporated bits of glass and mirrors from the environment into his painting and de Kooning had pasted the smile from a Camel ad onto one of his "women," about 1960 Kaprow, Dine, Oldenburg, Red Grooms, and Robert Whitman incorporated junk from the city into their environments. Kaprow, who studied composition with Cage, was the first to extend the concept of the environments to the theater as Happenings. But Oldenburg's ambition to produce the *Gesamtkunstwerk* made him the master of sixties' Happenings, as it led him often to conceive of his exhibitions as total environments. His *Store* (1961), in which plaster reproductions of real objects raised questions about their identity as art objects, was followed by oversized stuffed replicas of food, and subsequently by the eccentric "soft" typewriters, electric mixers, and fans. The painterly surface of such monumentalized re-created common objects as his *Hamburger with Pickle and Tomato Attached* (*Ill. 8–5*) recalls Abstract Expressionist paint handling, which has been transferred from the two-dimensional surface to the three-dimensional object. Similarly, George Segal's tableaux of real people in real situations, such as *Cinema* (*Ill. 8–6*), represent a kind of environmental genre that recalls American Scene painting.

Unlike Oldenburg and Dine, whose vision remained closer to Ab-

8-8. ROY LICHTENSTEIN, *Blam*, 1962.

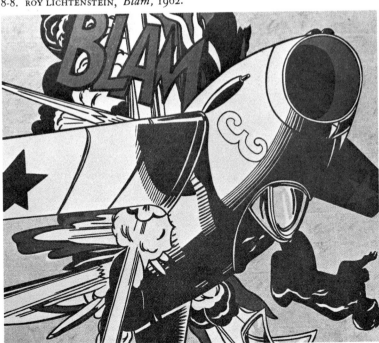

stract Expressionism, Roy Lichtenstein, James Rosenquist, and Tom Wesselmann worked in the early sixties as the young abstract painters were doing, bringing up their images close to the surface in imitation of the movie close-up, using brilliant color, and stressing surface tension. In *Early in the Morning* (*Ill. 8-7*), Rosenquist combined fragmented images in a dreamlike billboard Surrealism which marries Magritte's technique to collage space and composition. Lichtenstein's *Blam* (*Ill. 8-8*) is closer to Léger's bold, mechanical Cubism than to the comic strip that inspired it.

As pop art was born of the reaction of second-generation artists such as Rivers, Rauschenberg, and Johns to Abstract Expressionism, postpainterly abstraction also found its **antecedents** in the fifties. The chromatic abstractions of Newman, Rothko, and Reinhardt were part of its background. Josef Albers' simplified square-on-square compositions also provided examples of non-allusive, conceptual paintings, in which color takes precedence over design.

The series of exhibitions arranged by Clement Greenberg at French & Co. in 1959–60, including major shows by Newman, Gottlieb, Morris Louis, and Kenneth Noland, was important in establishing a climate for the new abstraction. Emphasizing the expressive power of pure color, early sixties' abstraction was characterized by even, non-textured

8-9. SAM FRANCIS, *Blue on a Point*, 1958.

8-10. HELEN FRANKENTHALER, *Mountains and Sea*, 1952.

paint application, flat, non-illusionistic space, and suppression of value contrasts in favor of the interaction of adjacent colors.

Although most of the second-generation Abstract Expressionists had chosen de Kooning as a model, a few, like Helen Frankenthaler, Sam Francis, and Friedl Dzubas, rejected de Kooning's ties to Cubist space and composition, and were drawn to Pollock's open, loose painting. Opposed to successive records of brushed gestures that crowded the canvas and threatened to swamp it with muddy overpainting, these painters chose to leave areas of the canvas free to "breathe." They allowed marks, stains, and blots to stand, discarding what was not usable rather than revising the same canvas. In *Blue on a Point (Ill. 8-9)*, for example, Sam Francis permitted islands of brilliant color to float on an open sea of unpainted canvas.

Helen Frankenthaler's gifts as an original colorist and her lyric sensibility equipped her to achieve a unique interpretation of Pollock's methods. With her, the conflict between painting and drawing that had plagued too many Abstract Expressionists did not exist because she chose to draw in paint. In 1952 she painted a large lyrical abstraction called *Mountains and Sea (Ill. 8-10)*, which in the fragility of its blues

and pinks and the thinness of its soaked paint looked strangely pallid and empty to most of her contemporaries. She was painting then as Pollock had done, directly into the raw canvas, and working on the floor rather than on the wall. *Mountains and Sea,* however, attracted the attention, in 1953, of Morris Louis and Kenneth Noland, two painters from Washington, D.C. Soon they were converted to staining paint into raw canvas in an effort to achieve the maximum opticality in their work.

In *Saraband (Ill. 8-14),* one of the series of "veil" paintings, Louis was able to communicate the sensation of color more directly and nakedly perhaps than had been done before. Because the successive veils of paint sink into the raw canvas and become identified with it, foreground and background are one. These pictures, which appear to materialize like natural phenomena emerging from a mist, seem to defy a reconstruction of the method by which they were created. No self-conscious shapes or hard contours inhibit their mysterious flow; the diaphanous superimposed veils, stained directly into each other, do not harden into the parallel planes of Cubist composition. In a series of later paintings, the so-called "Unfurleds" *(Ill. 9-5),* diagonal rivulets of color stream off each canvas toward its edges. In these, Louis presented colors in their purity and did not permit them to interpenetrate or to create an atmospheric haze. His last paintings of parallel bands placed adjacent to one another achieve the most straightforward presentation of pure, saturated colors, which seem burned into the canvas. The structure of these paintings is partly indebted to Noland's use of concentric rings as vehicles for the unhampered presentation of extremely original color combinations.

Noland arrived at this lucid means of structuring color in the late fifties, when he became increasingly concerned about the relationship of the image to the framing edge. Noland's structure did not relate to earlier geometric art, but was extrapolated directly from the chromatic abstraction of Rothko and Newman, as his method of staining directly into the canvas was derived from Pollock. By arriving at such a direct and candid means of presenting color, Noland played an important historical role, offering an alternative in his soft, blurred, and bleeding stained edge to the hardness and dryness of the mechanical precision of geometric paintings. Following his example, the Washington color painters, including Gene Davis, Tom Downing, Howard Mehring, and Paul Reed, arrived at a similar means of structuring pure color. In the early sixties, Noland began to allow the shape and proportion of the canvas field to determine the kind of structure it would contain. At first these were centered "bull's-eye" motifs, but

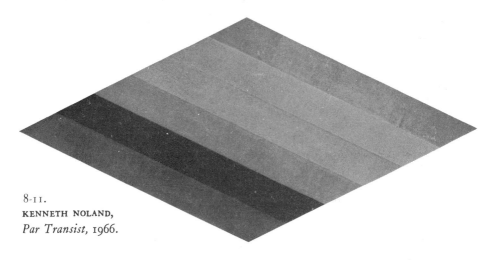

8-11.
KENNETH NOLAND,
Par Transist, 1966.

toward the mid-sixties they became symmetrical and asymmetrical chevrons and parallel bands of color.

In the bull's-eye and chevron paintings, areas of raw canvas are left unpainted, allowing the image to "breathe" or expand to achieve greater openness. In works like *Par Transist* (*Ill. 8-11*), however, Noland evenly saturated the entire canvas surface with closely keyed, stained color, causing the eye to focus that much more intensely on the interaction of juxtaposed colors. With characteristic logic, Noland lined up adjacent bands in such a way as to echo the perimeter of the

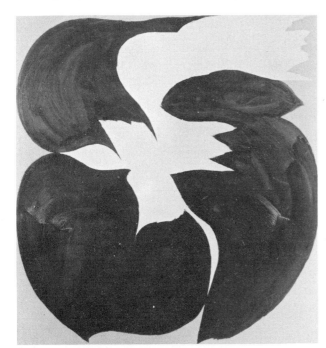

8-12. JACK YOUNGERMAN,
Anajo, 1962.

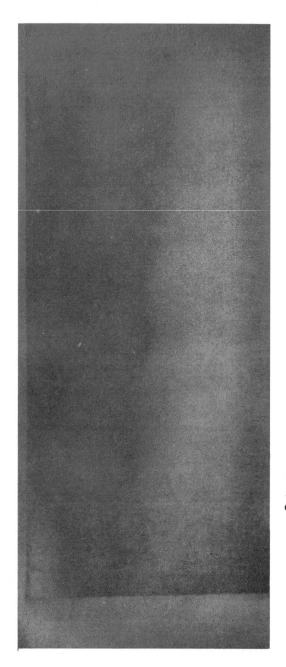

8-13. JULES OLITSKI,
*Prince Patutsky
Command*, 1965.

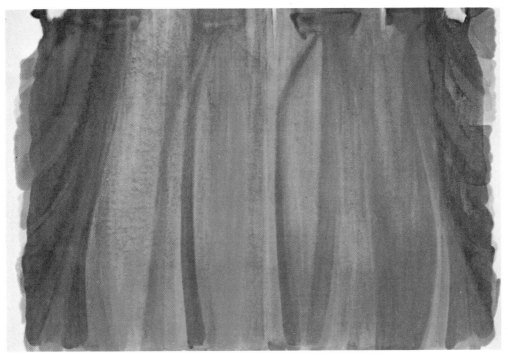

8-14. MORRIS LOUIS, *Saraband*, 1959.

8-15. ELLSWORTH KELLY, *Red Blue Green*, 1963.

lozenge-shaped support. The space in these painting is determined by the interaction of contrasting adjacent hues, not-by value contrast or drawing. In this sense it is purely "optical" space, which does not evoke the tactile sensation associated with line and value contrast. The opticality of Noland's paintings was further enhanced by his method of staining resonant color directly into the raw canvas, thus locating the image within the surface, rather than behind it as it appears in Cubist pictures.

Other leading post-painterly abstractionists included Jules Olitski, Ellsworth Kelly, Jack Youngerman, Al Held, Frank Stella, and Larry Poons. Olitski's first stained paintings, organized around cores, presented large areas of saturated color alternating with areas of bare can-

8-16. AL HELD,
Venus Arising, 1963.

vas. The lazy forms and opulence of his palette provide a voluptuous color experience. Later, abandoning shapes entirely in paintings like *Prince Patutsky Command* (*Ill. 8-13*), Olitski combined a process of dyeing with spraying that led to increasingly rich optical effects with great potential for his essentially hedonistic vision. In these paintings the shape of the rectangular canvas field is stamped out with particular vividness. Successive sprayings caused colors to melt into one another, producing a brilliance as dazzling as sunlight and an atmosphere as fluid and buoyant as sky and clouds. Because of his ability to achieve these atmospheric effects, Olitski's work seemed in many ways the first fully abstract version of Impressionism, which, like Olitski's mists and hazes, delighted in effects of light, atmosphere, and movement.

Kelly and Youngerman, having served apprenticeships to Constructivist painting in Paris, where both worked after the war on the G.I. Bill, returned to New York in the fifties. Confronting the latest developments of Abstract Expressionism, they modified their clear, flat images to conform with the scale and power of New York painting. Kelly allowed his bright, two-dimensional images, isolated on equally brilliant fields, to be interpreted either as figure or ground; Youngerman, on the other hand, became increasingly concerned with generating new shapes, such as the graceful forms in *Anajo* (*Ill. 8-12*). Kelly's immaculate surfaces are an outstanding example of "hard-edge" sixties painting, that aspect of the new abstraction which stressed hard, razor-sharp contours as opposed to blurred, stained edges. His *Red Blue Green* (*Ill. 8-15*) demonstrates how the principle of all-over composition could be extended to geometric painting.

Al Held's hard-edge paintings were intentionally less precise than Kelly's, since Held was far more intimately involved with Abstract Expressionism. Among the first to react against the unstructured look and ambiguous space of action painting in the late fifties, Held began to tighten his brushwork, ordering it into discrete, legible shapes. In the sixties, his work assumed the monumental proportions of the mural as his forms became increasingly bold and dramatic, as in *Venus Arising* (*Ill. 8-16*).

Frank Stella's logical progression through a series of black, aluminum, copper, rainbow, and purple "stripe" paintings had the inevitability of a programmed attack on the problem of pictorial structure. Dividing the canvas into equal parallel bands, he allowed the frame to generate the composition within its borders. In 1960, in an effort to make the internal dynamics of the painting conform more absolutely

to the framing perimeter, he began to notch the corners and cut holes in the centers of the aluminum paintings. This reduced illusionism to a minimum and further identified the image with the canvas surface. In the sixties, these shapes became more eccentric and took on an objectlike impassivity in such works as *Ifafa II* (*Ill. 8-17*).

Stella came close to producing absolutely flat paintings in his shaped metallic stripe pictures. He soon realized, however, that, because of the way the human eye perceives pictorial space, it was impossible to produce works without some illusionism if these were to remain paintings rather than become three-dimensional objects, which exist in real rather than illusory space. Consequently, in his paintings of the mid-sixties, he used a variety of devices to heighten a complex and often contradictory illusionism. In these, Stella showed himself converted to the primacy of color, and for the first time exhibited considerable gifts as a colorist. Large areas of flat color were laid out in eccentric geometric patterns that set up a play between the actual shape of the canvas support and the shapes depicted on the canvas.

The coin-sized dots and ellipses of Larry Poons' *Han-San Cadence* (*Ill. 8-18*), scattered across a brilliant field of contrasting color, induce perceptual effects, such as afterimages and vibrations, which cause the viewer to take a more active role. Poons, whose early paintings derive in equal measure from Pollock's all-over paintings, Newman's chro-

8-18. LARRY POONS, *Han-San Cadence,* 1963.

matic fields, and Mondrian's grids, became celebrated as an "optical artist" when the Museum of Modern Art held its exhibition of perceptual abstraction in 1965.

The term "post-painterly," as defined by Greenberg, implied that the traditional opposition of linear to painterly had been superseded by an opposition of tactile to optical. According to this interpretation, tactile painting, which stresses the sculptural qualities of modeling and value contrasts, was less suited to the development of painting than optical painting; in stressing the optical sensation of color, post-painterly abstraction was considered more appropriate to the purely visual medium of pictorial art. This argument presumed that the artist working in a particular medium should strive for a more explicit statement of the properties that exclusively belong to that medium, such as the property of opticality, which differentiates painting from sculpture. Furthermore, in the process of self-definition, an art form would tend toward the elimination of all elements that were not in keeping with its essential nature. According to this view, visual art would be stripped of all extravisual meaning, whether literary or symbolic, and painting would reject all that is not pictorial. In the sixties, this view of modernism brought about the emergence of a reductive, "minimal" art, which stressed the literal qualities of the painting—that it is two-dimensional and of a specific shape.

Chapter Nine

The Single Image: Minimal, Literal, and Object Art

My painting is based on the fact that only what can be seen there *is* there. It really is an object. . . . All I want anyone to get out of my paintings, and all I ever get out of them, is the fact that you can see the whole idea without any confusion. . . . What you see is what you see.

—FRANK STELLA, quoted in Bruce Glaser, "Questions to Stella and Judd," *Art News,* 1966

Characterized by a strong analytic thrust reflected in criticism as well as in art, the sixties was a period of investigation and redefinition of basic concepts as explosive and experimental as the years when Cubism was formulated. By the end of the decade, an entirely new set of attitudes toward space, shape, color, drawing, technique, and surface had virtually reversed Cubist aesthetics and established in America the first genuinely post-Cubist style.

During this fertile period, the American art public was enlarged and stimulated by a new wave of images diffused through the mass media, which acted, like the Armory Show postcards and publications and the WPA traveling exhibits, to raise the national level of art consciousness. The role of art in a democratic society was reappraised, with some unprecedented results, including the collaboration of artists with industry in various attempts to create new art forms utilizing technology. Pop imagery completed its cycle by returning to its own sources, itself inspiring advertisements and films, and Andy Warhol's experiments with primitive techniques in documentary anticinema affected filmmakers as Cézanne's and Gauguin's deliberate archaizing had the Cubists and Fauves.

Textile manufacturers and decorators seized on the abstract patterns of the geometric painters, but artists, for the most part, continued

in their painful private researches, which included a re-evaluation of the art of the past. As a result, an extreme degree of historical consciousness informed (and perhaps finally debilitated) the art of the sixties. On the other hand, the work of the masters, both old and modern, was thoroughly assimilated into American art, which consequently reached a new level of technical virtuosity and self-confident boldness.

Pop artists abandoned the role of naïve bumpkin to acknowledge their sources in fine art. A number paid overt if ironic homage to their heroes: Roy Lichtenstein based paintings on works by Cézanne, Picasso, and Mondrian, and also executed a series of lithographs inspired by Monet's "Cathedrals." In a gesture that indicates the close relationship of art to criticism, he recently acknowledged the debt to Léger that critics had perceived in his work by including a Léger reproduction in *Studio Wall with Sketch of Head (Ill. 9–1)*. This sophisticated comment on the relationship of representation to reproduction in the context of an age of mass media brings to mind Manet's painting of Zola, which includes a print of a painting by Manet's hero Velázquez. In many of his works, Lichtenstein reveals pop art's ties to such art-historical traditions as, in this case, the conscious introduction of popular imagery into fine art begun by Courbet.

Quotes and paraphrases abound in sixties' and early seventies' art. Claes Oldenburg burlesqued the monumental pomposity of a recent enlargement of a Picasso sculpture in a riotous soft Picasso (*Ill. 11–*

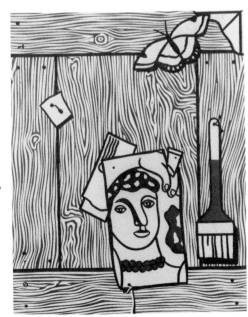

9-1. ROY LICHTENSTEIN, *Studio Wall with Sketch of Head,* 1973.

203

40). Larry Rivers, whose paintings of cigarette ads and money were a source of pop imagery in the fifties, also painted a version of Rembrandt's celebrated group portrait *The Syndics of the Cloth Drapers' Guild*. Jasper Johns, Andy Warhol, and Robert Rauschenberg considered the role of reproduction more literally, using silk-screen to transfer such well-known images as the Mona Lisa to canvas or paper. Tom Wesselmann included a Matisse in the background of *Great American Nude, No. 48*, a painting whose flat, sharply silhouetted shapes and bright colors are obviously derived from Matisse's own late cut-out gouaches (*Ill. 9–2*).

Exhibited in 1961 at the Museum of Modern Art, Matisse's flat, brilliantly colored cut-out shapes had an immense impact on such American artists as Ray Parker, Lee Krasner (*Ill. 9–3*), Ellsworth Kelly, Jack Youngerman (*Ill. 9–4*), and Frank Stella. Indirectly, his influence was felt by virtually all American painters involved with the large expanse of intense, saturated color that became the hallmark of sixties' abstraction.

Although the painting of the sixties appeared extremely diverse, in retrospect, common denominators become apparent. From the present vantage point, sixties' painting reveals a definite stylistic unity, linking flat and three-dimensional, abstract and representational, pop and "minimal" art. The source of the stylistic common denominators in American art of the sixties was the work of Jackson Pollock. Pollock's painting was so original he had no direct imitators; however,

9-2. TOM WESSELMANN, *Great American Nude, No. 48*, 1963.

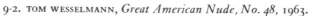

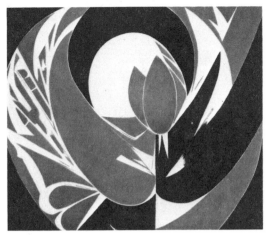

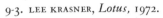
9-3. LEE KRASNER, *Lotus*, 1972.

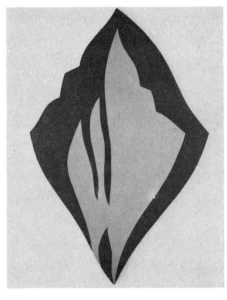

9-4. JACK YOUNGERMAN, *Rising*, 1972.

his influence was ultimately felt by artists as antithetical as Stella, Oldenburg, Morris Louis, Kenneth Noland, and Robert Morris, who briefly emulated him during their formative early years.

So thorough was Pollock's synthesis of the traditional polarities of linear and painterly, design and color that he came to represent the terminal point of Western painting in the minds of Happenings-and-environment theorist Allan Kaprow, pop sculptor Claes Oldenburg, and object-makers Don Judd, Robert Morris, and Dan Flavin, among others. For younger abstractionists, however, Pollock's use of such new materials as enamel and aluminum paint, as well as his development of an automatic technique of applying pigment in the drip paintings, pointed to styles that in various ways—including pouring, spilling, stamping, spraying, and silk-screening—dispensed with the successive marks left by hand painting. By eliminating brushstrokes, abstract color painters Jules Olitski, Kenneth Noland, Walter Darby Bannard, and others who followed their example could create unified, dramatic images that communicate with a striking optical immediacy, because of their lack of surface variation.

The most easily isolated stylistic feature of American art in the sixties is the single image, the simple gestalt that cannot be divided into parts, but which, like a Pollock web, demands to be perceived as a whole: at a single glance and in a single moment in time. What relates Noland's bull's-eye and Stella's stripe paintings to Judd's repetitive boxes and Oldenburg's oversize soft sculptures is the prece-

dence of the whole over any relationship of internal parts. "The balance factor isn't important. We're not trying to jockey everything around," explained Frank Stella.[1]

Besides Pollock's drip paintings, there are several other sources for single-image formats. The most important are Barnett Newman's banded field paintings (*Ill. 7–5*), Jasper Johns' flags and targets (*Ill. 8–3*), and Josef Albers' "Homage to the Square" (*Ill. 6–1*), an early example of painting in series. Gestalt-oriented abstract painters were mainly indebted to Newman and Albers. Pop and minimal artists derived more from Johns, who identified the image with the whole of the canvas field. Removing every trace of background, Johns created a confusion between picture and object that lent the picture-object "flag" an aura of literal presence.

Presence pursued as an end in itself was also evoked by translating qualities formerly found solely within a painting—for example, shape and volume—into their literal equivalents. Aggressive younger artists took one step farther the Cubists' assertion that the work of art was as real as any other object by making shaped canvases and colored reliefs, strange hybrids midway between painting and sculpture, that obtruded with literal three-dimensionality into real space. Such literalism had no precedent in European art. It is, however, entirely understandable when viewed in terms of the American preference for the factual, the pragmatic, and the explicitly concrete.[2]

The predilection for the most straightforward, simplified, and easily perceived formats that was typical of American abstract art in the sixties was seen as lacking inventiveness by many critics. They eyed these works in representational terms as awnings, mattress ticking, and radiator covers—to mention some contemporary descriptions of works by Noland, Gene Davis, Stella, and Judd, among others. At the time, few perceived that the artists deliberately intended to downgrade design in order to elevate color to new prominence. Nor was the elimination of internal compositional relationships connecting image and framing edge seen for what it was: the desire to communicate an image instantaneously rather than require the viewer to read it as a series of carefully composed fragments. By replacing Cubist *simultaneity*—the superimposition of successive views of the same object from different angles—with gestalt-based *instantaneity,* American artists of the sixties turned the central premise of Cubism inside out. The clear, simple, stylized, frequently symmetrical images they produced often have the forceful visual impact of heraldic emblems.

"Flatness, two-dimensionality, was the only condition painting

shared with no other art, and so modernist painting oriented itself to flatness as it did to nothing else," Clement Greenberg wrote in 1965.[3] Possibly modernist painting, or at least some of it, oriented itself toward things other than flatness, but certainly American art of the sixties oriented itself toward flatness as it did toward nothing else. This much vaunted flatness of sixties' painting, however, had more than exclusively formal implications. Dispensing with Cubism's flecked chiaroscuro planes, layered to give the illusion of a shallow cavity behind the surface, American artists of the sixties affirmed two-dimensionality more literally than any Cubist dared, relying more exclusively than ever before on flat areas of color to create shape and space. In doing so, they heightened still further the sense of presence and immediacy suggested by their quickly legible colored fields and single images.

Possibly this American taste for immediacy was conditioned by the speed-up in communications generally. Perhaps it was inevitable that, in an art so committed to the direct communication of color and light as independent phenomena, anything that might distract from purely optical experience was instinctively avoided. But surely it is no coincidence that artists became involved with instantaneously communicated images during a decade when the present was exalted over the past by a youth-oriented, tradition-defying, anti-authoritarian culture. *Freedom Now! Paradise Now!*—these were the slogans of the sensationalistic sixties, whose aesthetic of "See It Now" must be understood as fulfilling the needs of a society devoted to immediate gratification on all levels, including the visual.

Certain technical inventions such as sponges, aerosol cans, and electric spray guns facilitated the development of an art dedicated to im-

9-5. MORRIS LOUIS, *Alpha Delta*, 1961.

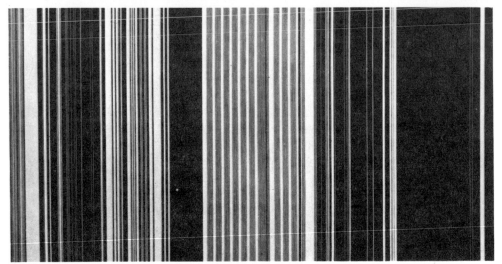

9-6. GENE DAVIS, *Satan's Flag*, 1970–71.

mediacy. Of crucial importance was the development of acrylic paint.[4] Because these plastic pigments dissolve in water rather than turpentine, they are absorbed more quickly and evenly than oils. Thinned to an extreme liquidity, they can be spilled, poured, sponged, and stained into canvas in such a way as to wed image indissolubly with surface. The visible union of pigment with ground acts to reaffirm the literal qualities of canvas (i.e., that it is a flat piece of woven cloth). This assertion in turn permitted the development of a new variety of purely optical, as opposed to tactile or depth-creating, spatial illusions.

The first major artist to use plastic paints was Morris Louis in his "Veils" (of 1954 and 1958–59), "Unfurleds" (of 1960–61; *Ill. 9–5*),

9-7. PAUL FEELEY,
Etamin, 1965.

208

9-8. SAM GILLIAM, *Carousel Form II*, 1969.

and late "Stripes" (of 1962). Indeed it may be argued that Louis could never have arrived at the stunning airy "Veils" (*Ill. 8-14*), which seem as mysteriously and spontaneously created as natural phenomena, without these water-soluble paints that allowed layer on layer of color to blend *within* the fabric of the canvas, without muddying it or concealing the woven surface. Louis' example was quickly followed by other painters of the so-called Washington Color School, including Gene Davis (*Ill. 9-6*), Howard Mehring, and Tom Downing. Closely associated with Louis, Noland, and the Washington School, Bennington, Vermont–based Paul Feeley painted symmetrical heraldic motifs that float on raw canvas fields (*Ill. 9-7*). A generation younger than the artists who first stained acrylic into canvas, Washington painter Sam Gilliam extended the method to its logical conclusion by leaving his soaked and splattered canvases permanently unstretched in order to emphasize their literal identity as pieces of colored cloth (*Ill. 9-8*).

The stain method popularized in the sixties by Helen Frankenthaler, Louis, and Noland translates the technique of water color from the page to the canvas: The white cloth of the canvas absorbs paint and reflects light through the color, just as the white page absorbs transparent color and reflects light in, for example, a Cézanne water color. The success of Helen Frankenthaler's 1970 retrospective at the

9-9. ROBERT DURAN,
Untitled, 1971.

Whitney Museum inspired a group of younger painters like Robert Duran (*Ill. 9–9*) to paint luminous, water-color-like canvases. The press quickly labeled these painterly works "lyrical abstractions" because of their vaporous, poetic quality. Among the most successful "lyrical abstractions" were those by Walter Darby Bannard resembling dappled Impressionist fields. They combined a formal grid structure with an informal randomness of spotted color (*Ill. 9-12*). An initiator of the "minimal" mode in painting, Bannard painted square, pastel-colored canvases with a single geometric image such as a square

9-10. WALTER DARBY BANNARD,
Green Grip I, 1965.

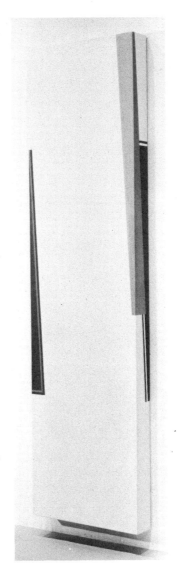

9-11. JO BAER,
V. Speculum, 1970.

or a triangle centered on a monochrome field in 1959 and 1960. Gradually complicating these images with illusionistic twists during the mid-sixties, he combined gloss and matt finishes to emphasize surface in works like *Green Grip I* (*Ill. 9-10*).

Another striking feature of the sixties' art generally was the tendency on the part of many artists, including Frank Stella, Ellsworth Kelly, Kenneth Noland, Walter Darby Bannard, Ron Davis, Don Judd, Robert Morris, and Jo Baer to work in series (*Ill. 9-11*). Coin-

9-12. WALTER DARBY BANNARD, *Young Phenix, No. 1,* 1970.

cidentally, the first to write on the importance of serial art was No-land's teacher, the French Purist Amédée Ozenfant. Like many of the early modernists fascinated with the idea of art as a kind of manufacture, Ozenfant saw working in series as a means of purifying a concept. He observed that in industry, "the first examples of a model to be turned out are always partly spoilt because tuning the machinery up to concert pitch is a long business."[5] The preference for serial imagery among American abstract artists in the sixties appears similarly motivated.

For an ironist like Andy Warhol, however, serial painting signified only the repetitiveness of industrial manufacture and the inescapable boredom of a mass-produced environment. Master of the *reductio ad absurdum,* Warhol painted a series of silk-screened images of Mao Tse-tung, implying that conformity was a universal phenomenon of the technological age, independent of political philosophy (*Ill. 10–21*). Warhol's espousal of a neo-machine aesthetic—he calls his studio the "Factory"—is reflected in his celebrated admission "I am a machine." Twenty years earlier, Pollock had claimed, "I am nature." The contrast between the two statements succinctly summarizes the differences

between the Abstract Expressionists, who aspired to crown Western culture with a heroic synthesis of the art of the past, and their heirs, whose colorful achievements and antics attracted the glare of international limelight to New York.

By the late sixties, this glare was so bright many artists were ready to flee marketplace and media for the privacy of their studios. Not surprisingly, the result was a wave of opposition to the attention-getting colossal size, intense, high contrast color, and mechanically precise hard edges of the early sixties. Together with the new painter-

9-13. FRANK STELLA,
Moultonboro IV, 1966.

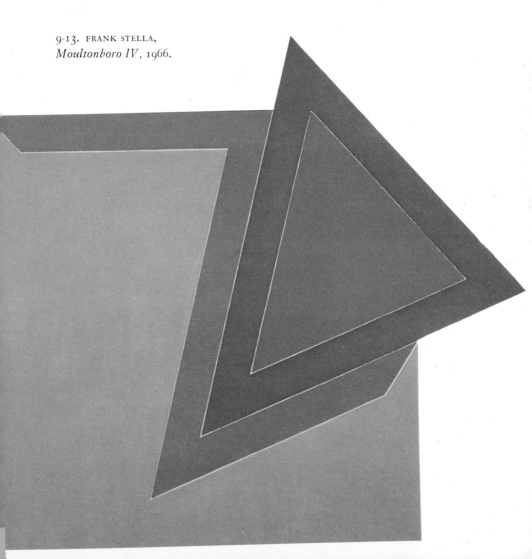

9-14. AL HELD,
Flemish I, 1972.

9-15. SVEN LUKIN,
Bride, 1964.

liness exemplified by lyrical abstraction came a return to illusionism, representing a reaction against the most extreme forms of flatness characteristic of minimalist styles of painting.

Surprisingly, one of the first to reject literal flatness was Frank Stella. For Stella's metallic stripe paintings had established the vogue for shaped paintings and centered images that dominated the early sixties. Introducing an element of illusionism into his "eccentric polygon" series in 1966, Stella combined an amputated partial perspective with unusual contrasts of various commercial pigments (*Ill. 9-13*), including the fluorescent Dayglo paints first used by such pop artists as James Rosenquist. Through intense color contrast and perspective, Stella alluded to depth. This spatial reading, however, was im-

9-16. MIRIAM SCHAPIRO,
Keyhole, 1971.

9-17. LARRY ZOX,
Barnards O.P.H., 1966.

mediately contradicted by the absence of the normal apparatus of illusionism, such as overlapping planes and value contrast.

Other artists who developed new forms of abstract illusionism in the late sixties and early seventies include Al Held, Larry Zox, Sven Lukin, Ron Davis, and Miriam Schapiro, who used computer-generated images to suggest apparently infinite vistas (*Ills. 9–14, 9–15, 9–16, and 9–17*). Ingenious though they were, however, these new types of abstract illusion were strictly antithetical to the kind of depth sensations created by the Cubists. Despite the often complex foreshortening and scale changes in such works, the illusion created is not fully three-dimensional because it is immediately canceled out by contradictory visual information.

In the paintings of liquid plastic by Californian Ron Davis, the reintroduction of systematic scientific perspective reveals the degree to which context changes meaning (*Ill. 9–18*). Initially inspired by Uccello, these works are painted with liquid fiberglass, which hardens to a glossy surface. So substantial and material is this surface, it is immediately identified by the eye as two-dimensional, no matter how convincing the three-dimensional illusion projected on it might otherwise be. The novelty of Davis' shaped paintings is that they cleverly oppose an extremely literalist interpretation of surface—which is visibly hard, resistant, and light-reflecting—and a highly developed illusionism utilizing a series of transparent and translucent glazes built up *behind* the surface: an unexpected inversion of the method used by the Flemish masters to achieve jewel tones through the appli-

9-18. RON DAVIS, *Red Top,* 1968–69.

cation of layers of glazes on top of the surface. Reversing the procedure of staining pigment into canvas, Davis creates glossy, impermeable finishes that are the surprising antithesis of the soft, absorbent, yielding surfaces of stained-color abstraction.

Other California artists, including Ed Ruscha, Billy Al Bengston, and Robert Irwin, also made original contributions to American painting in the sixties. Inspired by the ubiquitous billboards surrounding his Hollywood studio, Oklahoma-born Ed Ruscha painted banal subjects with such eccentric touches as the exaggerated perspective that links his work to the various surrealist tendencies common on the West Coast from San Francisco to Los Angeles (*Ill. 9–19*).

The first painter to investigate sprayed paint as a method of elimi-

9-19. ED RUSCHA, *Standard Station, Amarillo, Texas,* 1963.

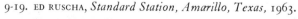

9-20. BILLY AL BENGSTON,
Boris, 1964.

nating the gestural element in Abstract Expressionism, Billy Al Bengston became known in the sixties for the centralized heraldic motifs of his lacquer and enamel paintings, which, in their technical perfection, rival the sleekness of custom cars and surfboards (*Ill. 9–20*).

In a series of mysterious pearlescent discs, Robert Irwin arrived at a subtle mediation between the extremes of literalism and illusionism.

9-21. ROBERT IRWIN, *Untitled,* 1969.

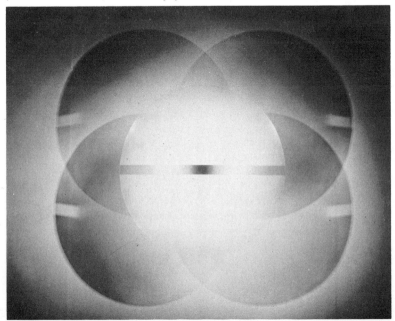

217

9-22. CLAES OLDENBURG,
*Lipstick on Caterpillar
Tracks,* 1969.

Sprayed with coats of shimmering paint, his shield-shaped discs were projected out from the wall so as to give the impression they were hovering in space (*Ill. 9–21*). Real shadows create the illusion that an aureole of light melts the discs' paper-thin edges into the surrounding normal light. For Irwin, these highly sophisticated works constituted the outer limits of painting. After finishing the series, he began working with environments, altering the shape and dimensions of interiors with curtains of theatrical scrim and other artificial barriers that divided real space, as Barnett Newman's bands divided pictorial space.

Another California artist who worked briefly with light projections, James Turrell, seemed about to fulfill the Synchromists' demand for a wholly immaterial art of pure light and color when he abruptly stopped exhibiting. Turrell's decision was symptomatic of a general crisis in the arts, felt in New York, but experienced even more acutely in other parts of America, where, because of fewer markets, distractions, or ties to an on-going tradition, artists were more vulnerable to an economic and political crisis.

There is no way yet of assessing the impact of the Vietnam war on American culture. One may only say that during the upheavals of the late sixties, many gifted artists and critics stopped working or went underground. Some were directly engaged in student revolutionary movements. In 1969, an artist whose work has consistently reflected social realities, Claes Oldenburg, erected the giant *Lipstick on Caterpillar Tracks* in front of the War Memorial at Yale University, his alma mater (*Ill. 9–22*). An obvious metaphor for the cannon with

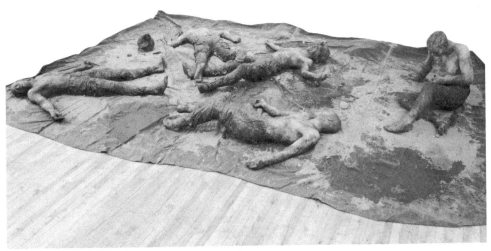

9-23. DUANE HANSON, *Vietnam Scene,* 1969.

missile, the twenty-four-foot-high *Lipstick* was the first of Oldenburg's monuments to be realized.[6]

Other artists, such as Peter Saul, alluded directly to the contemporary social crisis in bitter satire. Violence and brutality in general were commented on by many American artists. Typical of their work is super-realist sculptor Duane Hanson's bloody *Vietnam Scene* (*Ill. 9-23*). In Los Angeles, Ed Kienholz mocked America's bellicose activities in his *Portable War Memorial* and commented on the treatment of blacks in *Five Car Stud,* a brutal multi-figure tableau of four white men castrating a black victim. In a similar spirit, Andy Warhol included a race riot in his series of "disaster" paintings that focused on the American way of death.

By the end of the sixties, the optimism, self-confidence, and glamour of the Kennedy era celebrated by Robert Rauschenberg in *Buffalo II* (*Ill. 9-24*) had been destroyed by war and the tragic assassination recorded by Warhol in his portrait of the bereaved *Jackie* (*Ill. 9-25*). Chronicling national catastrophe as well as such moments of national jubilation as the moon-landing, Rauschenberg became, during the sixties, a kind of semi-official history painter—another indication of the extent to which pop art kept alive the traditional art-historical categories of portrait, landscape, still-life, genre, and history painting.

In the light of the harsh new realities, the prophets of affluence who had predicted the technological millennium of the Aquarian Age suddenly lost their allure. Faith shaken, more and more artists began looking exclusively inward, and art became again what it had been—

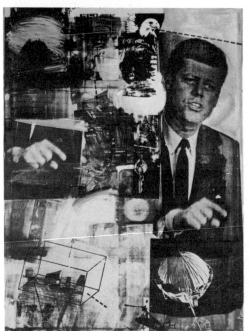

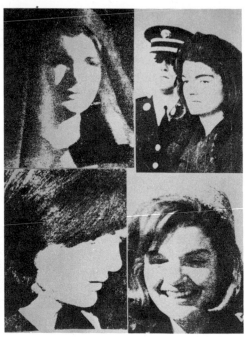

9-24. ROBERT RAUSCHENBERG,
Buffalo II, 1964.

9-25. ANDY WARHOL,
Jackie, 1965.

a personal quest, rather than public display. While some artists summoned the confidence to create public art, many retired into various modes of contemplative retreat and conceptual self-examination. According to Allan Kaprow, "Once, the task of the artist was to make good art; now it is to avoid making art of any kind. Once, the public and critics had to be shown; now the latter are full of authority and the artists themselves are full of doubt." [7]

Into the Seventies: Beyond the Object

In countries where revolution was more the issue, Happenings became the abuse of order, disruption for its own sake. But the American problem remains the schizoid psyche and its reeling from one extreme to another, from puritanism to abandon, from solicitude to aggression.

—CLAES OLDENBURG, *Raw Notes,* 1973

The history of every form of art comprises critical periods in which art aspires to produce effects that can be achieved only after a drastic modification of the technical *status quo,* that is to say by a new form of art.

—WALTER BENJAMIN, "The Work of Art in the Age of Mechanical Reproduction," 1936 [1]

Late in 1970, *Time* magazine commissioned a cover from Claes Oldenburg that was to express the mood of contemporary America after the revolutions of the heated sixties—political, sexual, and social, as well as artistic—had cooled down. Oldenburg's drawing, a portrait of the artist with an icebag on his head and frozen tears on his face, was rejected in favor of a more conventional image of Uncle Sam with a hangover; but no one could doubt the appropriateness of Oldenburg's metaphor for the bruised condition of the American psyche.

As the decade of the seventies opened, "future shock" seemed the common malady of artists and public alike. The frantic search for technical, formal, and conceptual breakthroughs that had become the staple of the radical rhetoric pervasive in both formalist and nonformalist late sixties' criticism, made it seem as though innovation were the proof of quality. The resulting rush by artists to claim the most extreme or radical positions for themselves led to a hysterical rash of experimentation that splintered any residual unity of style and propelled art out of the studio into the streets and onto the stage.

221

10-1. LARRY POONS,
Railroad Horse, 1971.

In his prophetic essay "The Work of Art in the Age of Mechanical Reproduction," Walter Benjamin indicated that crucial transformations of both the forms and functions of fine art were being made as a result of the invention of the reproductive media. Benjamin's essay was written in 1936, long before videotape, Xerox duplication, and computer technology had become available. Jet travel, space exploration, and satellite communication have changed the artist's consciousness as much as that of every other individual living in our explosive times, but the most important single stimulus to the development of new art forms, as well as to the renaissance of printmaking (including mass editions of offset lithographs and posters), in America in the sixties and seventies has been the invention of new reproductive media.

Both minimal and "conceptual" art defined themselves essentially in terms of their relationship to reproduction. Moving out from Ad Reinhardt's black paintings, which are generally considered the first contemporary minimal works, artists like Robert Irwin and Robert Ryman began making paintings that were deliberately unreproducible. In opposition to minimal art, conceptual art concentrates on processing raw data, documents, and statements by means of such techniques as mimeographing, Xerography, videotape, and all forms of photography. In this context, minimal art may be seen as an extreme stand in favor of what remains of Renaissance individualism, for

monochrome paintings can only be experienced on the basis of a one-to-one confrontation with the original. Conceptual art, on the other hand, accepts mechanical reproduction as a contemporary reality, if not *the* contemporary reality, negating any claims to the individuality of the art work.

That art is an experience, not an object, has been the credo of the modern avant-garde. During the late sixties and seventies, conceptual artists took this dictum even farther than their hero Marcel Duchamp. Artists like Joseph Kosuth, John Baldessari, Mel Bochner, Sol LeWitt, Lawrence Weiner, and Robert Barry concentrated on abstract language games, situations, and texts not intended to produce any objects for use or consumption. Impressed by the achievements of criticism in the sixties, artists—probably for the first time—began to usurp the powers and interests of critics. Art magazines started to function as the galleries of conceptual artists. But conceptual art was a predictable exaggeration: The sixties' preoccupation with conception over execution inevitably resulted, in the seventies, in the proclamation that *only* the idea counted.

The American tendency toward extremism, noted by Sadakichi Hartmann early in the century and echoed in Oldenburg's *Raw Notes,* rapidly diverted art from a mainstream European modernism toward more typically American exaggeration: on the one hand, the most esoteric conceptual art, and, on the other, the most hermetic art-

10-2. ALAN SHIELDS,
Wow, It's a Real Cannonball, 1972–73.

10-3. ROBERT MANGOLD,
Circle in and out of a Polygon II, 1973.

for-art's-sake virtually imageless abstraction. The artists in these two camps were united, however, in their revulsion from the notion of art as material object, as opposed to pure experience or state of mind.

Other typically American attitudes surfaced once the separation of American art from Europe was established. The pantheistic Transcendentalism that produced the vast grandiose landscapes of the Hudson River School in the nineteenth century, reappeared in the misty lyrical abstractions of the painters of pure atmospheric phenomena, Larry Poons (*Ill. 10–1*), Friedl Dzubas, and especially Jules Olitski, whose languid, flowing clouds and disembodied mists of hazy color attracted an entire school of imitators. Former geometric or minimal painters like Walter Darby Bannard, Larry Zox, and Dan Christensen were among the converts to Olitski's languorous imageless formats. Pushing drawing or design elements to the periphery in his trend-setting sprayed and paint-lathered works of the seventies, Olitski leaves the center an empty, free-floating sea or atmosphere of color.

Despite the general distaste for the notion of art as object, literalism —that is, the demand that elements of painting formerly depicted illusionistically define themselves as actual—continued to be explored. Literalism was carried to new lengths by artists like Alan Shields, who sewed lines on his unstretched paintings instead of drawing them (*Ill. 10–2*), and Richard Tuttle, who cut the colored shape out of its canvas background and identified it as a flat cloth by removing the

stretcher. In Robert Mangold's *Circle in and out of a Polygon II* (*Ill. 10–3*), the actual shape of the stretcher, rounded to a circle at the top, is contrasted with the drawn shape of an inscribed polygon that is angular where the stretcher is round, belling out below in counterpoint to the right angles of the base of the support.

Partially because they had fewer ties to the European tradition than Easterners, California artists developed an aesthetic based on craft. Focusing narrowly on the literal properties of materials, they further blurred the boundaries between the major and the minor, or craft, arts. Ceramics, for example, has been the principal medium for three leading California sculptors: Kenneth Price, Peter Voulkos, and John Mason. So widespread was the use of fiberglass, Plexiglas, and vacuum forming among younger California artists such as DeWain Valentine, Ron Cooper, Fred Eversley, and Peter Alexander, it was facetiously suggested that what Mondrian envisioned by "plastic and pure plastic art" was the technical brilliance of this second generation of California artists.

Plastic as a medium for pictorial art has also been used successfully not only by Ron Davis, but also by Craig Kauffman and Tom Holland. Recent works by both conform to the general tendency of painting in the seventies to be more complex, smaller in scale, filled with greater detail, and consequently more difficult and time-consuming to scan or read than the simplified gestalt images of the sixties. Holland's *Stoll* (*Ill. 10–4*) is painted in epoxy—an enamel paint—on a hard fiberglass surface to which cut-outs have been affixed with visible

10-4. TOM HOLLAND,
Stoll, 1972.

tacks that are, in a sense, the literalist equivalent of the *trompe l'oeil* tacks painted by Braque and Picasso in their Cubist still lifes. Like Holland, Kauffman leaves explicit traces of brushwork in a painted relief that shows a network of quasi-geometric tracery reminiscent of the leading in stained glass windows. A reaction against his monochrome, single-image, molded reliefs of the sixties, Kauffman's recent works reveal the hesitancy and imperfection of hand work as opposed to the reproducible perfectibility of machine-made objects.

The interplay between mechanical exactness and human error also animates recent works by Frank Stella (*Ill. 10–5*). Resembling giant collages, these reliefs have sections that literally project and recede. Commercial materials like Masonite, linoleum, and rug fabric alternate with painted surfaces in a bewildering scramble of familiar shapes, perspectives, and textures combined in an unfamiliar context. Reminiscent of the dynamic, asymmetrical geometry of the Russian Constructivist El Lissitzky, Stella's new works are far more arbitrary and eccentric than anything previously produced in a geometric vein. So precarious is the association of sharp planes shot through with oddly angled color indentations that it appears Stella succeeded in separating geometry—the basis of any classic system of harmony— from rationality. These arbitrary and, above all, frustrating paintings, in which planes are stopped short from passing through each other and tension is maximized by an opposition of powerful thrusts and counterthrusts, are the antithesis of the voluptuous high-key color fan and interlace paintings based on the protractor motif that Stella painted in the late sixties. In their multipartite complexity and sense of blocked movements they are typical of the uneasy sensibility of the disequilibrated seventies.

Also characteristic of the seventies is Stella's emphasis on surface as a concrete physical quality. However, his interpretation of surface as

10-5. FRANK STELLA, *Mogielnica II*, 1972.

10-6. JULES OLITSKI,
Seventh Loosha, 1970.

made of the literal materials of an industrial milieu is completely opposed to that of the color-field abstractionists, who regard surface as the crucial focus of painting in the seventies. "What is of importance in painting is paint. Paint can be color. Paint becomes painting when color establishes surface," Jules Olitski wrote in 1966.[2]

Formed in the Parisian ambience of *art informel,* which emphasized the importance of pigment as dense physical matter, Olitski came to stress surface in the seventies nearly as much as he had in his paintings of the fifties that were loaded with thick plaster crusts. After an initial series of atmospheric spray paintings, Olitski began experimenting with thicker and increasingly opaque paint. Following his example, Larry Poons rejected the transparent dyed fields of his dot paintings in favor of heavily impastoed surfaces so laden with paint their surfaces cracked, showing previously applied layers of color. In Poons' case, the connection with Monet's late water-lily paintings is more obvious than in Olitski's, although the latter obviously also owes a debt

to the atomized color of Neo-Impressionism as well as to its preference for a palette of flamboyant sunrise ochres and yellows or twilight tints of violet and mauve. Not since Turner, whose canvases have obviously inspired Olitski in recent works, has a painter been so intent on capturing—as opposed to merely representing—fleeting atmospheric effects (*Ill. 10–6*). Choosing to allude to light through color rather than to use real light (as Flavin has done with fluorescent tubes) Olitski had to resolve certain problems. Foremost was finding a means to define his canvases as pictorial statements, as opposed to, say, yard goods or wallpaper. His solution was to use drawing to define the limits of an elusively shifting color field. This created optical effects of great splendor: Interpenetrating layers of sprayed color appear to spread and coalesce before one's eyes. Drawing these linear boundaries near the periphery of his paintings, roughly parallel to the framing edges, Olitski could structure color without resorting to hard-edged shapes or Cubist planes.

Olitski's imageless painting defines the opposite end of the spectrum of abstract art in the seventies from Stella's structuralism. Yet paradoxically, Olitski, too, is indebted to Russian Constructivism.[3] In the series of paintings entitled "Sensation of Fading Away," Kasimir Malevich permitted his forms to shade off, paling away into infinity. Much in this spirit, Olitski revived tonal variation to give the impression that his images were not frontal, appearing instead to tilt away obliquely from the picture plane.[4] In emphasizing the texture of pigmented surface so vehemently, however, Olitski differed radically from Malevich, who was careful to efface his brushstrokes.

We may understand the pervasive emphasis on surface of recent abstract American painting as reflecting a sudden realization that the central problem for painters is no longer, as it was until the sixties, to distinguish painting from the other arts. The central issue today appears to be how painting can distinguish itself from other objects in the world. Essential to this definition was the realization that the only characteristic of painting that differentiates it from other types of objects is the fact that it is nothing more than a colored surface. This is the meaning of Olitski's seemingly cryptic remark that "paint becomes painting when color establishes surface."

Olitski's drawing along the edges of his canvas is reminiscent of Seurat's internal frames of pointillist dots; it is a contrivance to contain radiating color within the boundaries of a pictorial context, a means of structuring color without using hard contours. In works of other artists, however, drawing has been revived to play a more active

10-7. ROBERT MOTHERWELL,
Great Wall of China, No. 4, 1971.

10-8. KENNETH NOLAND,
Lift in Abeyance, 1971.

10-9. RICHARD DIEBENKORN,
Ocean Park, No. 67, 1973.

and vital role than it has had in American art since a decision was made in the sixties to eliminate detail—and with it drawing—felt to be a distraction from immediacy. For example, in Robert Motherwell's early seventies' paintings generally known as the "open" series, drawing creates spatial ambiguity and also provides a structural element that binds the field of color to its rectangular frame. A number of these works, such as *Great Wall of China, No. 4 (Ill. 10-7)* have the simplicity and directness of Zen ideograms, which Motherwell is known to admire.

Drawing plays an important role in Richard Diebenkorn's recent paintings as well. A figure painter for many years, Diebenkorn emerged at the end of the sixties as an abstract artist of rigor and intensity. In *Ocean Park, No. 67 (Ill. 10-9)*, a linear scaffolding frames a pale field enlivened by painterly surface variation. A variable, mottled, painterly surface is also characteristic of Kenneth Noland's softer, more subdued stained paintings of the late sixties and early seventies, crisscrossed by narrow ribbons of paired contrasting colors placed at rhythmic intervals. Noland's handling of surface has always been particularly sensitive, but in these more intimate, muted paintings, surface is handled with particular subtlety (*Ill. 10-8*).

Surface, the special concern of the seventies, is also emphasized by artists like Edward Avedisian and Alfred Jensen, both of whom evoke, in very different ways, a cosmic image. Avedisian's splattered

10-10. EDWARD AVEDISIAN, *Touch*, 1971.

paint technically recalls Hans Hofmann and Jackson Pollock, but his images are of celestial aureoles and meteoric pyrotechnics (*Ill. 10–10*). Jensen, on the other hand, creates hypnotically repetitious patterns of private symbols that have the mesmerizing optical effect of Islamic decoration (*Ill. 10–11*).

Undoubtedly, a desire for mystical, contemplative experiences has generally influenced the direction of those American artists in the seventies who attack a materialist, positivist aesthetic. Their disgust with hedonism was prophesied in the late works of Mark Rothko, which were imageless and virtually monochromatic, and the black paintings of Ad Reinhardt. Both Rothko and Reinhardt pointed toward an art so absolute and demanding that it requires a state of

10-11. ALFRED JENSEN,
A Circumpolar Journey, 1973.

231

focused consciousness different from our mundane way of seeing to be perceived at all. To see Reinhardt's nearly invisible black paintings or the somber, ascetic paintings in the Rothko Chapel at Rice University in Houston at all, an extreme degree of concentration, an expulsion of all other thoughts from the mind and other images from the eye, are required. After Reinhardt's death in 1967 and Rothko's tragic suicide in 1970, a number of artists continued their researches into the use of a severely reduced palette and image, among them James Bishop, Ralph Humphrey, and Robert Ryman (*Ill. 10–12*). Gently rounding the corners of his stretchers, Humphrey gives a literalist inflection to his pale canvases, while Ryman's all-white paintings emphasize the quality of paint as surface and its identity as a liquid film that is brushed on a cloth support. Before she stopped painting in 1967, Agnes Martin, on the other hand, created a highly sophisticated, elegant art from the simplest, apparently meager means (*Ill. 10–13*). Her paintings are like enlarged drawings: Fine lines, revealing tiny irregularities of pressure, are ordered into parallel bands or regular grids that have a strangely restful quality.

Of the many artists re-evaluating the role of drawing in painting, Helen Frankenthaler has found some of the freshest ways to use line in abstract painting. In *Summer Harp* (*Ill. 10–14*), drawing establishes the location of flat surface to complicate any spatial reading of broad expanses of floating color. Throughout the sixties, Frankenthaler held out against literalist and minimalist extremes, although she simplified her images considerably in paintings like *The Human Edge,* whose title may express a defiant challenge to the prevailing hard-edge style of the sixties. The experience of the sixties, however, left

10-12. ROBERT RYMAN,
General, 1970.

10-13. AGNES MARTIN,
Untitled, 1963.

10-14. HELEN FRANKENTHALER, *Summer Harp,* 1973.

her, like her contemporaries, more conscious of structural considera-
tions. A comparison of *Summer Harp* with *Mountains and Sea (Ill.
8–10)* illustrates the new role of drawing as both a structural and a
space-creating agent.

The reappearance of elements like perspective, detail, and drawing

10-15. BRICE MARDEN,
From Bob's House, No. 1, 1970.

10-16. DAVID NOVROS, *Untitled,* 1973.

in the seventies must be seen, not as a regression to Cubist modes, but in the light of the redefinition of the relationship of art works to real objects made in the sixties. For example, although David Novros and Brice Marden use simple geometric formats, their paintings differ in several crucial respects from earlier geometric painting. Like Ryman, Marden demonstrates that paint is just a surface film by stopping his sheets of dulled encaustic pigment just short of the canvas edge. Because wax, like enamel, does not sink into the canvas, surface is defined as independent of its support (*Ill. 10–15*). In a similarly literal vein, Novros defines line as actual by joining painted panels together, permitting the framing edge to act as a division between colored areas (*Ill. 10–16*).

Stimulated by recent developments, a number of veteran Abstract Expressionists like Jack Tworkov, Lee Krasner, and Robert Goodnough have rejected the gestural style of action painting in favor of more contemplative, static images. Goodnough's recent works dispense small patches of color across atmospheric fields of pastel-tinted canvas. Krasner was among the first New York School painters to work abstractly, and her dramatic, often foliate or floral images of the seventies interpret nature in stylized patterns reminiscent of mysterious totemic symbols. Krasner's interest in Jungian archetypes and primordial subjects as universal themes is shared by a number of younger artists like Nancy Graves, who has used prehistoric remains as well as aerial and undersea maps as subjects. For Graves, these maps

10-18. ROBERT COTTINGHAM, *Art*, 1971.

10-17. NANCY GRAVES,
Indian Ocean Floor I, 1972.

provide an *a priori* structure, a neutral means, for ordering color and line (*Ill. 10-17*). Other young artists have looked at subject matter even more indifferently, following the example of artists like Roy Lichtenstein, whose recent still lifes, though painted in the banal, simplified style of pop art, are far more closely related to the monumental still lifes of Cézanne, Matisse, and Léger than to the popular sources from which they originally derived (*Ill. 10-19*).

Riding the crest of pop art's success, a second wave of representational art depicting the American scene has achieved media prominence as Photo-Realism. Comparing Robert Cottingham's cynical comment on the meaning of art in American life—a movie marquee with the word "Art" spelled out in neon—with Lichtenstein's carefully constructed still life, one sees that Photo-Realism has ties, not to any tradition of fine art, but to the popular illustrations of Norman Rockwell (*Ill. 10-18*). Like Andrew Wyeth's meticulously detailed landscapes and figure studies, Photo-Realism impresses the layman with the artist's ability to reproduce reality as literally and uncritically as the camera. Whereas Wyeth's sentimental narrative art is directed at a public that looks back nostalgically to simpler times in a rural America, Photo-Realism is as deliberately deadpan as the popular new documentary movies of the American scene.

Resembling the gigantically enlarged images projected on movie screens, Chuck Close's portraits are a technical *tour de force*. More sophisticated than the work of other Photo-Realists, who paint the

235

10-19. ROY LICHTENSTEIN, *Still Life with Crystal Dish,* 1972.

American scene with the academic discipline of the commercial illustrator, Close's oversize images, such as the blow-up portraits of artists Alfred Leslie and Richard Serra (*Ill. 10–20*), are intended as a challenge to abstract art; as such, they share many of the formal qualities and techniques of abstract painting: for example, frontality, centering

of the image in the frame, and, as in Close's case, the use of a grid onto which tiny dots of color are sprayed with an airbrush until the completed image enlarges. Close deliberately works from photographs, exaggerating detail—especially unpleasant skin textures—even more than the sharp focus of the camera. He comments, like Andy Warhol in his paintings made from silk-screen photographs, on the relationship representation—particularly portraiture—bears to reproduction.

Warhol, however, gives his commentary a broader scope, demonstrating how the reproductive media (photography, silk-screen, etc.) have a leveling, equalizing quality that drains off meaning. The capacity of reproduction to reduce all images to the same common denominator is brilliantly exploited in Warhol's portraits. Warhol realized that the media create stardom, an instant and constantly changing pantheon of new gods and goddesses. Everyone upon whom his camera focuses becomes a star: An anonymous insurance executive is a star, Marilyn and Liz are stars, the Mona Lisa is a star, and Mao is a star (*Ill. 10–21*). In a final diabolical joke, Warhol has managed to place posters of Chairman Mao in the residences of our leading capitalists.

Countering the nihilism of Warhol and Photo-Realism is the revival of figure painting by such artists as Sidney Tillim, Jack Beal, Alex Katz, and Philip Pearlstein. Though he crops the figure at odd angles as a photographer might, Pearlstein does not work from photographs but from life. Beal and Pearlstein use cast shadows and patterns to

10-20. CHUCK CLOSE, *Richard,* 1973. 10-21. ANDY WARHOL, *Mao Tse-tung,* 1972.

10-22. PHILIP PEARLSTEIN, *Female Model in Robe Seated on Platform Rocker,* 1973.

contrast with the nude figure, creating strong two- and three-dimensional patterns, as if Matisse had suddenly decided to repaint Courbet's subjects (*Ill. 10–22*). More attracted by the simplifications and flattening of form characteristic of pop art, Alex Katz also paints a familiar world of family and friends.

10-23. BRUCE NAUMAN, *Study for Hologram,* 1970.

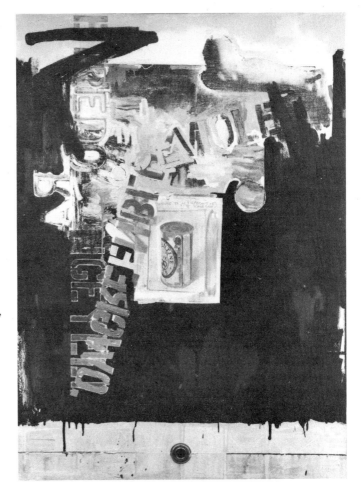

10-24. JASPER JOHNS,
Decoy II, 1972.

For every artist who still believes in the viability of pictorial representation, however, there are dozens heading straight for the reproductive media—photography, film, videotape, and such new technological inventions as holography—to record and project images. Some, like Bruce Nauman, are engaged in an extensive self-examination that involves the observation and sometimes distortion of the human body (*Ill. 10–23*).

The preoccupation with the body in works by artists like Nauman was foreshadowed in Jasper Johns' casts of fragments of the human anatomy in his 1955 *Target with Plaster Casts*. The dichotomy between the literally embodied and the immaterially disembodied reaches a crescendo of tension in Johns' difficult, disjointed works of the early

239

seventies. This dichotomy reflects a recurrent American dilemma. It is no accident that the eighteenth-century American theologian Jonathan Edwards is quoted so frequently in defense of the new abstract painting of disembodied pure phenomena.[5] Transcendentalism, and, for that matter, most forms of modern mysticism, echo the Puritan prejudice against the body as dross matter to be transcended metaphysically. At the opposite pole is American pragmatism, which demands literal embodiment and perceives reality exclusively in physical facts and actual objects.

Midway through the seventies, American artists are moving toward one extreme or another, having rejected, at least for the moment, an art dedicated to moderation of any kind. Informed with a new sophistication and a mature tradition of both art and criticism, they are producing works as complex as Johns' *Decoy II* (*Ill. 10–24*). Neither picture nor object, *Decoy II* is a unique symbiosis of printmaking—which has lately achieved new prominence as an American art—and painting. It incorporates recycled images drawn from Johns' previous lithographs, etchings, paintings, and sculpture, in a summation, not only of the artist's personal history but also of the history of art as experienced by a contemporary painter. *Decoy* intercalates impressions of objects with photographs of objects, such as the wax cast of a leg (in turn taken from life) originally seen pegged to the painting *Passage II*. The leg reappears many times in photographic reproduction in a series of related prints. A variety of painterly techniques in combination mix illusionism with the explicit flatness of the printed image. Layers of conflicting illusions and contradictory visual information are superimposed, only to be punctured by the actual brass grommet that pierces the lower edge of the canvas, demonstrating that painting remains—despite all the artifices at the disposal of the seventies' artist—what it was when Maurice Denis described it in 1890, "a flat surface covered with patches of color."[6]

Chapter Eleven

Sculpture for the Space Age

Plastic thought has geometrical possibilities that have not been exhausted by the requirements of Egyptian or Greek or Gothic cathedrals. These thoughts are pressing for expression and have not yet found a place, which is the reason why so much modern sculpture finds its way to museums of art, permanently unplaced, a specimen, not an actor in the life of the day.
—A. S. CALDER, *The American Architect,* December 8, 1920

Twentieth-century American sculpture, like twentieth-century American architecture, is dominated by a single genius. As Frank Lloyd Wright transcends national boundaries in architecture, so David Smith towers above his contemporaries, both American and European, as the sculptor who realized the potential of Gonzalez' and Picasso's welded metal Cubist works. And in the same fashion that Wright's last works point to the current direction in American architecture, the monumental steel pieces Smith executed before his death in an auto accident in 1965 announce the newest developments in American sculpture, developments that, it is hoped, portend a sculptural renaissance.

The last of the American arts to mature, American sculpture in the early part of the century was graced by a few interesting works, mainly based on French examples, which heretofore have been largely ignored. Eakins' reliefs, Davies' charming figures, and the classical works of the eccentric William Rimmer and of A. Stirling Calder, the father of Alexander Calder, represent examples of modeled and cast bronze sculpture that have a vitality and originality absent in the heavy-handed academic statues of the official sculptors, such as Gutzon Borglum, Daniel Chester French, and Anna Hyatt Huntington. Outside of Eakins, Davies, Rimmer, and the elder Calder, however, cast and modeled sculpture in America was, except for the outstanding contribution of the French émigré Gaston Lachaise, a dreary and pedestrian affair until the forties. This was the decade when Reuben Nakian began his mature work, and Jacques Lipchitz, perhaps the

greatest bronze worker of the twentieth century, arrived as a refugee to become an example for American sculptors, as the Surrealists were for American painters.

As in painting, the inadequacies of the academic tradition, the lack of a classical or high art, and the provincialism of American culture may be blamed for the poverty of American work in cast metals until the forties. The early twentieth-century genre sculpture of Abastenia St. Leger Eberle and Mahonri Young, tied as it was to Ash Can School imagery, can scarcely be called imaginative. Similarly, the Rodinesque works of the Swedish émigré Charles Haag were not particularly distinguished. And although the portraits done by Mrs. Whitney and her friend Jo Davidson have a certain elegance, they, too, finally must be judged minor efforts.

On the other hand, carving, in stone and wood, fared better. Beginning early in the twentieth century with Elie Nadelman's serpentine creatures, and continuing with Chaim Gross' acrobats and Raoul Hague's monumental abstract torsos, carving from the block of wood has had its high moments in America. Stone carving, in William Zorach's early work and in John B. Flannagan's original pieces, has also achieved a certain level. Again, one must see this activity within the context of the indigenous tradition, which was rich in examples of primitive carving, from ships' prows to cigar-store Indians. Thus, sculpture in America remained either provincially immature or tied to academicism long after painters had begun to experiment within the

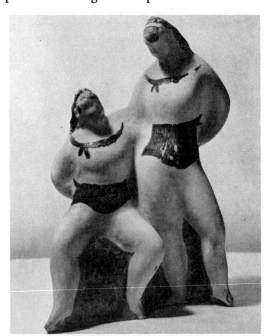

11-1. ELIE NADELMAN,
Two Women, ca. 1934.

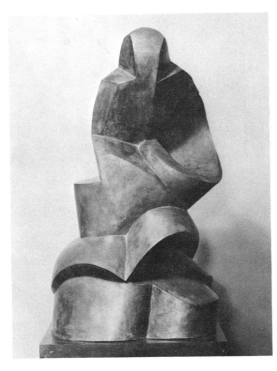

11-2. MAX WEBER,
Spiral Rhythm, 1915.

modern idiom. In the decade preceding the Armory Show, only Elie Nadelman had produced modernist sculpture of any consequence. His elegant painted wood figures, in their simplification and reduction to geometric volumes, parallel the treatment of the figure by painters such as Guy Pène du Bois. In such works as the painted terra cotta *Two Women* (*Ill. 11-1*), Nadelman shows his skill at treating mass in a summary manner. But charming, original, and sensitive as they are, Nadelman's waltzing couples and witty men in bowlers and bow-ties are limited in their range and ambition.

Similarly, the few isolated efforts made in the direction of abstract sculpture were unrealized promises. *Spiral Rhythm* (*Ill. 11-2*), Max Weber's 1915 sculpture, was among the first pieces of Cubist sculpture produced anywhere. And in America, Weber's sculptures were unique efforts. While Picasso, Duchamp-Villon, and Lipchitz translated Cubist planes into sculptural volumes in daring experiments, America could boast little more advanced than Robert Laurent's semi-abstract carvings, such as *The Flame* (*Ill. 11-3*). Even though Brancusi's first show was held in America, before World War II Laurent was apparently the only American (with the possible exception of Nadelman) to learn anything from the pure flow of Brancusi's reductive volumes.

Perhaps the most original American sculptor working in the teens

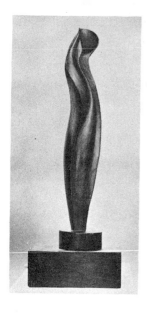

11-3. ROBERT LAURENT, *The Flame, ca.* 1917.

11-4. JOHN STORRS, *Seated Gendarme,* 1925.

and twenties was John Storrs, whose abstract architectonic sculptures, such as *Seated Gendarme* (*Ill. 11-4*), though of a remarkable quality, were barely acknowledged. Much more typical were the compromise solutions of Maurice Sterne and William Zorach, who looked to archaic and primitive art for a way to invigorate the figurative tradition. When Zorach abandoned painting for sculpture in 1917, he chose a far more conservative means of expression than the Cubist vocabulary of his paintings. His early works, like *Floating Figure* (*Ill. 11-5*), exhibited an admirable economy of means. Hailed for carving directly and staying close to the monolithic contours of the stone, Zorach achieved a major reputation in the thirties as his art became more sentimental and less inventive. This was probably so because his solidly built Maillol-like women, involved in domestic situations, and his idealized workers meshed perfectly with the ideology of the thirties. Along with Paul

11-5. WILLIAM ZORACH, *Floating Figure,* 1922.

Manship, a less gifted, more academic sculptor, Zorach was one of America's leading official sculptors of the decade.

The single sculptor to realize a major *oeuvre* in America before David Smith was Gaston Lachaise. Because of the erotic content of his work, Lachaise has received a somewhat belated recognition. However, owing to his skill as a craftsman, he never lacked commissions, and was well known in the twenties for his decorative garden sculpture of gulls, peacocks, and dolphins. But not until the sixties was the American public sufficiently mature to be exposed to Lachaise's most voluptuous earth goddesses, fertility symbols, and intertwined couples. He borrowed the latter motif from Rodin, charging it with an even more explicit sexuality, as in *Passion* (*Ill. 11-6*). Thus, even if not for his genius as a plastic artist, Lachaise would stand apart from his con-

11-6. GASTON LACHAISE, *Passion*, 1932–34.

11-7. GASTON LACHAISE, *Standing Woman*, 1912–27.

temporaries because of his frank treatment of unconventional subjects.

Born in Paris, Lachaise came to America in 1906, following the woman he later married who became his lifelong inspiration. After working in Boston for several years, he quite naturally found his way to 291; his interest in the generative forces of nature found parallels with the themes that Dove, O'Keeffe, and Stieglitz were exploring. Lachaise's portraits, which derived from Rodin's tradition of robust modeling, prompted people like John Marin and Marianne Moore to pose for him. During the twenties, Lachaise was supported in part by the portraits he made of the staff of the *Dial,* who also purchased other of his works. Many photographs of his sculpture were published in the *Dial,* and the first issue carried Lachaise's relief *Dusk* as its frontispiece.

Lachaise had been trained in the Paris Beaux-Arts Academy; consequently, when he arrived in the United States, a twenty-four-year-old journeyman-sculptor, he quickly found employment as the assistant to Henry Hudson Kitson, an academic sculptor of Civil War monuments. In 1912 he moved to New York, where he lived until his death in 1935. As the assistant to Paul Manship from 1914 to 1921, he watched Manship's popularity grow, while his own work was decried by official academic sculptors like Daniel Chester French as "an atrocity."

Lachaise's development as a sculptor proceeds from the rather modest curves of the languid early nudes to the vigorous plasticity of the *Standing Woman (Ill. 11-7).* This figure was the prototype for many later elaborations Lachaise made on the theme of the full matronly figure that tapered downward, balancing on slender tiptoes which seem hardly adequate to support the substantial form of the body. In his standing figures of the thirties, Lachaise's forms became more stylized and ponderous; in his fragmentary female torsos, his forms assumed

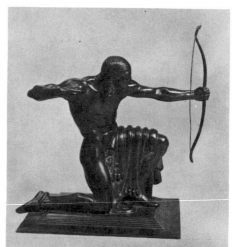

11-8. PAUL MANSHIP,
Indian Hunter, ca. 1926.

246

an almost abstract geometric quality, without losing their primitive, explosive sexual charge. Besides the standing and fragmentary female figures, Lachaise also executed a number of reliefs of female figures, as well as a series of architectural reliefs for the American Telegraph Building, the New York Electricity Building at the Chicago World's Fair (since destroyed), and the Rockefeller Center–RCA International Building. Toward the end of his life, Lachaise executed smooth, polished quasi-geometric torsos of heroic volumes as well as a number of extraordinarily forceful, baroque torsos, which embody the violence of the primitive forces of passion.

Lachaise's death in 1935 left America without a major sculptor. David Smith and Reuben Nakian were youthful experimenters who had not yet arrived at their mature styles. Manship and Zorach were officially praised, but their work was an American version of the international "moderne" of muscular athletes, heroes, and superworkers who sprang up all over Europe and America during the decade. Typical of these stylized figures is Manship's *Indian Hunter* (*Ill. 11-8*). The single

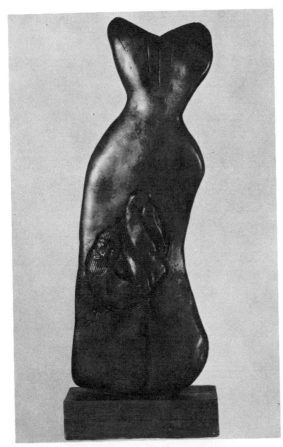

11-9. JOHN FLANNAGAN,
Jonah and the Whale, 1937.

247

sculptor of merit working primarily in the thirties was John Flanna-
gan, whose mystical religious imagery and organic forms relate his
work to the painting of Dove and Hartley. Flannagan's free-standing
wooden pieces are flattened carving, distorted in the manner of the
German Expressionists to approximate archaic and primitive sculpture.
His later works in stone reflect Brancusi's loyalty to the monolith
and to the sensuous properties of directly carved stone. Animal life
provided most of the imagery, although Flannagan began to look for
universal abstract symbols. For such works as the low carving of *Jonah
and the Whale* (*Ill. 11-9*), Flannagan wished to capture the "remote
memory of a stirring impulse from the depth of the unconscious." Like
the later work of the Stieglitz group, Flannagan's sculpture was a
deeply personal affair.

Outside of America, Alexander Calder was developing a sophisti-
cated sculptural art based on Miró's and Arp's forms. In the late twen-
ties, Calder designed a wire circus which revealed his promise as a
sculptor and his unconventional imagination and antic wit. But Calder's

11-10. ALEXANDER CALDER, *Little Red Under Blue*, 1947.

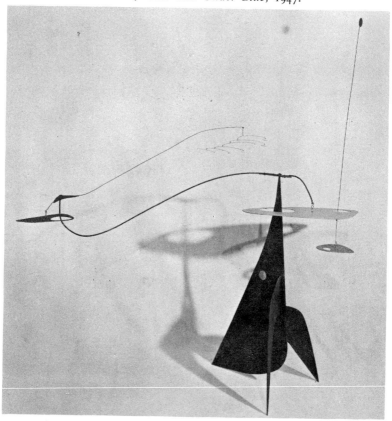

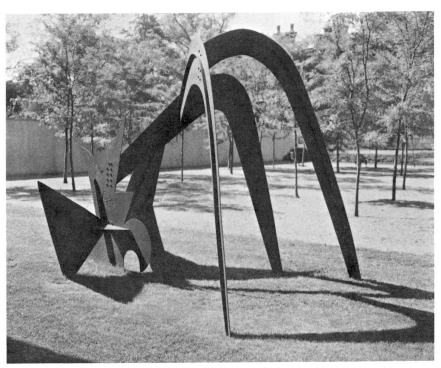

11-11. ALEXANDER CALDER, *Three Arches*, 1963.

great fame is as an abstract sculptor and pioneer of kinetic art. Calder
dates his conversion to both abstraction and movement from 1930,
when he visited Mondrian's studio. Mondrian's static rectangles caused
him to wonder "how fine it would be if everything there moved."
Earlier, Calder had experimented with hand-directed movement; now
he put his training as an engineer into practice, arriving at the subtle
balances of the suspended mobiles. These constructions used flat, free
shapes, derived from Miró, and colored balls whose concentric orbits
suggested the movement of the universe. The mobiles provided Calder
with a form in which both his plastic imagination and his mechanical
ingenuity could express themselves. In the late thirties, he began to
work on small constructions which did not move. These gradually
emerged as the stabiles, earthbound cousins to the mobiles. In works
like *Little Red Under Blue* (*Ill. 11-10*), Calder suspended mobiles from
static bases. Gradually, as the stabiles became increasingly monumental,
Miró's organic shapes gave way to Matisse's decorative plant and leaf
motifs. Constructed of thin sheets of painted metal bolted together, the
soaring arches, tails, and fins of the stabiles became the prototypes for
ambitious monumental sculpture in the fifties and sixties (*Ill. 11-11*).
The stabiles showed how sculpture could rest flat on the floor so that

249

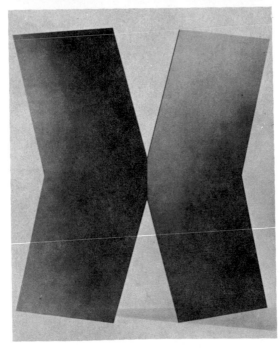

11-12. ELLSWORTH KELLY,
Gate, 1959.

bases could be discarded. In their use of painted cut-out metal sheets, they inspired an artist like Ellsworth Kelly to produce simple geometric sculpture, such as *Gate* (*Ill. 11-12*).

Living half the year in Europe and half in Connecticut, Calder has combined in his late work American largesse with European refinement. However, outside of scale and directness, his work has little in common with recent developments in American sculpture.

Abstract Expressionism was a style not easily translated into sculptural terms. The sculptors of David Smith's generation, contemporaries of the first-generation Abstract Expressionists, were subject to the same influences as the painters—the exhaustion of the Cubist aesthetic, the promise of Surrealist content and attitudes, and the need to find new forms and a new style.

The descendant of a pioneer blacksmith who settled in Decatur, Indiana, David Smith had worked in factories assembling metal parts before he applied the technique of welding to sculpture. At-the Art Students League, Smith studied painting with the Czech Cubist Jan Matulka, who taught him the rudiments of Cubism and Constructivism. Part of the small New York group of advanced artists in the thirties, Smith was exposed to abstract art through his friendships with Stuart Davis, Jean Xceron, and, especially, John Graham. Although he thought of himself primarily as a painter, in 1933 Smith was inspired to

borrow welding tools after seeing reproductions of Gonzalez' and Picasso's welded iron sculpture in *Cahiers d'Art*. Like Matisse, Picasso, and the other great sculptors of the twentieth century, Smith drew his inspiration from painting. He explained his transition from painting to sculpture, which occurred in 1930–33, thus:

My student period was involved with painting. The painting developed into raised levels from the canvas. Gradually the canvas was the base and the painting was a sculpture. . . . My student days, W.P.A. days, Romany Marie and McSorley days were with painters. . . . In these early days it was Cubist talk. Theirs I supposed was the Cubist canvas, and my reference image was the Cubist construction. The lines then had not been drawn by the pedants—in Cubist talk. Mondrian and Kandinsky were included.[1]

11-13. DAVID SMITH, *Blackburn—Song of an Irish Blacksmith*, 1950.

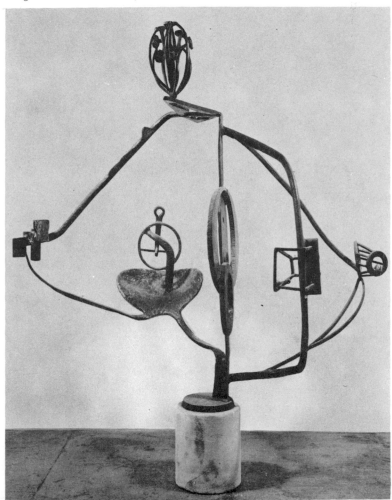

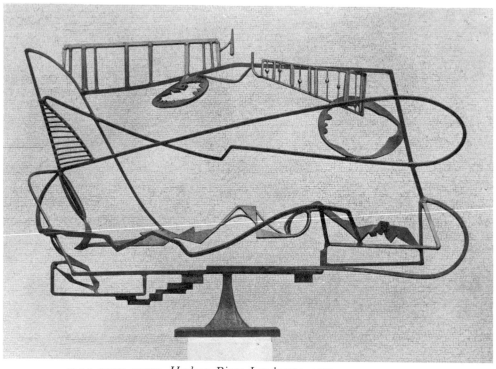

11-14. DAVID SMITH, *Hudson River Landscape,* 1951.

From 1937 to 1940 Smith produced the "medals for dishonor," bronze plaques whose expressionistic images were a searing moral indictment of the hypocrisies and injustices of contemporary society. Throughout his career, this moral force illuminates Smith's work and raises it above the level of the merely decorative.

During the war, Smith's sculptural output was curtailed because of his job as a welder in a defense plant, but in the late forties he began once again to make sculpture. Some of his works, which he called "interiors," seem directly based on Giacometti's *The Palace at 4 A.M.* On the other hand, his open welded steel constructions of the forties were often organized around a central core from which branchlike twisted rods and projections curved and intertwined. His masterpiece of 1950, *Blackburn—Song of an Irish Blacksmith (Ill. 11-13),* a steel and bronze sculpture, combines these rodlike forms with quasi-geometric planes and fanciful plantlike forms in a complex interplay. In the early fifties, Smith's constructions grew more linear and calligraphic, and solids gave way to the free play of "drawing-in-space," as in *Hudson River Landscape (Ill. 11-14).* Arriving at rhythmic silhouettes with transparent interiors, Smith's "drawing-in-space" in its spontaneous ability to gen-

erate new forms, appears akin to Surrealist automatism. In the fifties, Smith began to conceive his images in related series, the two major series of this period being "Agricola" and "Tank Totem." These works were based on the relationships of the human figure (Smith continued throughout his career to make figure drawings). In these sculptures, solids and transparencies alternated with shieldlike discs and rods. Many incorporated "found" objects, which had figured in his work since his collage-constructions of the early thirties. These had no associational value, but were usually standard industrial units which could be recombined within a series in different ways. Toward the end of the fifties, Smith's forms became more straight-edged, upright, and geometric, and less organic and fanciful. In the years before his death, his work came to fullest flowering in three major series, "Voltri-Bolton," "Zig," and "Cubi." The "Voltri-Bolton" series, begun in Spoleto, Italy, in 1962, touched off a period of sustained creative production which Smith maintained until his death. This series is the last based on the human figure. Combining found objects like tools with flat metal sheets cut into geometric patterns, Smith used the same basic set of shapes in a variety of basically planar relationships.

The new direction in Smith's work of the sixties, toward a more rigorously geometric, less fanciful style, parallels the changed direction of painting. The painted metal *Zig VII* (*Ill. 11-15*), for example, finds many analogies in the new abstraction, particularly in the chevrons and circles of Kenneth Noland. In fact, Smith once described himself as "a sculptor who painted his images." Because some of these works are designed to be seen only from a frontal view, they are even more

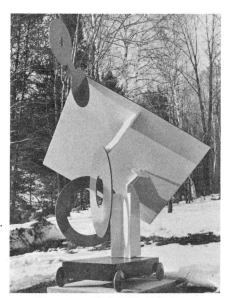

11-15. DAVID SMITH, *Zig VII*, 1963.

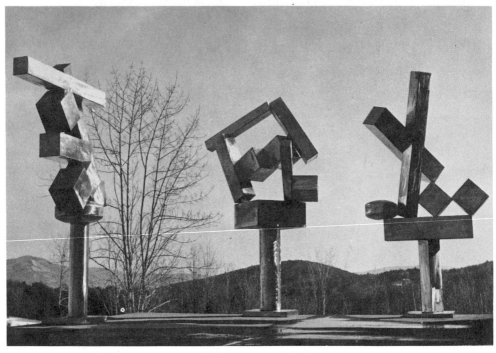

I I-I6. DAVID SMITH, *Cubi XVIII*, 1964; *Cubi XVII*, 1963; *Cubi XIX*, 1964.

pictorial in their insistence on silhouettes and planes. However, in the monumental stainless steel "Cubi" series (*Ill. 11-16*), Smith gives full play to three-dimensional volume, basing the relationships and epic scale on architecture rather than on the human figure. The series of cubes are balanced majestically yet dynamically above cylinders which thrust the mass of the sculpture above the viewer's head. The scored surface of the cubes causes their dense volumes to be dissolved in dazzling spangles of light. The brilliance of the metallic surface, polished to reflect sunlight (Smith wanted his sculpture to be seen out of doors), counterbalances the heaviness of the forms, providing a contradictory sense of buoyancy. The last works of the "Cubi" series, the architectonic gates, which combine openness with three-dimensional volume, represent a brilliant synthesis of Smith's main concerns. Thoroughly abstract, they point to the path Smith was about to pursue when his career was tragically cut short.

Smith's use of geometry as a flexible means of ordering rather than as a restrictive canon is characteristic of the manner in which American artists have used geometry. It bears certain analogies to Wright's free interpretation of geometry in his plans, forms, and ornaments, and supports the view that the typical American style is romantic. Like

the Precisionist painters, Smith was able to see the abstract value of concrete forms. The coincidence of the symbol and the structure links him to the aesthetic of the Abstract Expressionist painters who were his friends. Discussing his use of machine parts, Smith said, "When one chooses a couple of old iron rings from the hub of a wagon, they are circles, they are suns; they all have the same radius; they all perform the same Euclidean relationship."[2]

Like Wright, Smith was at ease in the twentieth century and felt no spiritual conflicts with the Machine Age. He did not feel obliged either to romanticize or to combat the machine. Machinery, he said, has "never been an alien element, it has been in my nature." His ambition was to turn his studio into a factory, where he could produce sculpture whose forms were as impressive, monumental, and contemporary as the locomotive. He preferred to work in iron or steel because it "possesses little art history. What associations it possesses are those of this century: power, structure, movement, progress, suspension, destruction, brutality."[3] Assessing Smith's work, Hilton Kramer concluded that his achievement lay "in submitting the rhetoric of the School of Paris to the vernacular of the American machine shop."[4]

In the forties, a number of other sculptors of Smith's generation began to work in welded metal. Like Smith, Seymour Lipton, Herbert Ferber, David Hare, and Ibram Lassaw adopted many of the attitudes of Abstract Expressionist painting, and were closely tied to its dynamic aesthetic.

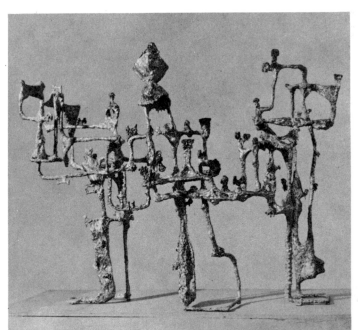

11-17. IBRAM LASSAW, *Procession*, 1955–56.

255

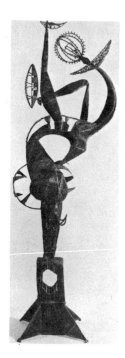

11-18. DAVID HARE, *Juggler*, 1950–51.

11-19. SEYMOUR LIPTON, *Sorcerer*, 1958.

One of the few Americans accepted by the Surrealists into their circle, David Hare incorporated Surrealist motifs in works such as the elegantly posed *Juggler* (*Ill. 11-18*). Ibram Lassaw's early gridlike structures were reminiscent of Mondrian's works, but he turned to freer structures in his more ornate, elaborate, later works, such as *Procession* (*Ill. 11-17*).

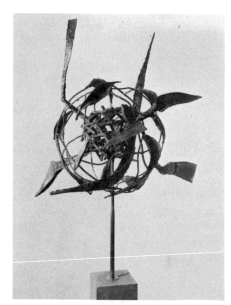

11-20. HERBERT FERBER, *Spherical Sculpture*, 1954–62.

A carver of social realist themes in the late thirties, Seymour Lipton abandoned the human figure in 1942 and began casting horns and skeletal pelvic forms. Lipton, like Hare and Ferber, became involved with the mythic themes of the Surrealists in the forties: the universal cycle of birth and death, primordial shapes, celestial and chthonian imagery. He outlined the "main genesis of artistic substance" as "the bud, the core, the spring, the darkness of earth, the deep animal fountainhead of man's forces."[5] He was especially attached to spiky, aggressive forms, which continue to appear even in his late work. Declaring that "everyone had used solid forms, pierced forms, prefabricated forms, etc.," Lipton said that he began to "feel the rightness of curved convoluted forms." Although his later works, such as *Sorcerer* (*Ill. 11-19*), are less convoluted, they still maintain the dramatic and lyrical tensions of his earlier forms.

In his work, Herbert Ferber has attempted to retain the energies of a restrained barbarism. Outside of Smith, he is virtually the only sculptor of his generation who sought to capture the energy of the gesture in the durable medium of metal. Turning away from representation in 1945, Ferber experimented in a number of materials, and made several cast bronzes of an aggressively Expressionist imagery. In the interest of working in open, welded sculpture, he refined this

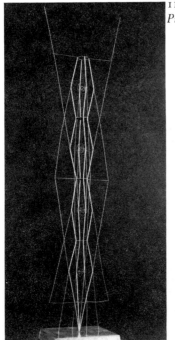

11-21. RICHARD LIPPOLD,
Primordial Figure, 1947–48.

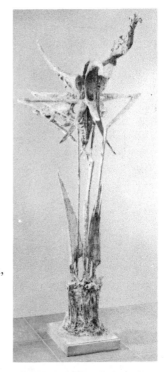

11-22. THEODORE ROSZAK,
Sea Sentinel, 1956.

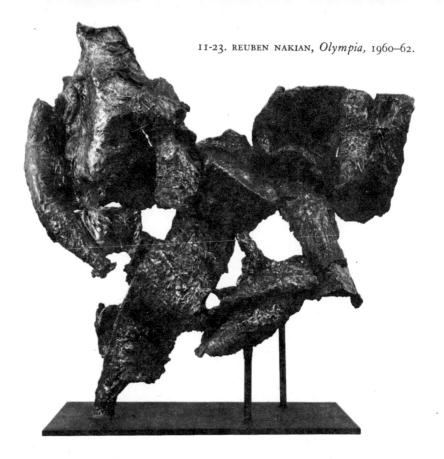

imagery in the fifties and early sixties into a series of large curves, folded like giant leaves or leaping around an open core, like arms grasping or attacking each other, as in *Spherical Sculpture* (*Ill. 11-20*). Arriving at a more monumental form of expression in the sixties, Ferber began enclosing these violent, aggressive forms in "cages" or environments; these giant enlargements of the leaping, writhing, baroque forms on a superhuman scale seemed to encompass the viewer as the "environmental" canvases of Pollock, Newman, Still, and Rothko had done.

Although Archipenko, one of the leading Cubist sculptors, had resided in the United States since 1923, his presence had little influence on American sculpture. Similarly, the arrival of Gabo and Lipchitz as refugees during World War II did not spur sculpture to the degree that the painters-in-exile transformed painting. However, Richard Lippold's string constructions, such as *Primordial Figure* (*Ill. 11-21*), may have been inspired by Gabo's example; and Theodore Roszak,

who had been making geometric sculpture in a Constructivist vein, may have been influenced to work in bronze by Lipchitz' work. Reuben Nakian, on the other hand, seems to have developed independently of any European precedent. Roszak, in the fifties and sixties, developed a powerful imagery based mainly on insect or plant motifs, as in *Sea Sentinel* (*Ill. 11-22*). Nakian, like Ferber and Lipton, was more involved with the baroque fullness of Abstract Expressionism, and, like the painters, often tried to express the pathos of ancient tragedy in abstract works. In the fifties, Nakian used flat planes of curved metal mounted on an armature, although more recently he has used draped and billowing forms, as in *Olympia* (*Ill. 11-23*).

Sculptors who worked primarily in wood in the forties and fifties are Isamu Noguchi, Raoul Hague, Louise Nevelson, and Gabriel

11-24. ISAMU NOGUCHI, *Kouros*, 1944–45.

11-25. RAOUL HAGUE, *Walnut—1949*, 1949.

11-26. GABRIEL KOHN, *Acrotere,* 1960.

Kohn. Noguchi, an American of Japanese descent, has never relinquished a tie to natural forms. Like Calder, Noguchi has his roots deep within the French tradition. As Brancusi's assistant, he learned to love the purity of simple, closed forms and polished surfaces; his respect for materials may have come partly from his Japanese heritage. Adapting his forms from the organic shapes of the Surrealists, Noguchi purged them of much of their mythic content, using them instead as a point of departure for highly sophisticated and refined works, such as *Kouros* (*Ill. 11-24*).

Raoul Hague has used the technique of direct carving to produce

11-27. LOUISE NEVELSON, *Black Majesty*, 1955.

smooth, supple, monolithic forms of an impressive volume and robustness. While suggesting the human torso, the volumes are sufficiently generalized to remain convincing as abstract forms, as in *Walnut-1949* (*Ill. 11-25*). The most original wood sculptor in America, Gabriel

11-28. MARK DI SUVERO, *Hank Champion*, 1960.

11-29. JOHN CHAMBERLAIN, *Mr. Press*, 1961.

Kohn, has adapted the techniques of carpentry, joinery, and ship-building to the art of sculpture. The tension and drama of the clean, quasi-geometrical shape of Kohn's *Acrotere* (*Ill. 11-26*) reside entirely in the inventiveness of the single unified form. Kohn's rejection of the base has led him to devise ingenious ways of balancing the blocky volumes. These balances are achieved by a series of thrusts and counter-thrusts, engineered toward producing maximum grace and elegance. Kohn's natural wood surfaces provide a changing patchwork of light and dark, where various sections of wood have been laminated to-gether; but they are unified by being part of a continuous plane or a single pure curve.

Louise Nevelson's constructions are made up of compartments and boxes fitted together, sometimes in sections large enough to constitute an environment; they are painted a single color—usually black, white, or gold—in order to give them unity. In her earlier wooden pieces, such as *Black Majesty* (*Ill. 11-27*), Nevelson used simple, organic shapes, but in the boxes of the late fifties and sixties, found objects and more complex forms are incorporated. Unlike her earlier works, which were to be viewed as sculpture-in-the-round, the more recent compartments and "walls" are to be seen frontally like reliefs.

The sculptors who emerged along with the second generation of Abstract Expressionists were interested, like them, in the effect of isolating and freezing movement. Mark di Suvero's beams in *Hank Champion* (*Ill. 11-28*) are connected with Kline's imagery; Chamberlain's crushed automobile parts in *Mr. Press* (*Ill. 11-29*) are related to de Kooning's colliding waves of paint; and David Weinrib's organic forms are related to Gorky's formal vocabulary. George Sugarman's

11-30. GEORGE SUGARMAN,
The Shape of Change, 1964.

11-31. PETER AGOSTINI,
Christmas Package, 1963.

11-32. RICHARD STANKIEWICZ,
Kabuki Dancer, 1956.

11-33. LEE BONTECOU,
Untitled, 1962.

11-34. JOSEPH CORNELL, *Chocolat Menier,* 1950.

The Shape of Change (Ill. 11-30), in its winding and curving, brightly colored forms, appears to share Al Held's "hard-edge" repertoire of forms; whereas Peter Agostini's plaster casts of balloons, egg cartons, pillows, etc., such as *Christmas Package (Ill. 11-31)*, anticipate pop imagery. Following Nakian's precedent of casting the casual folds of material draped over an armature, Agostini recently has been casting simpler, more volumetric forms such as tires. In the late fifties, junk sculpture (sculpture made of assembled found objects) was popular with artists such as Jean Follett and Richard Stankiewicz, whose witty *Kabuki Dancer (Ill. 11-32)* divorces junk from its usual associations. Similarly, Lee Bontecou has made elegant abstract works, using laundry bags stretched and sewn over a wire armature *(Ill. 11-33)*.

In the fifties and sixties, "assemblage" has emerged as a distinctly American form of sculpture. Like Surrealist objects, a lineal descendant of collage, assemblage—the art of joining unlikely objects or images together in a single context—has as ancestors Duchamp's 1913 *Bicycle Wheel* and Picasso's 1914 *Absinthe Glass with Spoon.* Because it uses material from the environment and lends itself to eccentric experiments, assemblage seems especially suited to the American temperament. At least three Americans have made significant works of assemblage; they are Joseph Cornell, H. C. Westermann, and Edward Kienholz. As early as 1936, Julien Levy, the celebrated Surrealist dealer, called Cornell "one of the few Americans . . . who understands

11-35. EDWARD KIENHOLZ, *The Birthday*, 1964.

the Surrealist point of view." Like Schwitters, Cornell is able to distill poetry and drama from ordinary fragments. But Cornell is not attracted to "merz" or garbage but to precious fragments—crystal goblets, bits of sparkle, etc. His "boxes" are actually three-dimensional collages, star-maps of a private universe. In fact, astronomical imagery is important to Cornell's iconography. Like Surrealist objects, Cornell's boxes present irrational juxtapositions, as in *Chocolat Menier (Ill. 11-34)*, with its tattered labels and worn surfaces. His objects in their new context take on new meanings akin to poetic metaphor.

The brutal sensibility of Kienholz could not be more at odds with Cornell's gentleness. The creator of monstrous brothels and images of death and decay, Kienholz is, above all, the moralist who sees disorder and decadence in contemporary society. Like Bruce Conner and a number of other creators of assemblage, Kienholz reverts to the seamy Surrealism and sordidness of Magic Realists like Ivan Albright. In a sense, his revolting images like *The Birthday (Ill. 11-35)* are related to international Dada and Surrealism; but even more, they seem a specifically American reaction—a kind of negative puritanism and extreme form of local eccentricity—to the American scene. And in gen-

266

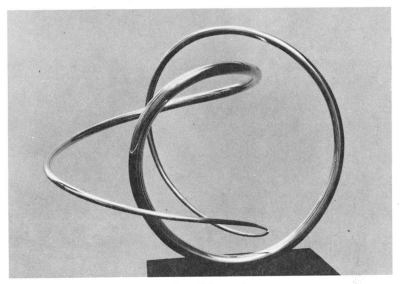

11-36. JOSÉ DE RIVERA, *Construction #85*, 1964.

eral, the recrudescence of Dada activity of the sixties may be attributed to the bizarreness and ironies of contemporary American experience.

The sixties was a decade of intense activity in sculpture. In the thirties and forties, according to Smith, many of the most promising American sculptors could not afford to build their planned works; however, Smith was able to overcome this difficulty and to transform his Bolton Landing studio into a fully equipped machine shop and

11-37. ROBERT MORRIS, *Untitled*, 1965.

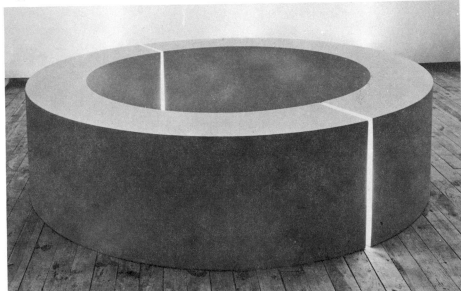

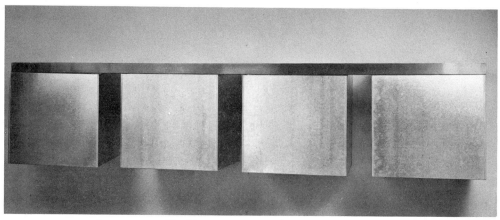

11-38. DON JUDD, *Untitled*, 1965.

factory for sculpture. This is the situation in which the most ambitious American sculptors would like to work today. For a number of years, artists like Ellsworth Kelly, Alexander Liberman, and José de Rivera had their pure, geometric conceptions industrially manufactured. The clean lines of works like Rivera's *Construction #85* (*Ill. 11-36*) were admired by a number of younger American sculptors dissatisfied with the tradition of open, welded sculpture as it was articulated by Picasso and Gonzalez and codified by Smith. These younger sculptors initially turned to elementary volumes, such as Robert Morris' untitled work (*Ill. 11-37*), and redundant three-dimensional reliefs like Don Judd's row of aluminum boxes (*Ill..11-38*). Like the images of the new abstraction, these minimal forms were meant to be seen as integral gestalts. Rather than organizing a series of parts related in the familiar way of form echoing analogous form, such blunt, clumsy structures, typical of the early sixties, eliminate parts in favor of the whole.

A number of artists, such as Judd, Morris, Ronald Bladen, and Larry Bell, began as painters and rejected painting on the ground that it lacked concreteness and actual presence. Their work often has less in common with traditional sculpture than with painting and architecture. Working mainly in industrial materials like sheet steel, aluminum, fiberglass, and molded plastics, these young sculptors brought new vitality and interest to sculpture, which for many years had been the stepchild of American art. Typical of such "primary structures," as minimal art was termed, are the mammoth plywood constructions of architect Tony Smith, which raised the possibility of the creation of a monumental sculpture based on volume rather than plane—the basis for Cubist-derived sculpture. Like Smith's, Judd's and Morris'

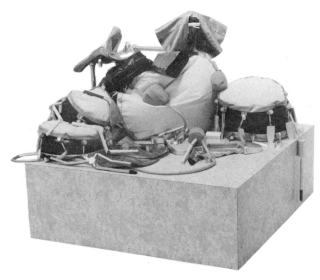

11-39. CLAES OLDENBURG,
Giant Soft Drum Set, 1967.

bulky structures, Claes Oldenburg's "soft" sculptures, made of stuffed and sewn canvas or vinyl, present a single image rather than a series of related parts. But unlike the makers of primary structures, who place primary emphasis on shape and pictorial color, Oldenburg remains interested in the traditional tactile values of sculpture. Of all the sculptors who emerged in the sixties, only Oldenburg invented a new formal vocabulary, based on a technical innovation that represented a significant departure from Cubist assemblage. Inspired by the giant stuffed props used in his theatrical Happenings, Oldenburg began in 1963 to sew cloth and, later, synthetic materials into limp, eccentric soft constructions that were the antithesis of the hard metals, sharp planes, and angular industrial construction of Cubist and Cubist-derived sculpture. In *Giant Soft Drum Set* (*Ill. 11-39*) and *Soft Picasso* (*Ill. 11-40*), an audacious if humorous challenge to the pioneer of Cubo-Constructivist sculpture, the artist emphasizes the provisional

11-40. CLAES OLDENBURG,
Soft Picasso, 1968.

269

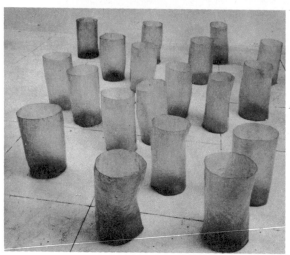

11-41. EVA HESSE, *Repetition 19, III*, 1968.

11-42. KEITH SONNIER,
Untitled, 1969.

nature of their explicitly mutable arrangements. Unlike Cubism's fixed metal assemblages, Oldenburg's loose, casual, drooping forms, like the human body for which they are obviously metaphors, are subject to the pull of gravity, and fall into varying configurations each time they are rearranged.

In the late sixties, Oldenburg's startling realization that sculpture need not necessarily be hard, planar, or geometric led many younger artists to revolt against the rigidity and deliberate, gestalt-oriented predictability of "minimal" sculpture. Eva Hesse (*Ill. 11-41*) and Keith Sonnier (*Ill. 11-42*) belonged to a group of young sculptors that included Alan Saret, John Duff, Robert Rohm, Lynda Benglis, and Richard Van Buren, who experimented with a variety of standing, leaning, and wall-mounted constructions that challenged the proclivity of minimal art toward bland, familiar, geometric volumes. Many such "anti-formal" or "post-minimal" works depend on chance and arbitrary arrangements, as opposed to the primary forms preconceived for manufacture by minimal artists. In their reaction against strictly delineated shape and formalized composition, post-minimal developments in sculpture may be seen as analogous to the free flow of liquid color in lyrical abstraction—signaling a similar reaction among sculptors against the hard-edge geometric style dominant in the art of the sixties. In their most extreme manifestations, anti-formal works simply

270

11-43. BARRY LE VA,
Untitled, 1967.

piled up or spread out, in more or less random ways, ephemeral materials with no claim to permanence.

Critics referred to a leading category of these ephemeral, mutable arrangements as "distributional" works. Among the first to scatter a variety of materials in a manner suggesting other potential arrangements of the same elements was Barry Le Va (*Ill. 11–43*). The idea that a work of art exists only when it is being exhibited, however, was initially the insight of Carl Andre, who specialized in illustrating the views on aesthetics of the eighteenth-century perceptual philosopher Bishop Berkeley. Using limestone bricks and other equally cheap and available industrial materials, Andre stacked modular units to create three-dimensional divisions of the spectator's space (*Ill. 11–44*). Such divisions were a literal, physical equivalent of Barnett Newman's divisions of the canvas into zones of color. They reveal the fundamentally pictorial derivation of post-minimal art—much of which looks like the contents of a late Pollock painting dumped out freely on the floor or strung up on the wall—floor and wall replacing canvas as background.

11-44. CARL ANDRE,
Exhibition April, 1966.

Because Andre's floor-hugging "carpets" were made of square plates of common metals obviously not attached to each other, the viewer in whose space such a visual event took place was highly conscious of the fugitive, provisional nature of the work of art. Emphasis on the ephemeral and the impermanent perhaps reflected the general feeling that, in the tense days of the late sixties, the unstable social fabric was held together only conditionally or arbitrarily. The most visually commanding formulation of provisional arrangement in sculpture was conceived by Richard Serra in his lead-plate pieces (*Ill. 11-45*). Made of a material that was visibly heavy, these constructions of flat or tubular rolled sheets of lead were implicitly dangerous, since their precarious balance, based on the principle of mutual support, as in a house of cards, suggested imminent collapse, adding an element of excitement to the notion of potentiality.

Serra's emphasis on the physicality of sculpture sets him apart from his more exclusively idea-oriented contemporaries. In his early "proc-

ess" pieces, for example, Serra recorded and exposed the manner in which he worked by including as part of the object the lead plates that had served as molds for molten wax and floor spatterings. From the first, his work had a drama and presence absent from the more cerebral and evanescent manifestations of post-minimal dematerialization (*Ill. 11–46*). As Serra matured as an artist, the two aspects of his sensibility—the conceptual and the physical—which had initially been combined in the highly influential process pieces, tended to be separately expressed in two types of work: theoretical video pieces and stable Constructivist steel-plate sculpture of monumental dimensions.

The polarization evident in Serra's work—on the one hand, toward the purely theoretical and conceptual, and, on the other, toward the monumental and the public—reflects the two major directions taken by sculptors generally in the late sixties and early seventies. A determination not to produce objects for a speculative art market persuaded a burgeoning group of younger artists to imitate Marcel Duchamp, *éminence grise* of the New York avant-garde well after his death in 1968, in emphasizing an intellectual idea over its embodiment in a physical object. The result of this reaction against the excesses of the marketplace, when art became merely another valuable exchange commodity, was a crescendo of Neo-Dada activity in performance and conceptual art. Among the most interesting artists to treat aesthetic concepts as more than disembodied ideas were Sol LeWitt and Dorothea Rockburne. LeWitt's walls, covered with a repeated graphic motif, literally unite art and environment. Rockburne's wall drawings have a similar effect, but are more complex conceptually, involving matching perceptions of similar phenomena in a manner that requires a synthesis of memory, spatial perception, and measurement. Using

11-47. DOROTHEA ROCKBURNE, *A, C, & D,* 1970.

similar but not identical shapes, Rockburne set up visual puzzles and puns that are both elegant and clever (*Ill. 11-47*).

Because of the expense involved in making, storing, and shipping sculpture, ephemeral works in cheap materials—which included paper and chalk, any kind of throw-away surplus, reprocessed natural fibers, scraps rejected by industry, and the cardboard, string, and wood of urban detritus—became increasingly popular around 1970, as the affluent society gave way to one of scarcity and shortage. Gone now, too, was the quality of permanence found in Rauschenberg's "combines," and Chamberlain's and Stankiewicz' junk assemblages that indicated a faith in the future. Replacing the junk vogue was an international art movement that took its name *arte povera* ("poor art") from a group of Italian artists who first popularized dematerialized ephemeral and conceptual works on the Continent.

Conceptual art, "process" and "performance" art, and *arte povera* have several things in common. All represent negative, often nihilistic, strategies for preventing art from becoming a mere commodity for speculation; all exist for the present moment alone; and all depend on the media and reproductive processes for international distribution of photographs and information. Like their mentor Marcel Duchamp, the best conceptual artists are involved in controversies that once occupied aestheticians and academicians; not surprisingly, many are employed by art schools where the reading of academic criticism has replaced the traditional training in craft technique.

Post-object art has taken one provocative and promising new direction, however, which involves a switch in focus from sculpture as an object to sculpture as an environment. Sculptural environments were initially explored by the Constructivists, especially by those with Dada connections like Kurt Schwitters and Frederick Kiesler, whose environments were shown in New York in the early sixties. Among the first New York School artists to become interested in environmental sculpture was Herbert Ferber, whose maquettes for architectural-scale environments are reminiscent of Giacometti's Surrealist interiors. Because Happenings relied heavily on sets and costumes, artists involved in such theatrical events frequently turned to environments when they exhibited in galleries. Allan Kaprow's *Apple Shrine* (1959) was among the earliest of these environments. Oldenburg's tacky cardboard cut-outs that make up *The Street* (1960) and three-dimensional objects assembled in *The Store* (1961) constitute examples of total environments. They differed from the post-object sculpture environments made in the late sixties and early seventies

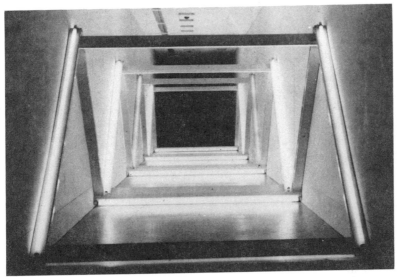

11-48. DAN FLAVIN, *Untitled*, 1969.

by such artists as Larry Bell, Robert Irwin, Don Judd, and Dan Flavin (*Ill. 11-48*), however, in that they reflect Kaprow's and Oldenburg's involvement with images and situations having psychologically charged associations. Current environmental art is, in the main, abstract and concerned with the psychology of perception itself.

How one sees—the spectator's awareness of his body in relation to spaces that have been altered, modified, or illuminated in some new way—rather than *what* one sees is the concern of an artist like Larry Bell in his mirrored glass environments, which reflect back shifting, partial images of the viewer (*Ill. 11-49*). New relationships between audience and object involving the viewer more intimately with the

11-49. LARRY BELL, *Untitled*, 1971.

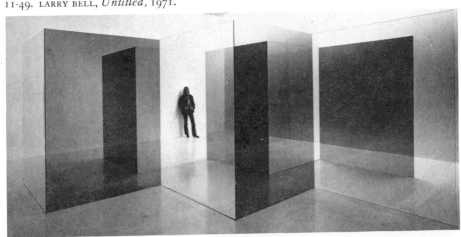

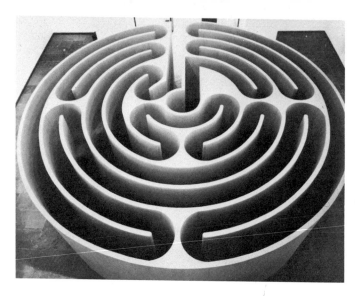

11-50. ROBERT MORRIS, *Labyrinth*, 1974.

art experience challenged the idea of art as a remote, static "work." Environments requiring intimate participation and dealing with the psychology of perception appealed to a younger generation of artists, including Bruce Nauman, Michael Asher, and Richard Serra, whose recent works surround the viewer in a room or open space, instead of acting as discrete objects around which the viewer must move. A protean performer, Robert Morris has experimented with conceptual, process, and participation pieces. His recent environmental *Labyrinth* traps the spectator-participant in a maze of painfully narrow corridors ending in *cul-de-sac* frustration analogous to the problematic social and political climate of the seventies (*Ill. 11–50*).

A pioneer of Happenings, Robert Whitman attempted a contemporary *Gesamtkunstwerk* as early as 1966. In *Pond* (*Ill. 11–51*) Whitman combined a series of concave Mylar mirrors, reflecting shimmering, distorted images of objects and people in the room, with projected words and images accompanied by wavering sounds. Co-direc-

11-51. ROBERT WHITMAN, *Pond*, 1968.

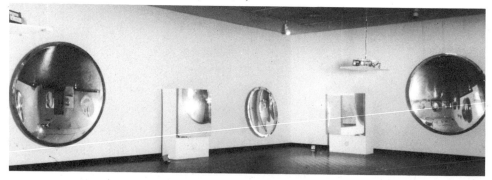

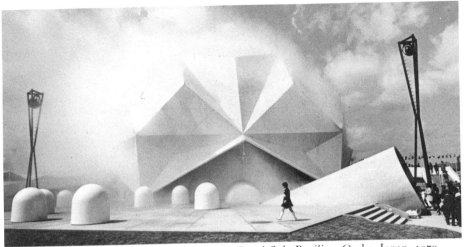

11-52. EXPERIMENTS IN ART AND TECHNOLOGY, *Pepsi-Cola Pavilion,* Osaka, Japan, 1970.

tor with physicist Billy Klüver of Experiments in Art and Technology (EAT), a collaboration of artists, scientists, and technicians experimenting in the use of advanced technology as an artistic medium, Whitman, along with Robert Breer and Forrest Myers, was responsible for the design of the Pepsi-Cola Pavilion erected in Osaka, Japan, for Expo '70 (*Ill. 11-52*). Myers' *Sun-Trak,* a sculpture designed to follow the path of the sun, was never completed. His frame of light encircling the cloud-capped building that housed a hemispherical mirrored dome, 90 feet in diameter, exemplified the interest of sculptors in using light as a means for articulating space. Kinetic artist Breer's life-size floats were electronically programed to move across the plaza outside and "converse" with spectators.

With the end of affluence came, if not a divorce, at least a temporary separation, between artists and industry. A final spectacular effort to marry art and technology, however, was a two-year project culminating in an exhibition in 1970-71 at the Los Angeles County Museum of Art. Representing the fruition of dreams of generations of artists to master technology, the exhibition included an artificial mud geyser by Robert Rauschenberg, a complex mirrored environment by Robert Whitman that projected real images into space, a sixteen-foot-high kinetic *Giant Icebag* by Claes Oldenburg (*Ill. 11-53*), a strobe environment by Boyd Mefferd, and a giant cardboard cave by Tony Smith.

Trained as an architect, Smith produced the most impressive minimal sculpture in the sixties. Some were finally realized on a scale big

277

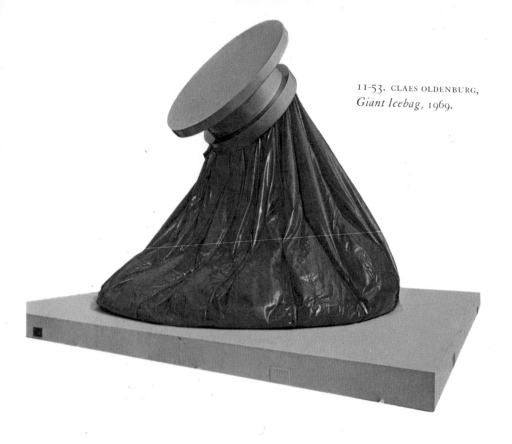

11-53. CLAES OLDENBURG, *Giant Icebag*, 1969.

11-54. TONY SMITH, *Gracehoper*, 1961.

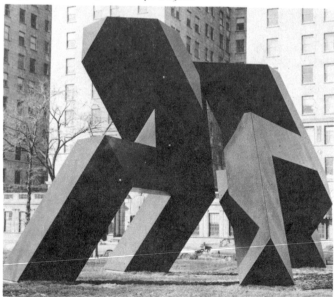

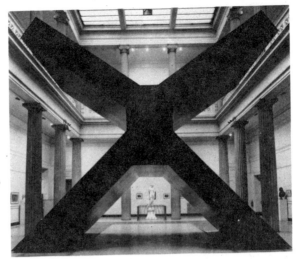

11-55. RONALD BLADEN, *The X*, 1967.

enough to vie with architecture for attention (*Ill. 11–54*). Often using a triangular module, Smith creates volumetric constructions that twist and turn in an abstract version of contrapposto. Huge size and geometric volumes are also employed by Ronald Bladen, whose *The X* (*Ill. 11–55*) resembles a colossal recollection of Vitruvian man, with arms and legs stretched in opposing directions.

Another artist who has recently begun working on a large scale, Alexander Liberman permits the spectator to walk inside of as well as around his forty-foot-high tubular environments like *In* (*Ill. 11–56*). The powerful thrusts and counterthrusts of his gigantic sculptures compete successfully with the industrial environment in terms of sheer drama and spectator involvement.

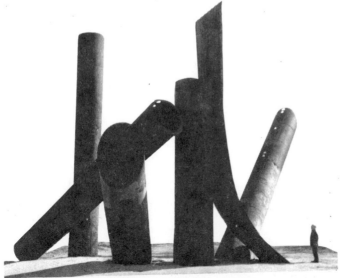

11-56. ALEXANDER LIBERMAN, *In*, 1973.

279

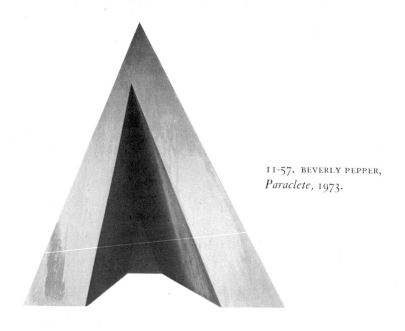

At present, sculpture in environments, especially public environments, is the most exciting challenge to American sculptors. Tony Smith, Claes Oldenburg, Louise Nevelson, Alexander Calder, and Beverly Pepper have all produced large-scale public works (*Ill. 11–57*). Yet the artist best equipped at this point to produce such works— Mark di Suvero—left America as a protest against the Vietnam war, developing his mature style in Germany, Holland, and France, where local industry cooperated in the production of such bold monumental works as *Ik Ook* (*Ill. 11–58*). One of the last pieces executed by di Suvero before his departure for Europe, *For Robling* (*Ill. 11-59*), typifies his increasing involvement with the jointed cores from which the "limbs" of his constructions spread and reach. Like Oldenburg, di Suvero was propelled to work on a new and larger scale by a political situation demanding symbols of protest. Beginning with the 1967 Los Angeles Peace Tower, which was based on a tetrahedron module that supported a forty-foot-high structure, di Suvero began to work on large, outdoor pieces. In the early seventies, di Suvero developed concepts he had been exploring since his involvement with the experimental Park Place group of sculptors in the early sixties. Replacing the rope and wood of his early constructions with steel beams and cables, he has lent another dimension of complexity to his sculpture in the form of kinetic elements like the horizontal swing that dramatically embraces *Ik Ook*. Movement, per se, however, is not central

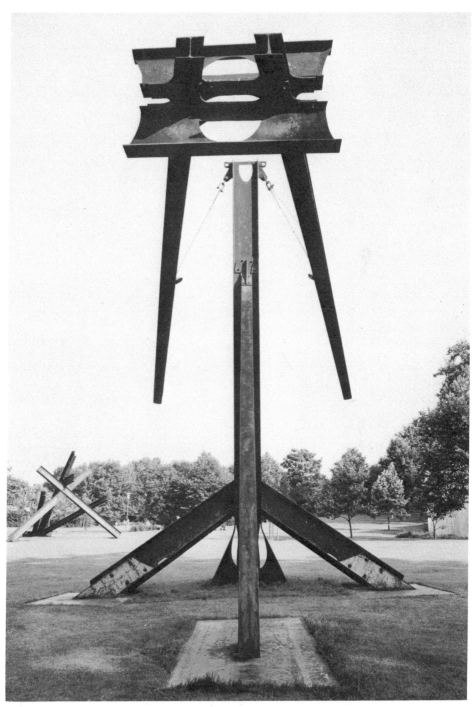

11-58. MARK DI SUVERO, *Ik Ook*, 1971–72.

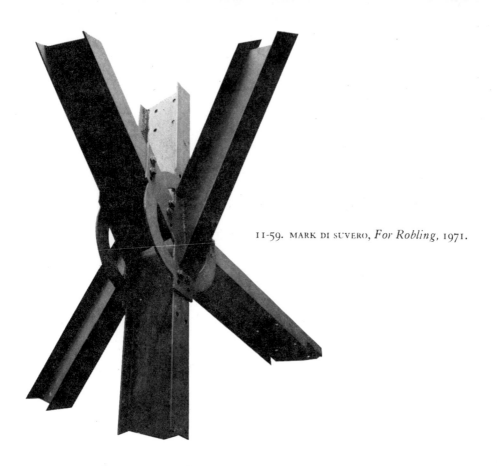

11-59. MARK DI SUVERO, *For Robling,* 1971.

to di Suvero's aesthetic as it is to that of exclusively kinetic artists like Len Lye and George Rickey. Lye, also known for his experimental films, often adds sound to electronic movement; Rickey, on the other hand, like di Suvero, uses the natural force of wind to gently sway his pieces, since most are designed to be placed outdoors.

The emergence of outdoor public environmental sculpture as a major development in recent American art is another reflection of the artist's desire to leave behind the artificial context of the museum and the limitations of the precious object. This wish to communicate with a larger public was an important part of a similar impulse behind pop art in the sixties; in the seventies, it has been a principal motivation for an increase in sculptural scale, ultimately leading some artists to work directly with the landscape itself. "Earthworks" is the term used by critics to describe the marks and forms made directly in, on, and with nature by artists like Michael Heizer, Dennis Oppen-

heim, and the late Robert Smithson, killed at the age of thirty-five in a plane crash while executing *Asphalt Slide* in a remote region of Mexico. Although most earthworks remain projects on paper, Smithson successfully changed the landscape of Utah with his *Spiral Jetty*, an artificially created extension of the shoreline of the Great Salt Lake in the familiar form of an archaic spiral (*Ill. 11-60*).

Earthworks like *Spiral Jetty* and *Asphalt Slide* indicate new directions artists are taking, bringing their art into the open, changing the environment itself. In some major cities like New York and Los Angeles, artists are painting walls with geometric and pop images that brighten the urban landscape. A number of artists, including Will Insley, Peter Pinchbeck, Tony Smith, David von Schlegell, Kenneth Snelson, Lucas Samaras, Sylvia Stone, Isamu Noguchi, and Herbert Ferber, are thinking along visionary lines for projects for total environments. A shift from private to corporate and state patronage of public art is creating new possibilities for a favored small group of painters and sculptors who extend the traditional forms and techniques into areas where painting, sculpture, and architecture are combined in public environments.

The democratization of art has created strange hybrids. The U.S. mails have been enlisted by artists like Neo-Dadaist Ray Johnson to

11-60. ROBERT C. SMITHSON, *Spiral Jetty,* 1970.

carry messages around the world; "body art" conceptualists like Chris Burden hold audiences spellbound with the suspense of masochistic performances that involve being shot at or otherwise endangered in acts calculated to attract the attention of a public that now seems shock-proof, but still eager for sensation.

As the decade progresses in a problematic climate of political and economic crisis, the arts endure, and their range has never been greater. No single style prevails, although each has its detractors and defenders. Mainstream modernism, which traces its lineage back to Picasso and Matisse, still flourishes, but its hegemony is constantly challenged by artists anxious to catapult into the future of mass media arts, earthworks, and participatory art. The feminist movement and black, Chicano, and Puerto Rican artists are beginning to inject healthy, fresh energy into the bloodstream of American art, as previously culturally disfranchised groups begin to make their contribution. The moment is one of great potential; it remains to be seen how it will be fulfilled.

Notes

CHAPTER ONE

[1] As quoted in Lloyd Goodrich, *Thomas Eakins, His Life and Work* (New York: Whitney Museum of American Art, 1933), p. 139.

[2] Everett Shinn, "Recollections of The Eight," in *The Eight* (Brooklyn: Brooklyn Institute of Arts and Sciences, 1943), p. 11. Catalogue of the Brooklyn Museum exhibition, November 24, 1943–January 16, 1944.

[3] Robert Henri, *The Art Spirit*, comp. Margery A. Reyerson (Philadelphia: J. B. Lippincott, 1960), p. 71.

[4] John Sloan, *Gist of Art* (New York: American Artists Group, 1939), p. 38.

CHAPTER TWO

[1] Alfred Stieglitz, "Six Happenings," *Twice a Year*, Nos. 14–15 (1946–47), p. 117.

[2] Oscar Bluemner, "What Is 291?" *Camera Work*, No. 47 (July, 1914), p. 53.

[3] Max Weber, "Chinese Dolls and Modern Colorists," *Camera Work*, No. 31 (July, 1910), p. 51.

[4] *Ibid.*

[5] Georgia O'Keeffe, Catalogue statement for an exhibition at the Anderson Gallery, January, 1923; quoted in Daniel Catton Rich, *Georgia O'Keeffe* (Chicago: Art Institute of Chicago, 1943), p. 22.

[6] Marsden Hartley, "Art—and the Personal Life," *Creative Art*, II (June, 1928), xxxii.

[7] Arthur Dove, as quoted in Frederick S. Wight, *Arthur G. Dove* (Berkeley: University of California Press, 1958), p. 37.

[8] *Ibid.*, p. 64.

[9] Elizabeth McCausland, *Alfred Maurer* (New York: Buchholz Gallery, 1943).

CHAPTER THREE

[1] Walt Kuhn, in a letter to his wife, December 12, 1911, published in *Art in America*, LIII, No. 4 (August–September, 1965), 71.

[2] As quoted in Milton Brown, *The Story of the Armory Show* (New York: Joseph H. Hirshhorn Foundation, 1963), p. 39.

[3] Walt Kuhn, as quoted in Brown, *ibid.*, p. 56.

[4] As quoted in Brown, *ibid.*, p. 26.

[5] Frank J. Mather, Jr., "Newest Tendencies in Art," *The Independent*, LXXIV (March, 1913), 512.

[6] Jerome Myers, *An Artist in Manhattan* (New York: American Artists Group, 1940), p. 37.

[7] *Ibid.*, p. 36.

[8] Quoted in Brown, *op. cit.*, p. 63.

[9] Milton Brown, *American Painting from the Armory Show to the Depression* (Princeton, N.J.: Princeton University Press, 1955), p. 52.

[10] Ben Benn, in the catalogue of the Forum Exhibition (New York: Hugh Kennerly, 1916), explanatory notes.

[11] W. H. de B. Nelson, in *ibid.*, p. 34.

CHAPTER FOUR

[1] Henry McBride, "A Hero Worshipped," *The Dial*, LXIX (July–December, 1920), 91.

[2] Andrew Dasburg, "Cubism—Its Rise and Influence," *The Arts*, IV (November, 1923), 280.

[3] Lee Simonson, "No Embargos," *Creative Art*, VIII (April, 1931), 255.

[4] *Ibid.*

[5] As quoted in William C. Agee, *Synchromism and Color Principles in American Painting* (New York: M. Knoedler & Co., Inc., 1965), p. 19.

[6] *Ibid.*, p. 36.

[7] *Ibid.*

[8] Henri Pierre Roché, statement on Patrick Henry Bruce, in the Catalogue of the Société Anonyme (New Haven, Conn.: Yale University Art Gallery, 1950), p. 144.

[9] *Ibid.*, p. 143.

[10] Charles Burchfield, "On the Middle Border," *Creative Art*, III (September, 1928), xxix.

[11] Charles Sheeler, as quoted in Lillian Dochterman, *The Quest of Charles Sheeler* (Iowa City: State University of Iowa Press, 1963), p. 11.

[12] Joseph Stella, "The Brooklyn Bridge (A Page of My Life)," *transition*, Nos. 16–17 (June, 1929), p. 87.

[13] Sheeler, as quoted in Dochterman, *op. cit.*, p. 13.

[14] Christian Brinton, *Modern Art at the Sesqui-Centennial Exhibition* (New York: Société Anonyme, 1926), unpaginated.

CHAPTER FIVE

[1] Sloan, *op. cit.*, p. 3.

[2] Arthur Dove, as quoted in Frederick S. Wight, *Arthur G. Dove*, p. 62.

[3] Stuart Davis, as quoted in H. H. Arnason, *Stuart Davis* (Washington, D.C.: National Collection of Fine Arts, 1965), p. 42.

[4] As quoted in Thomas Craven, *Thomas Hart Benton* (New York: Associated American Artists, 1939), p. 11.

[5] Thomas Hart Benton, *An Artist in America* (New York: Robert M. McBride & Co., 1937), p. 48.

[6] *Ibid.*, p. 319.

[7] Edward Hopper, "Charles Burchfield, American," *The Arts*, XIV (July, 1928), 7.

[8] Lewis Mumford, as quoted in Oliver Larkin, *Art and Life in America* (New York: Holt, Rinehart and Winston, 1964), p. 430.

[9] Peter Blume, in *Painters on Painting*, ed. Eric Protter (New York: Grossett & Dunlap, 1963), p. 244.

[10] George L. K. Morris, "Art Chronicle," *Partisan Review* (1943).

[11] Stuart Davis, as quoted in E. C. Goossen, *Stuart Davis* (New York: George Braziller, 1959), p. 13.

[12] *Ibid.*, p. 11.

[13] As quoted in J. J. Sweeney, *Stuart Davis* (New York: Museum of Modern Art, 1945), p. 16.

[14] As quoted in Goossen, *op. cit.*, p. 28.

[15] Stuart Davis, statement on his painting *The Paris Bit*, in Lloyd Goodrich, "Rebirth of a National Collection," *Art in America*, LIII, No. 3 (June, 1965), 89.

[16] Arshile Gorky, "Stuart Davis," *Creative Art*, IX (September, 1931), 213.

[17] *Ibid.*

[18] Clement Greenberg, "The Late Thirties in New York," in *Art and Culture* (Boston: Beacon Press, 1961), p. 232.

[19] William Seitz, *Hans Hofmann* (New York: Museum of Modern Art, 1963), p. 56.

[20] *Ibid.*, p. 39.

[21] Reported by Gorky's wife in a letter to Patricia Passloff, in *The 30's: Painting in New York* (New York: Poindexter Gallery, 1957).

CHAPTER SIX

[1] Peggy Guggenheim, *Confessions of an Art Addict* (New York: The Macmillan Co., 1960), p. 101.

[2] Peggy Guggenheim, introduction to *The Peggy Guggenheim Collection* (London: British Arts Council, 1964), p. 10. Exhibition at the Tate Gallery, December 31, 1964–March 7, 1965.

[3] André Breton, broadside for Gorky's exhibition at the Julien Levy Gallery, 1945. Museum of Modern Art Archives.

[4] Meyer Schapiro, "Gorky: The Creative Influence," *Art News,* September, 1957, p. 29.

[5] Julien Levy, foreword to William Seitz, *Arshile Gorky* (New York: Museum of Modern Art, 1962), p. 8.

[6] Seitz, *op. cit.,* p. 30.

[7] This discussion of Pollock's space and drawing is based on Michael Fried, *Three American Painters* (Cambridge, Mass.: Fogg Art Museum, 1965), pp. 10–23.

[8] Robert Motherwell, "The Modern Painter's World," *Dyn* (1944), p. 13.

CHAPTER SEVEN

[1] Barnett Newman, statement in the catalogue of the VIII São Paulo Biennial (Washington, D.C.: National Collection of Fine Arts, 1966), p. 9.

[2] The nature and chronology of this issue are discussed by Rubin in "Jackson Pollock and the Modern Tradition," *Artforum,* February–May, 1967. Article in four parts.

[3] Mark Rothko and Adolph Gottlieb, letter to *The New York Times,* June 13, 1943, Sec. 2, p. 9.

CHAPTER EIGHT

[1] Allan Kaprow, "The Legacy of Jackson Pollock," *Art News,* October, 1958, p. 24.

CHAPTER NINE

[1] As quoted in Bruce Glaser, "Questions to Stella and Judd," *Art News,* September, 1966, p. 55.

[2] Early manifestations of the literalist sensibility in American art include *trompe l'oeil* still life by John Peto, William Harnett, and John Haberle, among others. See Alfred Frankenstein, *The Reality of Appearance* (New York: Whitney Museum of American Art, 1972). A discussion of literalism in the sixties is included in my catalogue *A New Aesthetic* (Washington, D.C.: Washington Gallery of Modern Art, 1967).

[3] Clement Greenberg, "Modernist Painting," in *The New Art,* ed. Gregory Battcock (New York: E. P. Dutton, 1965), p. 103.

[4] Morris Louis was introduced to acrylic paint by his friend the paint chemist Leonard Bocour, who gave samples of Magna, the plastic paint he developed, to many artist friends, including Kenneth Noland and Friedl Dzubas.

[5] Amédée Ozenfant, *Foundations of Modern Art* (London: John Rodker, 1931). (First published in French under the title *Art,* in 1928.)

[6] Yale students commissioned Oldenburg to erect the first of his series of monuments, which previously existed only in drawings, because of a statement made by Herbert Marcuse to the effect that if a monument by Oldenburg could actually be erected, then people could no longer take seriously anything the government did. The absurdist, satiric aspect of Oldenburg's proposals for monuments, and their intent to expose the inflated rhetoric of contemporary politics, are discussed in my monograph *Claes Oldenburg* (New York: Museum of Modern Art, 1969).

[7] Untitled article in Dick Higgins, ed., *Manifestos* (New York: Something Else Press, 1966), p. 21.

CHAPTER TEN

[1] In Walter Benjamin; *Illuminations: Essays and Reflections,* ed. Hannah Arendt, tr. by Harry Zohn (New York: Harcourt Brace Jovanovich, 1968).

[2] Jules Olitski, statement in the exhibition catalogue of the 1966 Venice Biennale, p. 39.

[3] Several exhibitions of Russian Constructivism toured America in the late sixties and early seventies. The publication of Camilla Gray's *The Great Experiment: Russian Art, 1863–1922* in 1962 touched off the same kind of curiosity regarding Russian avant-garde art among minimal artists as did Robert Motherwell's 1951 anthology, *The Dada Painters and Poets,* among pop, Happenings, and environmental artists. The translation of Kasimir Malevich's essays into English and his retrospective at the Guggenheim Museum in 1974 augmented American involvement with Russian Constructivism. A radical political climate intensified American interest in utopian, visionary art of all kinds, including the projects of the French "visionary" artists Claude Ledoux and Etienne Boullée.

[4] See Rosalind Krauss, "On Frontality," *Artforum,* May, 1968, pp. 40–46.

[5] See Michael Fried, "Jules Olitski's New Paintings," *Artforum,* November, 1965, pp. 36–40. See also Kenworth Moffet, *Jules Olitski* (Boston: Museum of Fine Arts, 1973). Why Olitski's overtly hedonistic abstractions should call forth quotes from the Puritan preacher is a subject for discussion.

[6] Maurice Denis, *Art et critique,* in *Maurice Denis, theories: du symbolisme au classicisme,* ed. P. Revault d'Allones (Paris: Hermann, 1964), p. 33. (First published July 23 and July 30, 1890.)

CHAPTER ELEVEN

[1] David Smith, "Notes on My Work," *Arts,* XXXIV (February, 1960), p. 44.

[2] David Smith, "The Secret Letter," an interview by Thomas B. Hess in *David Smith* (New York: Marlborough-Gerson Gallery, 1964), unpaginated.

[3] *Ibid.*

[4] Hilton Kramer, *David Smith* (Los Angeles, Calif.: Los Angeles County Museum of Art, 1966), p. 4.

[5] As quoted in Sam Hunter, *Modern American Painting and Sculpture* (New York: Dell Publishing Co., 1959), p. 178.

Bibliography

Those works cited in the Chapter Notes are not included in the Bibliography.

GENERAL

Art in America, LIII, No. 4 (August–September, 1965). Archives of American Art issue
GELDZAHLER, HENRY. *American Painting in the Twentieth Century*. New York: Metropolitan Museum of Art, 1965.
HUNTER, SAM. *American Art of the Twentieth Century*. New York: Harry N. Abrams, 1973.
HUNTER, SAM. *Modern American Painting and Sculpture*. New York: Dell Publishing Co., 1959.
LARKIN, OLIVER W. *Art and Life in America*. Rev. ed. New York: Holt, Rinehart and Winston, 1964.
McCAUSLAND, ELIZABETH. "A Selected Bibliography on American Painting and Sculpture," in *Who's Who in American Art*, IV, 611–53. Washington, D.C.: American Federation of Arts, 1947. Originally appeared in the *Magazine of Art*, XXXIX (November, 1946), 329–49.

CHAPTER ONE

GLACKENS, IRA. *William Glackens and the Ashcan Group*. New York: Grosset & Dunlap, 1957.
New York Realists, 1900–1914. New York: Whitney Museum of American Art, 1937.
PERLMAN, BENNARD P. *The Immortal Eight: American Painting from Eakins to the Armory Show*. New York: Exposition Press, 1962.

CHAPTER TWO

Camera Work, 1902–17.
McCAUSLAND, ELIZABETH. *Marsden Hartley*. Minneapolis, Minn.: University of Minnesota Press, 1952.
MELLQUIST, JEROME. *The Emergence of an American Art*. New York: Scribner's, 1942.
ROSENFELD, PAUL. *Port of New York: Essays on Fourteen American Moderns*. New York: Harcourt, Brace, 1924.
291. Ed. Alfred Stieglitz. Nos. 1–12 (1915–16).
WILLIAMS, W. C., PHILLIPS, D., and NORMAN, D. *John Marin*. Los Angeles, Calif.: University of California Press, 1955.

CHAPTER THREE

Catalogue of the Forum Exhibition, Anderson Galleries. New York: Hugh Kennerly, 1916.
Collection of the Société Anonyme. New Haven, Conn.: Yale University Art Gallery, 1950.
SCHAPIRO, MEYER. "Rebellion in Art," in *America in Crisis*. Ed. Daniel Aaron. New York: Alfred A. Knopf, 1952.
WRIGHT, WILLARD H. "The Aesthetic Struggle in America," *Forum*, LV (January–June, 1916).

CHAPTER FOUR

BAUR, JOHN I. H. "The Machine and the Subconscious: Dada in America," *Magazine of Art*, XLIV (October, 1951).
BREESKIN, ADELYN. *Roots of Abstract in America, 1910–1950*. Washington, D.C.: National Collection of Fine Arts, 1965.

Friedman, Martin. *The Precisionist View in American Art*. Minneapolis, Minn.: Walker Art Center, 1960.
Ritchie, Andrew C. *Abstract Painting and Sculpture in America*. New York: Museum of Modern Art, 1951.

CHAPTER FIVE

American Abstract Artists. Annual Exhibition Catalogue and checklist from 1937.
Greenberg, Clement. "New York Painting Only Yesterday," *Art News*, Summer, 1957.
Kootz, Samuel. *Modern American Painters*. New York: Brewer and Warren, 1930.
Miller, Dorothy C. (ed.). *American Realists and Magic Realists*. New York: Museum of Modern Art, 1943.
O'Connor, Francis V. *Art for the Millions: Essays from the 1930's by Artists and Administrators of the WPA Federal Art Project*. Greenwich, Conn.: New York Graphic, 1973.
————. *Federal Art Patronage, 1933–43*. College Park, Md.: University of Maryland Press, 1966.
————. *The New Deal Art Projects: An Anthology of Memoirs*. Washington, D.C.: Smithsonian Institution Press, 1972.
Schapiro, Meyer. "Populist Realism," *Partisan Review*, IV (December, 1937–May, 1938). Review of Thomas Hart Benton autobiography.

CHAPTER SIX

Janis, Sidney. *Abstract and Surrealist Art in America*. New York: Reynal & Hitchcock, 1944.
Rubin, William. "Arshile Gorky, Surrealism and the New American Painting," *Art International*, VII, No. 2 (February 25, 1963).
————. *Jackson Pollock and the Modern Tradition*. New York: Harry N. Abrams, 1967.
Tiger's Eye, Nos. 1–9 (1947–49). Eds. R. and J. Stephan.

CHAPTER SEVEN

Arnason, H. H. *Abstract Expressionists and Imagists*. New York: Solomon R. Guggenheim Museum, 1961.
Artforum, Summer, 1965. A special issue on Abstract Expressionism.
Clyfford Still, Paintings in the Albright-Knox Art Gallery. Buffalo, N.Y.: Buffalo Fine Arts Academy, 1966.
Goossen, E. C. "The Big Canvas," *Art International*, II, No. 8 (November, 1958).
Hess, Thomas B. *Abstract Painting: Background and American Phase*. New York: Viking Press, 1951.
————. *Barnett Newman*. New York: Museum of Modern Art, 1971.
————. *Willem de Kooning*. New York: Museum of Modern Art, 1968.
Motherwell, Robert, and Reinhardt, Ad (eds.). *Modern Artists in America*. First Series. New York: Wittenborn, Schultz, 1951.
The New American Painting. New York: Museum of Modern Art, 1959.
New York School. Los Angeles, Calif.: Los Angeles County Museum, 1965.
O'Hara, Frank. *Robert Motherwell*. With selections from the artist's writings. New York: Museum of Modern Art, 1966.
Rosenblum, Robert. "Abstract Sublime," *Art News*, February, 1961.
Sandler, Irving. *The Triumph of American Painting: A History of Abstract Expressionism*. New York: Praeger, 1970.
Schapiro, Meyer. "The Liberating Quality of Abstract Art," *Art News*, Summer, 1957.
Tuchman, Maurice. *The New York School: Abstract Expressionism in the Forties and Fifties*. London: Thames and Hudson, 1969.

CHAPTER EIGHT

Alloway, Lawrence. *Systemic Painting*. New York: Solomon R. Guggenheim Museum, 1966.
Exhibition catalogues, Venice and São Paulo biennials.
Greenberg, Clement. "After Abstract Expressionism," *Art International*, VI, No. 8 (October 25, 1962).
————. "Louis and Noland," *Art International*, IV, No. 4 (May 25, 1960).
————. "Post Painterly Abstraction," *Art International*, VIII, Nos. 5–6 (Summer, 1964).

KIRBY, MICHAEL. *Happenings*. New York: E. P. Dutton, 1965.

LIPPARD, LUCY R. *Pop Art*. New York: Frederick A. Praeger, 1966.

New Abstraction, Das Kunstwerk, XVIII, Nos. 10–12 (April–June, 1965).

RUBIN, WILLIAM. "Younger American Painters," *Art International*, IV, No. 1 (January, 1960).

SEITZ, WILLIAM C. *The Responsive Eye*. New York: Museum of Modern Art, 1964.

STEINBERG, LEO. *Jasper Johns*. New York: George Wittenborn, 1963.

TILLIM, SIDNEY. "The New Avant-Garde," *Arts*, XXXVIII (February, 1964).

CHAPTER NINE

ALLOWAY, LAWRENCE. *The Shaped Canvas*. New York: Solomon R. Guggenheim Museum, 1964.

———. "Sign and Surface: Notes on Black and White Paintings in New York," *Quadrum*, No. 9 (1960).

BANNARD, WALTER D. "Notes on American Painting of the Sixties," *Artforum*, January, 1970.

BATTCOCK, GREGORY (ed.). *Minimal Art: A Critical Anthology*. New York: E. P. Dutton, 1968.

——— (ed.). *The New Art: A Critical Anthology*. New York: E. P. Dutton, 1966.

CARMEAU, E. A. *The Great Decade of American Abstraction*. Houston, Tex.: Houston Museum of Fine Arts, 1974.

CONE, JANE HARRISON. *Walter Darby Bannard*. Baltimore, Md.: Walters Art Gallery, 1974.

COPLANS, JOHN. *Andy Warhol*. Greenwich, Conn.: New York Graphic, 1970.

———. *Ellsworth Kelly*. New York: Harry N. Abrams, 1972.

———. *Serial Images*. Pasadena, Calif.: Pasadena Art Museum, 1968.

CRONE, RAINER. *Andy Warhol*. New York: Praeger, 1970.

FRIED, MICHAEL. "Art and Objecthood," *Artforum*, June, 1967.

———. *Morris Louis*. New York: Harry N. Abrams, 1970.

———. *Three American Painters: Kenneth Noland, Jules Olitski, Frank Stella*. Cambridge, Mass.: Fogg Art Museum, 1963.

GELDZAHLER, HENRY. *New York Painting and Sculpture: 1940–1970*. New York: E. P. Dutton, in association with the Metropolitan Museum of Art, 1969.

JUDD, DON. "Black, White and Gray," *Arts Magazine*, XXXVIII (March, 1964).

———. "Specific Objects," *Contemporary Sculpture, Arts Yearbook*, No. 8 (1965).

KOZLOFF, MAX (ed.). Jasper Johns. New York: Harry N. Abrams, 1968.

LIPPARD, LUCY R. *Changing: Essays in Art Criticism*. New York: E. P. Dutton, 1971.

MURDOCK, ROBERT M. *Modular Painting*. Buffalo, N.Y.: Albright-Knox Art Gallery, 1970.

NODELMAN, SHELDON. "Sixties Art: Some Philosophical Perspectives," *Perspecta 11: Yale Architectural Journal*, 1967.

ROSE, BARBARA. "The Graphic Work of Jasper Johns," *Artforum*, March and September, 1970.

———. "Pop Art in Perspective," *Encounter*, September, 1963.

———. *The Vincent Melzac Collection*. Washington, D.C.: Corcoran Gallery of Art, 1972. Washington School of Color Painters.

RUBIN, WILLIAM S. *Frank Stella*. New York: Museum of Modern Art, 1970.

RUSSELL, JOHN, and GABLIK, SUZI. *Pop Art Redefined*. New York: Praeger, 1969.

WOLLHEIM, RICHARD. "Minimal Art," *Arts Magazine*, XXXIX (January, 1965).

CHAPTER TEN

BATTCOCK, GREGORY (ed.). *Idea Art: A Critique*. New York: E. P. Dutton, 1973. Essays on conceptual art, body art, earthworks.

——— (ed.). *Minimal Art: A Critical Anthology*. New York: E. P. Dutton, 1968.

BURNHAM, JACK. "Alice's Head: Reflections on Conceptual Art," *Artforum*, February, 1970.

CELANT, GERMANO. *Art Povera*. New York: Praeger, 1969.

———. *Photo-Realism*. Hartford, Conn.: Wadsworth Atheneum, 1974.

DAVIS, DOUGLAS. *Art and the Future: A History/Prophecy of the Collaboration Between Science, Technology and Art*. New York: Praeger, 1973.

KAPROW, ALLAN. *Assemblage, Environments and Happenings*. New York: Harry N. Abrams, 1966.

KLÜVER, BILLY, and ROSE, BARBARA (eds.). *Pavilion: Experiments in Art and Technology.* New York: E. P. Dutton, 1973.

LeWITT, SOL. "Paragraphs on Conceptual Art," *Artforum*, June, 1967.

LIPPARD, LUCY. *Six Years: The Dematerialization of the Art Object.* New York: Praeger, 1973.

McSHINE, KYNASTON. *Information.* New York: Museum of Modern Art, 1970.

MEYER, URSULA. *Conceptual Art.* New York: E. P. Dutton, 1973.

SMITH, BRYDON. *Fluorescent Light, Etc., from Dan Flavin.* Ottawa: National Gallery of Canada, 1969.

SMITHSON, ROBERT. "Entropy and the New Monuments," *Artforum*, June, 1966.

TUCHMAN, MAURICE. *Art and Technology.* New York: Viking Press, 1971.

TUCKER, MARCIA, and MONTE, JAMES. *Anti-Illusion: Procedures/Materials.* New York: Whitney Museum of American Art, 1969.

CHAPTER ELEVEN

AGEE, WILLIAM C. *Don Judd.* New York: Whitney Museum of American Art, 1968.

Artforum, Summer, 1967. A special issue on American sculpture.

BOCHNER, MEL. "Primary Structures," *Arts Magazine*, XL (June, 1966).

BURNHAM, JACK. *Beyond Modern Sculpture: The Effects of Science and Technology on the Sculpture of This Century.* New York: George Braziller, 1968.

Catalogues of the Whitney Annual. (Sculpture and painting in alternate years.)

CONE, JANE HARRISON. *David Smith.* Cambridge, Mass.: Fogg Art Museum, 1965.

Contemporary Sculpture. Introduction by William C. Seitz. *Arts Yearbook*, No. 8 (1965).

COPLANS, JOHN. *Don Judd.* Pasadena, Calif.: Pasadena Art Museum, 1971.

Fourteen Sculptors: The Industrial Edge. Minneapolis, Minn.: Walker Art Center, 1969. Essays by Barbara Rose, Christopher Finch and Martin Friedman.

FRY, EDWARD F. *David Smith.* New York: Solomon R. Guggenheim Museum, 1969.

GOODALL, DONALD. "Gaston Lachaise, 1882–1935," *Massachusetts Review*, Summer, 1960.

GREENBERG, CLEMENT. "Cross-Breeding of Modern Sculpture," *Art News*, Summer, 1952.

GRIFFEN, HOWARD. "Auriga, Andromeda, Camelopardis," *Art News*, December, 1957. On Joseph Cornell.

HUDSON, ANDREW. "Scale as Content," *Artforum*, December, 1967.

"The Ides of Art: 14 Sculptors Write," *Tiger's Eye*, No. 4 (June, 1948).

JOHNSON, ELLEN. *Claes Oldenburg.* London: Penguin, 1971.

KOZLOFF, MAX. "Further Adventures of American Sculpture," *Arts Magazine*, XXXIX (February, 1965).

———. "Mark di Suvero," *Artforum*, Summer, 1967.

KRAUSS, ROSALIND. *Terminal Ironworks: The Sculpture of David Smith.* Cambridge, Mass.: MIT Press, 1971.

LICHT, JENNIFER. *Spaces.* New York: Museum of Modern Art, 1969.

LIPPARD, LUCY R. *Minimal Art.* The Hague: Gemeentemuseum, 1968.

LIVINGSTON, JANE, and TUCKER, MARCIA. *Bruce Nauman.* New York: Whitney Museum of American Art, 1973.

McSHINE, KYNASTON. *Primary Structures.* New York: Jewish Museum, 1966.

MICHELSON, ANNETTE. *Robert Morris.* Washington, D.C.: Corcoran Gallery of Art, 1969.

O'HARA, FRANK. *Nakian.* New York: Museum of Modern Art, 1966.

ROSE, BARBARA. *Claes Oldenburg.* New York: Museum of Modern Art, 1970.

Sculpture in America Today. Los Angeles, Calif.: Los Angeles County Museum, 1967.

SEITZ, WILLIAM C. *The Art of Assemblage.* New York: Museum of Modern Art, 1961.

SWEENEY, JAMES J. *Alexander Calder.* New York: Solomon R. Guggenheim Museum, 1964.

TILLIM, SIDNEY. "Earthworks and the New Picturesque," *Artforum*, December, 1968.

TUCHMAN, MAURICE. *American Sculpture of the Sixties.* Los Angeles, Calif.: Los Angeles County Museum, 1967.

VARIAN, ELAYNE H. *Art in Process: The Visual Development of a Structure.* New York: Finch College Museum of Art, 1966.

List of Illustrations

Artists are listed in alphabetical order. All works are oil on canvas unless otherwise noted. Numbers opposite titles indicate Chapter and Plate No.

BELLOWS, George (1882–1925)
Stag at Sharkey's, 1907 3-13
36¼" × 48¼"
The Cleveland Museum of Art, Hinman B. Hurlbut Collection

The Circus, 1912 3-5
34" × 44"
Addison Gallery of American Art, Phillips Academy, Andover, Mass.

Dempsey and Firpo, 1924 3-15
51" × 63¼"
Collection Whitney Museum of American Art, New York

BENGSTON, Billy Al (1934–)
Boris, 1964 9-20
Oil lacquer on board, 62" × 48½"
Courtesy Blum Hellman Gallery, New York

BENTON, Thomas Hart (1889–)
City Scenes, 1930 5-6
Oil on board, 77½" × 145½"
New School for Social Research, New York

BIDDLE, George (1885–)
Sweatshop, ca. 1935 5-11
Study for fresco, fifth floor stairwell, Justice Department Building, Washington, D.C.
Tempera on board, 40¾" × 31⅛"
Collection University of Maryland, College Park, Md.

BISHOP, Isabel (1902–)
Nude, 1934 5-4
Oil on composition board, 33" × 40"
Collection Whitney Museum of American Art, New York

BLADEN, Ronald (1918–)
The X, 1967 11-55
Painted wood, 272" × 294" × 150"
Courtesy Fischbach Gallery, New York

BLUEMNER, Oscar (1867–1938)
Old Canal Port, 1914 2-1
30¼" × 40¼"
Collection Whitney Museum of American Art, New York

BLUME, Peter (1906–)
South of Scranton, 1931 5-15
56" × 66"

The Metropolitan Museum of Art, New York, George A. Hearn Fund

BOLOTOWSKY, Ilya (1907–)
White Abstraction, 1934–35 5-35
36¾" × 19"
Courtesy Grace Borgenicht Gallery, New York

BONTECOU, Lee (1931–)
Untitled, 1962 11-33
Welded steel with canvas, 75" × 83" × 28"
Courtesy Leo Castelli Gallery, New York

BRAQUE, Georges (1882–1963)
L'Affiche de Kubelick (Le Violon),
1912 3-9
18" × 24"
Collection Andreas L. Speiser, Basel, Switzerland

BRUCE, Patrick Henry (1881–1937)
Still Life, ca. 1929–30 4-9
23¼" × 36"
Collection Benjamin Garber, New York

BURCHFIELD, Charles (1893–1967)
Noontide in Late May, 1917 5-8
Water color and gouache, 21⅜" × 17⅜"
Collection Whitney Museum of American Art, New York

CALDER, Alexander (1898–)
Little Red Under Blue, 1947 11-10
Iron-like construction, 58" × ca. 82"
Courtesy Fogg Art Museum, Harvard University, Cambridge, Mass.

Three Arches, 1963 11-11
Painted metal, 108" × 112½" × 145"
Munson-Williams-Proctor Institute, Utica, New York

CARLES, Arthur B. (1882–1952)
L'Eglise, ca. 1910 2-2
31" × 39"
The Metropolitan Museum of Art, New York, Arthur H. Hearn Fund, 1962

Courtesy The Downtown Gallery,
New York
Photograph Geoffrey Clements

The Paris Bit, 1959 5-27
46″ × 60″
Collection Whitney Museum of American Art, New York, Gift of the Friends of the Whitney Museum of American Art

DE KOONING, Willem (1904–)
Untitled, 1937 5-36
Oil on board, 8″ × 13½″
Collection Mr. and Mrs. Stephen D. Paine, Boston
Photograph Barney Burstein

Queen of Hearts, 1943–46 6-27
Oil on board, 46″ × 27½″
Collection the Hirshhorn Museum and Sculpture Garden, Smithsonian Institution, Washington, D.C.

Pink Angels, ca. 1947 6-31
52″ × 40″
Collection Mr. and Mrs. Frederick R. Weisman, Beverly Hills, Calif.

Woman, 1948 6-28
53½″ × 44½″
Collection the Hirshhorn Museum and Sculpture Garden, Smithsonian Institution, Washington, D.C.

Sailcloth, ca. 1949 6-30
27″ × 32″
Courtesy Sidney Janis Gallery, New York

Woman, I, 1950–52 6-29
75⅞″ × 58″
Collection The Museum of Modern Art, New York

DE RIVERA, José (1904–)
Construction #85, 1964 11-36
Bronze, 8″ × 10″ × 10″
Collection Mr. and Mrs. Herbert Beenhouwer, Scarsdale, N.Y.
Courtesy Grace Borgenicht Gallery, New York

DEMUTH, Charles (1883–1935)
Trees and Barns, Bermuda, 1917 4-19
Water color, 9½″ × 13½″
Williams College Museum of Art, Williamstown, Mass.

Machinery, 1920 4-20
Tempera and pencil on cardboard, 24″ × 19⅞″
The Metropolitan Museum of Art, New York, Alfred Stieglitz Collection, 1949

Incense of a New Church, 1921 4-23
25½″ × 19¾″
Howard Collection, Columbus Gallery of Fine Arts, Columbus, Ohio

My Egypt, 1927 4-30
Oil on composition board, 35¾″ × 30″
Collection Whitney Museum of American Art, New York

DI SUVERO, Mark (1933–)
Hank Champion, 1960 11-28
Wood and chain, 84″ × 120″
Collection Mr. and Mrs. Robert C. Scull, New York
Courtesy Park Place Gallery, New York

For Robling, 1971 11-59
Welded steel, 118″ × 132″ × 96″
Collection Mr. and Mrs. S. I. Newhouse, Jr.
Photograph Eric Pollitzer

Ik Ook, 1971–1972 11-58
Painted steel, 288″ × 480″
Collection the artist
Courtesy Richard Bellamy, New York
Photograph Bernd Kirtz, BFF

DICKINSON, Edwin (1891–)
The Fossil Hunters, 1926–28 5-19
96½″ × 73¾″
Collection Whitney Museum of American Art, New York

DICKINSON, Preston (1891–1930)
Industry, II, ca. 1924 4-1
24¾″ × 30″
Collection Whitney Museum of American Art, New York, Gift of Mr. and Mrs. Alan H. Temple
Photograph Oliver Baker Associates

DIEBENKORN, Richard (1922–)
Ocean Park, No. 67, 1973 10-9
100″ × 81″
Courtesy Marlborough Gallery Inc., New York

Collection Whitney Museum of American Art, New York, Gift of the Friends of the Whitney Museum of American Art
Photograph Geoffrey Clements

GRAVES, Nancy (1940–)
Indian Ocean Floor I, 1972 **10-17**
Acrylic on canvas, 90″ × 72″
Collection First City National Bank, Houston, Texas
Courtesy Janie C. Lee Gallery, Houston, Texas
Photograph Shunk-Kender

GREENE, Stephen (1918–)
The Burial, 1947 **5-18**
42″ × 55″
Collection Whitney Museum of American Art, New York

GUSTON, Philip (1913–)
Passage, 1957–58 **7-16**
65″ × 74″
Collection Mr. and Mrs. David E. Bright, Beverly Hills, Calif.
Courtesy Los Angeles County Museum of Art

HAGUE, Raoul (1904–)
Walnut—1949, 1949 **11-25**
Walnut, 45″ × 26″ × 14″
Collection Mr. and Mrs. Roy R. Neuberger, New York

HANSON, Duane (1925–)
Vietnam Scene, 1969 **9-23**
Mixed media tableau
Courtesy OK Harris Gallery, New York

HARE, David (1917–)
Juggler, 1950–51 **11-18**
Steel, 80¼″ h.
Collection Whitney Museum of American Art, New York

HARTLEY, Marsden (1877–1943)
Mountain Lake, Autumn, ca.
 1908 **2-8**
Oil on academy board, 12″ × 12″
The Phillips Collection, Washington, D.C.

Painting, Number 5, 1914–15 **2-11**
39½″ × 31¾″
Collection Whitney Museum of American Art, New York, Anonymous gift

Movement #2, 1916 **4-4**
Oil on composition board, 24″ × 20″
Courtesy Wadsworth Atheneum, Hartford, Conn.

Fishermen's Last Supper—Nova
 Scotia, 1940–41 **2-9**
29⅞″ × 41″
Collection Mr. and Mrs. Roy R. Neuberger, New York
Photograph Geoffrey Clements

HELD, Al (1928–)
Venus Arising, 1963 **8-16**
Acrylic on canvas, 71″ × 49″
Courtesy André Emmerich Gallery, New York

Flemish I, 1972 **9-14**
Acrylic on canvas, 60″ × 60″
Courtesy André Emmerich Gallery, New York

HENRI, Robert (1856–1929)
Laughing Boy, 1907 **1-6**
24¼″ × 19⅛″
Collection Whitney Museum of American Art, New York

HESSE, Eva (1936–72)
Repetition 19, III, 1968 **11-41**
Fiberglass units, approx. 20″ high, approx. 12″ diameter
Collection The Museum of Modern Art, New York, Gift of Anita and Charles Blatt
Courtesy Fischbach Gallery, New York

HOFMANN, Hans (1880–1966)
Effervescence, 1944 **6-5**
54⅛″ × 35½″
University Art Museum, University of California, Berkeley

Cathedral, 1959 **6-6**
74″ × 48″
Collection Professor William Rubin, New York

300

NEVELSON, Louise (1900–)
Black Majesty, 1955 **11-27**
Painted wood, 65″ × 32″
Collection Whitney Museum of American Art, New York, Gift of Mr. and Mrs. Ben Mildwoff through the Federation of Modern Painters & Sculptors

NEWMAN, Barnett (1905–70)
The Euclidean Abyss, 1946-47 **7-2**
28″ × 22″
Collection Mr. and Mrs. Burton Tremaine, Meriden, Conn.

Tundra, 1950 **7-5**
72″ × 89″
Collection Mr. and Mrs. Robert C. Scull, New York

NOGUCHI, Isamu (1904–)
Kouros, 1944–45 **11-24**
Pink Georgia marble, slate base, 117″ × 34⅛″ × 42″
The Metropolitan Museum of Art, New York, Fletcher Fund, 1953

NOLAND, Kenneth (1924–)
Par Transist, 1966 **8-11**
Acrylic on canvas, 114″ × 240″
Courtesy André Emmerich Gallery, New York

Lift in Abeyance, 1971 **10-8**
Acrylic on canvas, 100¼″ × 24³⁄₁₆″
Courtesy André Emmerich Gallery, New York

NOVROS, David (1941–)
Untitled, 1973 **10-16**
106″ × 76″
Courtesy Bykert Gallery, New York
Photograph Nathan Rabin

O'KEEFFE, Georgia (1887–)
Portrait W, No. II, 1917 **2-7**
Water color, 12″ × 9″
Collection Mr. and Mrs. James W. Alsdorf, Winnetka, Ill.
Courtesy The Downtown Gallery, New York

Black Spot, No. 2, 1919 **2-6**
24″ × 16″
Collection Mr. and Mrs. Irving Levick, Buffalo, N.Y.

New York Night, 1928–29 **4-28**
40⅛″ × 19⅛″
Nebraska Art Association, Sheldon Gallery, Lincoln, Neb.

OLDENBURG, Claes (1929–)
Hamburger with Pickle and Tomato Attached, 1963 **8-5**
Plaster, cloth, metal, and enamel, 72″ × 72″ × 72″
Collection Carroll Janis, New York
Photograph Geoffrey Clements

Giant Soft Drum Set, 1967 **11-39**
Vinyl and canvas, 84″ × 72″ × 48″
Collection Kimiko and John Powers
Courtesy the artist
Photograph Ralph E. Mates and Paul Katz

Soft Version of Maquette for a Monument Donated to Chicago by Pablo Picasso (Soft Picasso), 1968 **11-40**
Canvas, rope, and acrylic paint, 38″ × 28¾″ × 21″
Collection William Copley, New York
Courtesy the artist
Photograph Nathan Rabin

Giant Icebag, 1969 **11-53**
Vinyl, hydraulic mechanism, and wood, 84–192″ × 144–180″
Courtesy Los Angeles County Museum of Art

Lipstick on Caterpillar Tracks, 1969
Steel and aluminum, 288″h. **9-22**
Collection Yale University Art Gallery, New Haven
Courtesy the artist
Photograph Harry Shunk

OLITSKI, Jules (1922–)
Prince Patutsky Command, 1965 **8-13**
164½″ × 70½″
Courtesy André Emmerich Gallery, New York

Seventh Loosha, 1970 **10-6**
Acrylic on canvas, 107½″ × 68″
Courtesy Knoedler Contemporary Art, Lawrence Rubin, New York
Photograph Eric Pollitzer

PARKER, Ray (1922–)
Untitled, 1959 8-1
68½" × 69"
Albright-Knox Art Gallery, Buffalo,
N.Y., Gift of Seymour H. Knox

PEARLSTEIN, Philip (1924–)
*Female Model in Robe Seated on Plat-
form Rocker*, 1973 10-22
72" × 60"
Courtesy Allan Frumkin Gallery, Inc.,
New York
Photograph Eric Pollitzer

PÈNE DU BOIS, Guy (1884–1958)
Woman with Cigarette, 1929 3-14
36¼" × 28¾"
Collection Whitney Museum of Amer-
ican Art, New York

PEPPER, Beverly (1924–)
Paraclete, 1973 11-57
Steel, 192" × 342"
Collection the artist

PICABIA, Francis (1878–1953)
Dances at the Spring, 1912 3-7
47½" × 47½"
Philadelphia Museum of Art, Louise
and Walter Arensberg Collection

PICASSO, Pablo (1881–1973)
The Studio, 1927–28 5-39
59" × 91"
Collection The Museum of Modern
Art, New York, Gift of Walter P.
Chrysler, Jr.

POLLOCK, Jackson (1912–56)
Untitled, ca. 1937 6-16
15" × 20"
Courtesy Marlborough Fine Art, Ltd.,
London
Mural, 1943 6-18
95½" × 228"
The University of Iowa, Iowa City
Pasiphaë, 1943 6-19
56⅛" × 96"
Courtesy Marlborough-Gerson Gallery,
Inc., New York
Totem Lesson II, ca. 1945 6-17
70⅛" × 60"
Collection Mrs. Lee Krasner Pollock
Courtesy Marlborough-Gerson Gallery,
Inc., New York

Eyes in the Heat, 1946 6-20
54" × 43"
Collection Peggy Guggenheim, Venice
Mural on Indian Red Ground,
1950 6-21
72" × 96"
Collection Professor William Rubin,
New York
Number 27, 1951 6-22
Duco on canvas, 53¾" × 74"
Courtesy Marlborough-Gerson Gallery,
Inc., New York

POONS, Larry (1937–)
Han-San Cadence, 1963 8-18
Acrylic and fabric dye on canvas, 72"
× 144"
Des Moines Art Center–Nathan Emory
Coffin Memorial Collection
Courtesy Leo Castelli Gallery, New
York
Railroad Horse, 1971 10-1
Acrylic on canvas, 94¼" × 303"
Courtesy Museum of Fine Arts, Bos-
ton, Charles H. Hayden Fund, 1971
Photograph Eric Pollitzer

POUSETTE-DART, Richard
(1916–)
Desert, 1940 6-7
42" × 72¼"
Collection the artist, Suffern, N.Y.

PRENDERGAST, Maurice
(1859–1924)
Piazza di San Marco, ca. 1898 1-13
Water color on paper, 16⅛" × 15"
The Metropolitan Museum of Art,
New York, Gift of the Estate of
Mrs. Edward Robinson, 1952
The Promenade, 1913 1-14
30" × 34"
Collection Whitney Museum of Amer-
ican Art, New York, Bequest of
Alexander M. Bing

RAUSCHENBERG, Robert
(1925–)
Satellite, 1955 8-2
Combine painting, 80" × 42½"
Collection Mrs. Claire Zeisler, Chicago
Courtesy Leo Castelli Gallery, New
York

SEGAL, George (1924–)
Cinema, 1963 8-6
Plaster, illuminated Plexiglas, and
metal sign, 118″ × 96″ × 39″
Courtesy Sidney Janis Gallery, New
York

SERRA, Richard (1939–)
Number 1 (Two Plates with Pole),
1969 11-45
Lead antimony, approx. 51″ × 98″
× 48″
Courtesy Leo Castelli Gallery, New
York
Photograph Peter Moore

Untitled, 1970 11-46
Lead, 19″ × 108″ × 179″
Collection Jasper Johns
Courtesy Leo Castelli Gallery, New
York

SHAHN, Ben (1898–1969)
The Passion of Sacco and Vanzetti,
1931–32 5-13
From the Sacco-Vanzetti series of 23
paintings
Tempera on canvas, 84½″ × 48″
Collection Whitney Museum of Amer-
ican Art, New York, Gift of Edith
and Milton Lowenthal in memory
of Juliana Force

SHEELER, Charles (1883–1965)
Chrysanthemums, 1912 3-4
24″ × 20″
Collection Whitney Museum of Amer-
ican Art, New York, Gift of the
artist
Photograph Oliver Baker Associates

Barns, 1917 4-17
Conté crayon on paper, 6″ × 8¹⁵⁄₁₆″
Albright-Knox Art Gallery, Buffalo,
N.Y., Gift of A. Conger Goodyear

Barn Abstraction, 1918 4-18
Black conté crayon on casein paper,
17¾″ × 24¼″
Philadelphia Museum of Art, Louise
and Walter Arensberg Collection

Classic Landscape (River Rouge Plant),
1931 4-22
25″ × 32¼″
Collection Mrs. Edsel B. Ford, De-
troit, Mich.

American Interior, 1934 4-21
31½″ × 30″
Yale University Art Gallery, New
Haven, Conn., Gift of Mrs. Paul
Moore

SHIELDS, Alan (1944–)
Wow, It's a Real Cannonball,
1972–73 10-2
Mixed media, 72½″ × 72½″
Collection Beatrice Monti da Rezzori,
Milan
Courtesy Paula Cooper Gallery, New
York
Photograph Robert E. Mates and
Paul Katz

SHINN, Everett (1876–1953)
*Sixth Avenue Elevated After. Mid-
night,* 1899 1-8
Pastel on paper, 8″ × 12½″
Collection Mr. and Mrs. Arthur G.
Altschul, New York

SLOAN, John (1871–1951)
The Cot, 1907 1-7
36¼″ × 30″
Bowdoin College Museum of Art,
Brunswick, Me., bequest of George
Otis Hamlin

Hairdresser's Window, 1907 1-4
31⅛″ × 26″
Courtesy Wadsworth Atheneum, Hart-
ford, Conn.

The Wake of the Ferry, 1907 1-9
26″ × 32″
The Phillips Collection, Washington,
D.C.

Sunday, Women Drying Their Hair,
1912 3-2
25½″ × 31½″
Addison Gallery of American Art,
Phillips Academy, Andover, Mass.

SMITH, David (1906–65)
*Blackburn—Song of an Irish Black-
smith,* 1950 11-13
Steel and bronze, 38½″ × 40¾″
Estate of the artist
Courtesy Marlborough-Gerson Gallery,
Inc., New York

Hudson River Landscape, 1951 11-14
Steel, 75″ l.
Collection Whitney Museum of American Art, New York
Photograph Geoffrey Clements

Zig VII, 1963 11-15
Painted steel, 94¾″ × 100⅜″
Courtesy Marlborough-Gerson Gallery, Inc., New York

l. to r.: Cubi XVIII, 1964; *Cubi XVII,* 1963; *Cubi XIX,* 1964 11-16
Stainless steel, 107″ h.; 107¾″ h.; 113⅛″ h.
Courtesy Marlborough-Gerson Gallery, Inc., New York

SMITH, Tony (1912–)
Gracehoper, 1961 11-54
Sheet steel, 276″ × 264″ × 552″
Collection The Detroit Institute of Arts, commissioned by the Founders' Society and Friends of Modern Art

SMITHSON, Robert C. (1938–73)
Spiral Jetty, 1970 11-60
Earthwork (Great Salt Lake, Utah)
Photograph courtesy John Weber Gallery, New York

SONNIER, Keith (1941–)
Untitled, 1969 (destroyed) 11-42
Flock and string, 108″ × 48″
Courtesy Leo Castelli Gallery, New York

SOYER, Raphael (1899–)
Office Girls, 1936 5-2
26″ × 24″
Collection Whitney Museum of American Art, New York

SPENCER, Niles (1893–1952)
Erie Underpass, 1949 4-26
28″ × 36″
The Metropolitan Museum of Art, New York, Arthur H. Hearn Fund, 1950

STANKIEWICZ, Richard (1922–)
Kabuki Dancer, 1956 11-32
Iron and steel, 84″ h.

Collection Whitney Museum of American Art, New York, Gift of the Friends of the Whitney Museum of American Art

STELLA, Frank (1936–)
Ifafa II, 1964 8-17
Metallic powder in acrylic emulsion on canvas, 89″ × 155″
Collection Mr. and Mrs. Robert C. Scull, New York
Courtesy Leo Castelli Gallery, New York

Moultonboro IV, 1966 9-13
Acrylic on canvas, 110″ × 120¼″
Courtesy Knoedler Contemporary Art, Lawrence Rubin, New York
Photograph Eric Pollitzer

Mogielnica II, 1972 10-5
Mixed media, 86½″ × 124″
Courtesy Leo Castelli Gallery, New York
Photograph Eric Pollitzer

STELLA, Joseph (1880–1946)
Battle of Lights, Coney Island,
 1913–14 4-3
76″ × 84″
Yale University Art Gallery, New Haven, Conn., Collection Société Anonyme

Brooklyn Bridge, 1917–18 4-27
Oil and lithographic crayon on sheet, 84″ × 76″
Yale University Art Gallery, New Haven, Conn., Collection Société Anonyme

Collage #11, ca. 1921 4-11
11½″ × 17″
Collection Mr. and Mrs. Morton Baum, New York
Courtesy Zabriskie Gallery
Photograph John D. Schiff

STILL, Clyfford (1904–)
1943-A 7-4
Oil on blue cloth, 35½″ × 30″
Collection the artist, Westminster, Md.
Photograph Eric Pollitzer

Jamais, 1944 7-3
65″ × 31½″
Collection Peggy Guggenheim, Venice

1948-D, 1948 7-6
92″ × 80″
Collection Professor William Rubin, New York

STORRS, John (1885–1956)
Seated Gendarme, 1925 11-4
Bronze, 18″ h.
Courtesy Zabriskie Gallery, New York

SUGARMAN, George (1912–)
The Shape of Change, 1964 11-30
Laminated wood, 72″ h.
Collection Arnold H. Maremont, Chicago
Courtesy Stephen Radich Gallery, New York

TAYLOR, Henry Fitch (1853–1925)
Guitar Series, ca. 1914 3-16
32″ × 20″
Courtesy Noah Goldowsky
Photograph John D. Schiff

TOBEY, Mark (1890–)
New Life (Resurrection), 1957 7-1
Tempera, 43⅜″ × 27¼″
Collection Whitney Museum of American Art, New York, Gift of the Friends of the Whitney Museum of American Art

TOMLIN, Bradley Walker
(1899–1953)
Number 20, 1949 7-18
86″ × 70¼″
Collection The Museum of Modern Art, New York, Gift of Philip Johnson

TWORKOV, Jack (1900–)
Watergame, 1955 7-17
Collection Mr. and Mrs. Lee V. Eastman, New York
Courtesy the artist, New York

WALKOWITZ, Abraham (1880–1965)
New York, 1917 2-5
Water color, ink, and pencil, 30⅝″ × 21¾″
Collection Whitney Museum of American Art, New York, Gift of the artist in memory of Juliana Force

WARHOL, Andy (1930–)
Jackie, 1965 9-25
Silk-screen ink on paper, 40″ × 30″
Courtesy Leo Castelli Gallery, New York
Photograph Rudolph Burckhardt

Mao Tse-tung, 1972 10-21
Silk-screen, 36″ × 36″
Courtesy Leo Castelli Gallery, New York

WEBER, Max (1881–1961)
Figure Study, 1911 2-3
24″ × 40″
Albright-Knox Art Gallery, Buffalo, N.Y., Charles W. Goodyear Fund

Chinese Restaurant, 1915 2-4
40″ × 48″
Collection Whitney Museum of American Art, New York

Rush Hour, New York, 1915 4-2
36″ × 30″
Courtesy The Downtown Gallery, New York
Photograph Geoffrey Clements

Spiral Rhythm, 1915 11-2
Bronze, 24½″ h.
Collection the Hirshhorn Museum and Sculpture Garden, Smithsonian Institution, Washington, D.C.

WESSELMANN, Tom (1931–)
Great American Nude, No. 48.
1963 9-2
Mixed media, 81″ × 106″
Private collection
Courtesy Sidney Janis Gallery, New York

WHITMAN, Robert (1935–)
Pond, 1968 11-51
Mixed media
Courtesy Bykert Gallery, New York
Photograph Eric Pollitzer

Index

Page numbers in italic denote illustrations.

315